We Are One

We Are One

A PHOTOGRAPHIC CELEBRATION OF DIVERSITY IN AMERICA

BY RUSSEL HILES

BEYOND WORDS PUBLISHING, INC.

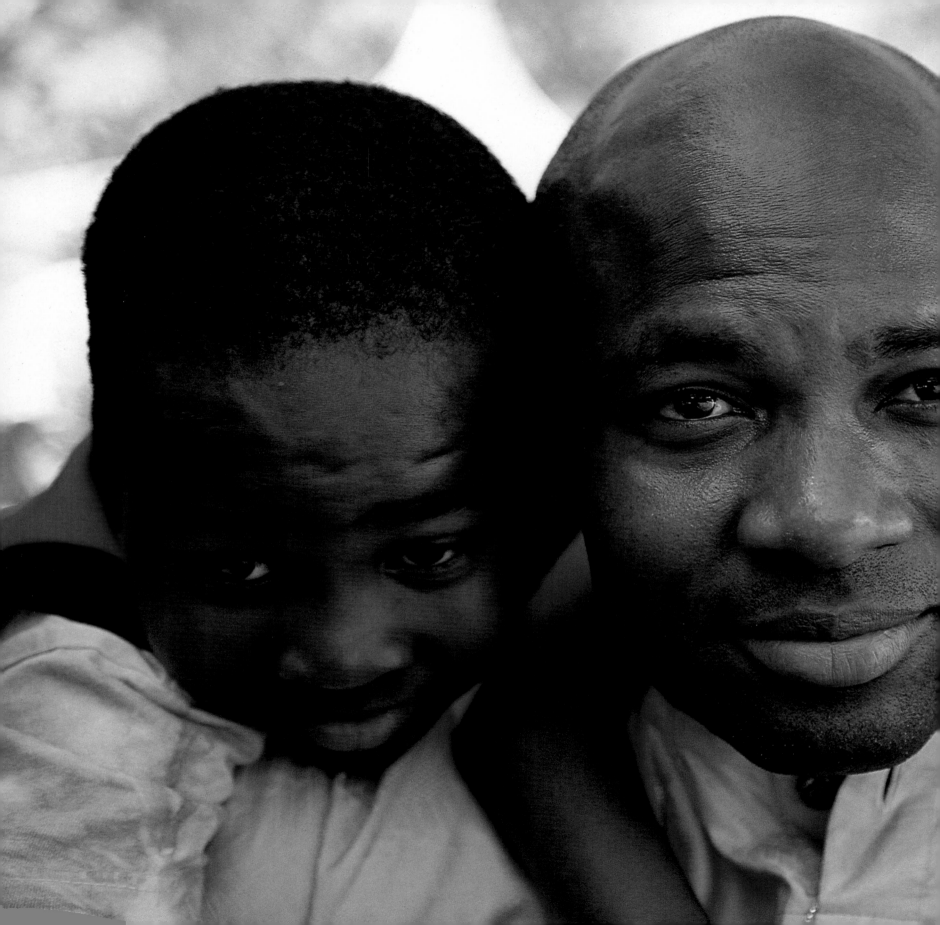

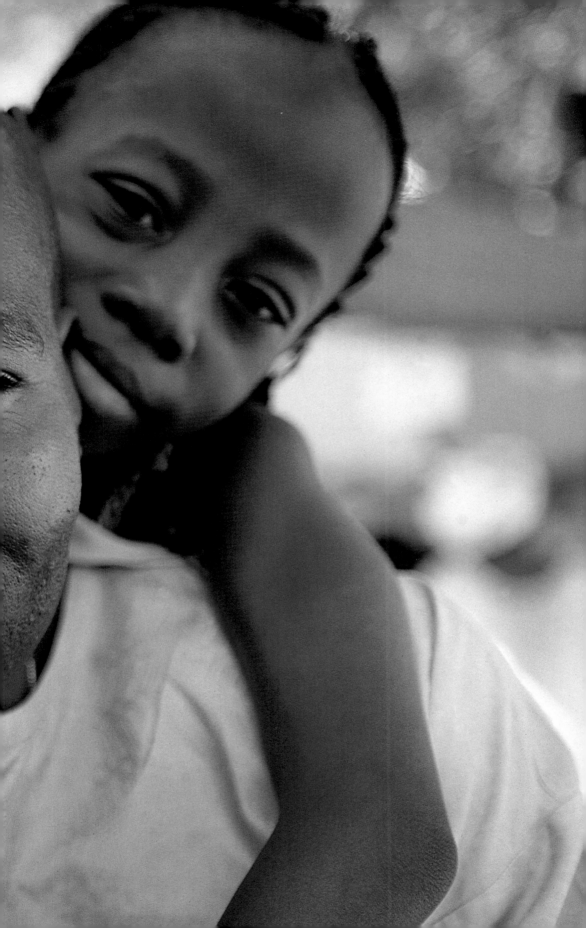

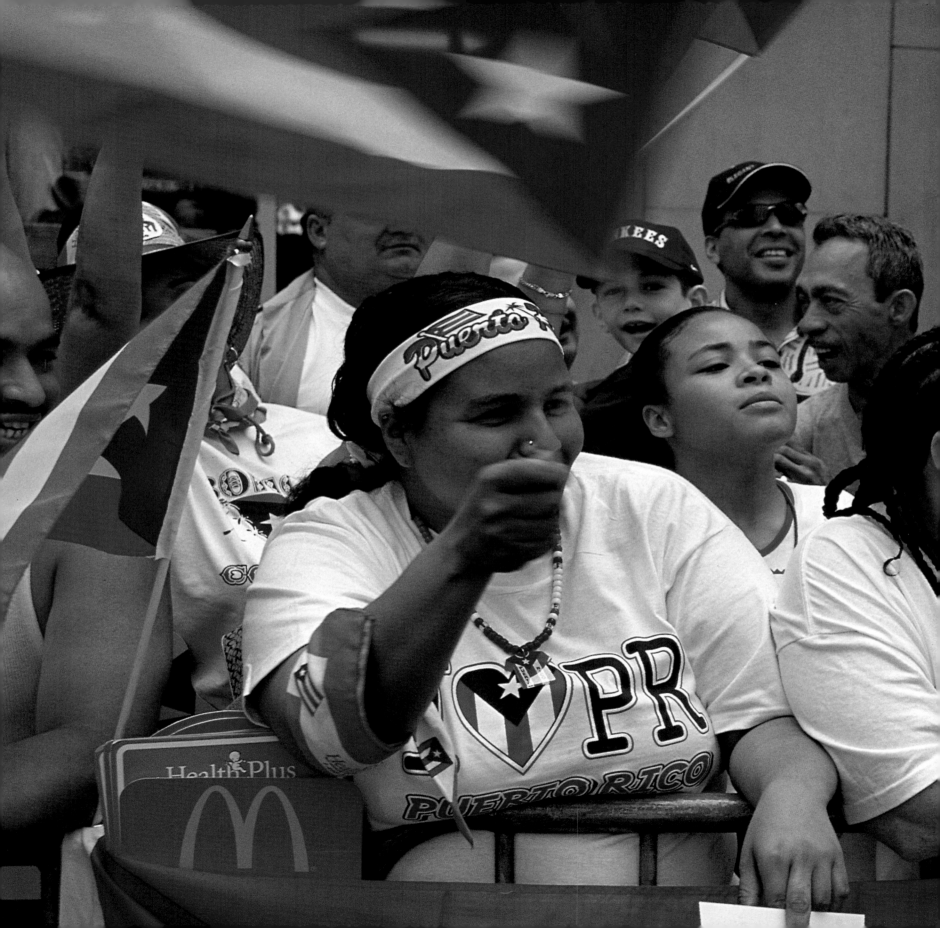

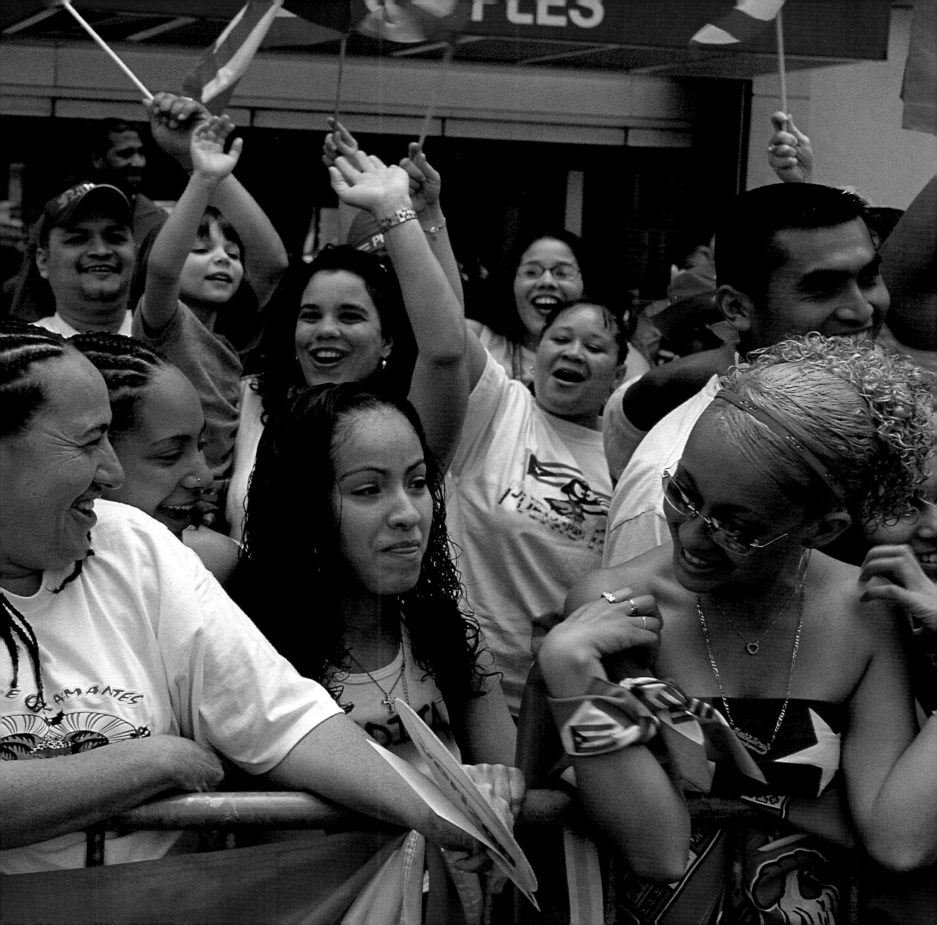

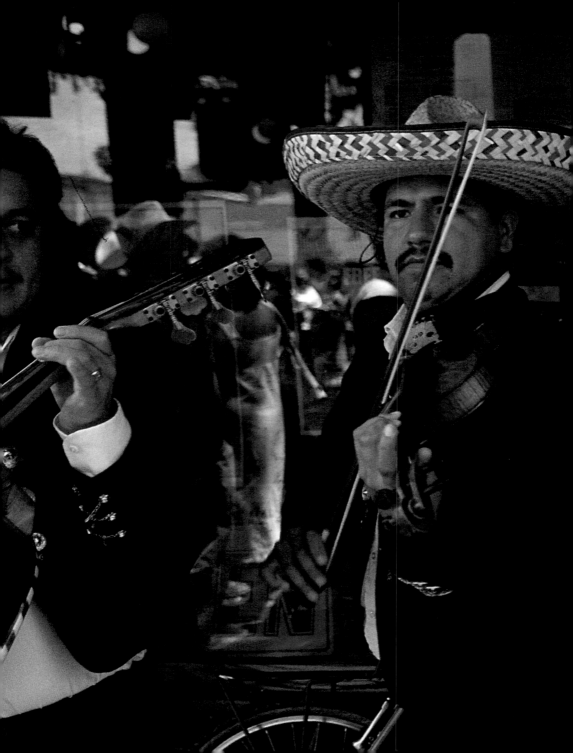

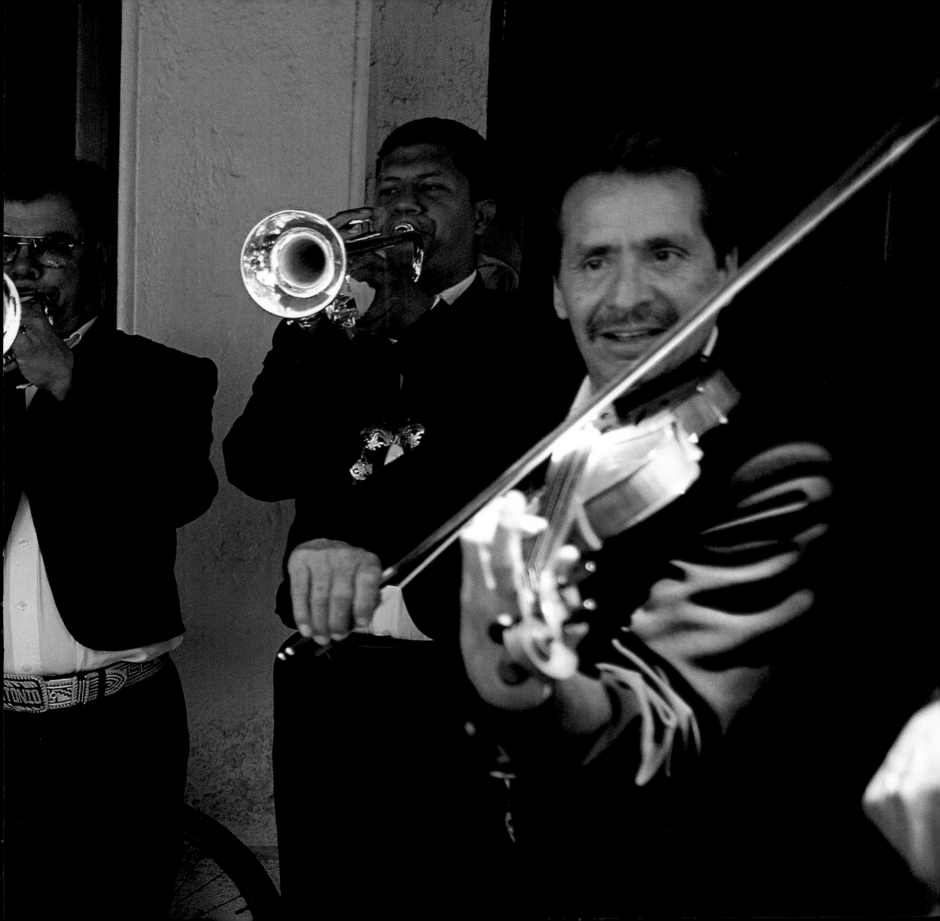

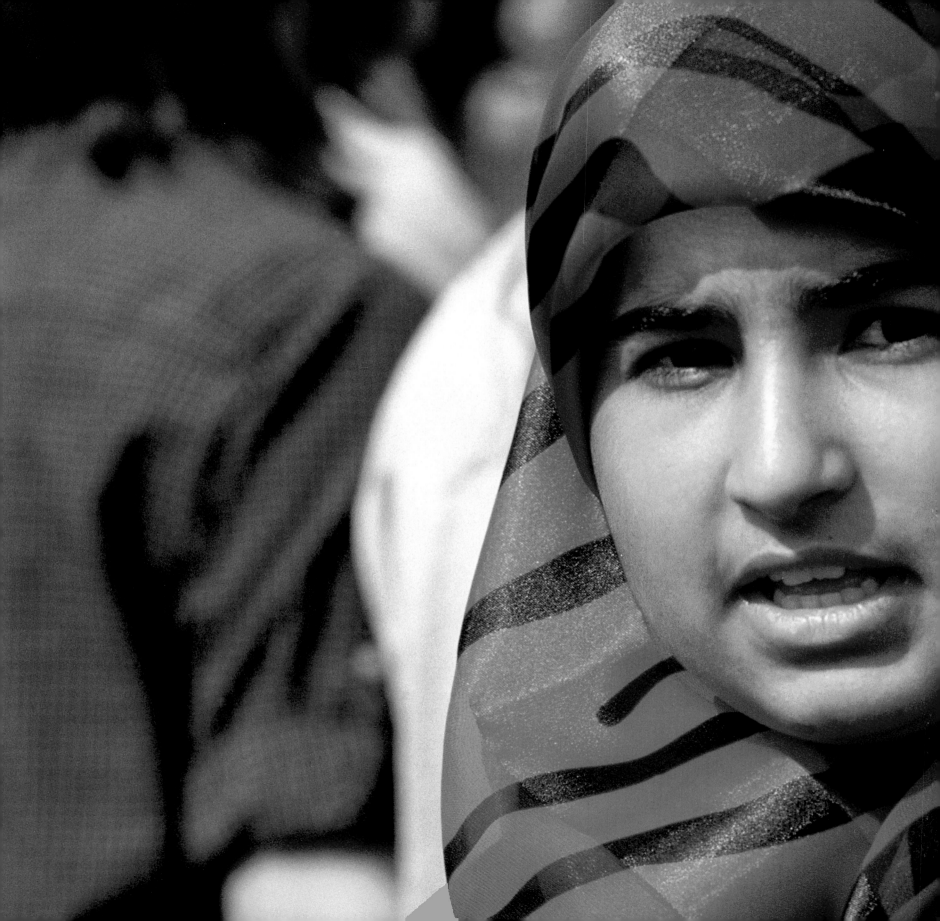

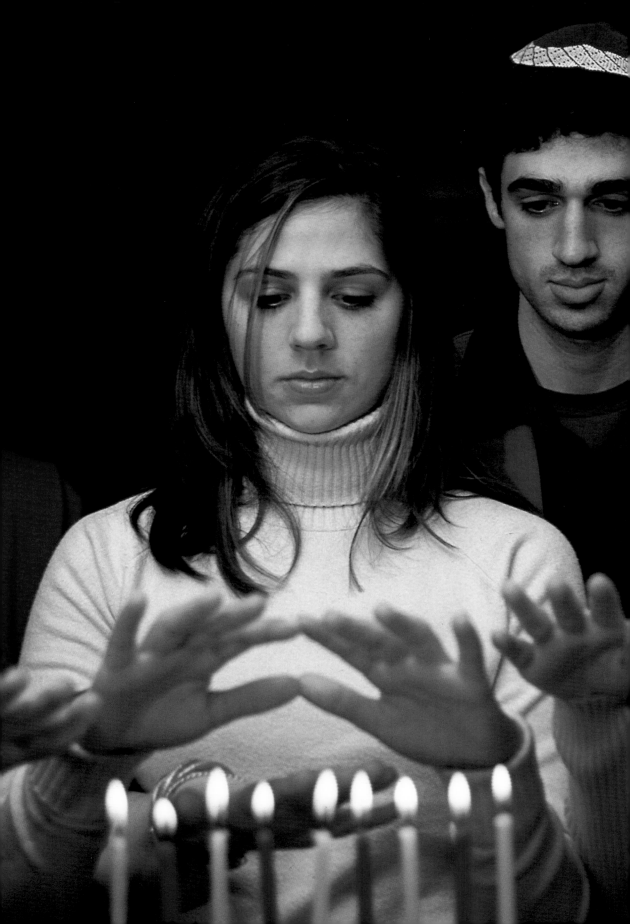

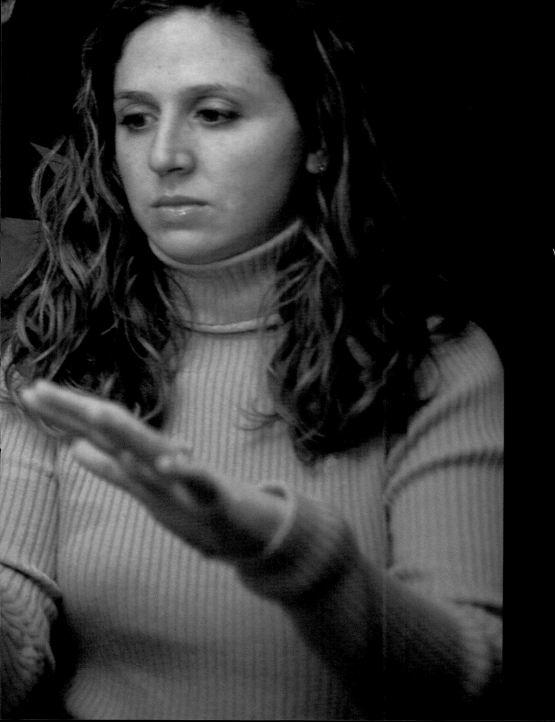

To Teri, Shelby, Bennett, and Alison,
with all the warmth and love a father can giv

A special acknowledgement to those
wonderful scientists at the Diabetes Research Institute
whose magnificent dedication is curing diabetes.
We all thank you.

DIABETES
RESEARCH
INSTITUTE

UNIVERSITY OF
MIAMI SCHOOL
OF MEDICINE

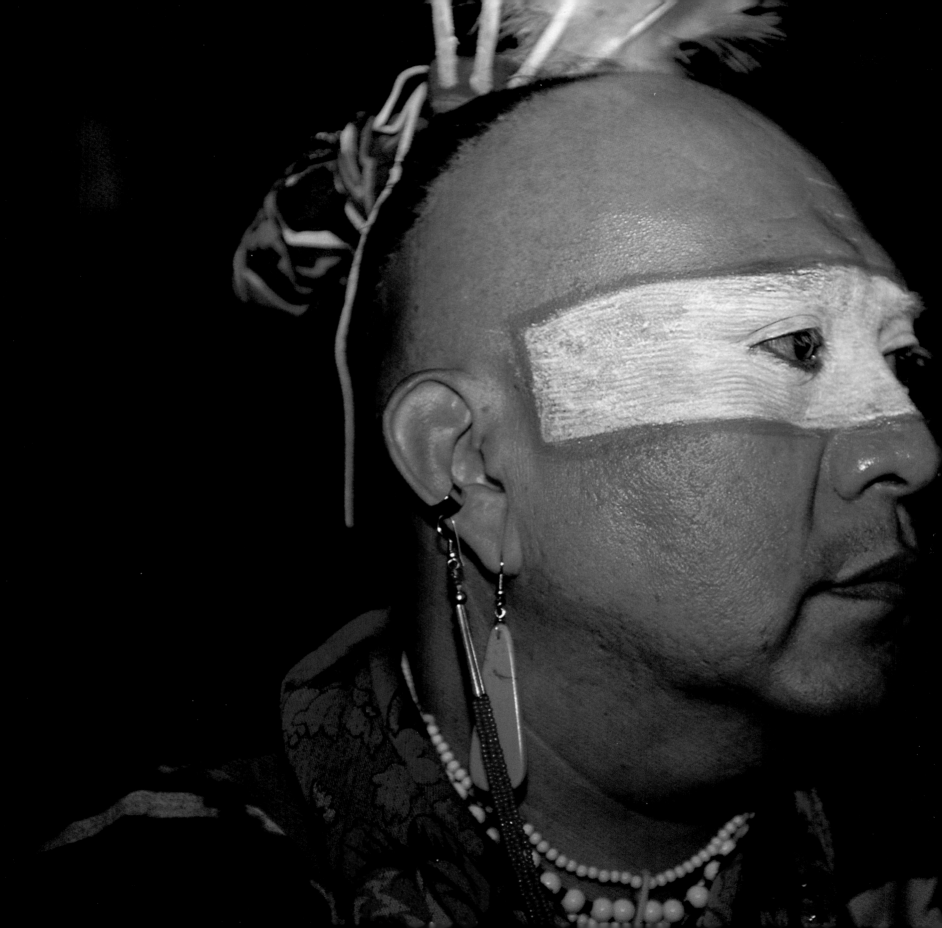

Contents

Foreword

I am African. I am Asian. I am European. I am Mexican. I am all of these because of the cultures that have bred me. We are all one race. We are the human race. And we are the exquisite culmination of all the cultures that have preceded us. We are all human beings. We all have anger in our souls but love in our hearts. We all share the same angst; all of us have struggled, and yet we have all triumphed just the same.

Words have strange meanings to us all. For hundreds of years we have been using a divisive term that we call "race" to distinguish characteristics of others and to define our lineage. Some of us use *race* as a pejorative and distinctive mechanism to establish our superiority over others and thus to make ourselves feel better. But this selfish approach is one that none of us should ever use.

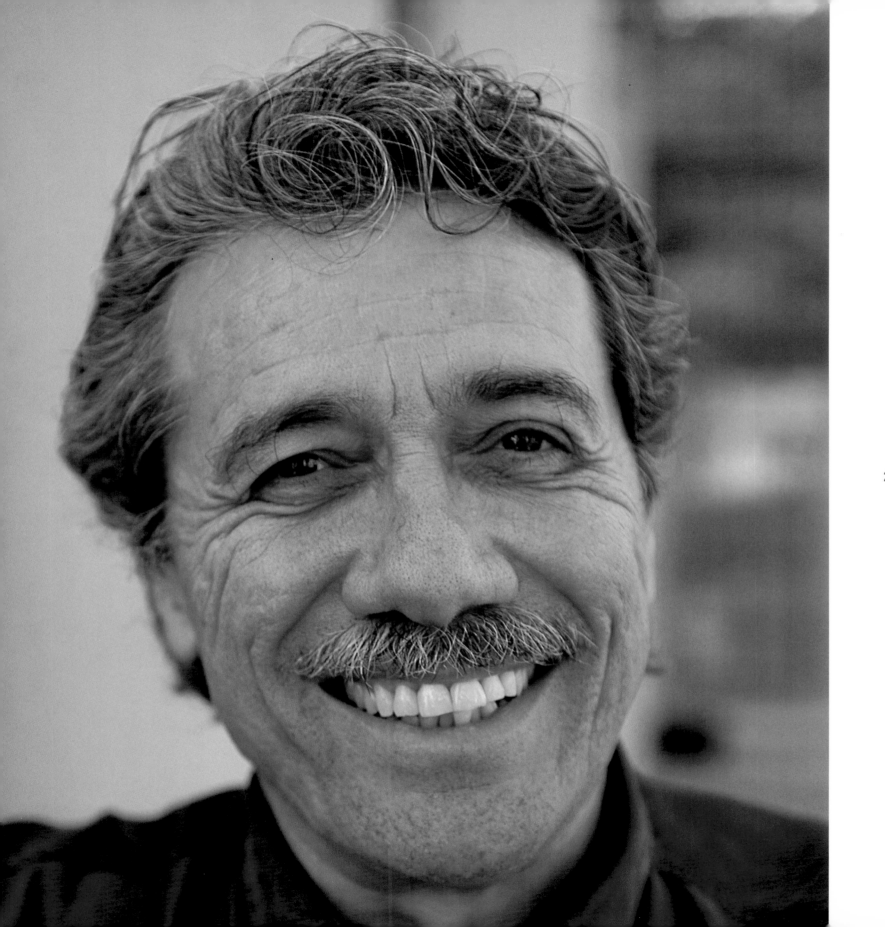

I wish it were more obvious to everyone that rejection and the pushing away of others breed hatred and ill will, whereas the opposite result is achieved when we strive to be benevolent and assist others. A strange occurrence takes place when that happens; those who we push forward yearn to pull us forward with them and, at times, even further than themselves. Like skaters on open ice, as we lead the last individual forward, they pull us along with them, and beyond them, to even greater heights. So too, our acceptance and love of each other empowers us all and enables those who are being uplifted to uplift others as well.

I am a third-generation Latino living in the United States. My grandparents were born in Mexico and came to this country poor and uneducated. They gave me opportunities to rise to where I am, to soar. I embrace the diversity about me; I love every part of it. If you trace backwards through my ancestral heritage, you will pass through the realm of my Mexican ancestors; on to my European ancestors; through my Asian ancestors; to my African roots. I cannot conceive of being any different than what I am. While my DNA remains constant, my very bodily makeup is transformed through all of these different cultures and different humans. True, they may have had different rituals for their belief in God, different surroundings in which they lived, and different spoken languages that are alien to me, but they spawned my very existence and made me who I am.

I am proud of my ethnic diversities and of this magnificent country in which I live. There is no other country on earth that has such diversity, with its various freedoms. Freedom gives rise to opportunity, and opportunity gives rise to the phenomenal lives we lead. I recognize where I came from and how I exist within the framework of this magnificent land. And I, too, have heroes such as César Chávez. Though he is a cultural icon with no different DNA than me, he represents my ideals and my love of all mankind and is representative of what we all embrace. None of us should be tolerant of anything less than an open, fair, and free society in which we share our love and passion for each other's differences. Yes, we are different, but we are all one people.

As you can see in the following pages, this book allows us to view our similarities and our differences. Our similarities are that we are all one people, and we all love the freedoms that this wonderful country provides. Our differences are in our individual cultural rituals and activities that make us interesting and diverse. Embrace that diversity, my friends; embrace it. Yes, we are different, but "We are one."

—*Edward James Olmos*

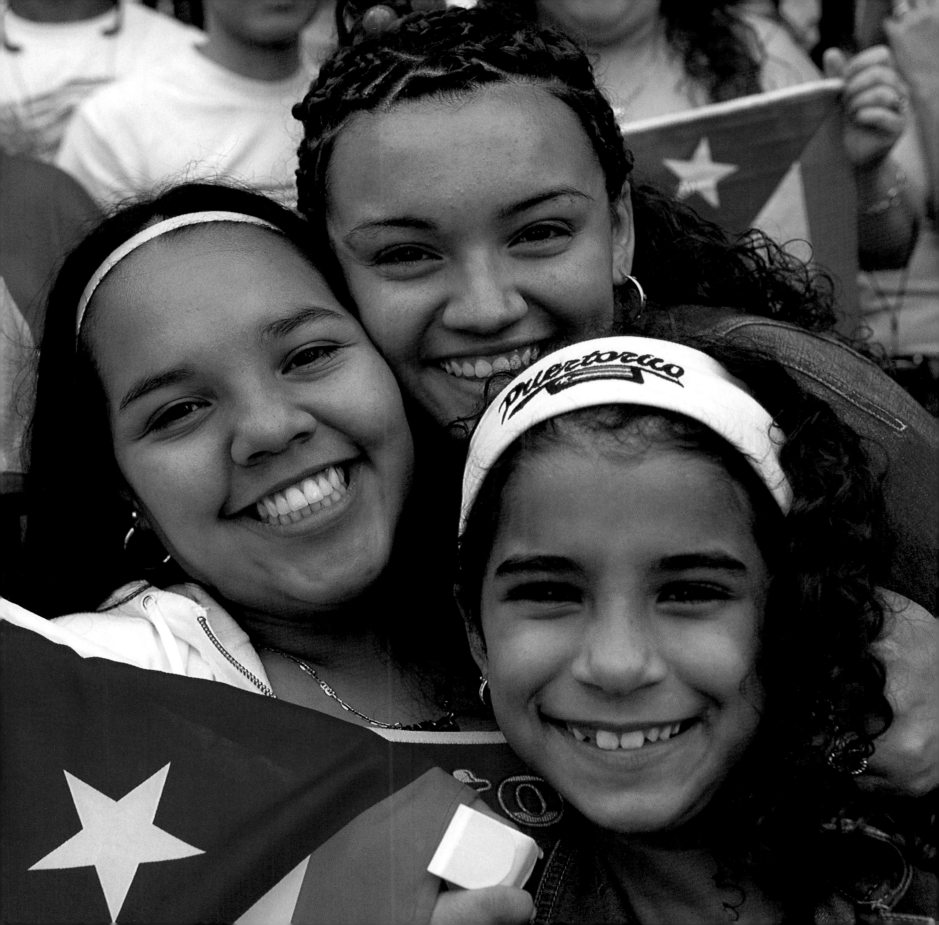

This is neither a historical text, nor is it an anthropological treatise. It is quite simply a celebration—a celebration of people. It is one man's photographic record of the simple proposition that America is a living collage of human beings who have come from all points on the globe to this wonderful country. They've come in search of freedom in all of its permutations—economic, political, religious, and social—and to exercise the right of all people to do, say, think, and believe anything they care to, as long as they do not hurt others.

As I travel through every corner of this remarkable country, I am privileged to witness the integration of our country's ethnic diversities and the strength it brings to our country and individuals alike. This elegant combination of cultures and experiences provides a great cauldron of ideas which, when blended

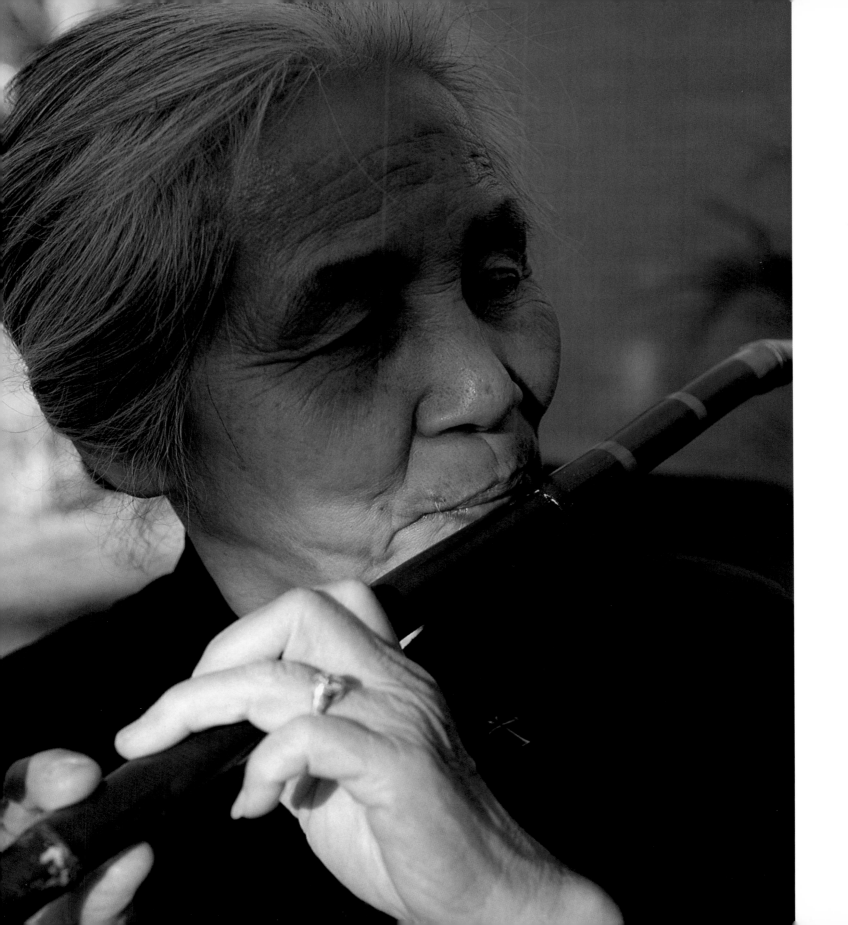

together within the matrix of a democratic system, allows for dramatic levels of national stability and growth. The United States is a prime example of diversity at work in a modern society, elevating the economy and all of the people within it to a higher level. We are a world society, a world people. We are one nation, America.

America is a colorful, dynamic scene with multitudes of diverse immigrant groups making up the American culture. Each contributes its own unique values and traditions, but they often borrow from one another: music, food, and dress of each cultural group merges with that of the others. Corned beef and cabbage have become a traditional meal for all Americans in cold weather and on rainy days. Tacos, burritos, and tostadas, along with carne asada and salad, are standard barbecue fare. Health-conscious Americans spend countless hours in Japanese restaurants eating sashimi and sushi. Vietnamese pho bowls and Chinese lo mein have become nearly as common as Italian spaghetti, fettuccini, and pizza. Our language has become mixed as well; many of us express ourselves with words which come from more than one culture or historical language.

Someone once said that America is not built on people but on ideas and ideals. That thought has drawn millions of immigrants from around the globe to this country in search of their goals. Not all of those who come have grand dreams, nor are they all successful in executing their plans. Some come simply for the opportunity to work in order to provide food for their families. Others come with hopes of riches and to exploit their business opportunities to the fullest. However, all who come do so

for the opportunity to be free and to live in a democratic society where they have the chance to succeed. They are keenly aware of the fact that every religion, every culture, every ethnic identity, every language, and every ideal is tolerated in the United States. They know that the greatness of America is in its strength to tolerate every different ethnic group that lives here, and to provide every individual with the right to have a voice in the politics of this nation.

It is appropriate to briefly mention the policies of this country which have allowed people to emigrate from various parts of the world to America over the years. Prior to 1924, there were no laws limiting immigration to the United States. The early settlers came freely, other than the Africans who were forced onto slave ships. Others came in large numbers during the 1800s, especially toward the end of the century. For those who came later, the various immigration laws enacted during the twentieth century had a significant impact on their ability to reach America. The Immigration Act of 1924 established a national origins quota system, and the Immigration and Nationality Act of 1952 continued the policy of limiting immigration based on national origin. In 1965, significant changes were made to American immigration laws. The 1965 legislation abolished the national origins quota system and opened the door for countless new immigrants to come to the United States. The Immigration Act of 1990 sets forth our current immigration policies, although some policy changes have been made since 2001.

Once immigrants have reached American soil, like grains of sand moved about by waves on the beach,

they are absorbed into our society and our communities. And yet throughout the country each and every year, these ethnic groups continue to celebrate their unique cultural identities. Families and friends gather together at festivals with food, parades, and cultural events staged for all who care to partake. The photographs in this book capture some of those activities.

With my many travels and experiences, it has become more evident to me than ever that it is through the open-minded innocence of children that the gifts of tolerance, democracy, and freedom are passed on to succeeding generations. All of the fundamental ideals of this great land flow through their eyes, ears, and senses. Hopefully, their observance of this country's celebration of its diversity will further open their minds. And then they, too, will realize that every culture we embrace has something of value to share, and they will see that our greatness is in that diversity and that our strength is in our political system of freedom.

This book and its contents are truly a celebration of "we the people"—a magnificent gathering of individuals within our fifty states that contain an extraordinary assembly of diverse and hardworking people. Each of us, individually, adds to the collective fabric of our nation. And although I've identified thirty ethnic groups that appear to be the most dominant in our history and our current culture, I fully recognize that there are numerous subgroups to each one of these ethnicities. I focused on the larger objective of capturing the essence of each group. The images I have photographed are also not intended to be all-inclusive of the ethnic group with which they are iden-

tified but are simply representative. I further acknowledge that not all of the ethnic groups I have identified are nationalities. Some, such as Jews, Arabs, Amish, and others, transcend national focus and present a broader cultural identity. Thus, I beg indulgence from the reader for the liberties I have taken.

And last but certainly not least, the reader should know that fifty percent of the proceeds from this book will be donated to the Diabetes Research Institute at the University of Miami in Miami, Florida, to aid the distinguished scientists there who are fighting to find a cure for that sinister disease.

—*Russel Hiles*
Summer 2005

Not like the brazen giant of Greek fame

With conquering limbs astride from land to land;

Here at our sea-washed, sunset gates shall stand

A mighty woman with a torch, whose flame

Is the imprisoned lightning, and her name

Mother of Exiles. From her beacon-hand

Glows world-wide welcome; her mild eyes command

The air-bridged harbor that twin cities frame,

"Keep, ancient lands, your storied pomp!" cries she

With silent lips. "Give me your tired, your poor,

Your huddled masses yearning to breathe free,

The wretched refuse of your teeming shore,

Send these, the homeless, tempest-tossed to me,

I lift my lamp beside the golden door!"

—Emma Lazarus

The Indigenous People

PRIOR TO 1500

ESKIMOS AND OTHER ALASKAN NATIVES

NATIVE AMERICANS

HAWAIIANS

The Indigenous People

Long ago, the early humans traveled across the land chasing other animals and plants for food. The necessities of life demanded that they seek shelter and provisions for their survival. Wandering farther and farther across Asia, the travelers stopped at the most northeasterly projection of land and looked across the ice bridge to a new earthen territory on the other side. Still seeking food and shelter, they entered into this new land some 40,000 years ago as the first inhabitants of what is now known as North and South America.

Others from the southeastern part of Asia, over thousands of years, traveled across the sea from island to island in makeshift boats and rafts, ending in the Hawaiian Islands.

These brave humans became the seeds of the indigenous people who were living in North America when the early European settlers arrived thousands of years later.

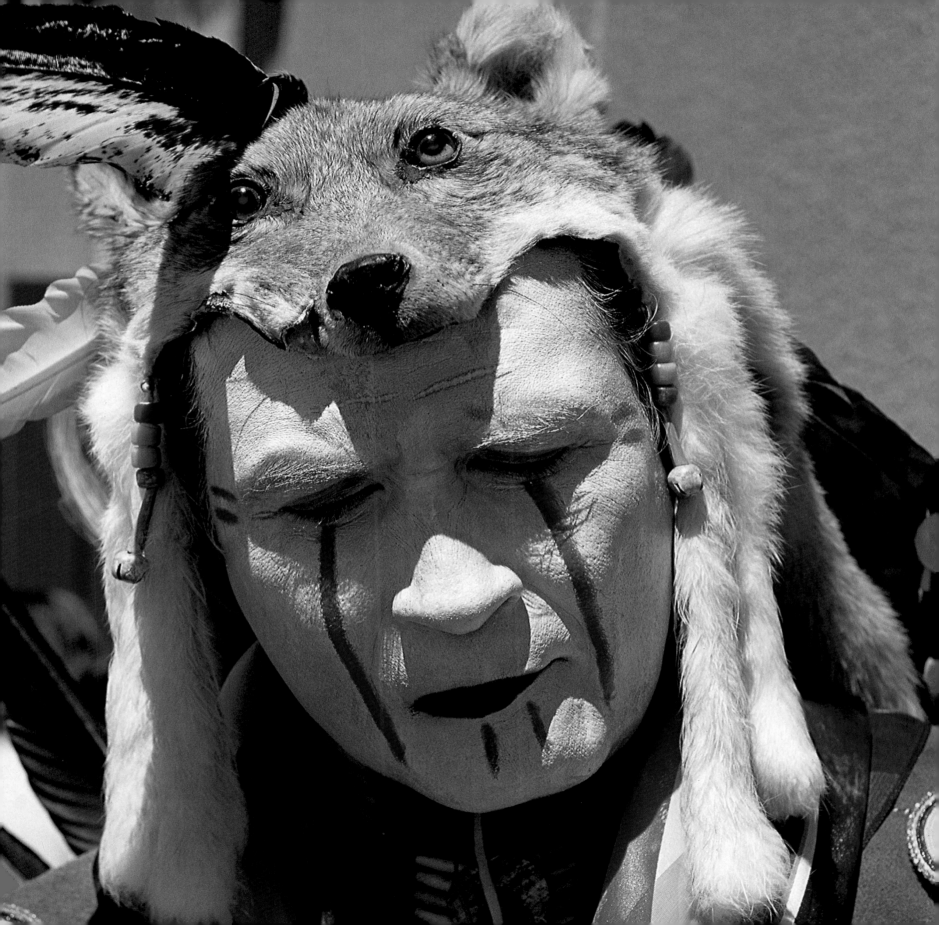

Who are these people that live in the furthermost regions of the United States and that are thought to be perhaps the oldest inhabitants of North America? Called Eskimos by Europeans and those of other western cultures, they are a complement of peoples that include the Inupiats, Yup'iks, Athabascans, Tlingits, Haidas, and Aleuts. Anthropologists believe that these people originated in Asia and migrated to North America over 40,000 years ago by traveling north through Siberia, crossing a land bridge at the Bering Strait, and arriving on the Seward Peninsula of present-day Alaska. Theirs wasn't a single emigration but rather one of waves of migrants coming to North America, with the immigrants relocating to various regions within the continent. It is believed that they traveled into the Great Plains of America and, as some purport, even further into the Central American peninsula and South America, where they settled and established the great societies of the Aztecs, Maya, and Incas.

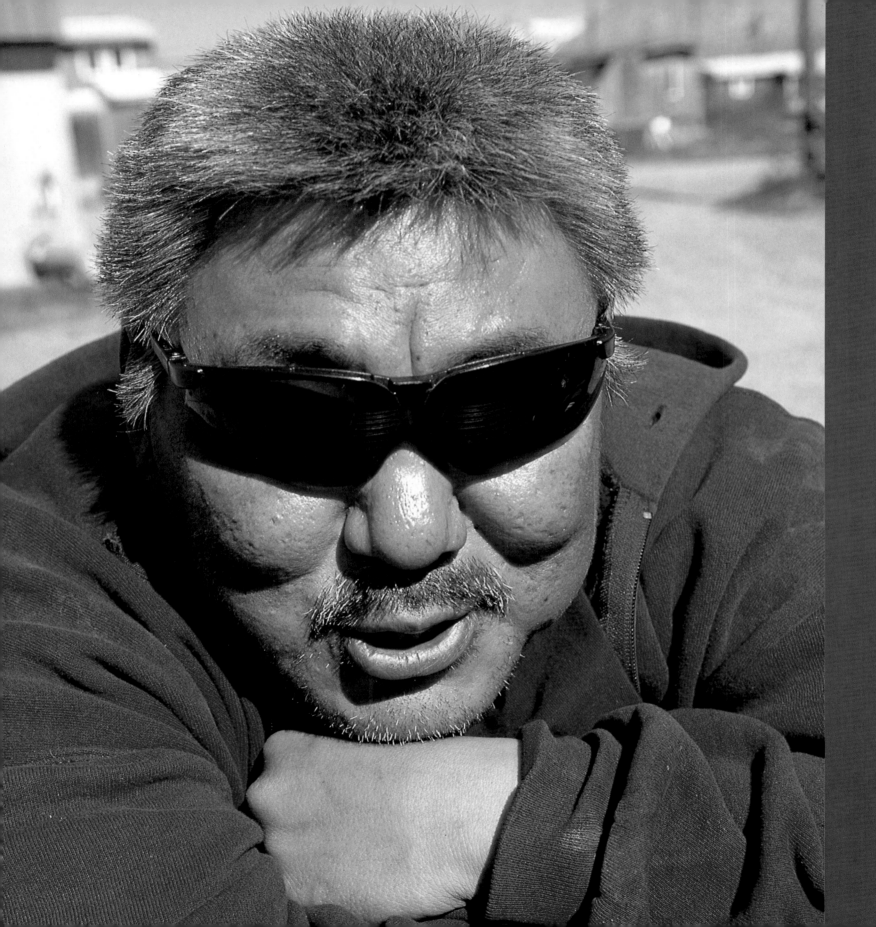

The Inupiats live above the Arctic Circle and to this day maintain a lifestyle that is centered on the traditions of their ancestors; their very survival is dependent on seal, whale, caribou, and fish for their food, clothing, and shelter. These efficient and frugal people let nothing go to waste; virtually every part of an animal is used in some aspect of daily life. Skins are made into clothing, fish and meat provide daily and future sustenance, the sinew of the caribou muscle is used for thread, and the bones are used for sewing needles.

Arctic life is harsh, and survival is often determined by one's hunting skills and the strength of the community. Eskimos live in small clustered groups and villages with populations numbering from several hundred to no more than a thousand in any one location; some still live in the traditional villages of their ancestors. It is within these communities that their ancestral customs and traditions are practiced and the wisdom and skills of their elders are passed down. They celebrate every aspect of their rich culture; songs and dance recount ancestral histories and legendary hunting adventures; traditional dress is embellished with iconic symbols of the hunt and the wildlife that are such an integral part of their lives. And while many have taken advantage of more modern tools for hunting and fishing, their spirited hearts remain steadfast to tradition and a culture that honors wilderness and their cherished freedom to enjoy it. Not even the brutal Arctic winters can dampen these hardy spirits. These resilient people endure some of the most extreme weather on the globe; winter temperatures as savage as eighty degrees below zero; three-plus months of darkness when the sun never breaks over the horizon, and when it does, it brings summer months of perpetual sunlight as bright and warm at midnight as if it were mid-day, though typically the summer temperatures barely reach forty degrees.

Coping with extreme weather conditions is not the only challenge Eskimo populations experience; disputes over land rights have been contentious. The Yup'ik and Inupiat peoples, along with other native Alaskans, have continuously argued that the land on which they reside is theirs, that the Russians never had any right to sell it to the United States, and that therefore the United States has no claim to it. This controversy intensified with the discovery of oil on the north slope of Alaska, and the disputes over title claims eliminated oil development for a time. Seeking resolution, in 1971 the United States government signed into law the Alaska Native Claims Settlement Act, providing a cash settlement of nearly $1 billion and the distribution of 44 million acres of land to twelve regional and 200 village corporations. This was an effort to not only aid economic development but foster assimilation of Alaskan Natives into the American way of life. However, the Yup'iks and Inupiats held fast to their claim that the land was theirs and ignored the government mandates, believing them to be in conflict with their traditional hunting, fishing, and gathering activities.

Working toward further resolution, in 1980 the United States government passed the Alaska National Interest Lands Conservation Act, giving priority to Alaskan Natives for subsistence living. This act assured "Native Alaskans" continuance of their traditional ways of hunting

and fishing, and allowing all within the village to take freely of the stockpiles of food to provide for their families. This provision brought about a blending of traditional ways with those of a more modern lifestyle. Soon communities saw satellite television, cell phones, and miscellaneous supplies including cars and trucks flown into remote wilderness locations. Villages were now benefiting from having their own electrical generators that provided light and heat, and school systems were established. And though this paradoxical melding of ancient traditions with modern conveniences may seem peculiar, it works.

Today, Eskimos and other Alaskan Natives enjoy their vigorous cultures that are rich in tradition and unique in style. Their creative spirit is expressed not only through their dance and song but is exhibited in their exquisite handcrafted art that is traded or sold at social gatherings. They are a fun-loving people who relish competition, and when they are not participating in local community games, events like the World Indian-Eskimo Olympics provide the perfect forum for them to showcase the skills and talents that not only sustain their cultures but save their very lives. These indigenous people are a magnificent tribute to human endurance, and they add a marvelous dynamic to our ethnic wholeness.

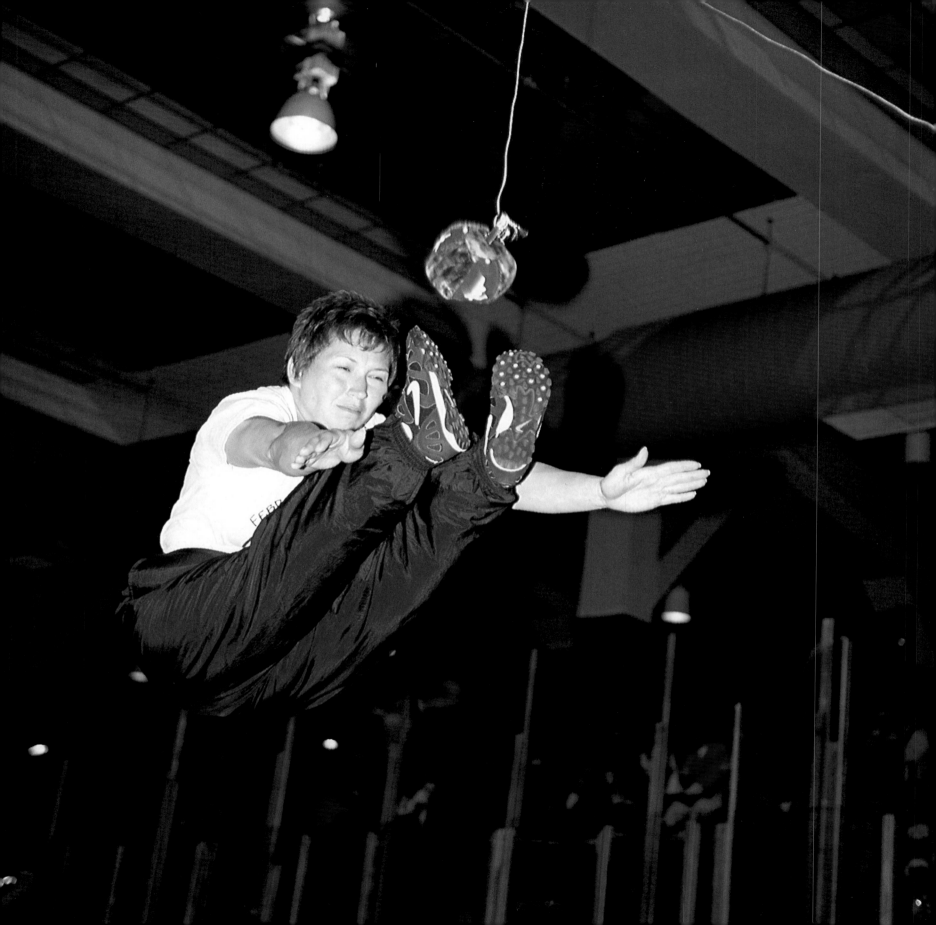

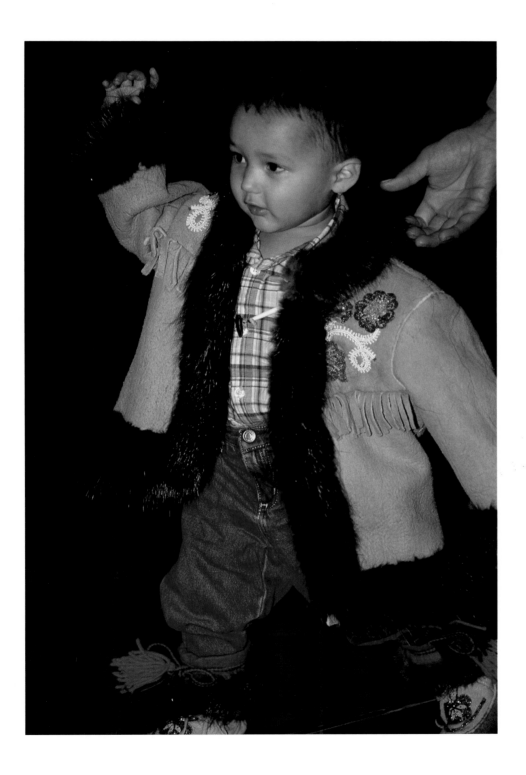

Each summer, usually in Fairbanks, Alaska, the World Eskimo-Indian Olympics is held in some indoor or outdoor stadium. Native Americans, either Eskimos or Indians by heritage, participate in games of skill unique to their culture. The entrants come from various parts of the United States and Canada to participate; however, the games are dominated by Alaskans. These games of skill are accompanied by a parade with people in native dress, and a festival with traditional foods.

The woman on the far left must jump in the air, perform a scissors maneuver, and kick a ball hanging from a string approximately eight feet in the air; a phenomenal feat for anyone. This woman, who is only 5'6", became the champion. The young boy to the right received an award for his exquisitely decorated coat.

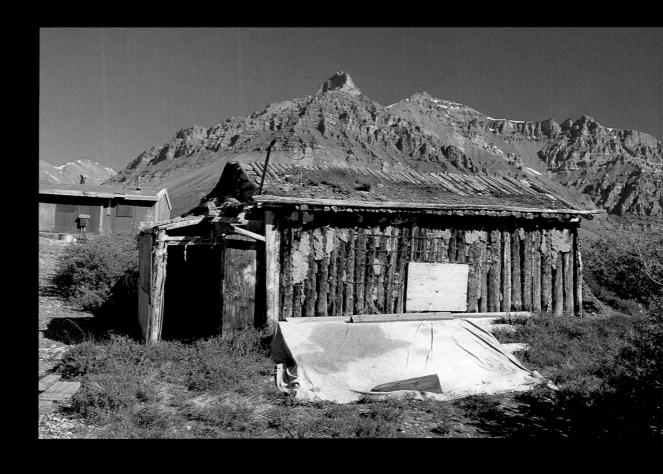

ANAKTUVUK PASS, ALASKA, 2003

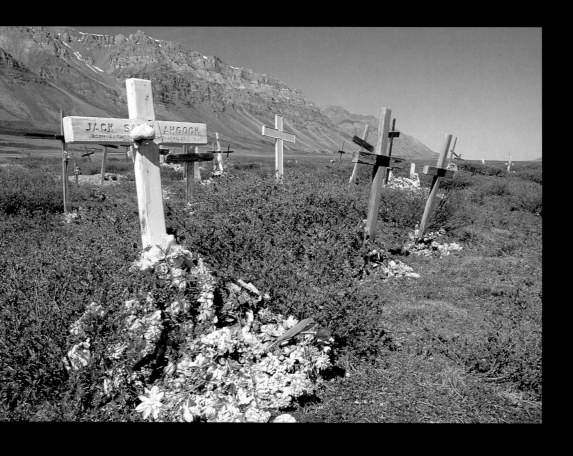

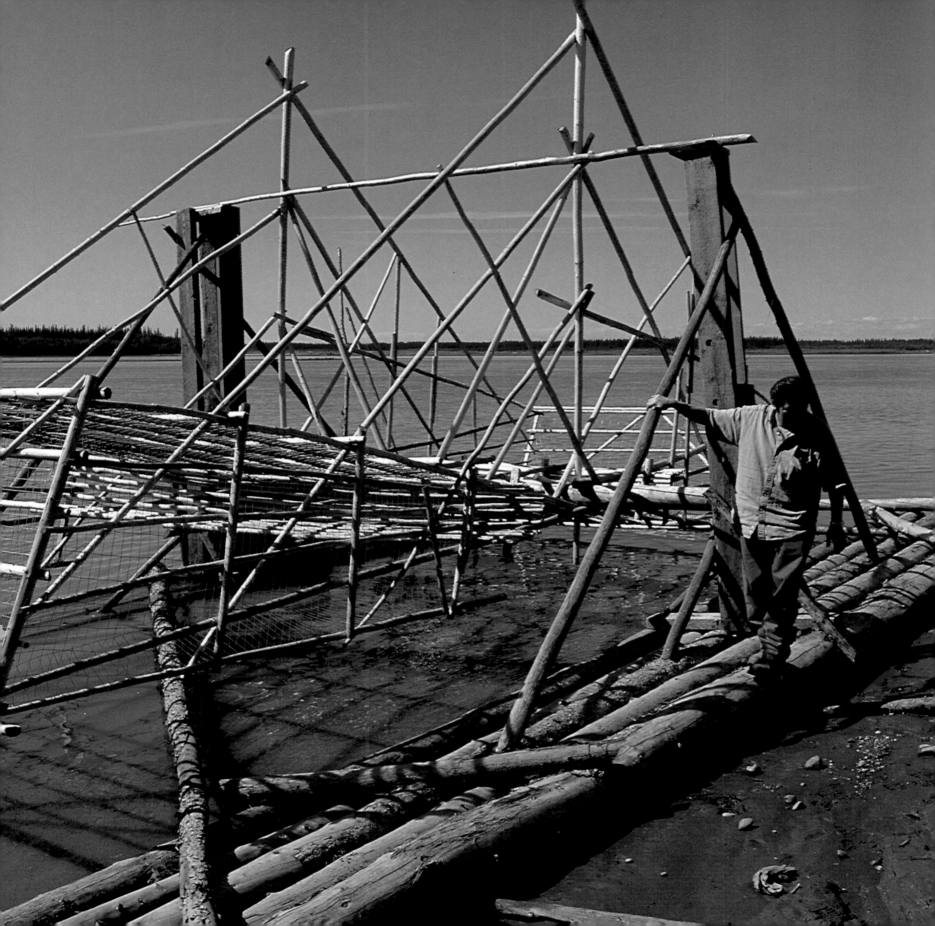

ANAKTUVUK PASS, ALASKA, 2003

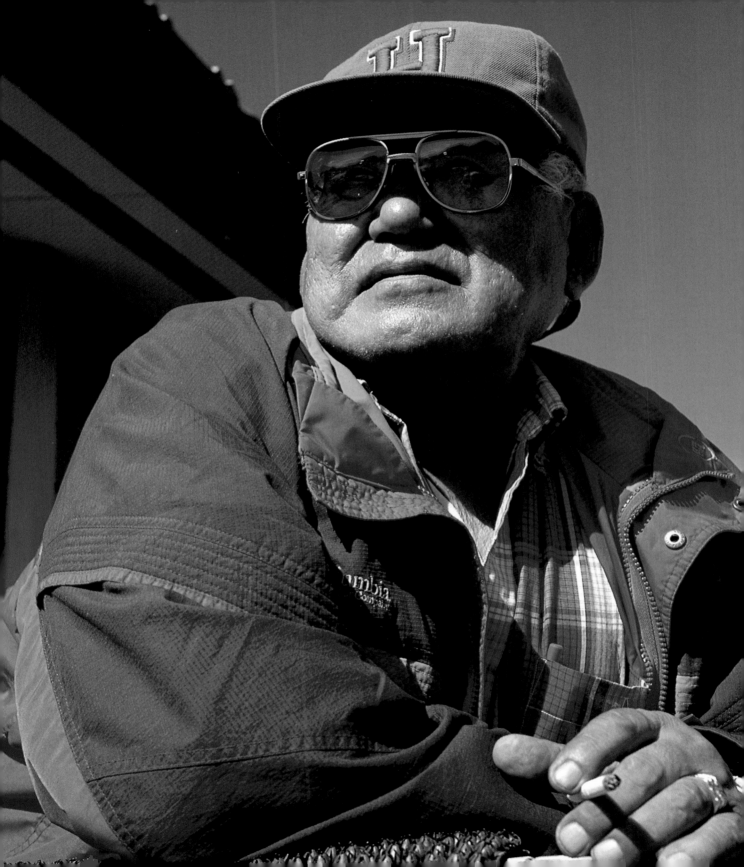

The indigenous peoples of America, believed to have originally emigrated from Asia thousands of years ago, would eventually populate the entire North American continent. They crossed into Alaska and then spread into the coastal regions of the Pacific Northwest and east across Canada and then down into the Northeast and New England; some migrated into the Great Plains; others traveled as far as Central and South America, where they established societies that flourished for hundreds if not thousands of years.

Today, we may think of the indigenous peoples of North America as American Indians—one people, one culture. Yet Native Americans are very distinct in their individual cultures and tribal traditions. They are many nations of many tribes; Alaska's Northwest Coast includes the Haida, Inuit, Inupiat, Netsilik, and Tlingit; the Northeast and New England hosts the Algonquin, Huron, Iroquois, Menominee, Munsee, Ojibwa, Seminole, and Wampanoag; Great Plains tribes include the Cherokee, Comanche, Kiowa, Lakota Sioux,

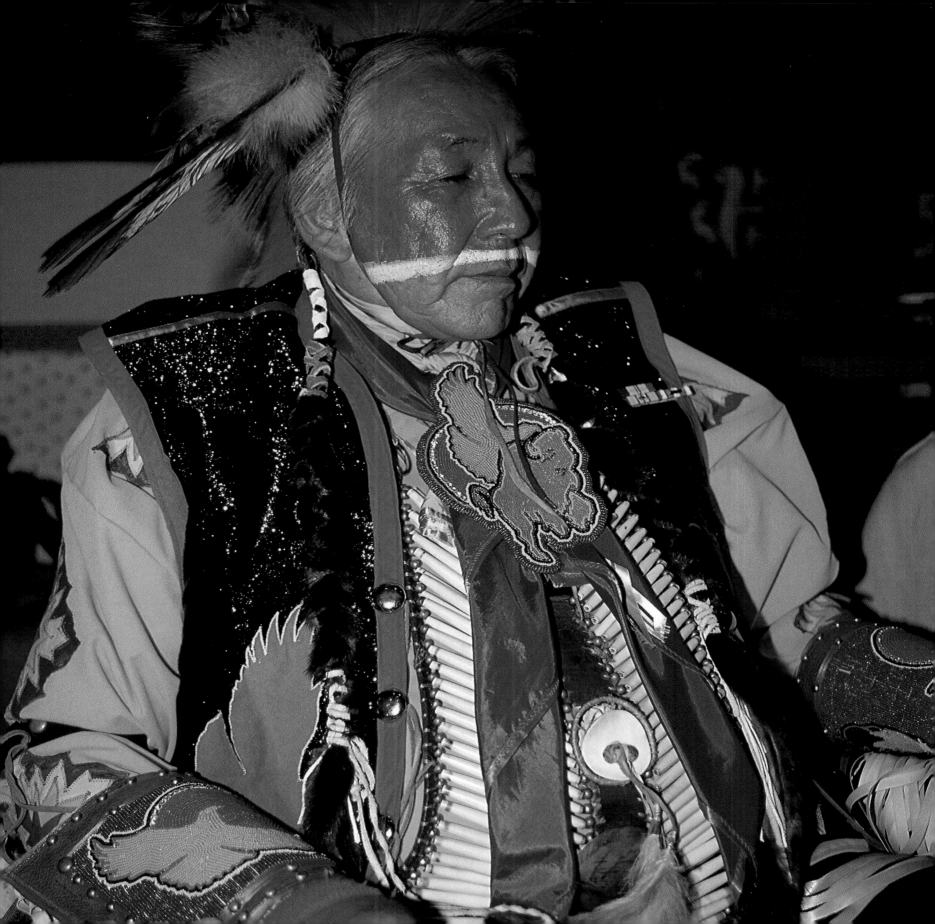

Osage, and Pawnee; the Pacific Northwest finds the Arapaho, Kwakiutl, Mesquakie (called the Fox Indians), Salish, Tsimshia, Umatilla, and Yakima; the upper western regions of the United States are home to the Blackfeet, Cheyenne, Chickasaw, Crow, Mandan, Modoc, Nez Percé, Skokomish, Shoshone, and Yuki; and the lower western states are represented by the Apache, Havaupai, Hualapai (so-called Yuman tribes), Mohave, Papago (including the Tohono O'odham and Pima Indians of south-central Arizona), Hopi, Navajo (Diné), Paiute, Pueblo, Yavapai, and Zuni. And this list is far from comprehensive; it is, at best, representative.

Aside from their territorial boundaries, each tribe has its own traditional language, dress, rituals, and customs. Regional topography and climate contribute greatly to each tribe's unique culture and lifestyle. Many of the early tribes maintained subsistence societies, dependent on regional resources for hunting, fishing, and gathering food; others developed more sophisticated cultures with well-defined political systems. While some tribes were nomadic, others established permanent communities. Their histories were recorded through oral traditions passed on from generation to generation.

Early European settlers to the New World began to clash with the Native Americans, leading to a series of wars that lasted until 1890, when the United States Army massacred a number of Sioux at Wounded Knee. The official policy of the American government was to treat the individual tribes as unique, independent nations, and settle differences with treaties. But treaties were almost always broken and encroaching settlers, often with gov-

ernment sanction, deprived the tribes of their ancestral lands. Some tribes were deported across the Mississippi to open land in the south for re-settlement (the Trail of Tears). Eventually, Native Americans were reduced to living on reservations, which are protected areas where their tribal laws remain in force, but are often not located on their ancestral homelands. Here, even though they received payments from the government, corruption, drugs, and alcohol became widespread problems. In recent years, many tribes have built casinos to lure visitors to spend money that is used to help support the members of these tribes and their communities.

Famous Native Americans can be found in all walks of life. Students of American history know the names of those they studied in school—Pocahontas, Squanto, and Sacajawea, among others. Many know the famous chiefs who fought against the westward movement of the European settlers, leaders such as Tecumseh, Black Kettle, Geronimo, Cochise, Sitting Bull, and Chief Joseph. More recently, there have been actor Iron Eyes Cody, who appeared in more than 130 films and over 40 television series from the 1930s to the 1980s; athlete Jim Thorpe; and Ira Hayes, one of the Marines who raised the flag on Iwo Jima. Buffy Saint-Marie is a famous singer, Ben Nighthorse Campbell is the only Native American currently serving in Congress, Winona LaDuke was a vice presidential candidate in the 2000 election, and Wilma Mankiller was the first woman to serve as chief of the Cherokee nation (1985-1995).

Today, Native American culture continues to be preserved and celebrated across our country on tribal lands

under federal protection. Native Americans identify with their land and its wildlife, honoring each in heart and spirit with sacred reverence. Their dance, song, and ceremonial rituals bear witness to their steadfast commitment to their ancestral ways and time-honored customs. They gather together at regional powwows, potlatches, and other Native American festivals, performing traditional dances and ceremonies that strengthen tribal bonds, renew pride in their heritage, and honor their ancestors.

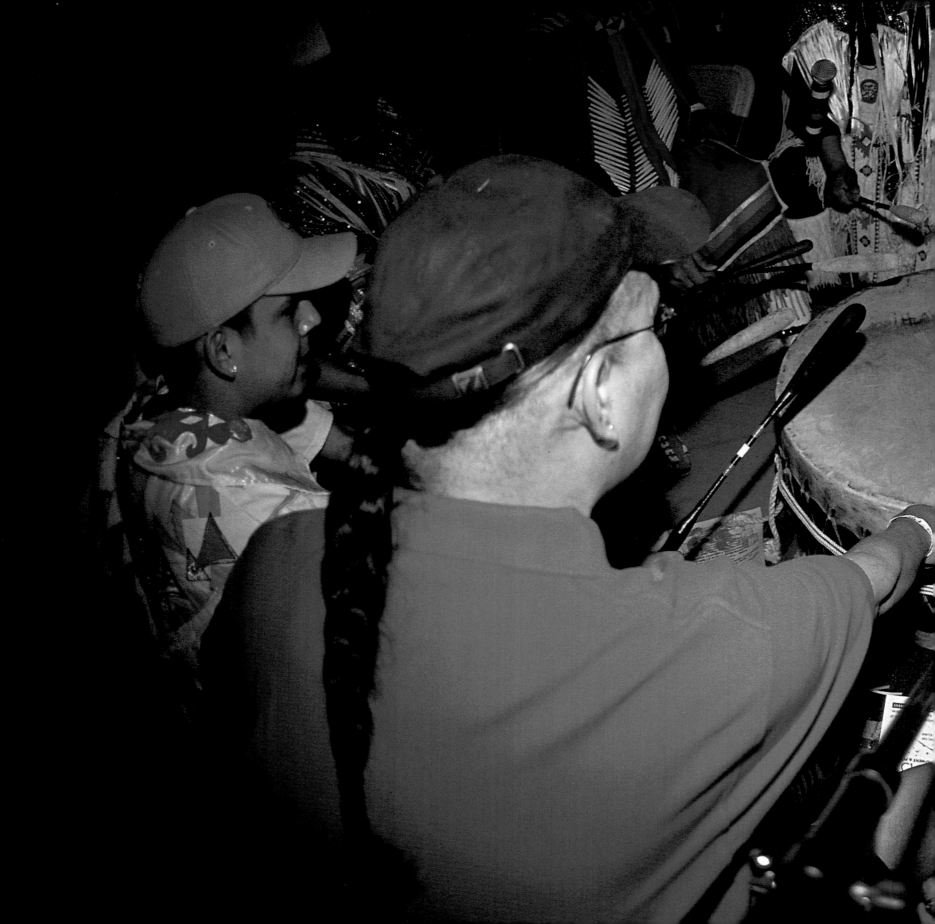

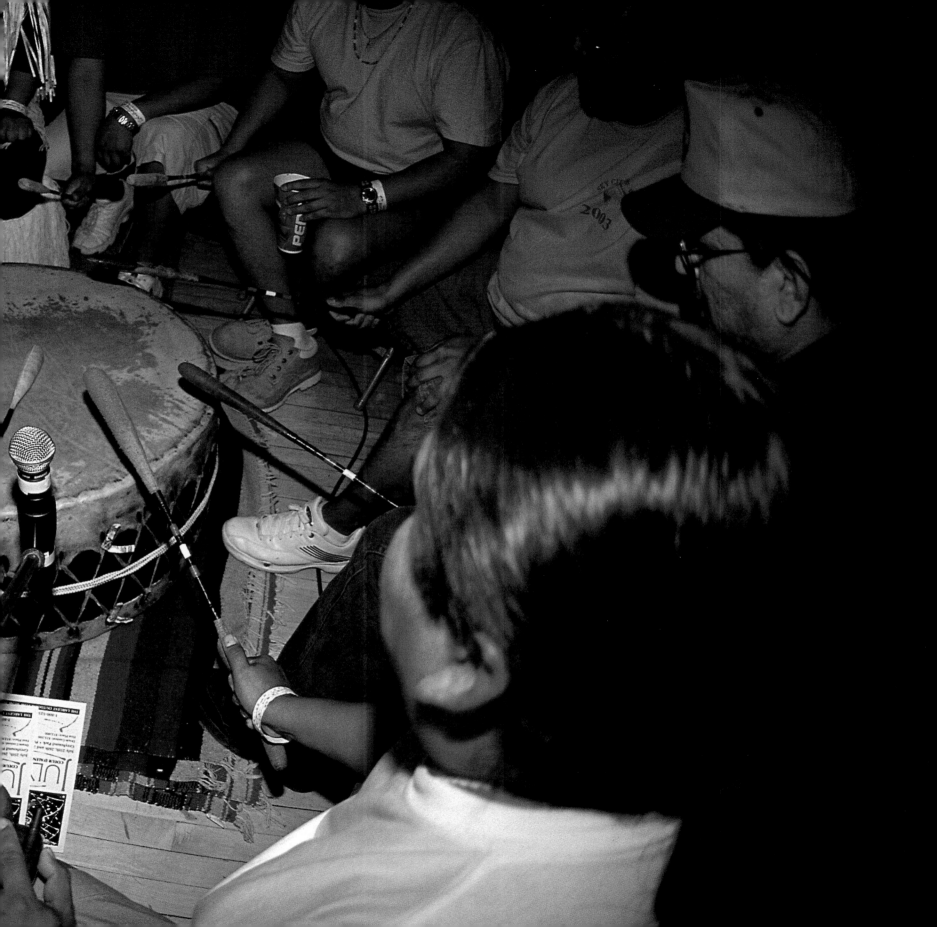

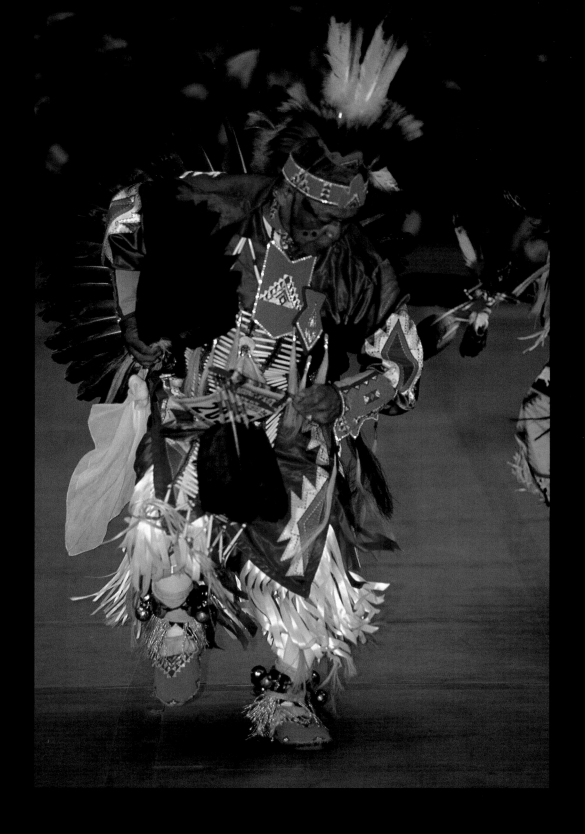

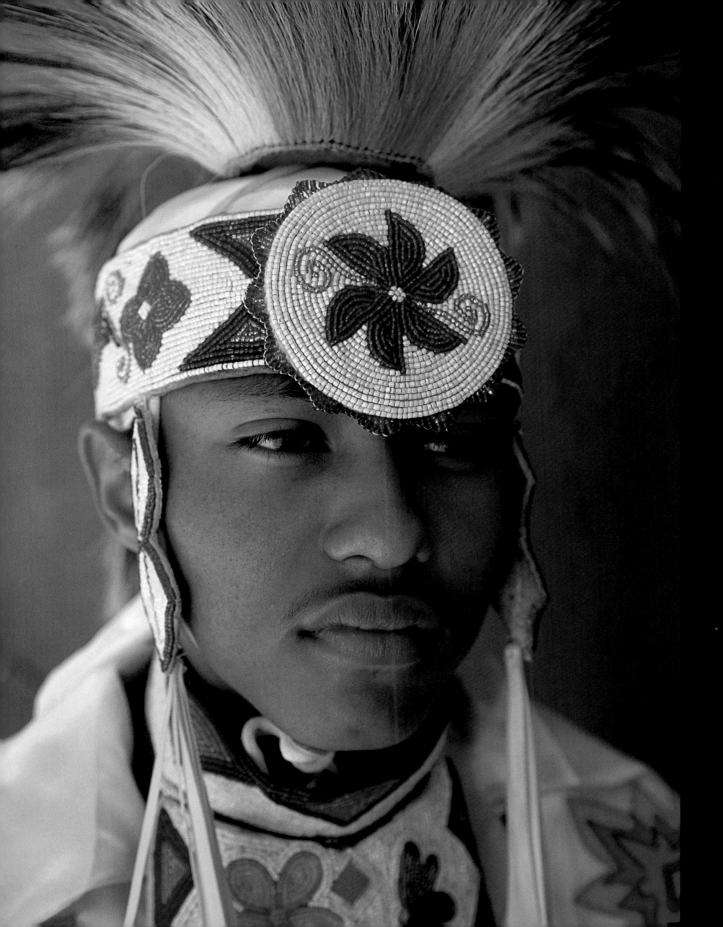

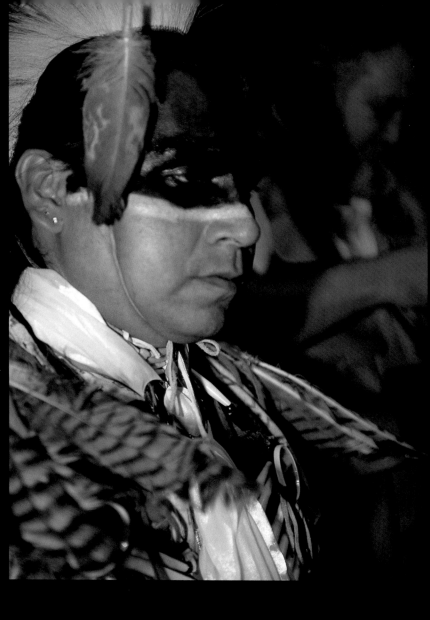

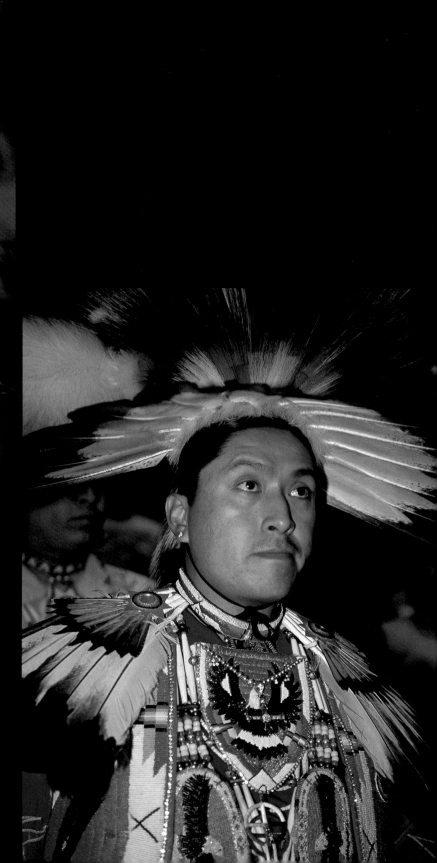

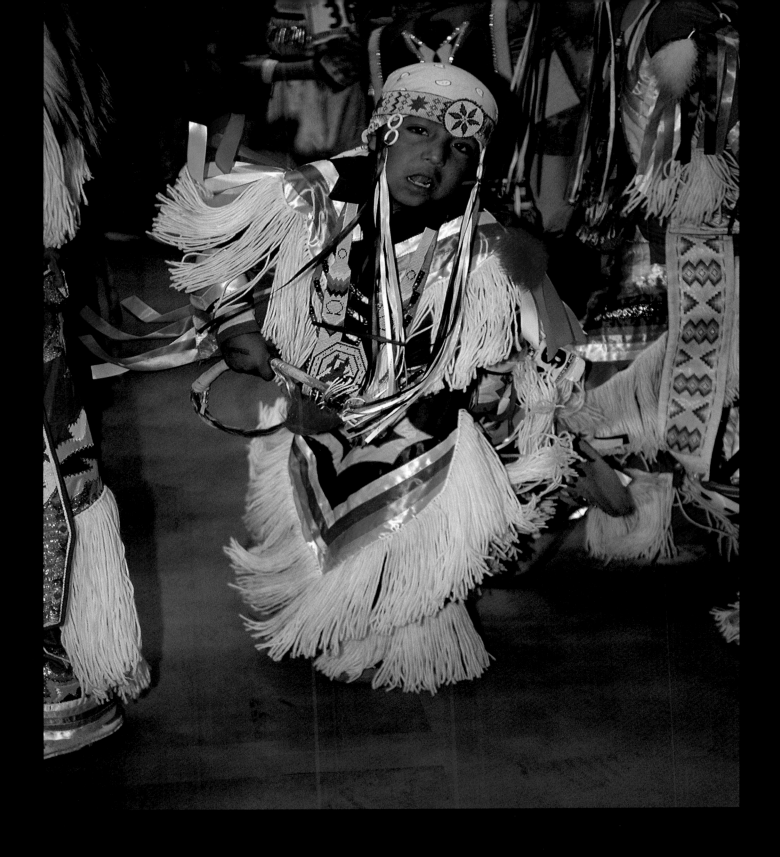

ALBUQUERQUE, NEW MEXICO, 2003

In recent years, Native Americans have used one of their only remaining resources to generate wealth. Reservation lands are governed exclusively by federal laws and not state laws or regulations. Native American tribes have been permitted to build gambling casinos and hotels on their property, attracting millions of visitors each year. The Pechanga Resort & Casino in northern San Diego County, California, rivals any casino in Las Vegas or Atlantic City.

A visit to Hawaii is an exceptional experience of lush tropical beauty, white sandy beaches, and rugged volcanic mountains. Its tropical climate, soft trade winds, and magnificent surf provide not only a perfect playground for water activities and abundant seafood, but its fertile valleys overflow with succulent fruits and vegetables. There are nine islands in the Hawaiian group, all formed as a result of volcanic eruptions eons in the past.

The first inhabitants of these islands are believed to have come from Southeast Asia, crossing the Pacific Ocean by way of the Marquesas Islands around 300 A.D. They were a hardworking people, comprised of farmers and stone builders who established close-knit societies and a distinctive culture that has been passed down from generation to generation through oral tradition. Sometime after 1100 A.D., another wave of Polynesian immigrants stepped upon Hawaiian shores. These newcomers proved to be more aggressive and strong-willed than their predecessors, and after a series of violent clashes, they

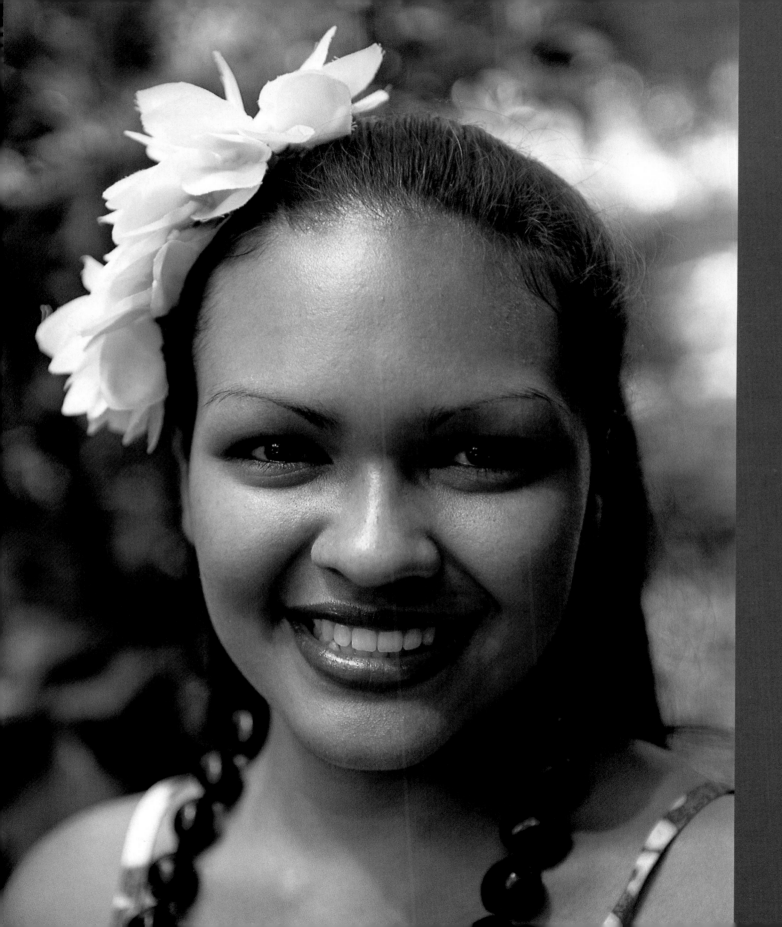

established themselves at the top of a rigid class system and, in spite of encounters and intrusions by other foreign peoples, retained control for several centuries.

In the mid-sixteenth century, Spaniards discovered these islands but kept their location secret in the hope that other colonizing countries would not discover them. By the mid-eighteenth century, both the British and the French had located the islands. The European explorers were not only taken by the beauty of the tropical wilderness, but they developed a fondness for the island people.

Control of the islands remained divided among many chieftains until 1795, when Kamehameha the Great united the entire island group under his reign. After Kamehameha's death in 1819, the monarchy began to weaken under pressure brought about by the growth of the agricultural industry that produced sugar, coffee, and pineapples. The great success of this industry initiated an economic dependency between the island people and those of the mainland United States.

During the following decades, the monarchy wrestled with the problems of decreasing revenue and private ownership of land. In 1864, Kamehameha V, a descendant of the original king, issued a new constitution strengthening the power of the monarchy and introducing new laws to protect the rights of the common man. However, by 1873 the heavy burden of taxation on local farmers had generated open talk of Hawaii's affiliation with the United States. In 1893, the people revolted, overthrew the monarchy, and established a provisional government headed by Sanford B. Dole. In 1894, Hawaii declared itself a republic and pushed for annexation to the United States, which took place in 1898. Although Hawaii was first considered more of a recreational destination to most people in the United States, it wasn't until 1941, when the Japanese attacked Pearl Harbor, that interest in Hawaii heightened. After a series of labor disputes following World War II, the importance of Hawaii to the United States became clear, culminating in 1959 with Hawaii becoming the fiftieth state.

Hawaiians are a loving, graceful people who warmly embrace the world with "Aloha," their traditional expression for love, joy, sympathy, hello, and farewell. They are a people whose ancestral hula dance speaks the language of the heart; their music is an expression of the soul. They are a spiritual people who relish celebrating nature's beauty through colorful pageantry of flowers, foliage, and traditional costume. Their frame of mind is enhanced by living in this lush tropical locale with its beautiful vegetation and tropical trade winds that blow off the warm Pacific Ocean. Their strong family values and joyful hearts add greatly to the depth of the American spirit.

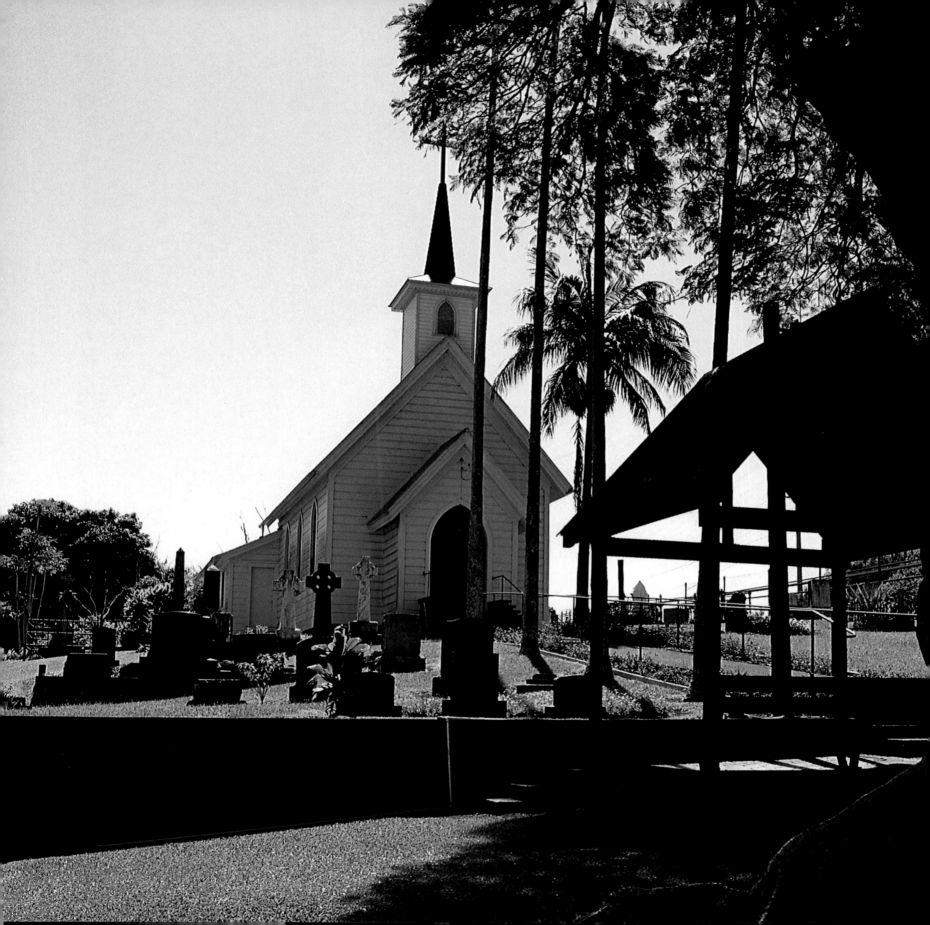

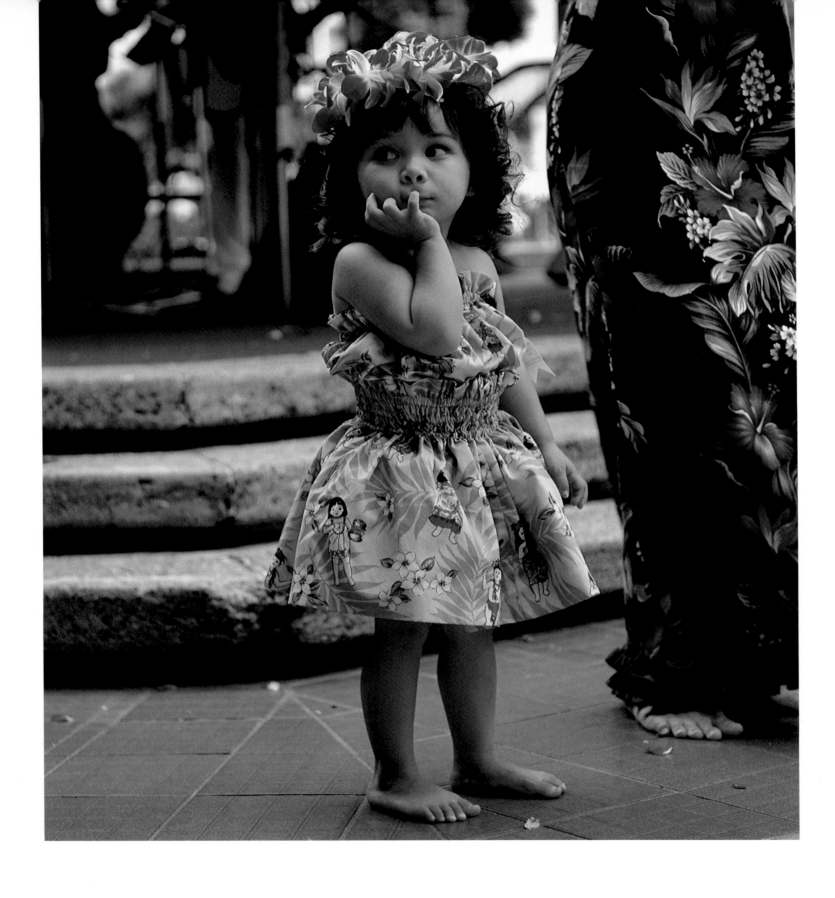

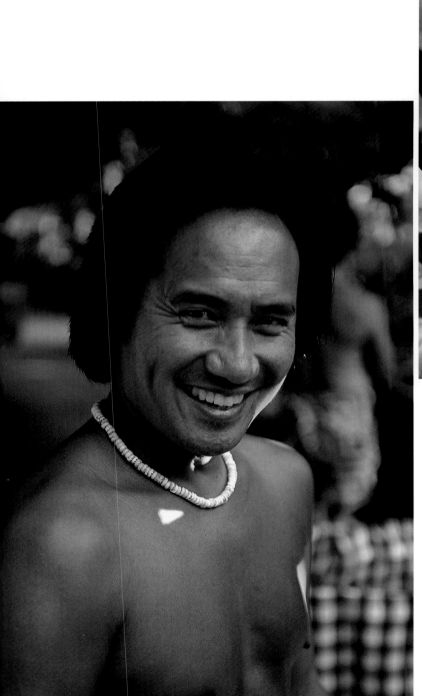

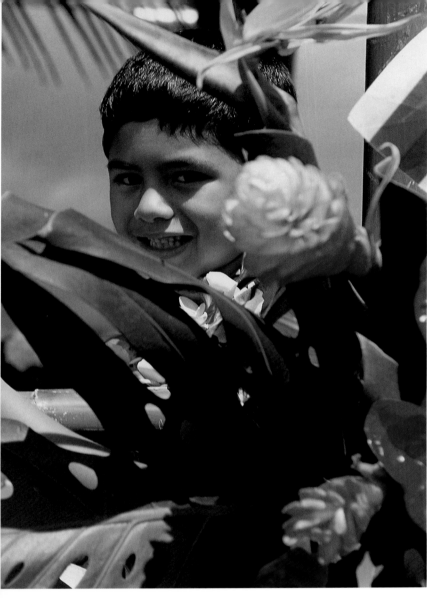

HAWAII, 2003

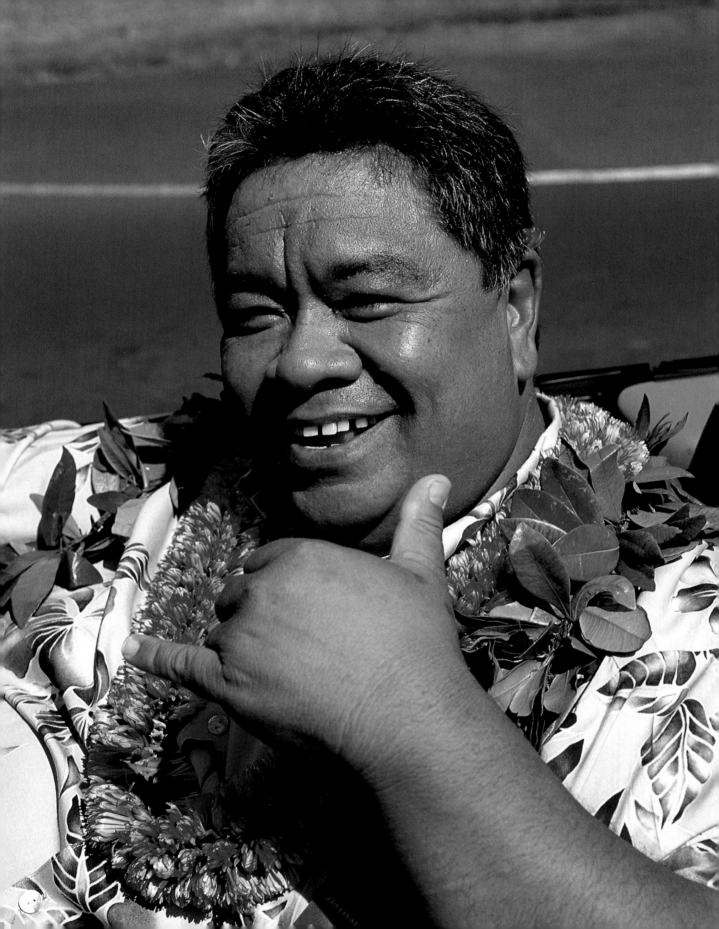

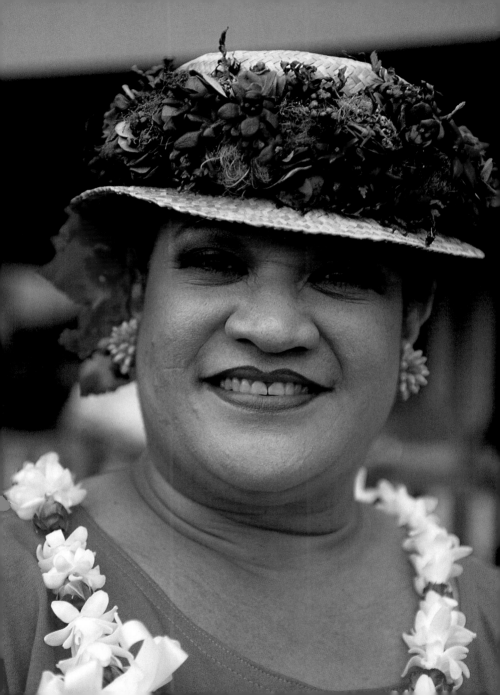

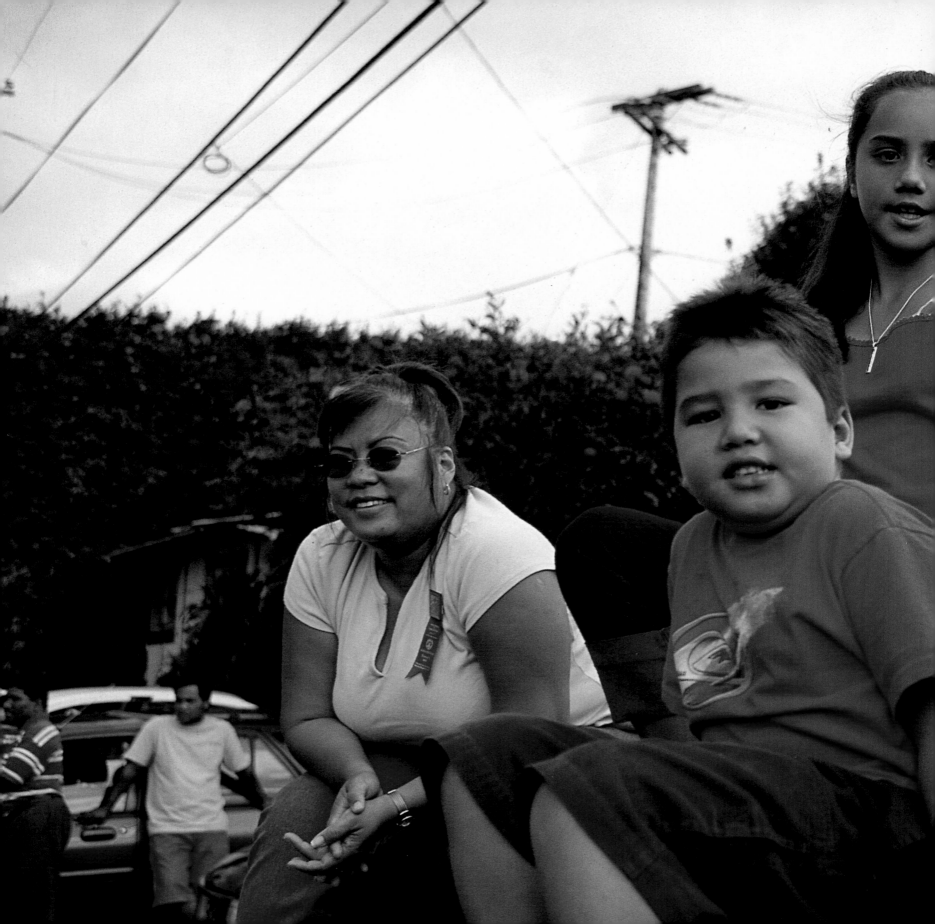

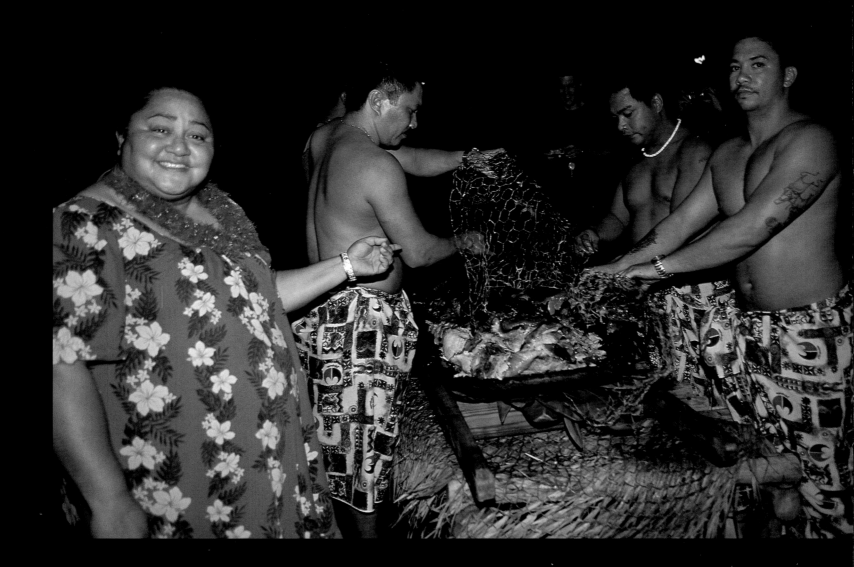

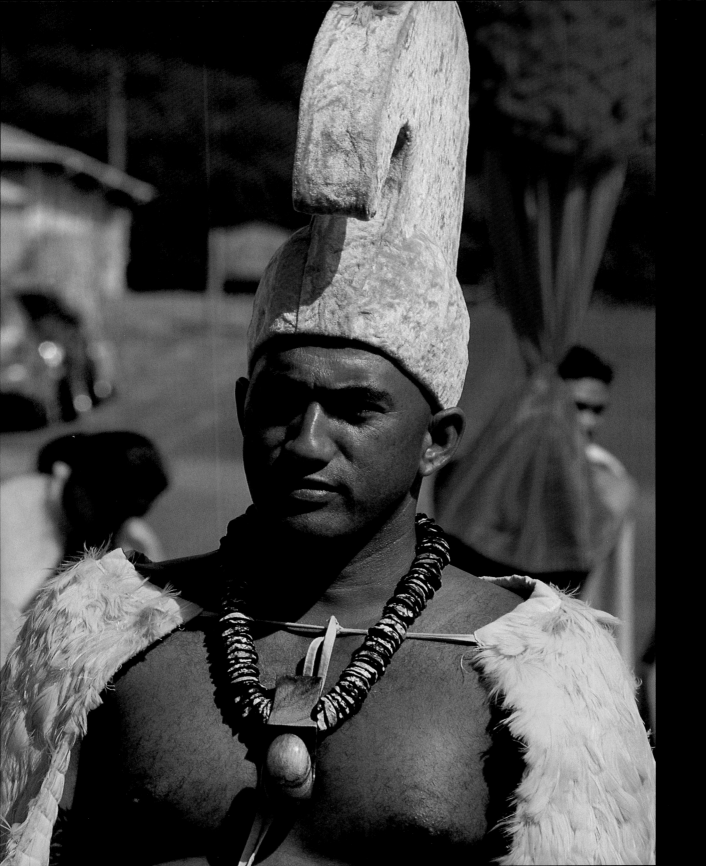

The Early Settlers

1500 TO 1700

LATIN AMERICANS

ENGLISH

FRENCH

AFRICANS

GERMANS

AMISH

SCANDINAVIANS

The Early Settlers

Some tens of thousands of years after those intrepid wanderers crossed the Bering land bridge and populated a substantial portion of what is now North and South America, Europeans traveled across the Atlantic Ocean in search of new territories.

First came the Scandinavian explorers traveling relatively short distances into the far reaches of North America. They were followed hundreds of years later by Scandinavian settlers, as well as by Spanish, English, French, and German immigrants to the New World. Bringing with them African slaves, and religious traditions developed hundreds of years earlier, these early settlers aimed to tame the wilderness, conquer the land, and bring back to their native lands the spoils of the New World. These early settlers found the road far more difficult than they imagined, the rewards, initially, far less, and ultimately found themselves developing a new world they considered far better than the one they left behind.

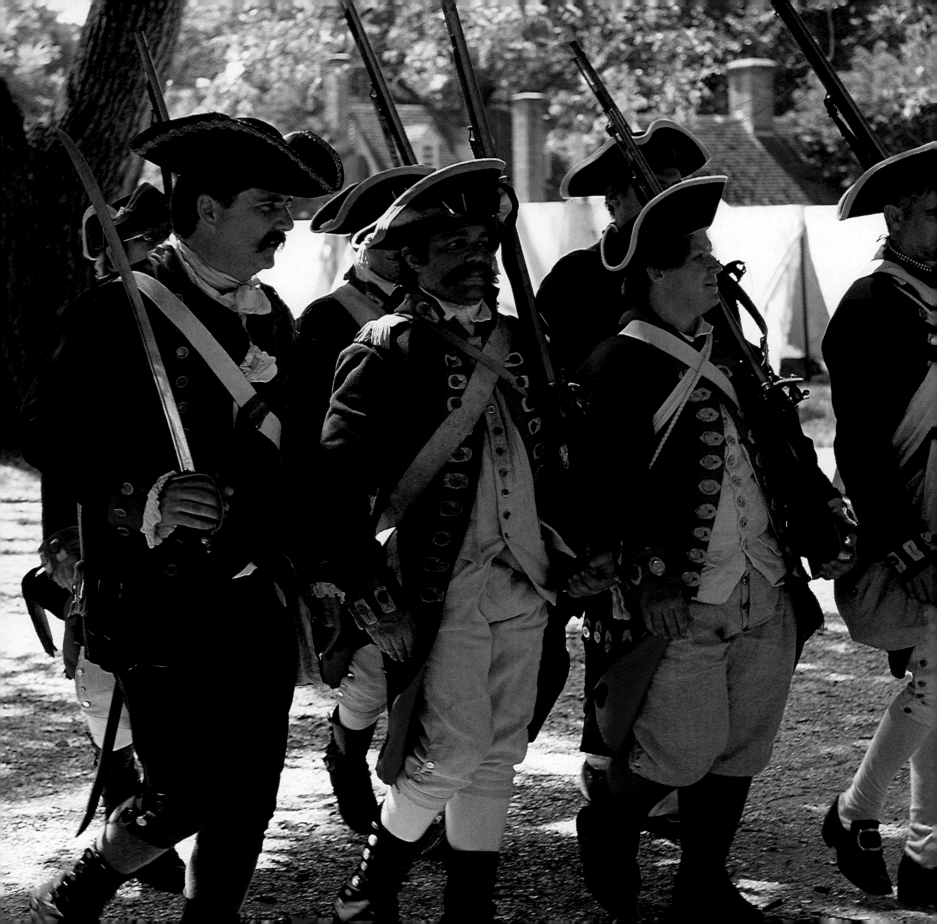

Latin Americans are a composite of ethnic diversities comprised of Spaniards, Mexicans, Native Americans, and others. It is believed that the people who first inhabited the southwestern United States and Mexico initially came over the Bering Strait to settle in North America and migrated south. These people became the indigenous Native Americans. Some stayed in the area which is now part of the United States, and others traveled farther south into what is now Mexico, Central America, and South America. The fascinating history of some of their descendants has been traced back thousands of years to the magnificent civilization of the Aztecs.

Traditionally, the Aztecs enjoyed a nomadic lifestyle. According to legend, when Aztec leaders saw an eagle with a serpent in its mouth perched on top of a cactus, they took this as a religious omen; a sign directing them where to stop and build their cities. And build they did. So powerful was their empire, that it would withstand numerous assaults throughout the centuries, until the early

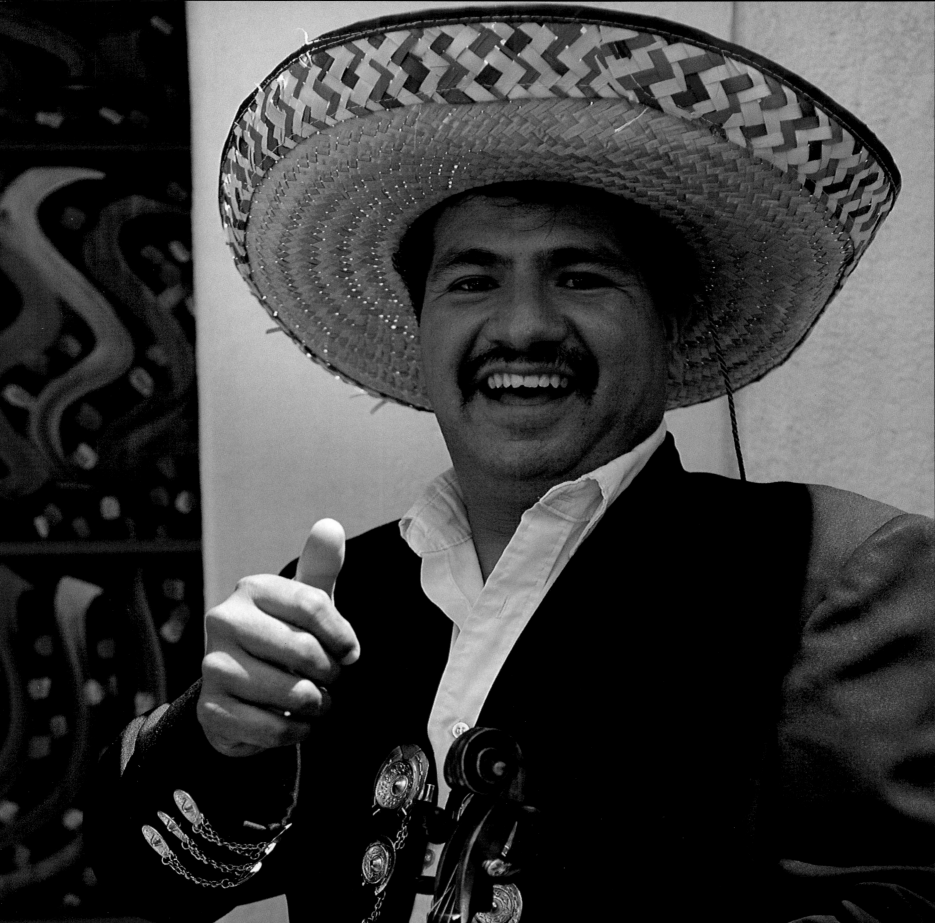

1500s, when Spain sent Hernando Cortés to seek new trade routes and wealth in foreign lands. Smart and aggressive, Cortés not only brought Catholicism with him, but new technologies in the form of weapons that the Aztecs had never before encountered. Relentless in his pursuit of riches, Cortés overpowered the Aztecs and conquered their civilization. The rest was "history"; European Spaniards blended with the indigenous population in Mexico, resulting in the creation and evolution of the unique culture of the present-day Latinos.

The North American continent would experience the influence of this new culture with the influx of Latinos who migrated north to settle in the regions now known as Texas, New Mexico, Arizona, California, Nevada, Oregon, and Colorado. Embracing Catholicism, these newcomers brought with them a unique blend of Spanish and Indian traditions. They introduced cultural variations in the cultivation and preparation of Native American foods such as corn, avocados, potatoes, squash, and beans. A flat form of bread known as a "tortilla" was developed as a dietary staple; this could be eaten with chicken or red meat, avocados, tomatoes, and/or beans. Latinos also demonstrated their individualized cultural personality in their costumes and daily dress. Hats with wide brims and open shoes made for comfortable living styles and made sense in a warm climate. Colorful threads and dyes found their way into fabrics, embroidered blouses, leather handbags and blankets.

Foods from Mexico and other Latin American countries have become very popular in the United States. Breakfast menus in restaurants offer *huevos rancheros,* most households stock tortillas and salsa, and one can find tacos, burritos, enchiladas and tostadas in fast food establishments across the country. Regional cuisines based on food from Latin America have developed from San Diego, California to Santa Fe, New Mexico to the "Tex-Mex" style of barbeque in Texas.

Today, Latinos reside in communities throughout the United States, with their largest populations located in the southwestern region of the country. They are, in fact, the largest single population group in the state of California. Most school children growing up in California, no matter what culture they are from, learn about Cinco de Mayo (May 5), a holiday commemorating a Mexican victory against the French army in 1862. This day is celebrated with food and music throughout Mexican-American communities. Other Latin American holidays and celebration days include Mexican Independence Day in mid-September and Dia de Los Muertos (day of the dead) in late October.

Whether Latinos choose to participate in the fields of art and entertainment, politics, or science, their creative energies and unique spirit of enthusiasm is reflected in the outstanding performances of people such as actor and producer Edward James Olmos; theatrical producer and co-founder of Repertorio Español, Gilberto Zaldivar; film director, producer, and writer Robert Rodriguez; Pulitzer Prize-winning photographer José Galvez; 2003 Pulitzer Prize-winner for drama, Nilo Cruz; first Hispanic elected to the Georgia senate, Senator Sam Zamarripa; American labor leaders and co-founders of the United Farm Workers Union, César Chávez and

Dolores Huerta; and mathematical biologist and co-founder of the Mathematical and Theoretical Biological Institute, and recipient in 1997 of the Presidential Award for Excellence in Science, Mathematics, and Engineering Mentoring, Dr. Carlos Castillo-Chavez.

While many Latin American families have lived in the United States for generations, in recent years many others from Mexico, Central and South America have come north to our country in search of employment. Many take jobs as domestic servants, gardeners, factory workers and farm workers. Some have crossed the border without U.S. immigration documents, and there has been much discussion about our country's immigration policies with respect to these immigrants. However, although Latinos from other countries are looked upon by many as immigrants, geographically speaking, they have not moved. Their status is clouded only by political borders superimposed on their cultural homelands over the last three hundred years. These hardworking and interesting people are happy to be included within the political boundaries of the United States. They, too, recognize the freedoms enjoyed by living in the United States, and the opportunities this country provides for economic mobility. America's strength of heart and its flourishing cultural spirit is greatly attributed to the warmth of these gracious people.

SANTA BARBARA, CALIFORNIA, 2003

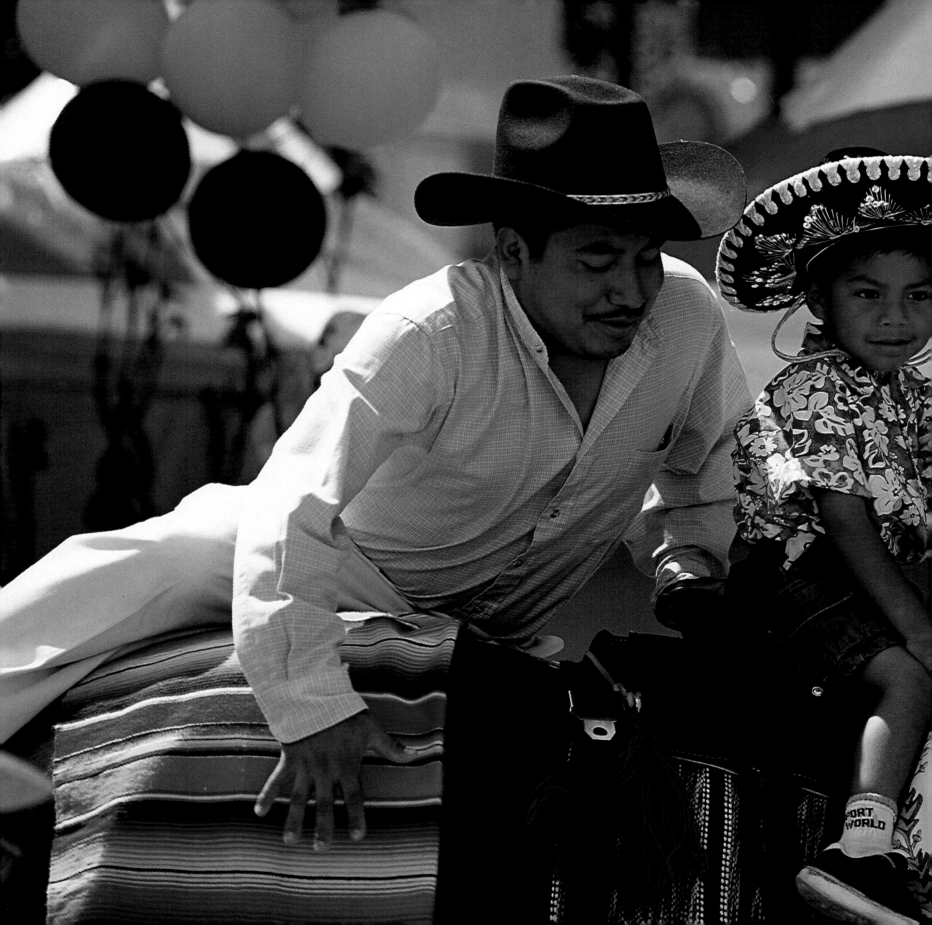

Several times a year in Los Angeles, California, Latinos hold fiestas (festivals) on Olvera Street, a historic marketplace known as the birthplace of the City of Los Angeles. Everyone from the youngest toddler to the oldest person comes to the celebrations. With music, food, rides, and other festivities they celebrate California's Latin American heritage.

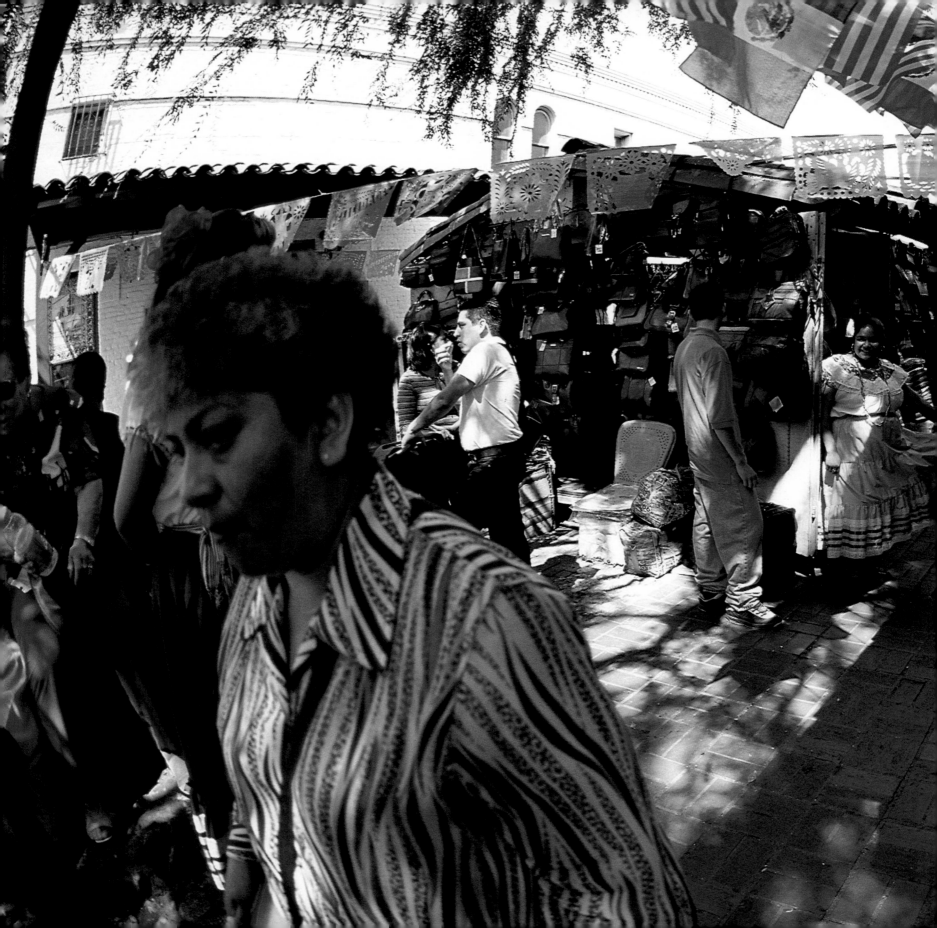

OLVERA STREET,
LOS ANGELES,
CALIFORNIA, 2003

America is truly a rich composite of ethnic personalities and customs. Yet our country's democratic foundation is based on the principles of its English ancestors. Of course, the infusion of other European cultures and the influence of the Native American populations greatly enhanced that foundation. But it was the English who were the dominant players in setting the tone and style of American society and our political system. Their Christian ways and Puritan values not only influenced but sustained the development of the first fledgling colonies of Jamestown and the Massachusetts Bay Colony. Our standards for freedom and justice have their underpinnings in the character and revolutionary ideals of those early English settlers.

While there had been attempts to conquer the land which would become the continental United States as early as the 1500s by the Spanish, English, and other northern Europeans, none succeeded until the early 1600s. On the death of Queen Elizabeth in 1603, King James I brokered peace between the English and the Spanish. Shortly after the signing of the peace treaty in 1606,

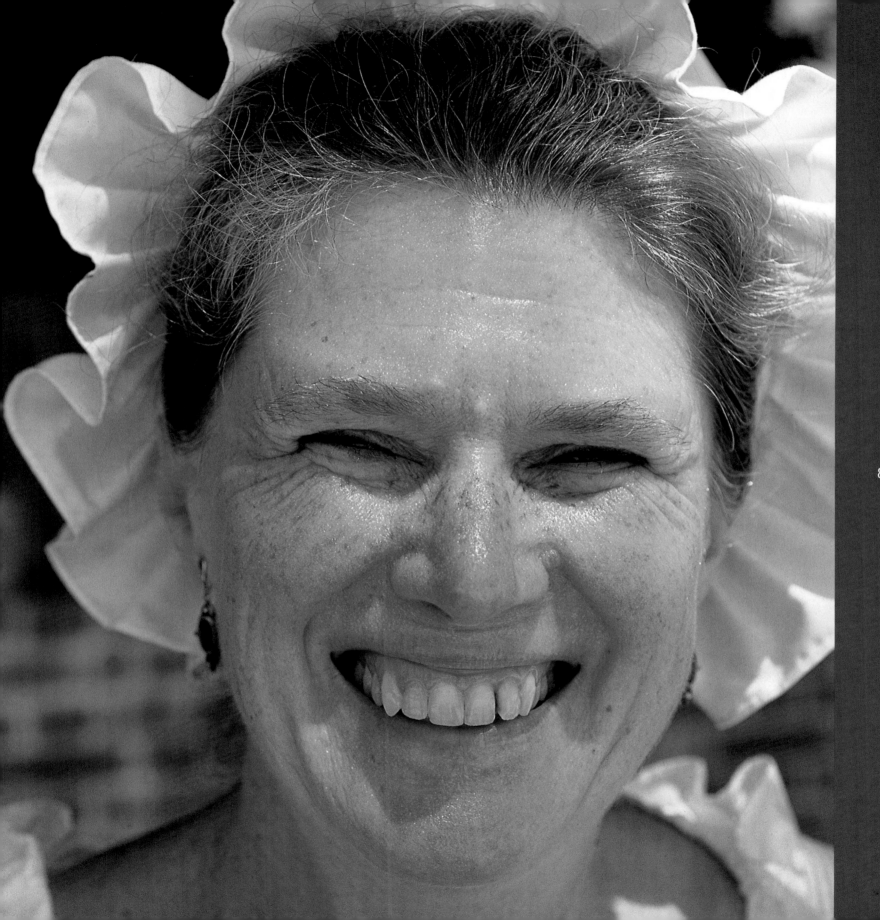

the Plymouth Company was chartered and England's campaign to establish colonies in the New World commenced. Of course, economics played a major role in this venture, as investors anticipated high profits from the discovery of gold and treasure as well as the development of a timber industry that they anticipated would relieve the pressure on England's denuded forests and those in Western Europe. But economic rewards were not the only motivation for their expansion. In spite of the treaty with Spain, the English were seeking to establish strategic outposts to fend off and equalize the Spanish prowess on the open seas. By securing a foothold in the New World, they not only succeeded in this goal but also impeded the spread of Catholicism by introducing the English form of Protestant Christianity to America.

The early efforts at establishing settlements in the wilderness terrain not only tested English resolve but individual character as well. The first arrivals in the new territory struggled to survive brutal winters, near starvation, disease, and unfriendly encounters with the indigenous people. They relied on support from Mother England; ships arrived with more settlers and provisions, helping to sustain the expansion efforts. But it wasn't long before the newcomers learned to live off the land and became better at protecting themselves and their communities, having adopted new defense strategies from encounters with the various indigenous tribes. For the next 150 years, life in the colonies blossomed under English rule, but so too did a newfound spirit of autonomy germinate. Although their political allegiance was to the king of England, the distance and isolation from their homeland fostered their sense of independence, and they developed some resentment and defiance against the crown. When edicts of taxation without representation were imposed upon the colonists by the English Parliament, they rebelled, and the birth of a new nation was imminent. The Revolutionary War lasted from 1775-76, and the United States declared its independence in 1776.

Courage and an independent nature characterizes these New World English. They demonstrated the strength and determination necessary to build a new nation—to become a people united by fundamental concepts of self-government with elected leaders and who championed individual liberty and freedom. Among these distinguished patriots were individuals such as George Washington, Thomas Jefferson, John Adams, and Benjamin Franklin—each believing in the goodness of man and the sanctity of a free and democratic republic. It is upon the backs of these English ancestors that our nation was founded and continues today as one nation, one people, with freedom for all of its citizens.

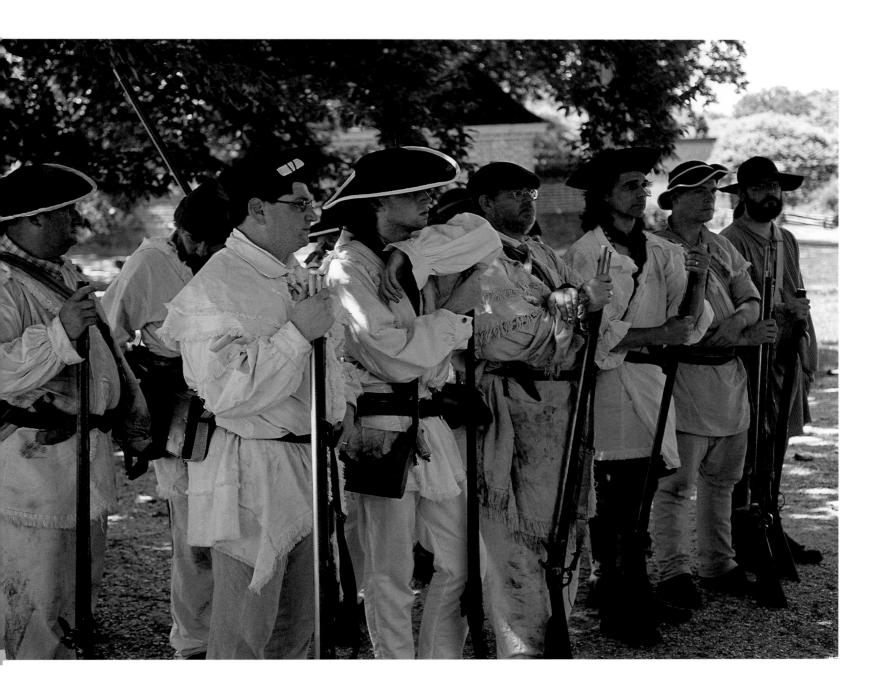

WILLIAMSBURG, VIRGINIA, 2004

WILLIAMSBURG, VIRGINIA, 2004

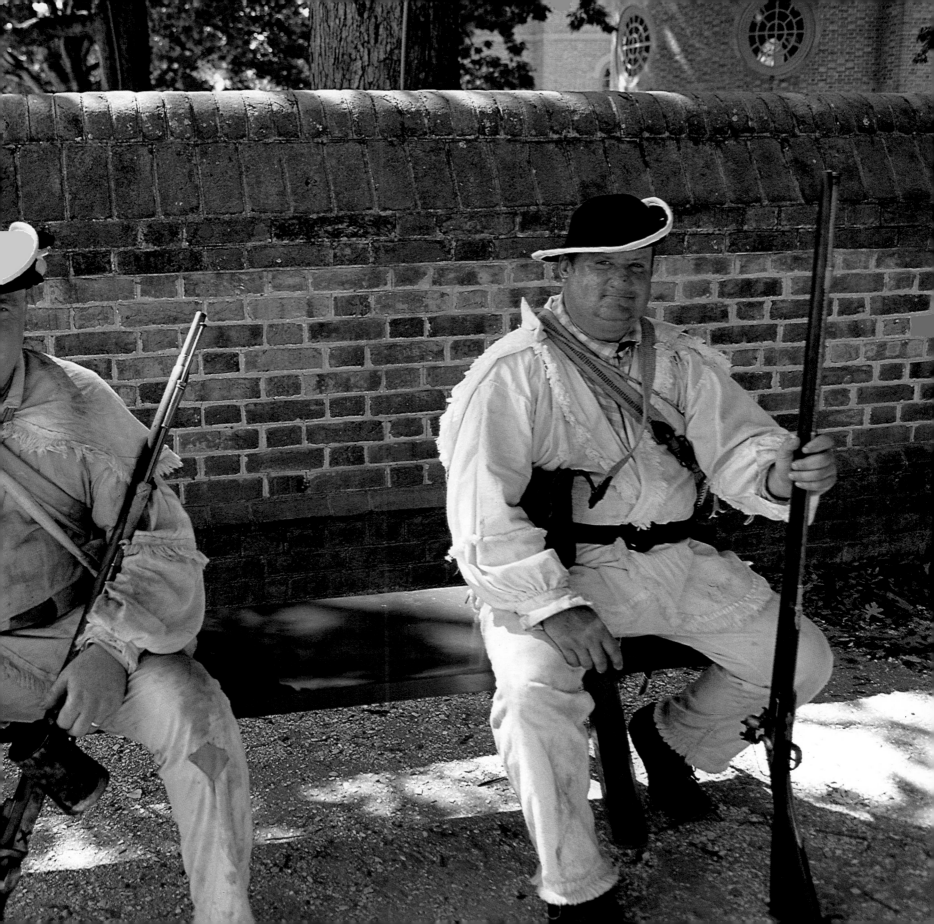

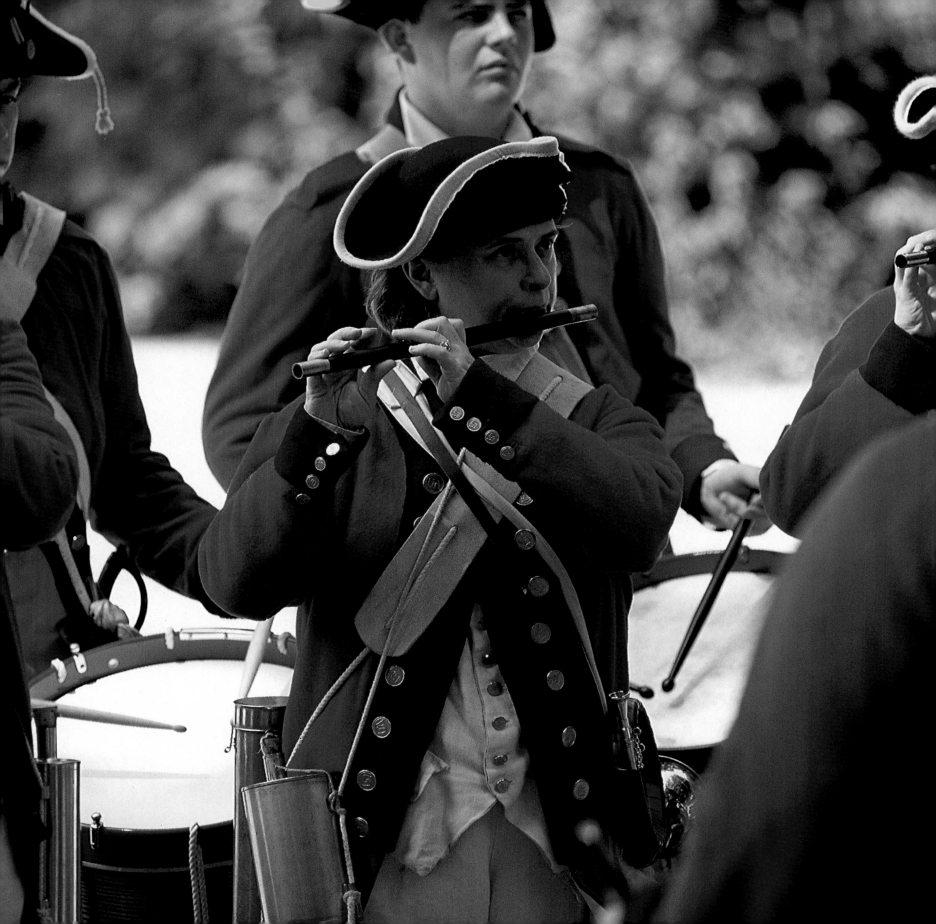

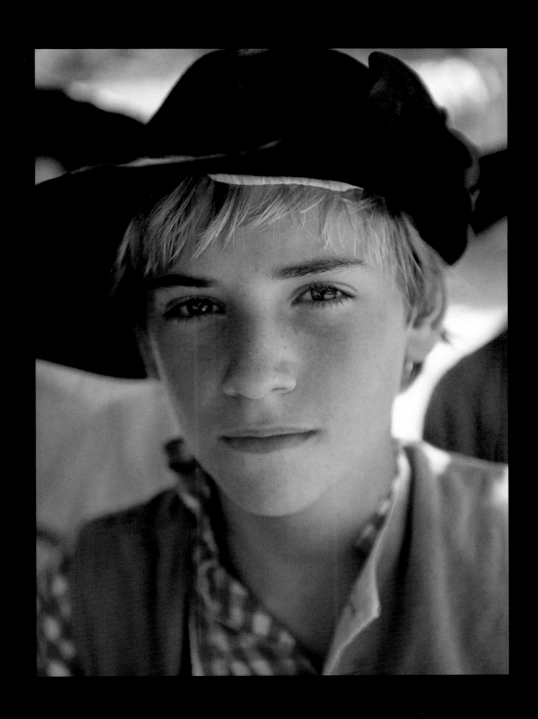

WILLIAMSBURG, VIRGINIA, 2004

If asked to point to one example of the French influence in America, one might look to Louisiana and its city of New Orleans—affectionately known as the Big Easy. Historically, this region of the country was controlled at one time or another by several different entities; the Spanish, the French, the Confederate States of America, and ultimately the United States of America. Officially founded and ruled by the French, New Orleans holds the unique distinction of being the only city in the United States where French was the predominant language for more than a century.

The region known as Louisiana was discovered by a Spanish army officer in 1541, but it remained dormant for another 140 years until 1682, when French-Canadian fur traders with an accompaniment of Jesuit missionary priests traveled from Canada down the Mississippi River and ended up in the port of today's New Orleans. It was Robert Cavalier de La Salle who planted a cross on the spot and decreed the area be called Louisiana, in honor of King Louis XIV of France. For the next 15 years, however, France did little to develop

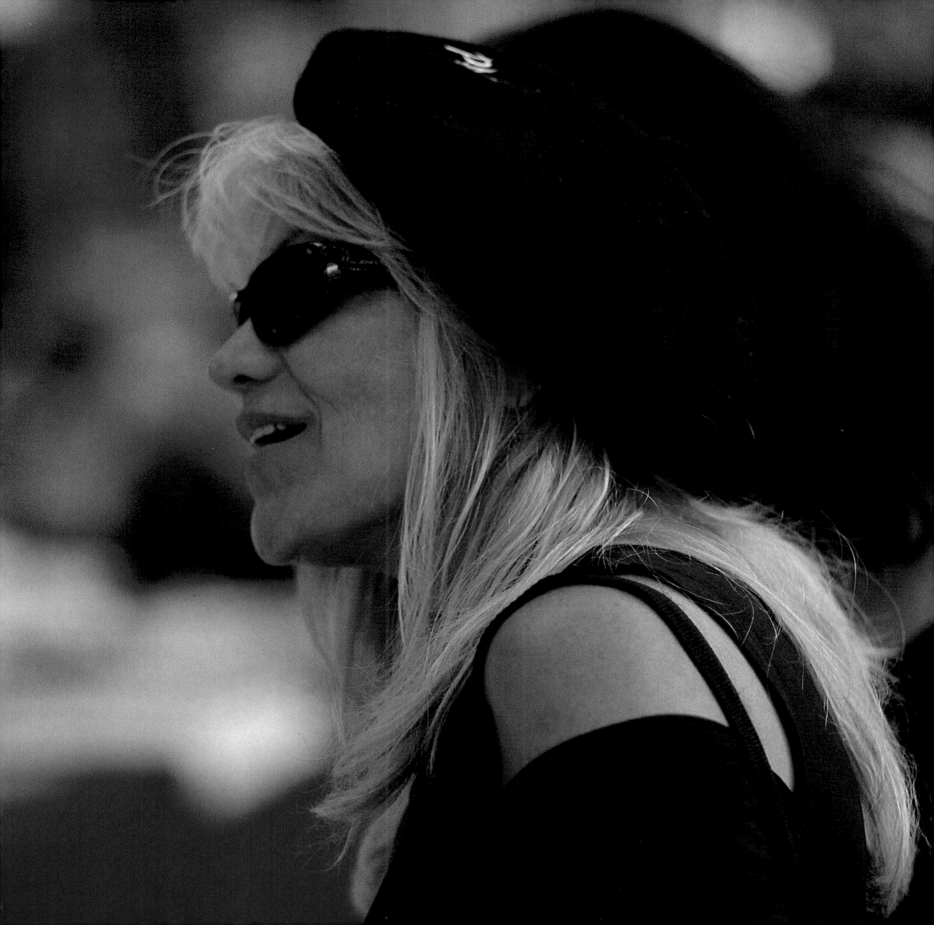

any colonization of the territory, expending their energies instead engaged in a protracted war with England. At the end of the war in 1697, however, French attention was refocused on America when Pierre Le Moyne Sieur d'Iberville, a young French Canadian, approached the king with his thoughts on expanding the French empire in the New World. The king granted permission for the expansion campaign, and directives were given to build forts in the New World to fend off any British encroachment. The settlements in Louisiana prospered under the expertise of French farmers and traders. And it was not until a war with the British that French control of Louisiana was transferred to Spain and England.

Naturally, not all French coming to the New World migrated to Louisiana. Fleeing religious persecution, French Huguenots emigrating directly from France as well as from other regions in Europe settled in established colonies along the east coast in Massachusetts, New York, and Pennsylvania. Others would migrate farther to the south and settle in Virginia and South Carolina. Thousands of French Canadians were forcibly removed from their homeland in Canada after British occupation and scattered along the Atlantic seaboard colonies. And like so many immigrants coming to America, they brought with them talents and skills. They were then, as they are today, accomplished physicians, artisans, and craftsmen.

Some famous Franco-Americans include first lady Jacqueline Bouvier Kennedy Onassis, poet Stephen Vincent Benet, essayist Henry David Thoreau, actress Claudette Colbert, union organizer Eugene V. Debs, and Senator Robert La Follette.

The French are a noble and vibrant people who are proud of their traditions. Their culture continues to punctuate the American scene with its fine cuisine, exquisite designs in classical and provincial furniture, architecture, fashion, and cosmetics. America's French heritage is well reflected in our appreciation for living life fully and in celebrating the beauty in life.

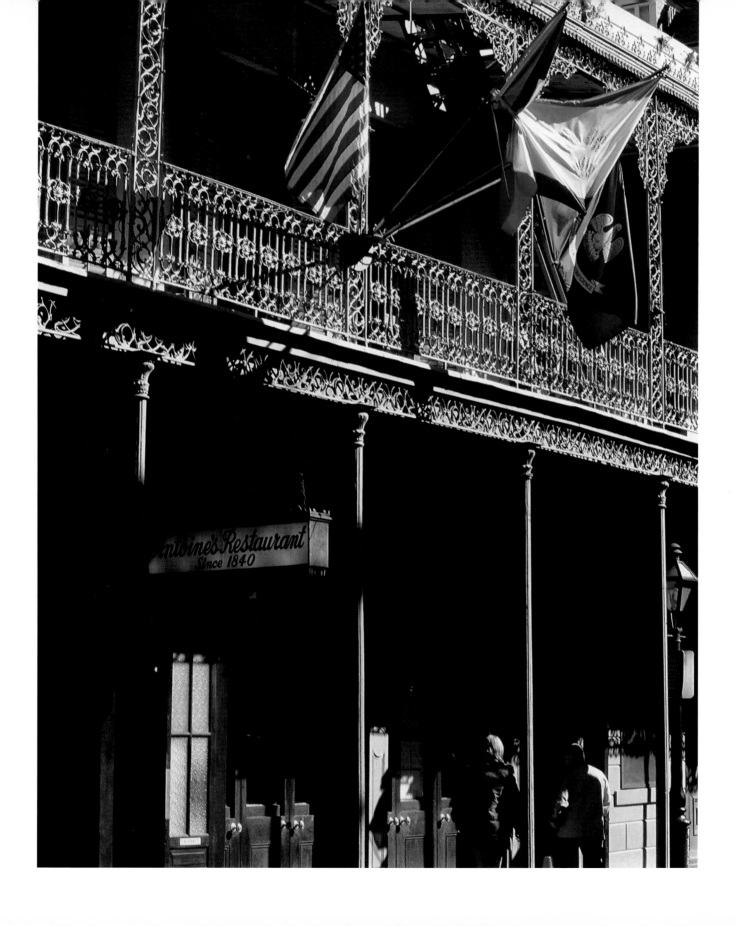

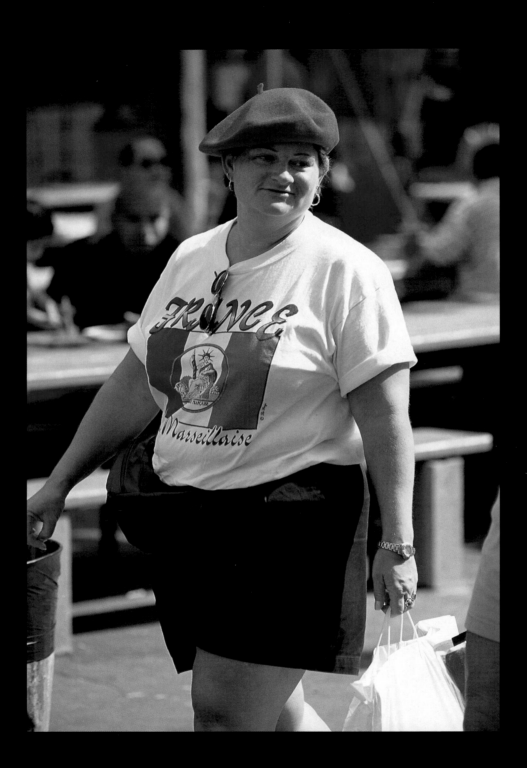

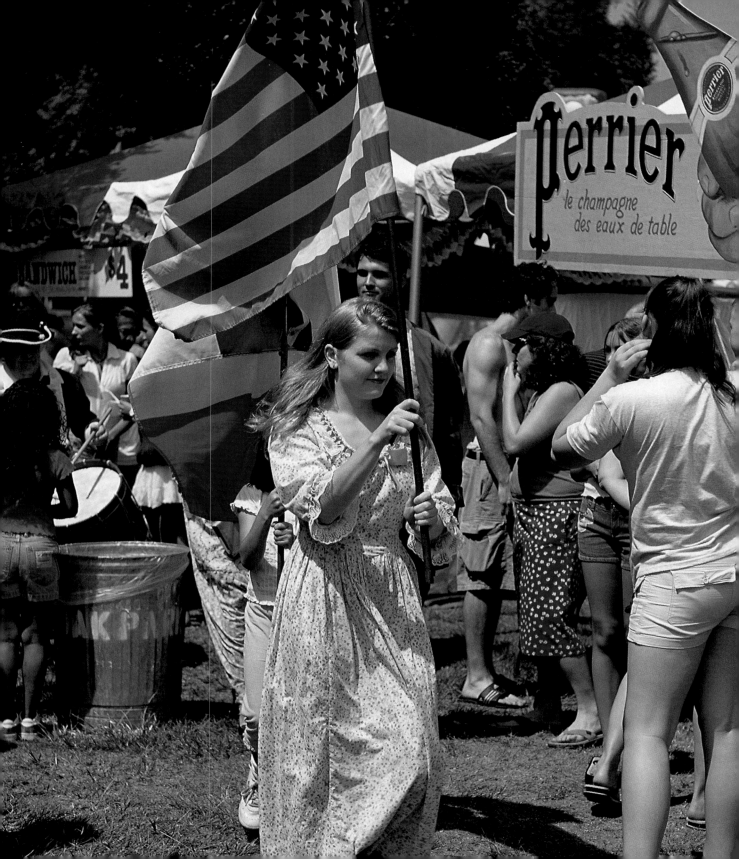

Over the years, New Orleans, Louisiana has grown to become the renowned location of the Mardi Gras festival and the home of jazz music in America. Also known for its unique Cajun cuisine, New Orleans has many excellent restaurants.

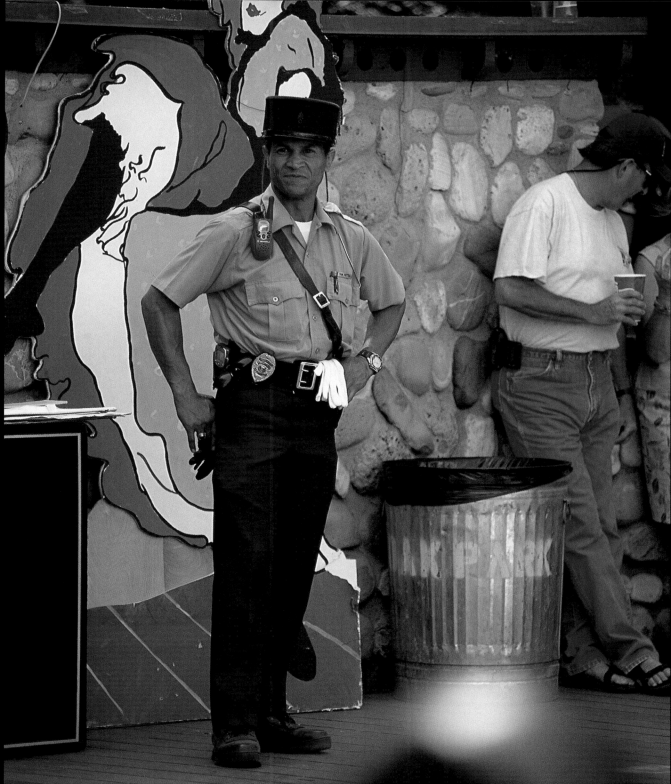

In spite of all our good qualities, we humans are capable of perpetrating some of the most despicable acts of inhumanity. When acquiring or defending territory, we destroy each other, massacring vast numbers of people, and at times, we kill in an effort to punish or prevent a societal behavior. But perhaps one of mankind's lowest and most inhumane acts is the capture and sale of other human beings as if they were a commodity. Although slavery did not originate within our borders, sadly it was adopted and acquiesced to by us and was actually promoted as an acceptable practice in our country. As heinous as this behavior was, it proved to spawn some of the most magnificent achievements of its victims and of the continuing generations of those proud people who first came to this land as slaves.

The practice of trading and keeping humans as slaves was a tradition established thousands of years before the founding of the Americas. The ancient Romans had slaves. The Spanish, Portuguese, and English explorers

were notorious for exploiting populations in newly discovered lands. And when there became a need for huge numbers of laborers to work the large plantations in the burgeoning colonies of the New World, it was the English shippers who further capitalized on kidnapping thousands of Africans and bringing them to America to work as slaves. The first documented arrival of slaves occurred at Jamestown in 1619, to be followed by tens of thousands more until Congress abolished the slave trade in 1808. Trading of African slaves was an accepted way of life in America, and people were sold into bondage with no hope of freedom for themselves, their children, or their families.

Although slavery was protected by the Constitution, the presence of such a malevolent institution in the United States proved to be the major divisive factor between the northern and southern sections of the country. Economically impracticable in the North, slavery was gradually abolished, with impetus given by the Quakers and others who believed in the equality of all people, regardless of the color of their skin. But in the South, the institution continued to prosper. Politicians attempted numerous compromises over slavery, but nothing worked. Finally, in 1861, following the election of Abraham Lincoln, eleven Southern states seceded from the Union, prompting four bloody years of civil war, and resulting in the abolition of slavery in the United States. Even though black Americans were now free, many states legislated "separate but equal" facilities, in effect reducing African-Americans to second class status. It wasn't until 1954 that the "separate but equal" laws were

overturned, leading to a more progressive civil rights movement that continues yet today.

Although African-Americans are not the only ethnic group to have suffered the cruelty and indignity of discriminatory acts and practices, their struggle is symbolic. And while many other cultures in America have endured some form of oppression, none was as contemptible as slavery. Many slaveowners attempted to strip their newly-imported slaves of their African heritage, prohibiting their languages and celebrations. Over time, their cultural heritage became a distant memory. Part of the Civil Rights movement included getting in touch with their heritage. Although there was a "Back to Africa" movement in which scores of African-Americans went back to their home continent, they found that they were more American than they realized and the movement failed. Still, the 1977 television series *Roots*, based on author Alex Haley's search for his own family's origins, fueled a new movement to celebrate the heritage of African-Americans. More and more African-Americans became interested in their past and began to organize celebrations of their ethnic heritage, including the adoption of Kwanzaa as a holiday.

From the mid-1960s to the present, African-Americans have enjoyed a renewed vibrancy and cultural explosion. And today, Americans look back with admiration at the incredible achievements of its African progeny. We applaud their pride of heritage and the celebration of their culture, and we marvel at their stellar accomplishments. There are many examples of their individual and group achievements found in every profession. Examples include Marian Anderson in music,

George Washington Carver in science, Martin Luther King in Civil Rights, Thurgood Marshall in law, and Henry Aaron, Jesse Owens, Wilt Chamberlain, and Muhammad Ali in sports. LeVar Burton, Bill Cosby, Vanessa Williams, Eddie Murphy, and Halle Berry are just a few of the scores of African-American Hollywood stars. Our music industry has been enriched by the development of both jazz and the blues; both genres trace the historic journey of Africans through American culture. More recently, African-Americans have pioneered the rap and hip-hop music genres. African-Americans truly provide a unique perspective and valuable insight into life in our society. America owes a great debt of gratitude to their enduring spirit and their tenacity, which continues to define freedom in American democracy.

ABOVE: LOS ANGELES, CALIFORNIA, 2003
LEFT: NEW YORK CITY, NEW YORK, 2004.

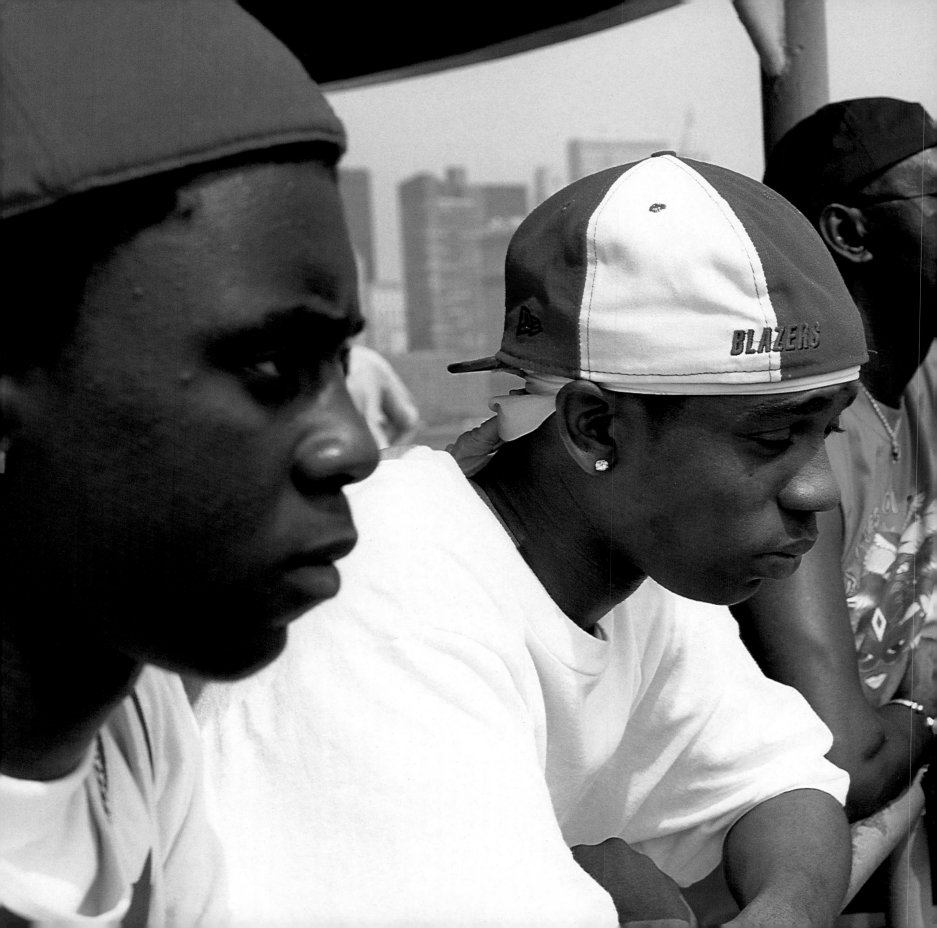

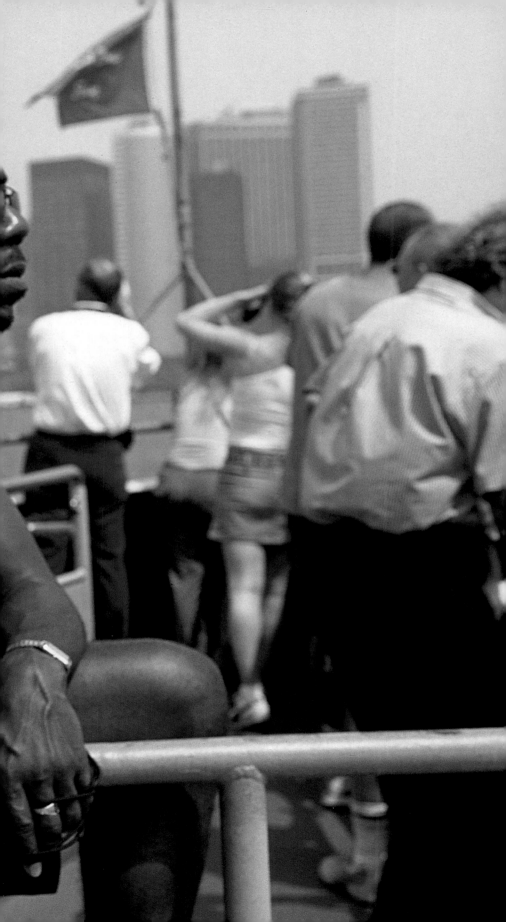

Nestled in the beautiful, green landscape of southern Minnesota is the small town of New Ulm. The citizens here are proud that their lineage is one of the purest of German heritage in this country. This tiny town is so authentically German that the residents speak principally German, and visitors and residents leaving the town pass a sign which reads *auf Wiedersehen*. Like so many of the new immigrants when first arriving in America, the Germans formed tight-knit communities like New Ulm, taking comfort in sharing their traditional values and customs. While some would remain in these concentrated colonies for generations, over time many would leave to resettle in towns and cities across the country.

Germans are the largest ethnic group living in the United States; more than 25 percent of the American population identify themselves as having German ancestry of some sort. It is little wonder, because from the time that immigration records were kept in this country, over seven million Germans have immigrated to the United States. It is believed that the first Germans to migrate

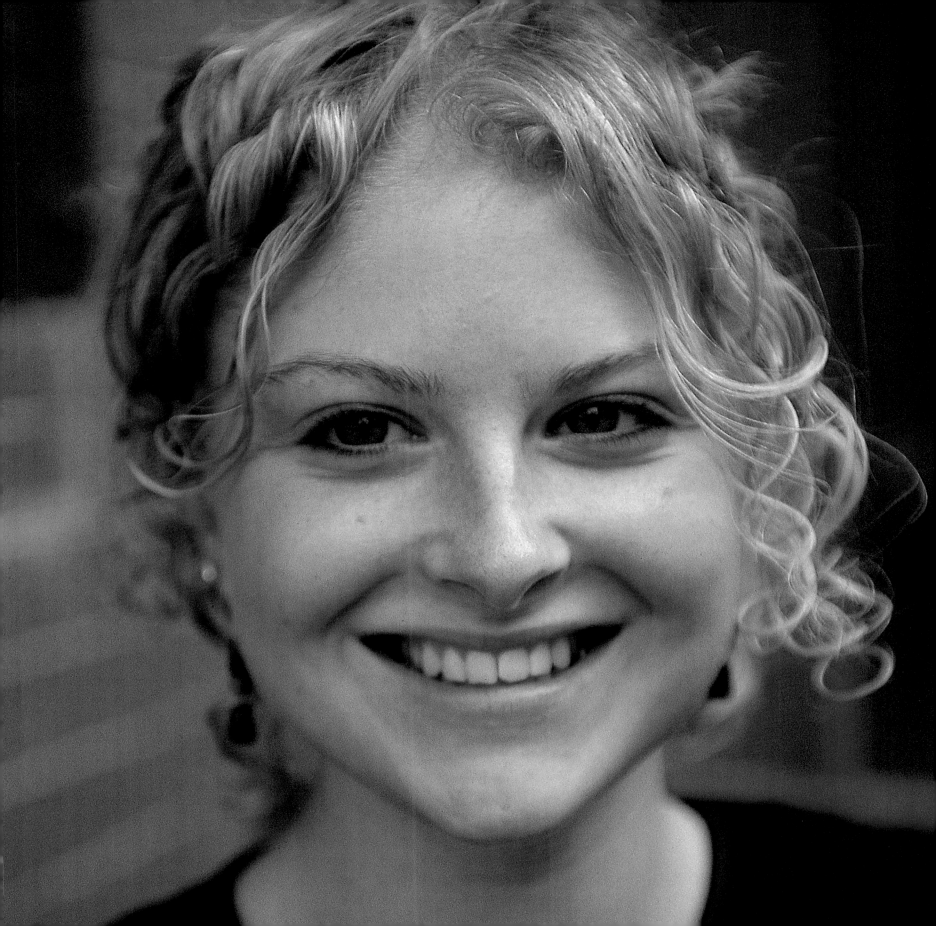

to America were part of the early explorations of the North American continent. Germans participated in the Viking conquests around 1000 A.D.; they accompanied Christopher Columbus at the time of the discovery of the New Americas; and they were at Jamestown in 1607 at the time the first colony was formed. By the mid-1700s, there were approximately 250,000 Germans counted among the American population.

History holds a key to understanding German migratory motivations. Continual oppression by the Holy Roman Empire, and its demand that the German population adhere to Catholic religious doctrines, caused many Germans to rebel during the 1700s. Opposition to religious doctrines had been the cause of strife in Germany throughout the 1500s and 1600s. So strong were the differences in religious opinion that they led Martin Luther and his followers to break away from the Catholic Church, thus initiating the Protestant movement in Christianity and the formation of the Lutheran Church as well as other Protestant organizations. During the 1600s and 1700s, there was such great intolerance for religious differences that many in the German population resolved to leave their homeland; seeking refuge elsewhere, they emigrated to North America.

The large numbers of early German immigrants had a significant impact on our country's development. Although their primary motivation for migrating to America was freedom from religious persecution, others came for the economic opportunities as well. For the most part, German immigrants had no delusions of grandeur; primarily farmers and craftsmen, they plied their skills and worked hard at enriching the farmlands in the fertile regions of Ohio, Pennsylvania, and Indiana. Their stoic nature and strong sense of fundamental values typified their work ethic and non-intrusive lifestyle, endearing them to all who worked and lived around them. The Amish people, of German descent, settled in eastern Pennsylvania, and today they maintain a unique lifestyle within American society.

Ultimately, German business savvy and intelligence, coupled with entrepreneurial spirit, resulted in the creation of some of the strongest and most prosperous companies within the American business landscape. Germans established businesses in the brewing industry like Pabst, Schlitz, and Busch beers. And today, German ingenuity continues to influence all aspects of American industry; agriculture, business, engineering, music, and science. This ethnic group has fostered many prominent Americans whose accomplishments not only contributed greatly to the prosperity of America but to its character— people such as wealthy entrepreneur John Jacob Astor; notable scientists Franz Boas and Albert Einstein; Laureate in physics and Nobel Prize winner Maria Goeppert-Mayer; baseball hero George Herman "Babe" Ruth; President Dwight D. Eisenhower; and actress Marlene Dietrich. It is clear that German-Americans have contributed much to American culture.

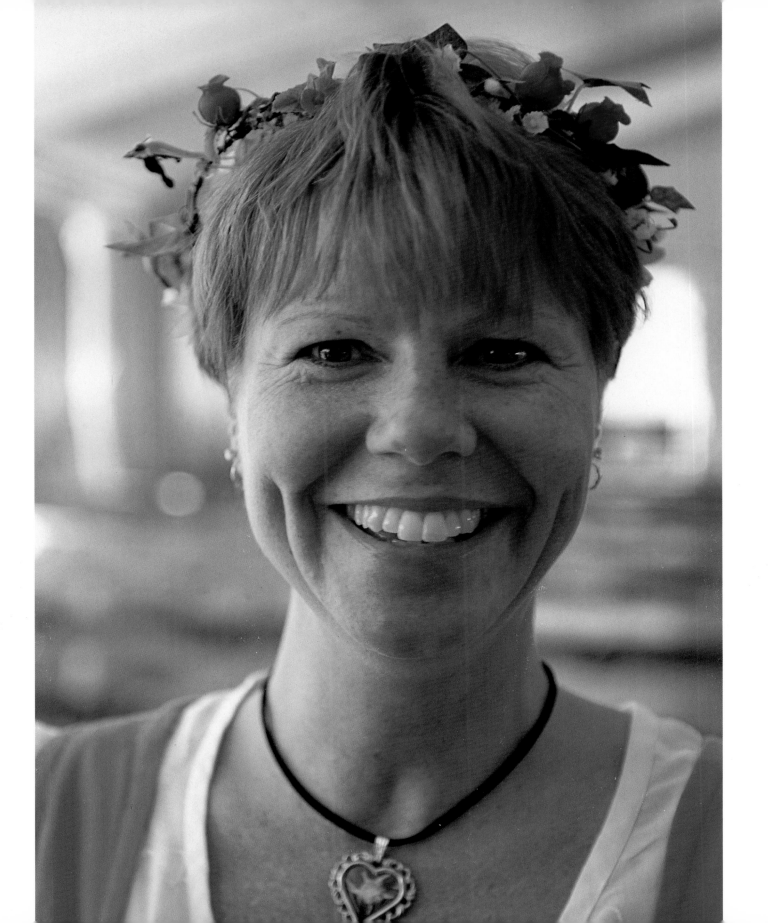

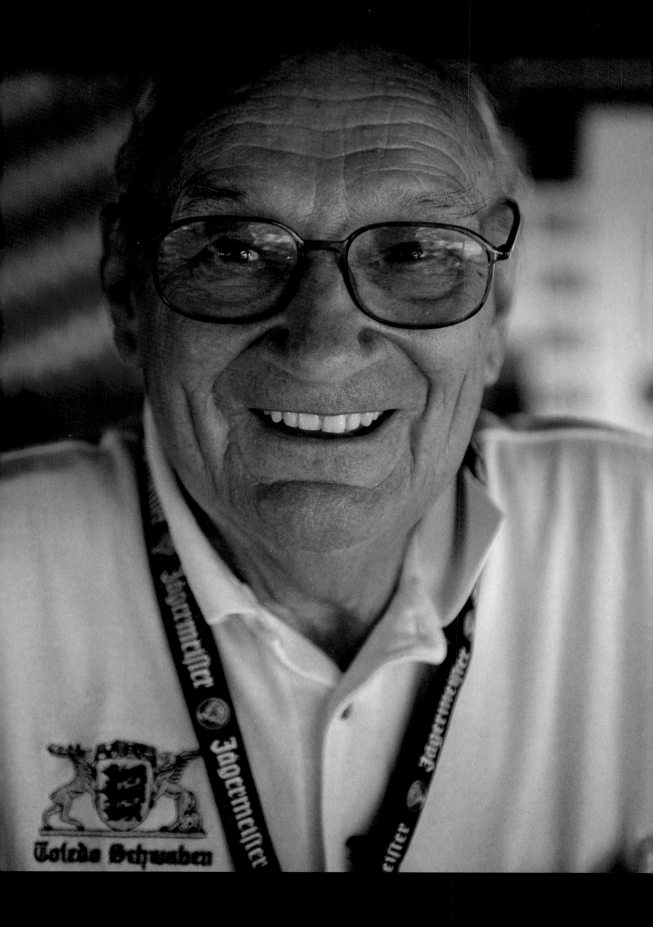

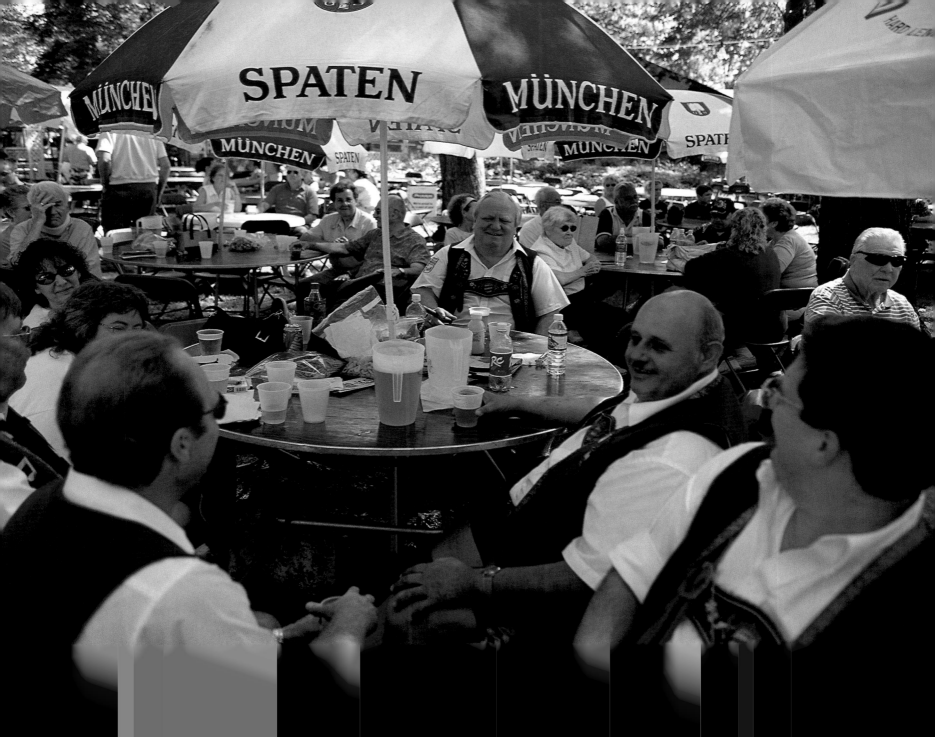

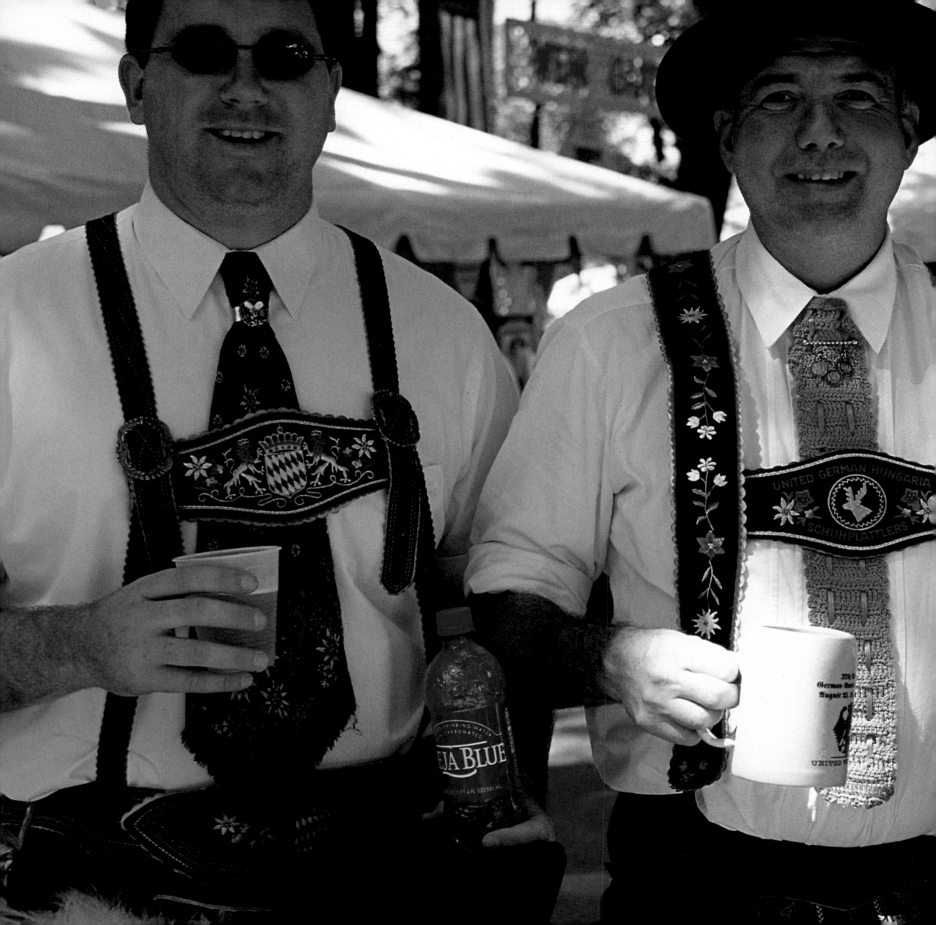

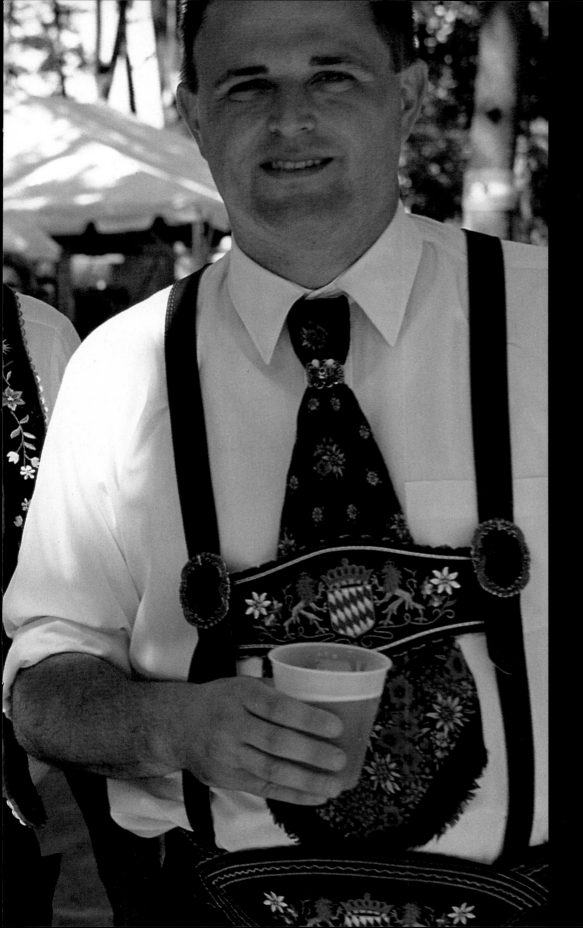

Several times a year, the German-American Festival Society holds festivals in a large park in Oregon, Ohio. Although the Oktoberfest is the most well-known, at the end of each summer the German-American Festival is held on those same grounds. A tournament on the soccer field involving Bavarian sports teams is sponsored in part by several American brewing companies. Dancing, competitions, and other traditional German activities are included. Of course, German is spoken quite fluently by a substantial number of the partygoers and a good time is had by all.

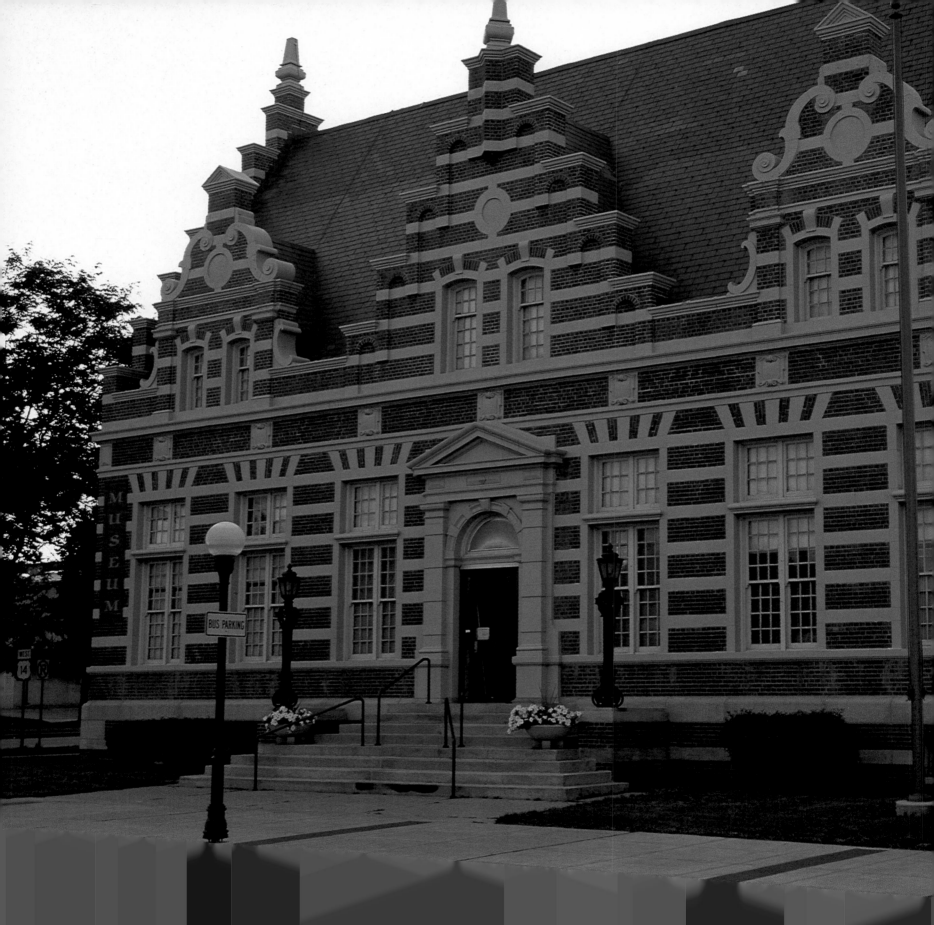

In New Ulm, Minnesota, the Brown County Historical Society is now housed in this building. This unique building, designed in the German Renaissance style, was constructed in 1910 to be a federal Post Office. It is a tribute to the dominant German population of the city, whose immaculate streets and building signage, as well as the language of most all of the inhabitants, is distinctly German. The town's name was selected in 1854, at the time of its founding, since the original settlers were from Wurttemberg, Germany, and its principal city of Ulm.

Call them stubborn or simply intensely devoted to their faith, but the Amish are an outstanding example of living wonderfully productive lives without support from our advanced technological world. They have lived in America for over three hundred years, maintaining their cohesive and collective society apart from others, with no desire to assimilate or be assimilated. A remarkably self-sufficient and private people, they want nothing more than to be left to their own devices; to live life based on their doctrines, customs, and strict code of ethics. Christian in belief, they host their religious gatherings in the various homes within their community instead of in churches, and they pass on their wisdom through custom and oral tradition. They continue to speak in a German dialect; hence their popular nickname of the "Pennsylvania Dutch" (a direct translation of the German Pennsylvanische Deutsche). Extraordinarily self-reliant and industrious, the Amish build their own homes; make their own furniture, appliances, and

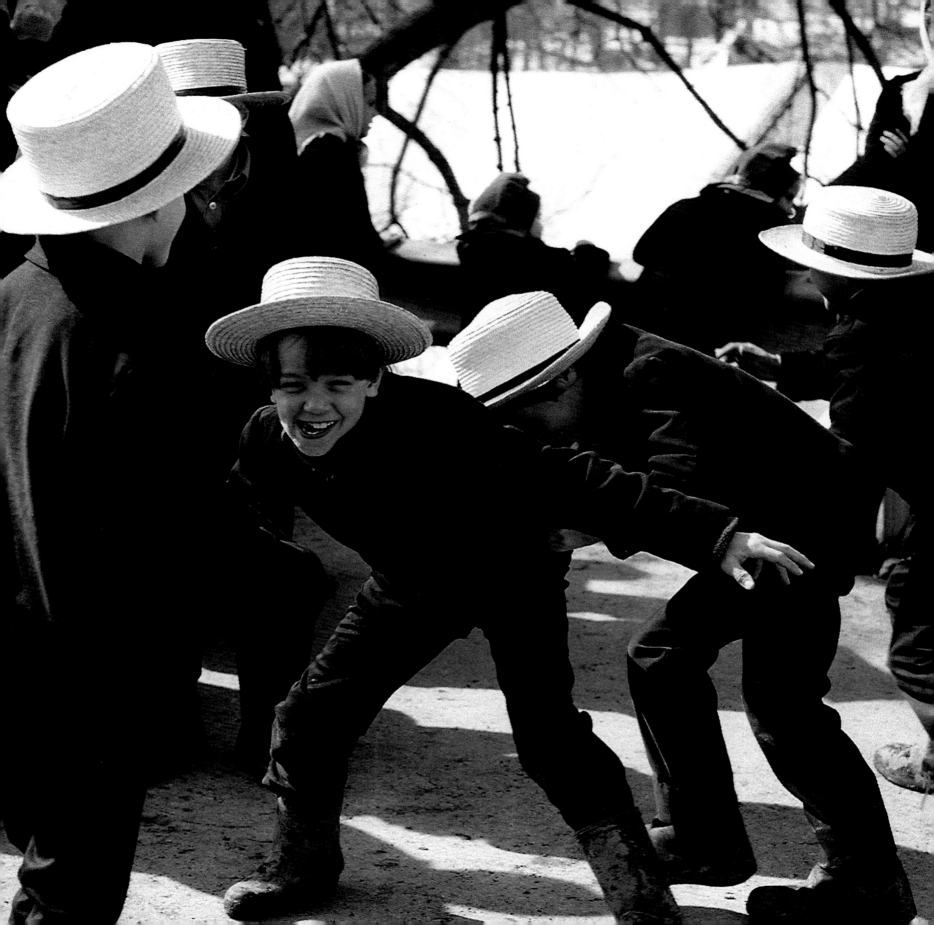

clothing; and grow their own food, typically without the use of electricity. Their handcrafted tools, beautiful quilts, and other fine handmade items are highly prized across the country. Intensely loyal, the Amish traditionally provide for all within their community.

The Amish are religious Anabaptists (they oppose infant baptism), a product of the Mennonites and Swiss Brethren of Western Europe. Mennonites are also Anabaptists but are followers of Menno Simons. The Amish, a division of the Mennonites, are followers of Jacob Ammann, founder of their sect in the Alsace region of France. A farmer and tradesman, Ammann broke with the Mennonites over a number of interpretations of belief, including the practice of shunning members who left the church. Considered revolutionary and heretical by early to mid-1600 standards, the nonconforming Mennonites and Amish were hunted, captured, and slain as religious heretics by both Catholics and Protestants. Fleeing persecution, many banded together to escape into the foothills of the surrounding regions. Ultimately, they fled across the Atlantic to take refuge in the new land of America and, as early as 1683, established a Mennonite community in Germantown, now a political subdivision of present-day Philadelphia. Other migrations followed in the early 1700s, with Mennonites and Amish coming to America from Alsace in France, Rhineland-Pfalz (Palatinate) in Switzerland, and Baden in Germany. Arriving in America, they settled principally in Pennsylvania. Over the years, groups of Amish have moved to Ohio and other states in the midwest, New York, and Canada. In 1992, the Amish population numbered slightly less than 150,000 in the entire country, and today, the most densely populated Amish region in the country is located in Lancaster County, Pennsylvania.

The Amish are hardworking Americans who cherish their religious freedom. Their communities comprise immaculately groomed farms, abundant in fields of grains and harvests of luscious fruits and vegetables. Their daily activities exemplify their steadfast commitment to a simple Christian life based on the New Testament. They are pacifists, do not vote or hold public office, and refuse to take oaths in court. They cling to their traditional ways; working their farms with horse-drawn wagons and plows; rejecting the use of electricity and related luxuries such as radio, television, and personal computers; and shunning motorized vehicles, traveling instead within and outside of their communities by horse-drawn buggy or sleigh. While their lifestyle may appear peculiar to most modern Americans, their industrious spirit, good nature, and kindness expressed to their fellow man is greatly admired. They may stand out in a crowd because of their simplicity of dress and humble manners, but they are distinguished by their allegiance to their beliefs, their devotion to their culture, and the way in which they embrace their traditional values. They are a wonderful and distinctive part of our American community.

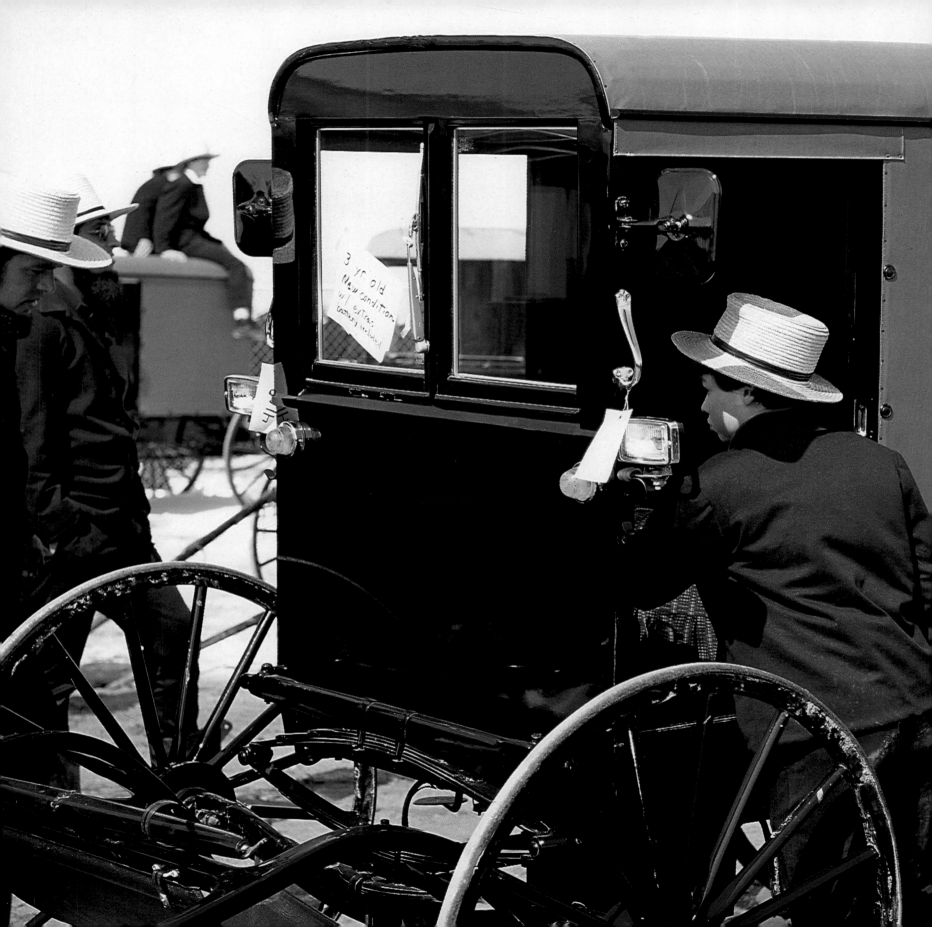

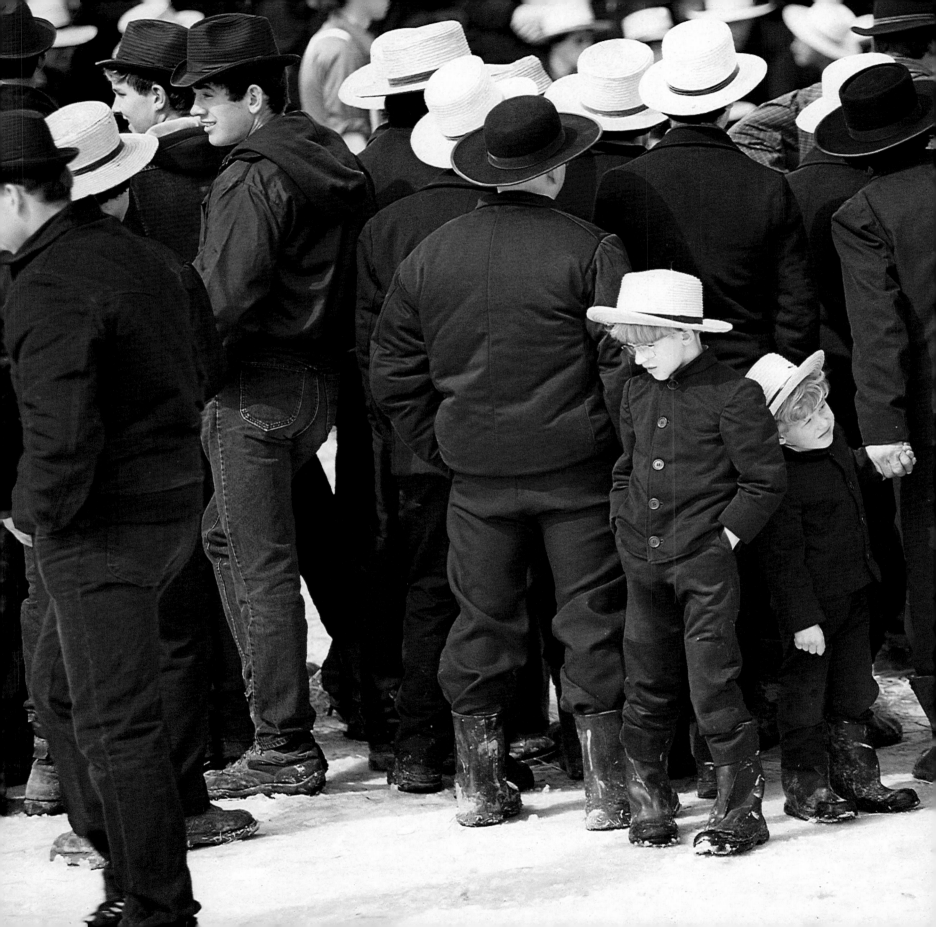

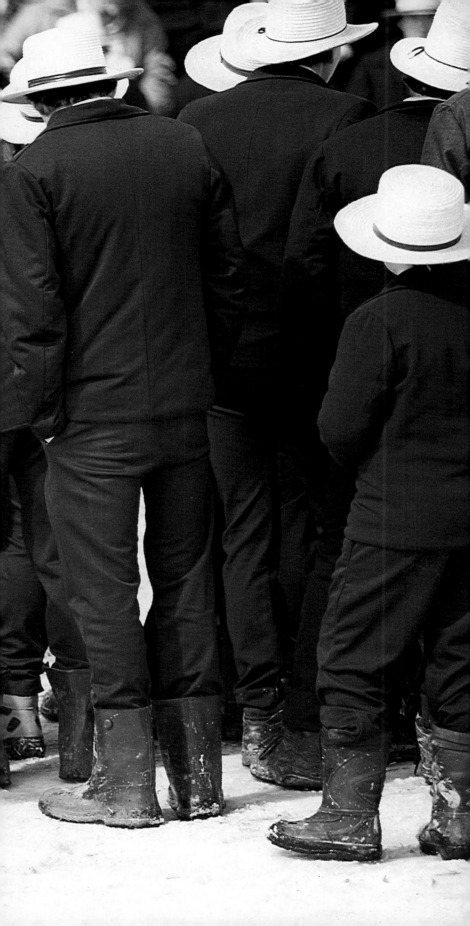

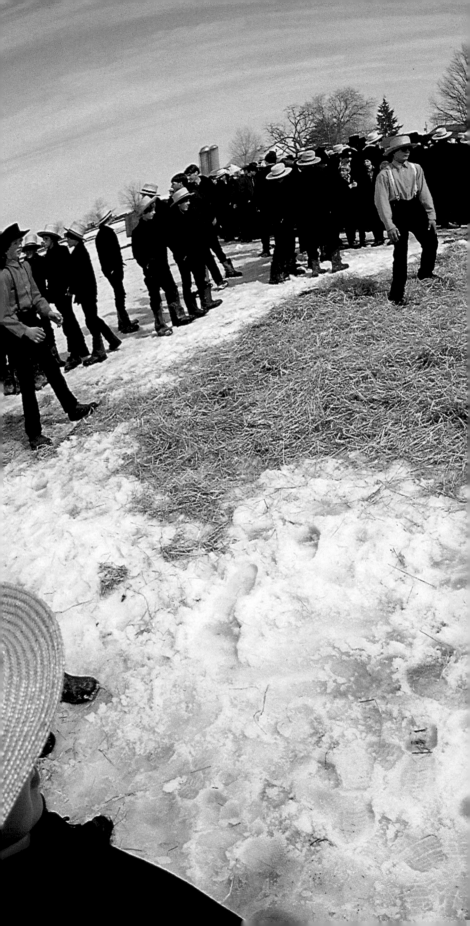

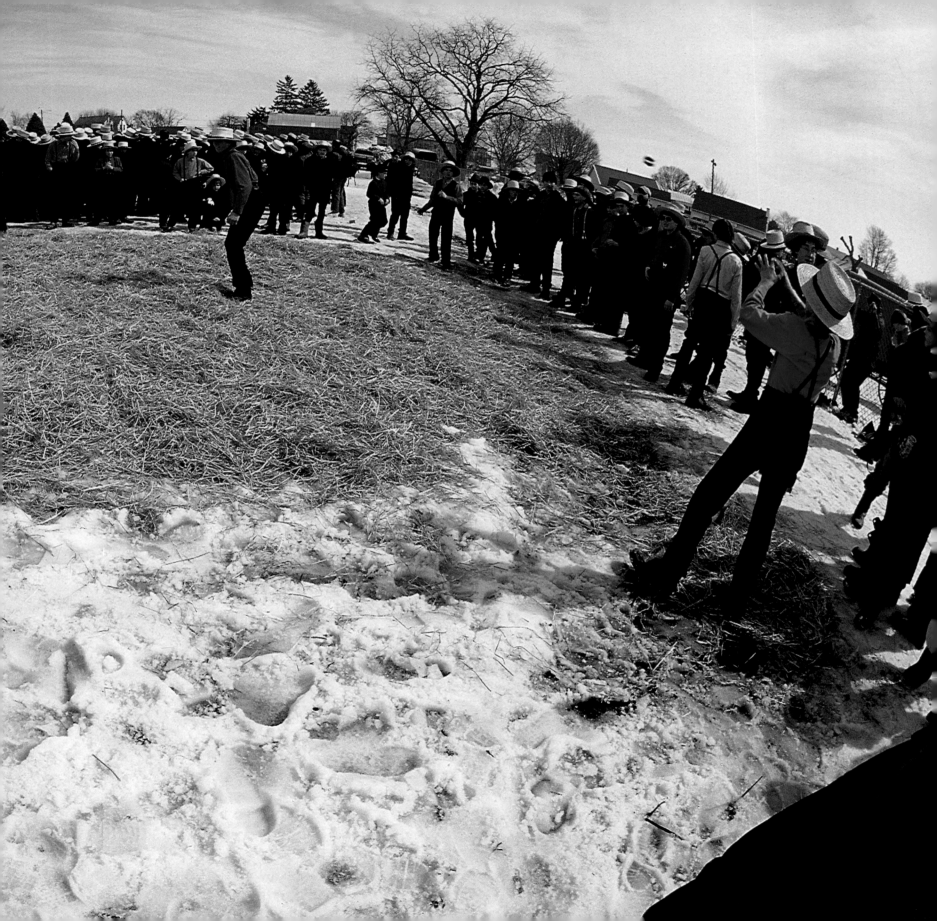

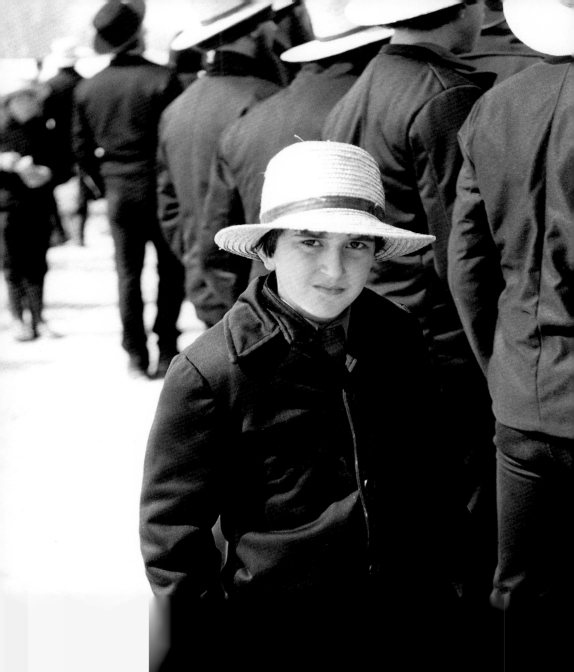

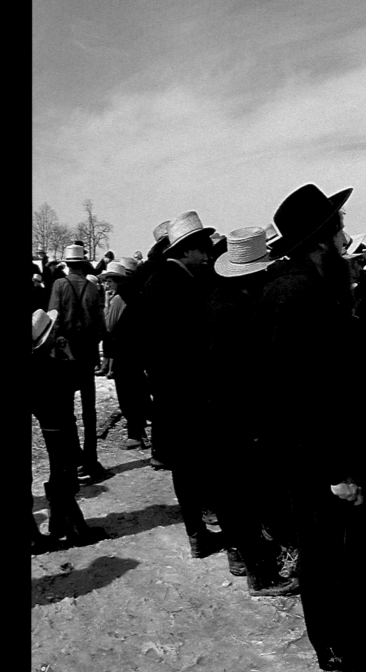

the mud sale, horses, bridles,
buggies, as well as other farm
ent, are auctioned off. The auc-
es place in the center of a ring,
e interested men stand around
g into the middle of the auction.
e curious boy heard the shutter
my camera snap, and he turned
to see what was going on. The
continued to concentrate on the
uction in the early morning sun.

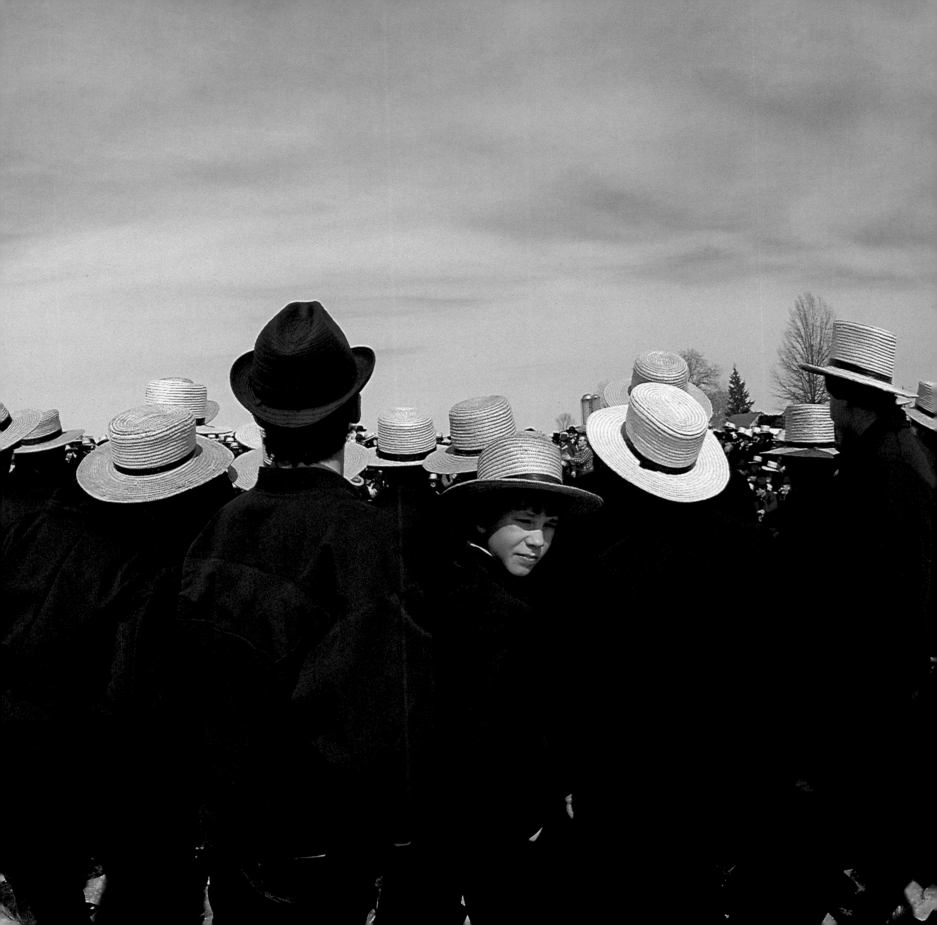

Scandinavians make up the populations of Denmark, Finland, Iceland, Norway, and Sweden. The inhabitants of these countries are descendants of Nordic people who arrived there over 10,000 years ago. For hundreds of years, Nordic people have been typified as having blond hair, blue eyes, and fair skin, although not all of their ethnic groups share those features. What they do share is that they all come from the cold climates of Northern Europe and endure some of the harshest winters known on the planet.

Vikings, as they came to be known over time, were seafarers as early as the ninth century. By the time of Leif Eriksson's expedition to the North American continent, they had already traveled through Scandinavia, Europe, Iceland, and Greenland. It was Leif Eriksson and his group of rugged country-men who ventured toward North America around 1000 A.D. and arrived in Canada. Though they explored parts of North America, these intrepid sailors never settled there at that time. In the 1600s, Swedish expeditions sailed to America and established small colonies along the Delaware River that were

eventually absorbed into the later English colonies of Pennsylvania and Delaware. Though small in numbers, the Swedes introduced the log cabin to the American landscape.

It was not until the nineteenth century that Scandinavian migration to America became significant. During the early 1800s, the population on the Scandinavian home front began to rise sharply; around 1820, Norway alone supported one million people. Finding work was ever more difficult, and people were having trouble providing for their families. By 1840, word had spread throughout Scandinavia that traveling to America would be beneficial; the immigrants would be given free land and the ability to grow with the country. These opportunities, coupled with their harsh winter life and lack of economic success, propelled many Scandinavians to contract "America fever." Over the next hundred years, 800,000 Norwegians emigrated to the United States to take advantage of the promises awaiting them in the land of plenty.

Eager and full of hope for new beginnings, most of these new immigrants traveled as family groups aboard cargo ships carrying goods from Sweden to America. Between 1851 and 1930, over two million Swedes came to the United States; about 300,000 Finnish immigrants arrived between 1870 and 1920. America welcomed 15,000 Icelanders between 1870 and 1900; and approximately 250,000 Danes emigrated between 1850 and 1900. The Scandinavian migration infused America with hardworking immigrants who settled principally in the northern midwestern states, significantly increasing the populations of Minnesota, Wisconsin, and Michigan.

Many Scandinavians would travel farther west to settle in Kansas and Iowa. Over time, these warm and loving people put down roots across the United States, developing strong communities not only in the midwest, but in cities such as Brooklyn, New York, and Solvang, California.

Principally Lutheran, Scandinavians not only enhanced our country's religious atmosphere but the work ethic as well. This group of enterprising newcomers certainly made their mark on America, producing manufacturing giants such as Vincent Bendix's Machinery and that of George Norman Borg of the Borg Warner Company. Eric Wickman started a small bus company that grew into Greyhound Bus Lines. Thorstein Veblen became a noted economist. Charles Lindbergh became a famous pilot. And Knute Rockne became the renowned football coach at Notre Dame. The entertainment industry also reflected their influence with celebrated talents such as Edgar Bergen, Greta Garbo, Lawrence Welk, and Ozzie and Harriet Nelson. And the world of sports heralded stars like Babe Didrickson Zaharias, the first famous woman golfer. Earl Warren, the former Chief Justice of the United States Supreme Court, is renowned for his decision in the *Miranda* case. Perhaps not a household name, Gutzon Borglum also made his mark by carving the heads of four presidents on one of America's most treasured national monuments, Mount Rushmore.

Today, Scandinavians blend almost seamlessly into the American scene, and we celebrate them not because of their ethnicity but for their individual and collective contributions to this country. They have broadened our landscape and enhanced our lives beyond measure.

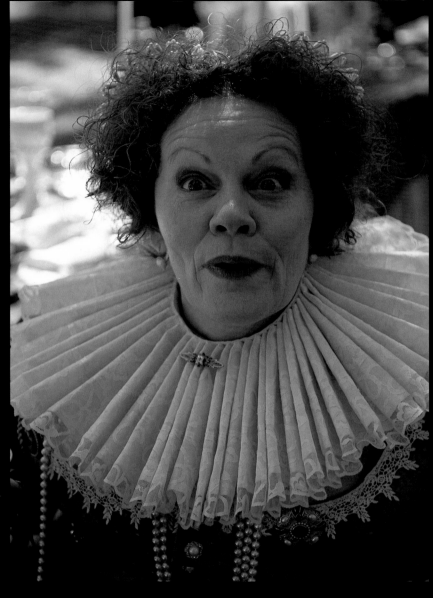
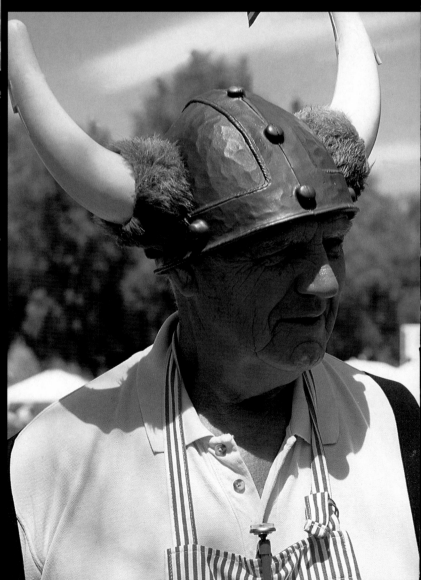

SANTA BARBARA, CALIFORNIA, 2004

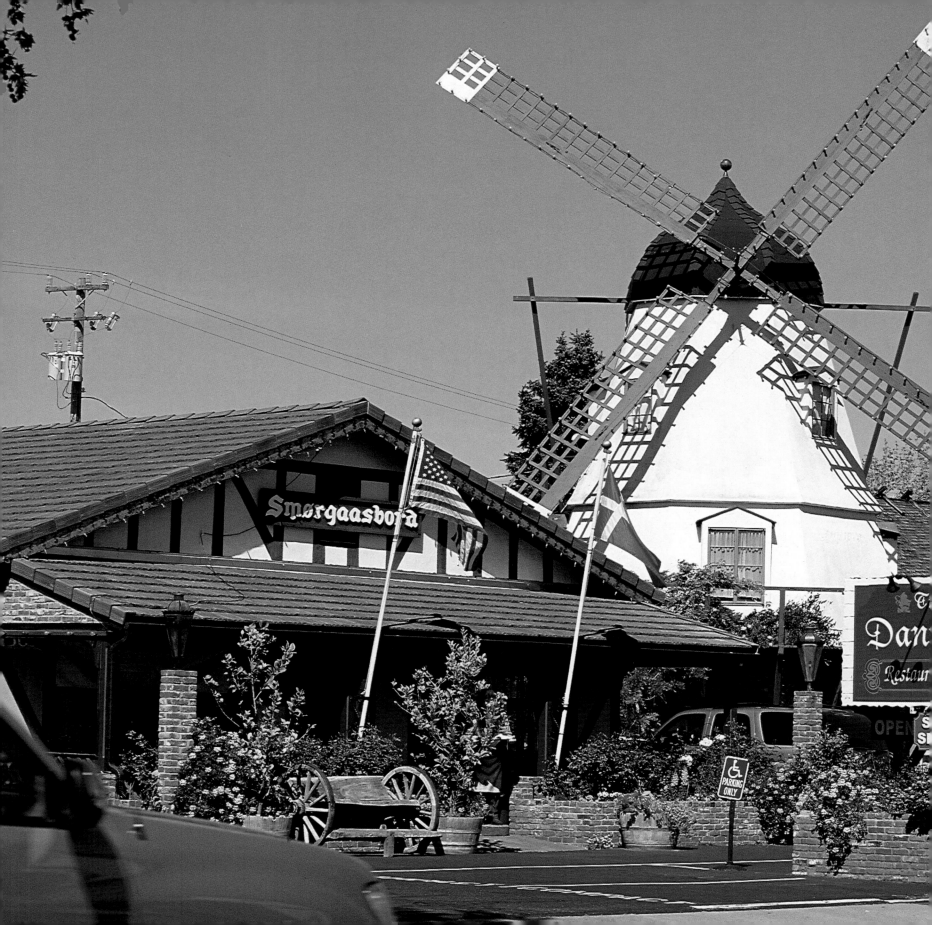

Solvang, California, was founded in 1910 by a group of Danish immigrants. Most were educators and Lutheran pastors, and they were in search of land upon which to form a school. They purchased property on the Rancho San Carlos de Jonata after seeing its lush land with a flowing river and oak covered hills. Naming their new home "Solvang", the Danish word for "sunny fields", they established their school, and an entire community, with a distinctly old world feel, including windmills and Danish buildings. Solvang is now considered by many to be the Danish capital of America.

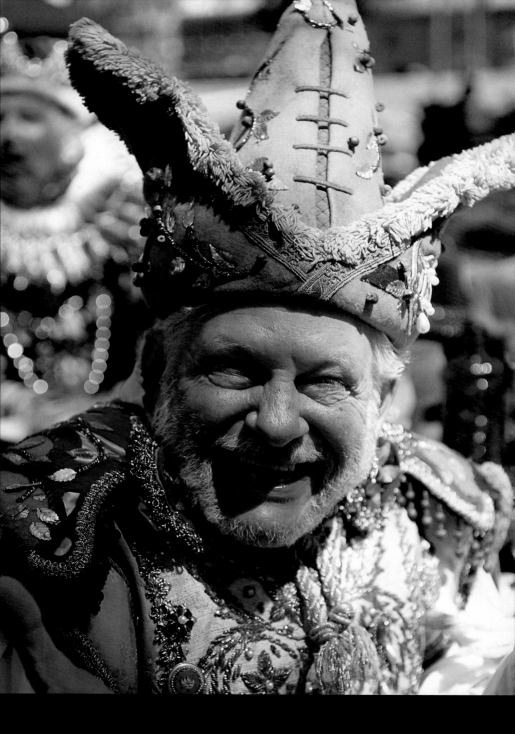

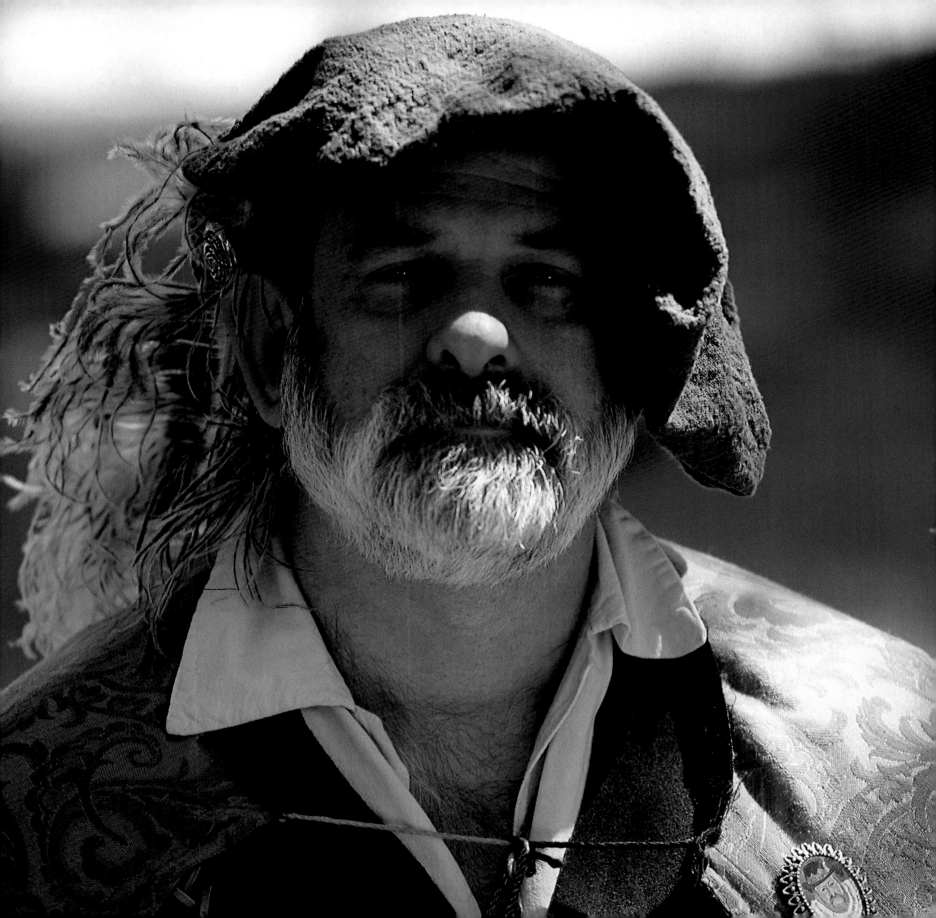

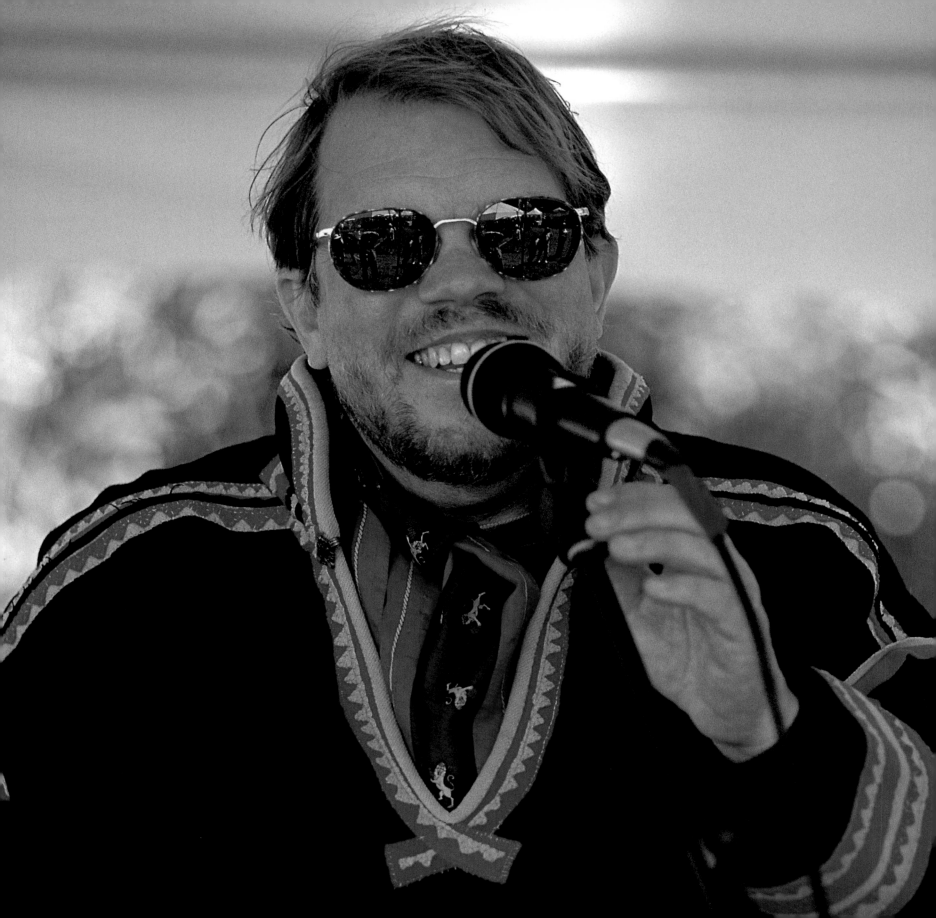

The New Immigrants

1700 To 1850

RUSSIANS

JEWS

IRISH

SCOTS

The New Immigrants

By 1700, the American populace consisted of the indigenous people and European settlers. The villages dotting the eastern seaboard had grown from small settlements into actual towns. A hundred years had passed since the first European settlers had made their homes on the American continent. It was now time for the new immigrants to slowly, but methodically, form the basis of this new country. Over the next 150 years, American values would be proposed, debated, and ultimately developed into our modern political system.

However, many of the new immigrants who came to America from Europe between 1700 and 1850 found themselves shunned and unwelcome. They were seen as invaders in this new land with new religions and new values to visit upon the existing inhabitants. Not only were they unwelcome, they were disparaged at every turn. They struggled, they worked hard, and they prospered. In the end, the contributions of these new immigrants to American society were absolutely vital to the development of this magnificent country.

Russian influence in American culture has been a staggered one; first was their exploratory venture into the great western territory now known as Alaska. In 1741, two Russian vessels sighted a landmass not far from Russian Siberia, and although attempts to explore this vast new wilderness were initially aborted, the Russians did take note of the extraordinary abundance of fur animals and their trade potential. Over the next four decades, Russia took advantage of the fur bonanza principally by using the forced labor of many Native Alaskans to harvest the animals. This exploitation would expand throughout the region, down the Alaskan coast, and as far south as San Francisco. So lucrative was this fur enterprise that they established a Russian-American company to ship their bounty to the eager markets waiting in Russia and China. This activity continued for over a hundred years until competition from the British and the Americans eventually culminated in 1867, with the Russians selling the entire Alaskan territory to the United States for $7.2 million,

a transaction still disputed today by the Native Alaskans as an invalid sale of their land.

Russia's second wave of immigration to American soil did not occur until the late twentieth century. Prior to this migration, conditions in Russia were turbulent. In 1917, the czars were overthrown, which resulted in the eventual absorption of the satellite countries by the then dominant Russian culture. This subsequently led to the creation of the Union of Soviet Socialist Republics, a powerful nation that remained intact for over seventy years, exerting total control of the populace until 1991, when it collapsed to become a number of independent states. It was not until after 1991 that significant numbers of the Russian-dominated population were permitted to emigrate to other countries of their choice. It was at this time the world saw hundreds of thousands of Russians emigrate to various countries and, primarily, to American shores. Although there were a few Soviets who actually emigrated to the United States prior to 1991, they were principally members of the intelligentsia seeking political asylum.

Russian immigrants arriving in this country came with hopes and dreams for religious expression, freedom of speech, and economic opportunity. Their willingness to work hard helped to endear them to their new society. Today, while Russians populate many regions within the United States, the largest groupings are found along the eastern seaboard and in San Francisco. Although many of these new immigrants have had a relatively easy time in the assimilation process, others have found adjusting to American society more difficult. Women and children found adapting to the new American lifestyle most challenging.

Cultural differences in men and women's traditional roles became readily apparent; in Russia, the grandmother, or "Babushka," is the stalwart of the family, a pragmatic, strong woman who shops for food, cooks, and cares for the grandchildren as though they were her own. The Russian husband, although important financially, is not the central focus of the family's activity. He is simply the person who works and brings home a paycheck, and is not involved in family decisions. The Russian wife, after giving birth to the children, takes on responsibilities as a breadwinner, entering the workforce to help provide income for the family, leaving the children and all of the homemaking chores in the capable hands of the Babushka. At the time of Russian migration to the United States, these Old World Russian traditions were not as prevalent in most American families; the matriarchal figures were less dominant, there was less dependency on grandmothers for household and child-rearing responsibilities, and fathers had more prominent roles. These cultural differences caused significant consternation within Russian immigrant families.

While some Old World traditions are long-lived, the assimilation of Russian immigrants to American society has been a steady and determined venture. A straightforward, philosophical people, Russian immigrants not only embrace their American lifestyle but enrich it because of their commitment to honor their cultural traditions of family values, respect for hard work, and support of the arts and education. A number of Russian-Americans have become very famous in their fields. They include dancer Rudolf Nureyev, actor Yul Brynner, novelist Vladimir Nabakov, helicopter designer Igor Sikorsky, and sociologist Pitirim Sorokin.

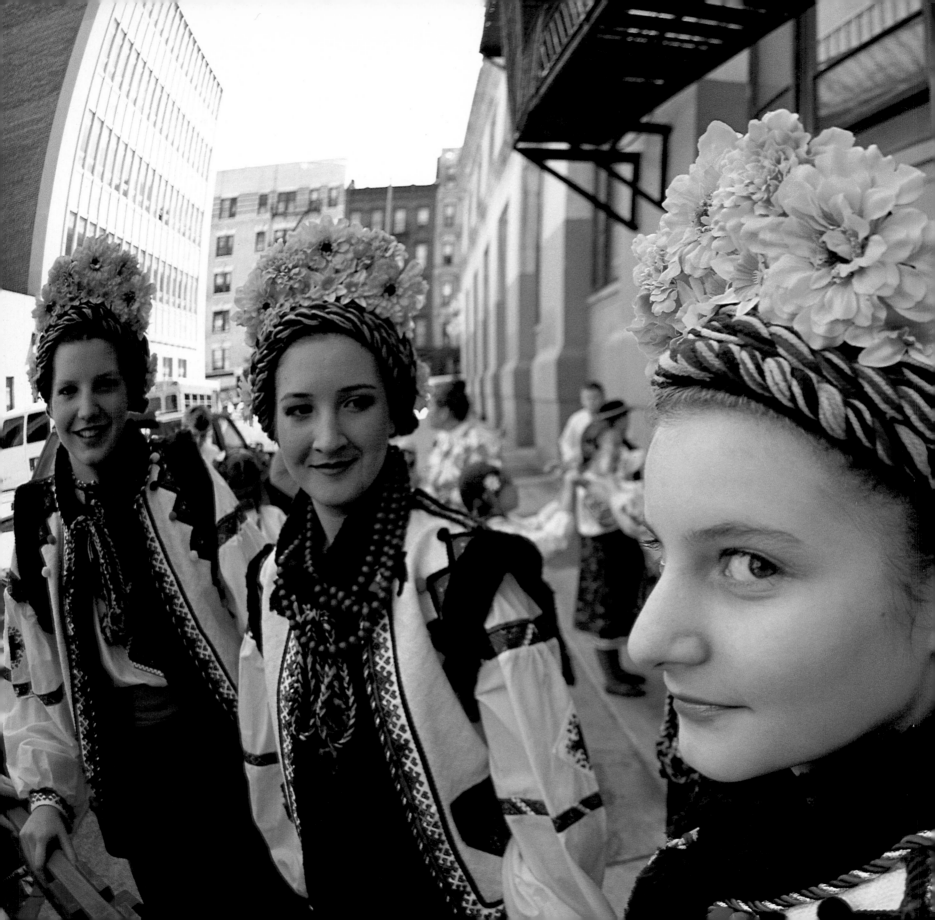

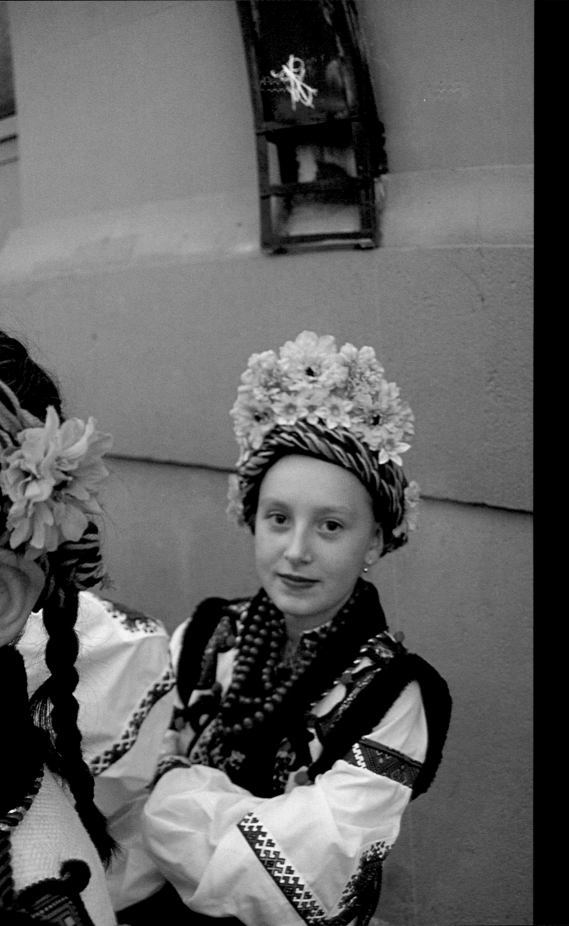

Every year a Ukrainian Russian Festival is put on in the lower east side of Manhattan, in New York City. A dance festival and dance competition is held in the streets along with a display of Russian memorabilia and Russian food.

These beautiful young women, wearing intricate costumes, were part of a dance troupe waiting to climb the steps and perform on stage. Parents and grandparents proudly helped them dress, and cheered them on during their per-formance.

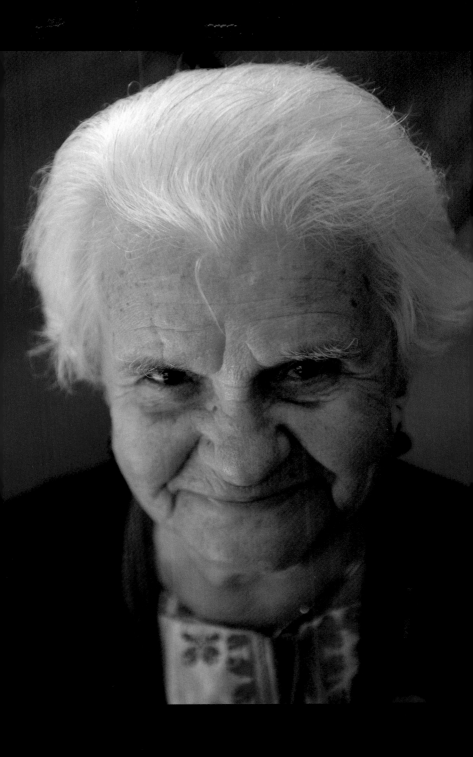

W YORK, 2004

Every year in late February, the
Russian Center of San Francisco
puts on the Russian American
Festival. It is a celebration of food,
dance, music, and art held at the
San Francisco Russian Center.

Here, children perform on stage to
the accolades of adoring parents.
It is fascinating watching them
perform traditional Russian dances
in costume, with boys of tender
years acting like men 20 years
older than themselves, kicking
their legs out in front of their bod-
ies like older Cossack soldiers.

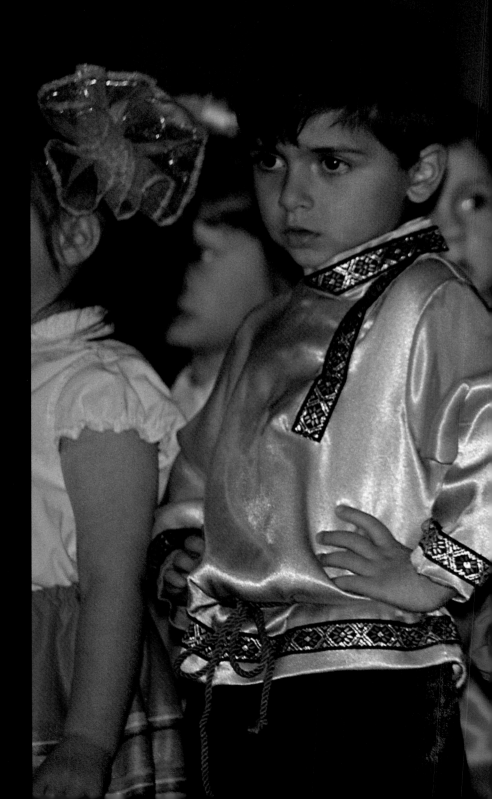

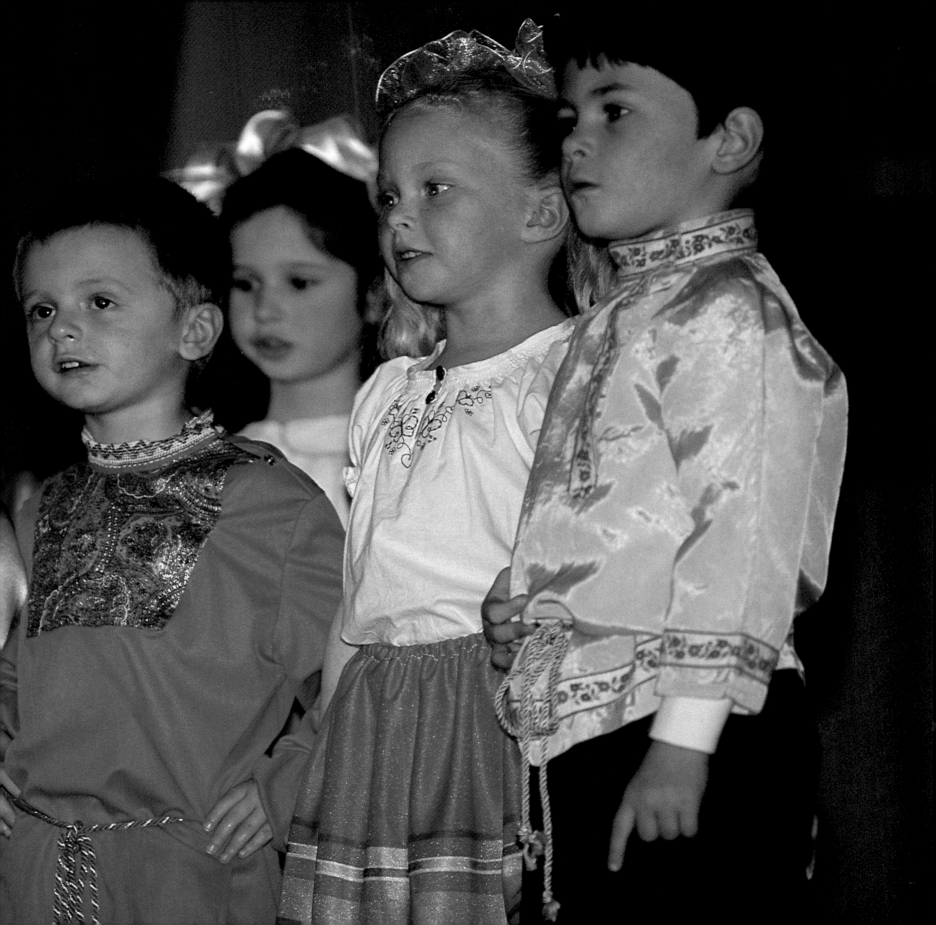

One distinct paradox among this country's ethnic groups is the American Jew. On one hand, many Jews have completely assimilated into the American lifestyle. On the other hand, Jews remain a cohesive anomaly, distinct in their cultural activities and separate, in some aspects, from American society.

While there are several communities of Orthodox Jews in the United States (especially in New York and Los Angeles), and many conservative Jewish synagogues (which offer a blend of traditional practices and modern interpretation), it is Reform Judaism which has flourished in America. Originally conceived in Germany in the early 1800's, Reform Judaism not only guides the vast majority of American Jews but now comprises the largest Jewish population in the world.

Contrary to popular belief, Jews were part of the American landscape long before the mass migrations of the late 1800s. In fact, it is believed that a few

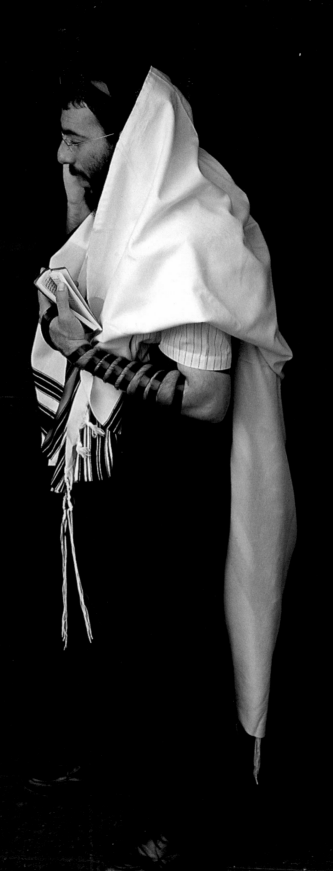

Jews arrived in the early 1600s and helped to found the new colonies. In 1654, a small group of Jews from Brazil arrived in New Amsterdam. New England, and specifically Massachusetts, having been founded and controlled by Puritans, proved a difficult environment for these new arrivals. Jews suffered persecution and discrimination by the Puritans, who associated Jews with the death of Christ. Jews could not vote or hold property, and they were not welcomed unless they denounced their religion and accepted Christianity. This resulted in Jews leaving New Amsterdam to find work inland. By the early to mid-1700s, only 250 Jews remained in the New World. Over the ensuing hundred years, their population increased to over 2,000, concentrated principally in the large trading-port cities of Charleston, New York, and Philadelphia, where they founded synagogues and close communities.

As the country's population grew and the boundaries of the new nation expanded, Jewish communities remained in these port cities. Their assimilation into the American culture was beginning, but they continued to suffer from discrimination because of their unwavering Orthodox beliefs and cultural differences. Fostered by jealousy and continued anti-Semitism, Jews found themselves forced to live in close proximity to one another in poor neighborhoods.

By the mid-1800s, Europe was convulsing in revolutionary activity. Jobs were scarce and the population was increasing. Extreme pressures on the European Jews, combined with Germany's brutal policies of discrimination, forced a mass migration of German Jews to America. Jews from Ireland, Italy, and other Western European countries also began their migrations. At the same time, America was on the move. Following the doctrine of Manifest Destiny that would extend American rule to the Pacific Ocean, suddenly there was a great opportunity for growth and a need for more people. Thus, the Irish, Germans, Italians, and others who were able to find a way to this new "promised land" did so in massive numbers. As the port cities grew, so did the Jewish population of shopkeepers, merchants, and manufacturers. New York, Philadelphia, Charleston and Newport, Rhode Island became centers of Jewish activity. In the fifty years after America's Civil War, more than thirty-five million immigrants came to this country, principally from Europe. When czarist Russia began its campaigns forcing its poor out of the country, America's doors opened. More than two million of the incoming immigrants were Jews. It is estimated that 15 percent or more of European Jewry came to America, representing nearly 8 percent of all the immigrants during that time.

These new Jewish immigrants, determined to prosper in America, were successful—but not by accident. Jews had the advantage of being more educated than many other immigrant groups. Jewish children were taught at a very young age to read the Torah and other Jewish writings, and as adults, they were able to read several languages and were more proficient in English than some immigrants. Skilled merchants and brokers, Jews soon found people in their new home

who were eager to take advantage of their experience. America desperately needed their expertise in dealing with foreign markets and trading goods.

Through hard work and smart negotiations, Jews established successful trade enterprises. Their success, however, would prove to be a double-edged sword. Their financial success made them targets of petty jealousy and, once again, victims of anti-Semitism. Thus, their neighborhoods became well-defined Jewish enclaves through the end of World War II. It was not until the early 1950s, with some help from then President Eisenhower, that Americans would be reminded that everyone should bond together and enjoy each other, regardless of religious differences. This trend continued with the implementation of the Civil Rights Act of 1964, and came at a time when America was experiencing growth in its metropolitan suburbs, the expansion of the Reform and Conservative branches of Judaism, and the rise of the Democratic Party. All of these factors helped to provide an environment for a much greater tolerance and broader assimilation of Jews in America.

Jewish Americans have enriched American culture in a variety of fields, including science (Robert Oppenheimer and Jonas Salk), politics (Henry Kissinger and Joseph Lieberman), business (the founders of Ben & Jerry's, Haagen Dazs, Dunkin Donuts), sports (Mark Spitz and Sandy Koufax), clothing design (Calvin Klein and Levi Strauss), music (Barbara Streisand and Bob Dylan), movies (William Shatner, Steven Spielberg, Mel Brooks), and comedy (Rodney Dangerfield, Jerry Seinfeld, the Marx Brothers).

Today, American Jews celebrate their distinctive traditions, holidays, and religious customs with great joy and reverence. They continue to honor their rich heritage, treasure their family values, and hold knowledge and education in greatest esteem. They are a warm and giving people who love America and are proud to call it home.

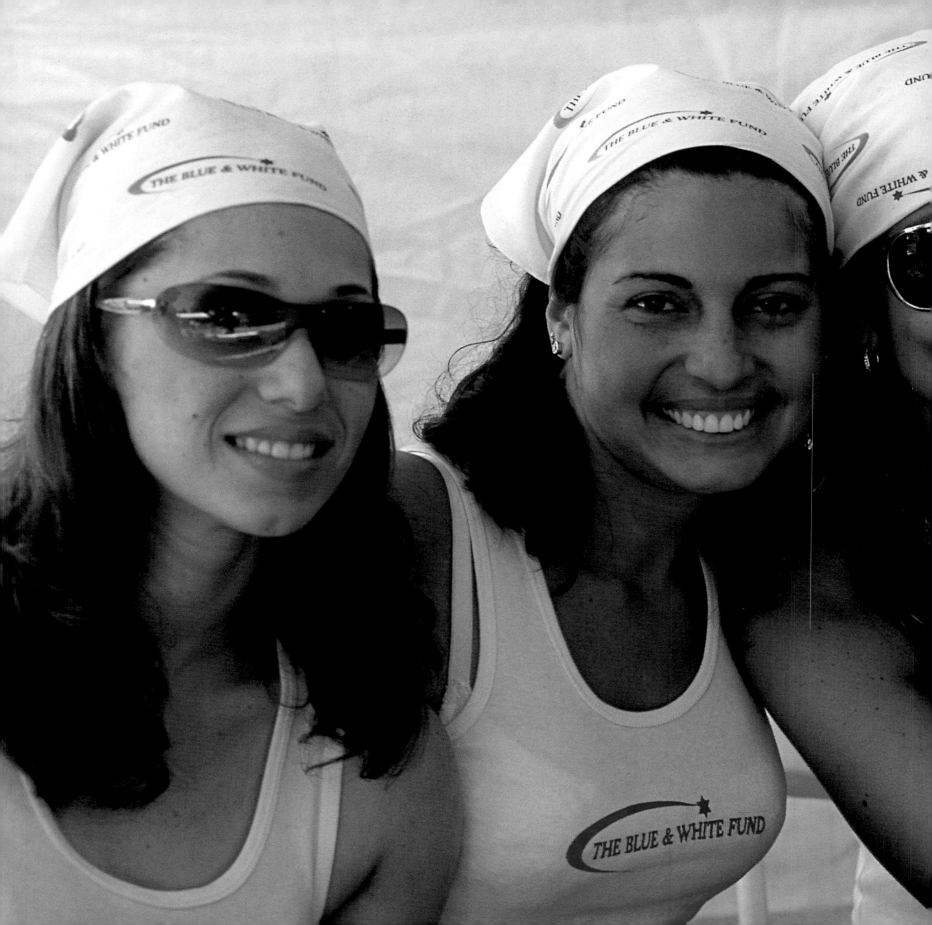

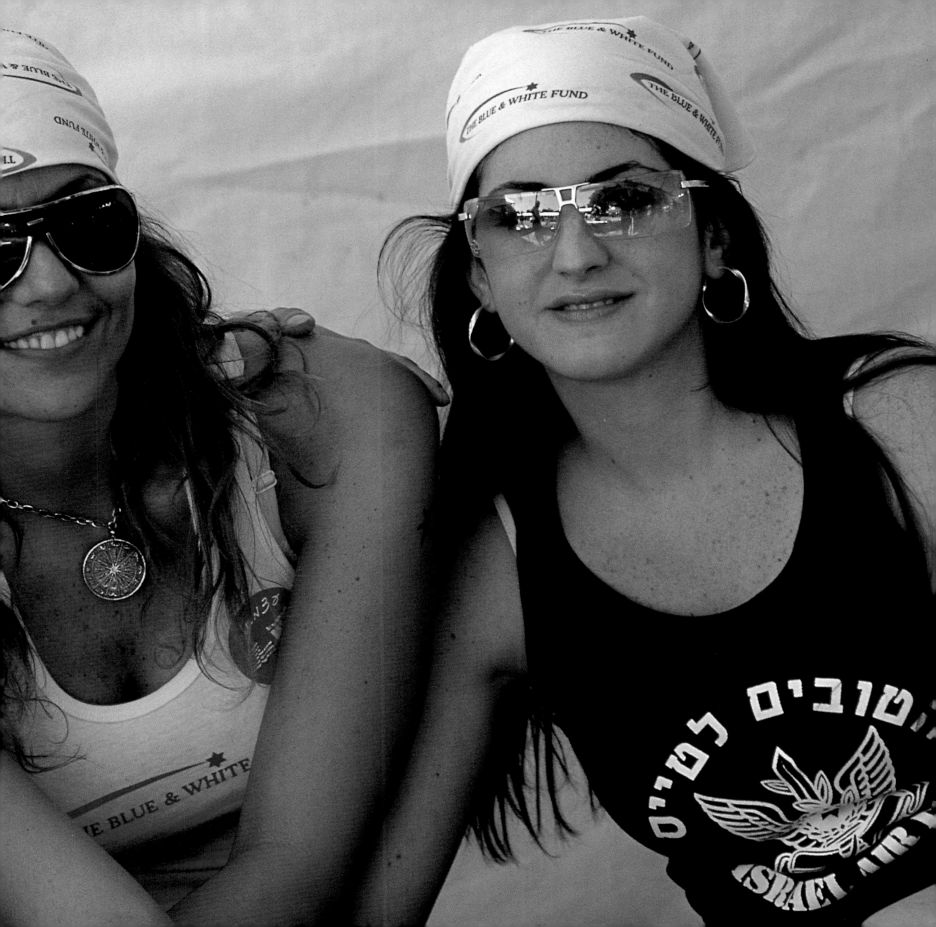

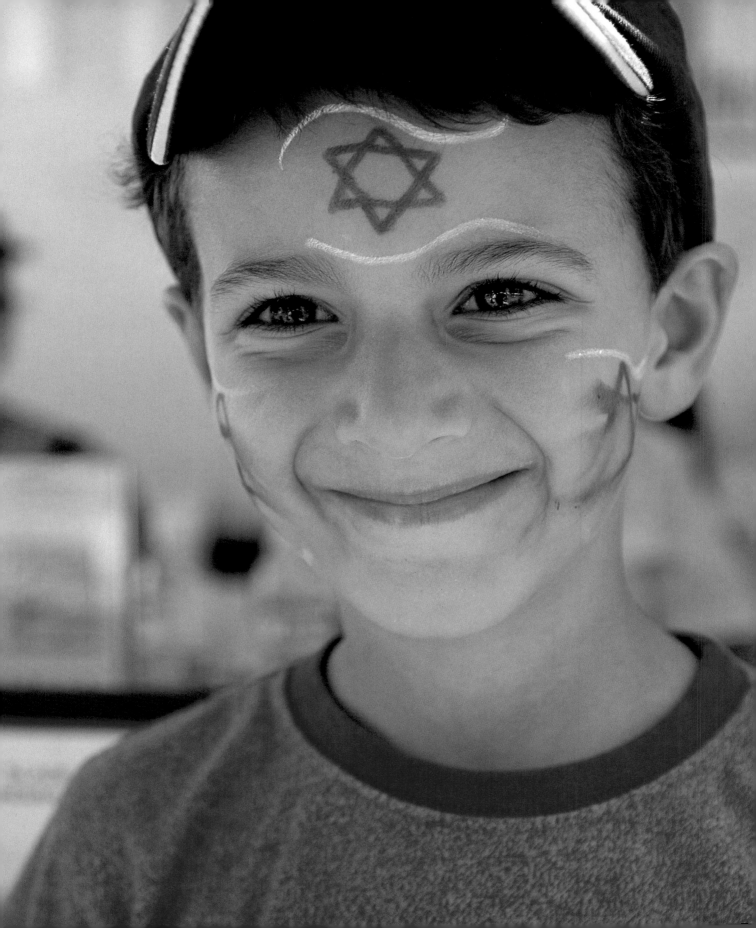

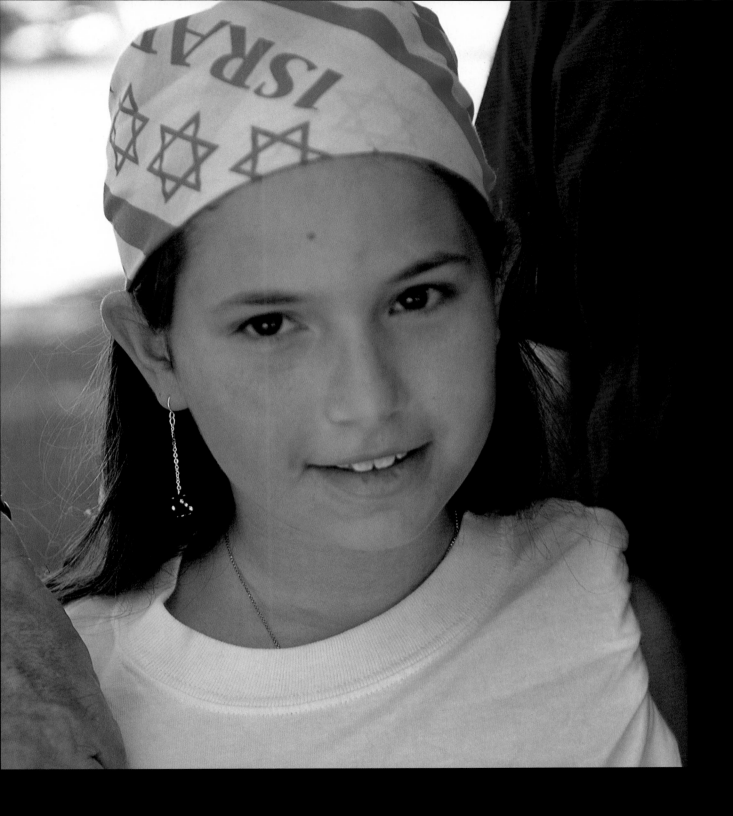

ANGELES, CALIFORNIA, 2004

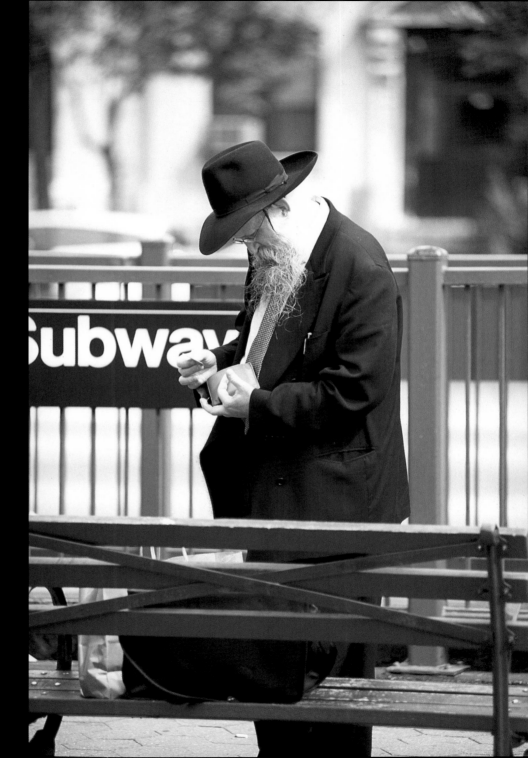

Brooklyn, New York is the traditional home of Hasidic Jews in America. At the Yeshiva (school) at 770 Eastern Parkway, a young rabbi in training takes a break from studying the Torah (Old Testament) to spend a few moments outside in the sunshine. At the subway entrance, only a few yards away, an older rabbi prepares to leave the Yeshiva Learning Center.

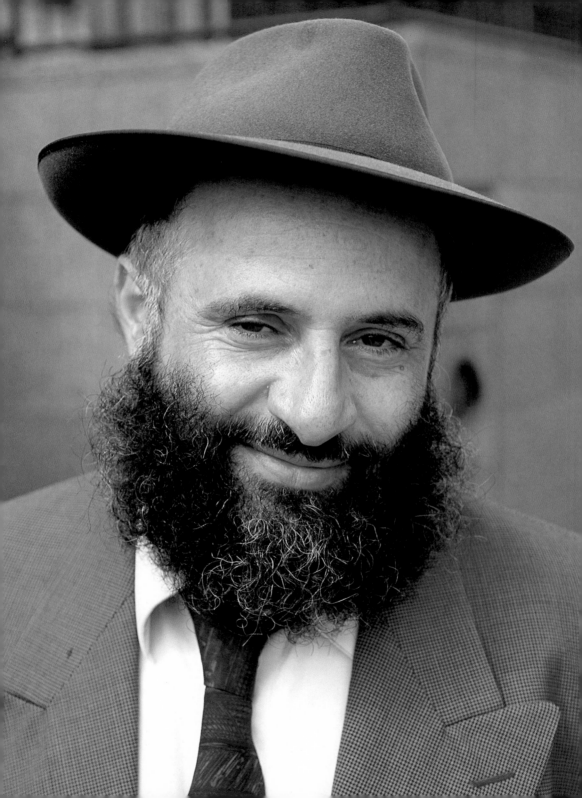

For one day each year in mid-March, "Everyone is Irish." That day is St. Patrick's Day. A time when everyone dons a wee bit of green and celebrates— even if we aren't Irish! The Wearing of the Green, be it a shamrock or green clothing on St. Patty's Day (as it is affectionately known) symbolizes the green hills of Ireland and Irish pride, and is a reason to party. Parades and celebrations throughout the country give rise to traditional Irish music and dance, and Irish beer; even rivers run Irish green in some of our largest cities. It is a day filled with joy and reflection on one of America's wonderful ethnic groups who, like so many other immigrants coming to this country, survived overwhelming challenges in their homeland as well as during their migration and their relocation to the New World. The Irish played a major role in America's ethnic development. By 1860, roughly two million Irish immigrants had arrived in the United States, making up nearly twenty-five percent of the populations of major cities such as New York and Boston, and they were the dominant ethnicity in

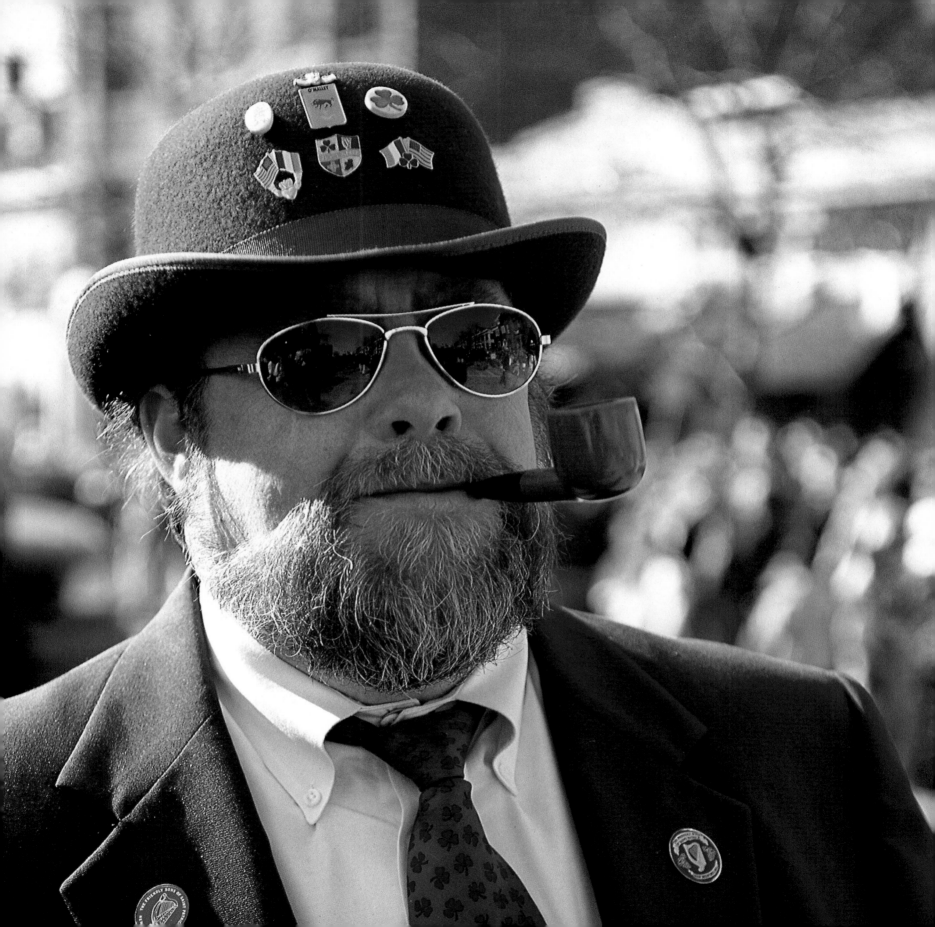

Philadelphia, St. Louis, Cincinnati, and Detroit, thus becoming one of the most assimilated ethnic groups in our nation's history.

Irish history, like so many others, was one of struggle against oppression and discrimination. In their Emerald Isle homeland, Catholics battled against the imposition of Protestantism by the British Crown. In an attempt to bend the Irish Catholics to British control, in 1534 the British instituted a series of laws and restrictions that, by 1715, had deprived Catholics of their civil rights in their own country. By 1801, England had established the United Kingdom, adding Ireland, Scotland, and Wales to its territory, which divided the population into two religious factions. Not only did British laws restrict the religious activities of Catholics, but the Irish were excluded from owning land. As a result, by 1841, roughly ninety-five percent of Ireland's rural farming population was relegated to poverty.

As England became more industrialized, Irish commodities became less desirable. Unable to compete for income, Irish craftsmen and farmers left their homes by the hundreds of thousands. Homeless and poor, their miseries were compounded by starvation when in 1845 a mysterious fungus in Ireland's potato fields all but destroyed every crop in the country. Between 1845 and 1855, it is estimated that a million Irish men, women, and children died of starvation and related illnesses; a million-and a half of the famine's survivors fled to the United States and Canada. Many Irish immigrants could not afford to pay for their passage and indentured themselves as servants to pay for their journey. Although they faced servitude and had to suffer extraordinarily harsh conditions while huddled within the bowels of the steerage compartments in the transport ships, they felt it was a better option than the alternative of starving to death in their native land. Their difficult migration would be further riddled with heartbreak; between 1847 and 1853 fifty-nine ships carrying immigrants were lost at sea. Those newcomers who successfully made the journey in the mid-1800's added to the existing half a million Irish already living in the United States.

Although their dream was to establish farms in this country, the vast majority of the new Irish immigrants could not afford to purchase farm equipment or to travel to the interior states to look for affordable land. With the farming calamities in Ireland still fixed in their memories and their lack of finances, most of these new immigrants turned instead to other opportunities to make a living, working as laborers and mill workers. Poor, and with little or no education, these hardy souls took to the challenge, carving out new lives in this mostly Protestant country. Finding comfort in familiarity, they congregated in Irish-Catholic communities, termed "Irish towns," often the only places they could afford housing.

Never afraid of hard work, these new immigrants put their shoulders to the grindstone constructing railroads, working in coal mines and in other manual labor jobs. Irish women contributed by making lace and peddling other goods to help buy food and other necessities for their families. Taking whatever jobs they could find in spite of low wages caused the Irish to suffer further discrimination and misconceptions. The Irish were held responsible

for everything from encouraging low wages, to contributing to unemployment and crime in various cities, to outbreaks of disease. This derogatory opinion of the Irish continued until the time of America's Civil War, when these new Irish-Americans contributed mightily to the success of the Union Army, being instrumental in forming some of the strongest and most skilled fighting units.

After the Civil War, Irish Catholics realized that education was a necessary factor for their cultural survival as well as the way to improve their personal wealth. Education brought prosperity to many Irish Catholics. With their priorities set, they pushed forward using their influence and money and with help from the Catholic Church, established many of America's finest universities. In 1960, America elected its first Irish Catholic president, John Fitzgerald Kennedy. Other notable Irish-Americans were contributing their talents as well to every aspect of American culture; people such as inventor and visionary Henry Ford, theatrical and music legend George M. Cohan, renowned literary novelist F. Scott Fitzgerald, Statesman and Speaker of the House of Representatives Tip O'Neill, and United States Supreme Court Justice Sandra Day O'Connor, just to name a few.

Today, the Irish are appreciated and celebrated for their generous spirit and strength of heart. Whether they contribute as artists, members of congress, doctors, or lawyers, or are policemen and firemen like those who were first on the frontlines on 9/11, these Irish-Americans bring their special energy and a spirit of pride to our collective American character.

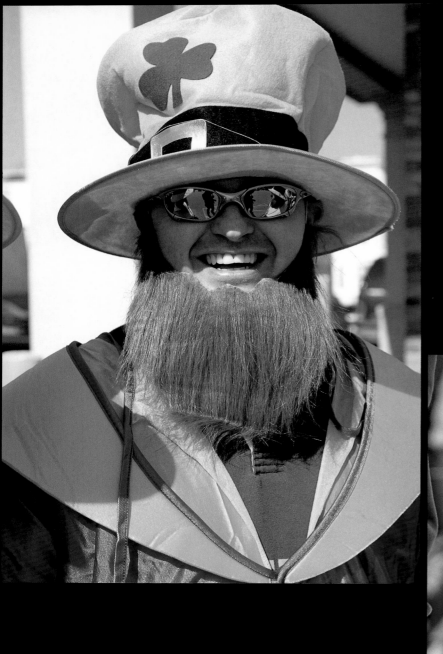

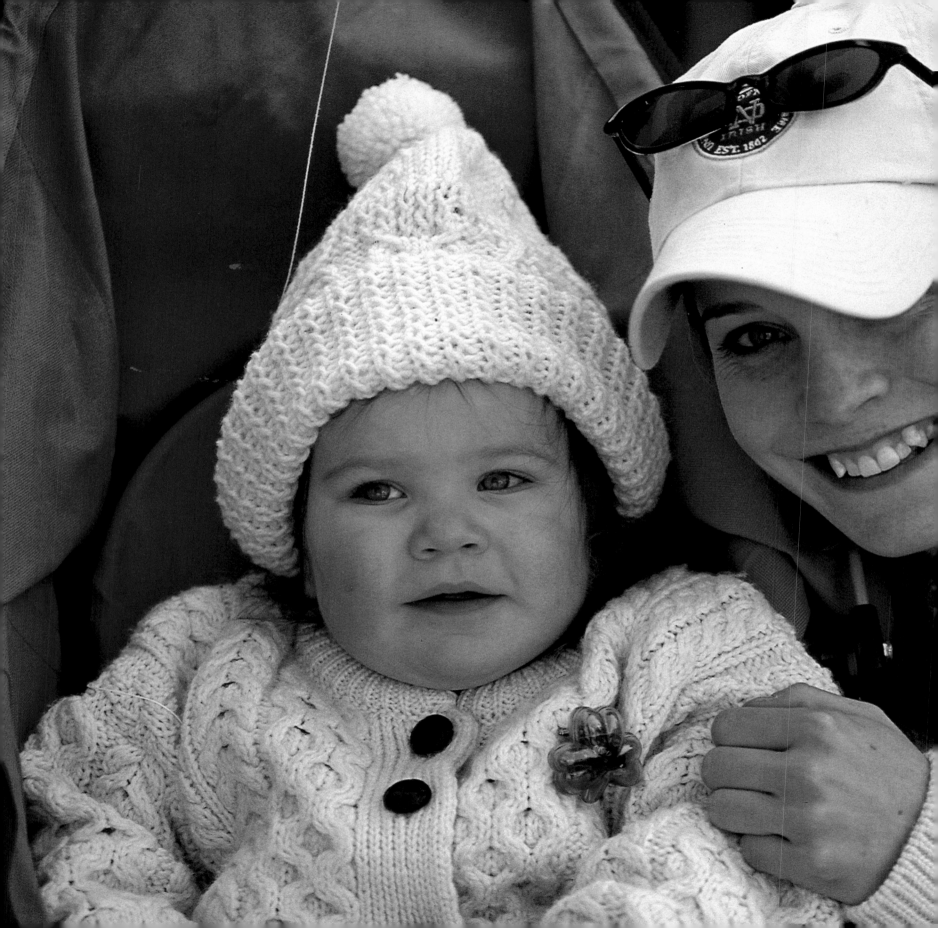

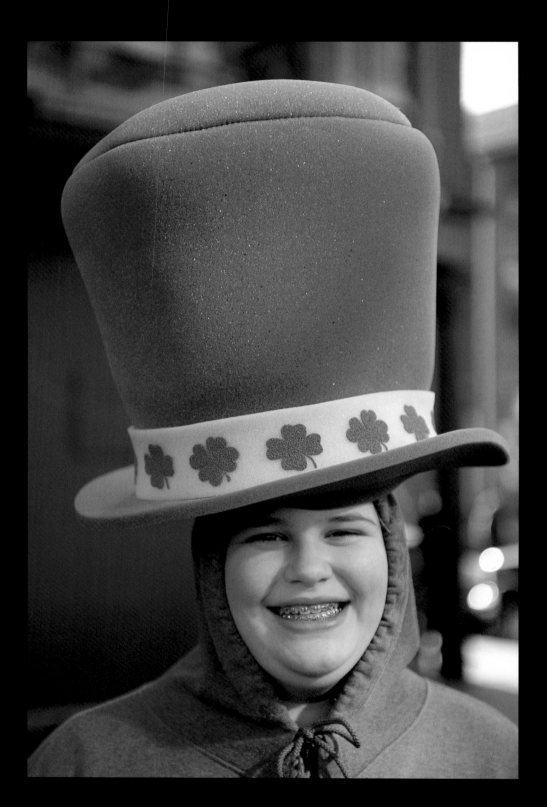

In mid-March of every year, several cities around the country turn green. None is greener, however, than South Boston, home of the Irish in America.

As a photographer, it is an absolute joy to walk among "southies" for the day. The parades begin in early morning and don't end until after dark. Then, everybody congregates to have dinner, and celebrate into the evening.

Thankfully, I had 30 rolls of film with me that day since I was capturing images for nine straight hours. My poor Nikon camera never worked so hard.

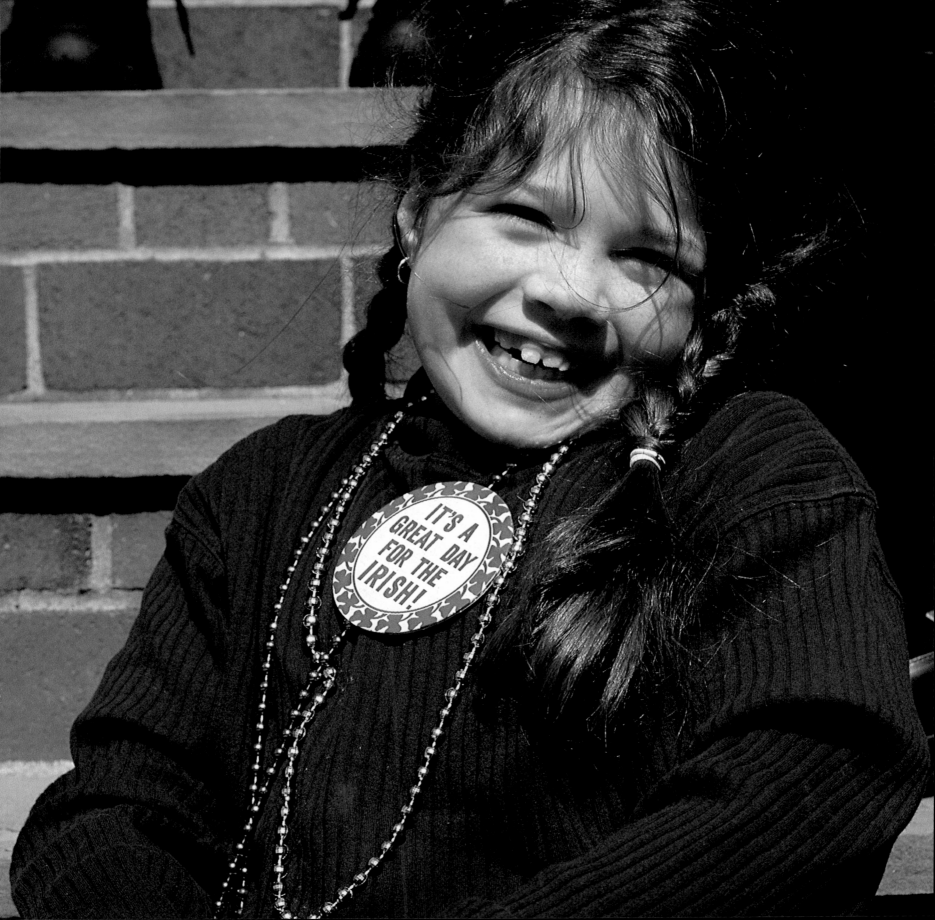

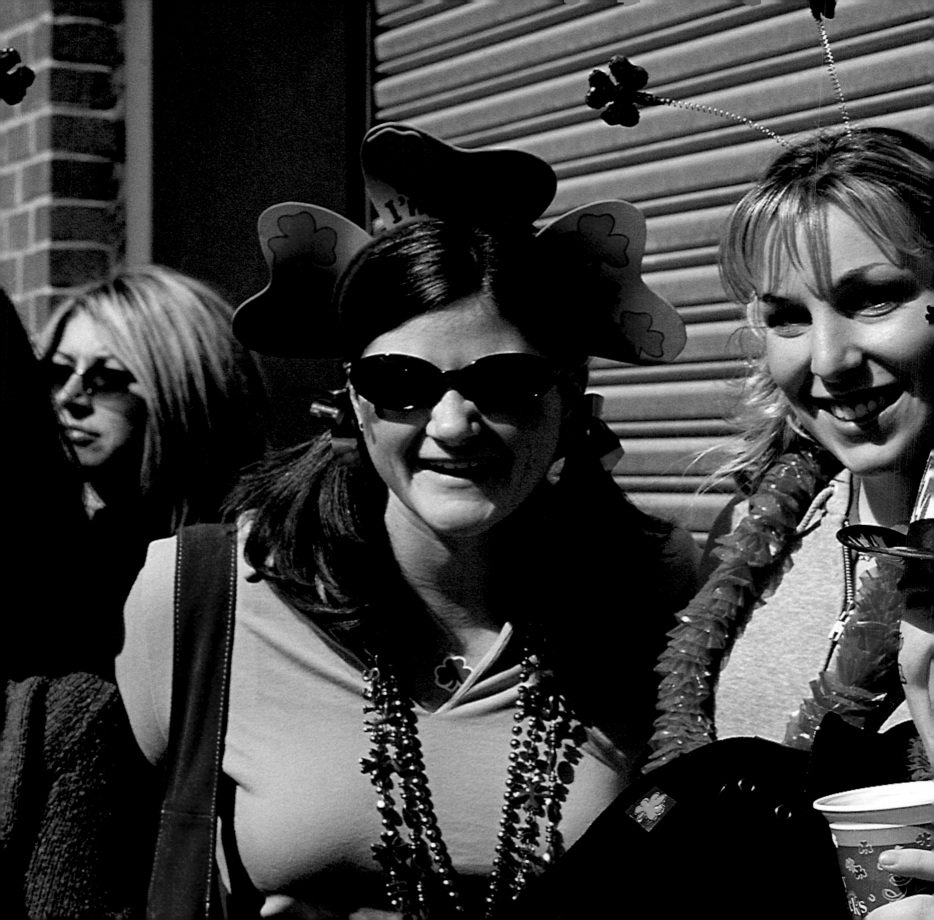

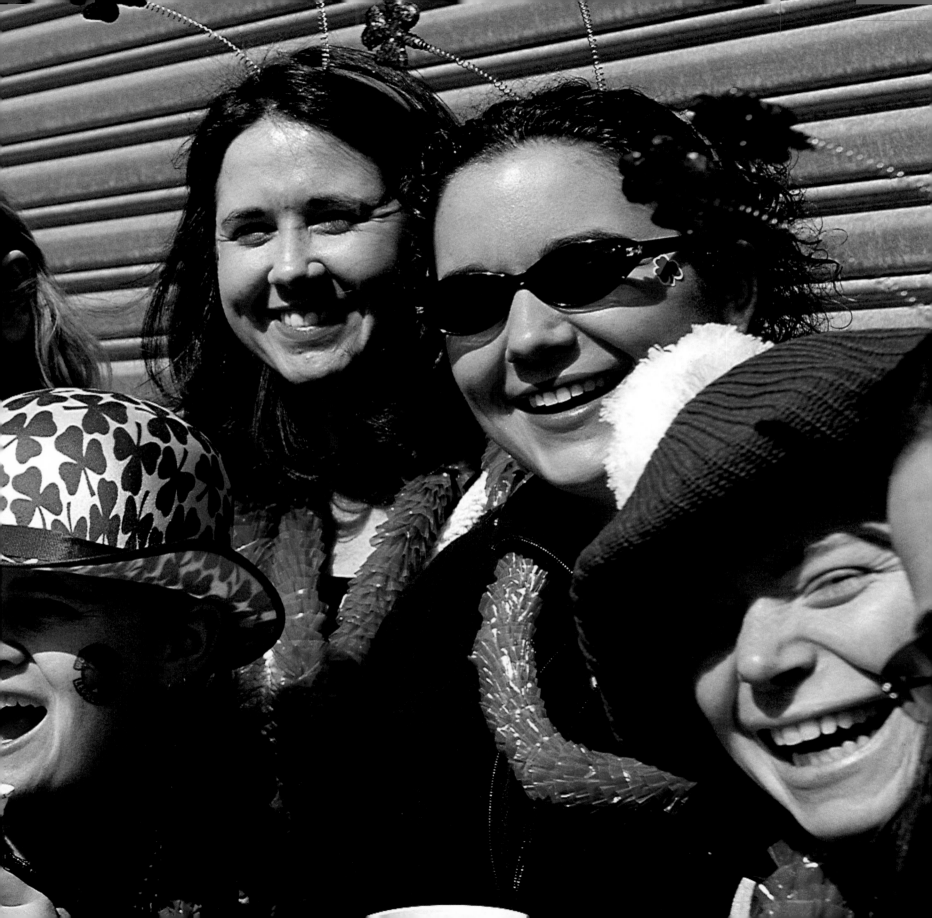

Along with the English, the Scots helped to lay the cultural and political foundations of American society. Their enduring strength of body and character had spirited these people in their quest for national sovereignty in their homeland. And strange as it may be, this small country of sparse population played a large part in creating the very essence of American ideals and culture.

Their quest started many hundreds of years ago after the fifth century departure of the Romans from the British Isles. Over the ensuing thousand years, the inhabitants of the rugged northern territory now known as Scotland were constantly engaged in wars for independence from British rule. Control of the Scottish highlands and lowlands became a seesaw battle that was constantly tempered with the religious dominance of the day—first Catholicism, then the Church of England, and finally in the mid-1500s, the establishment of Protestantism and its refinement to Presbyterianism. Struggles between

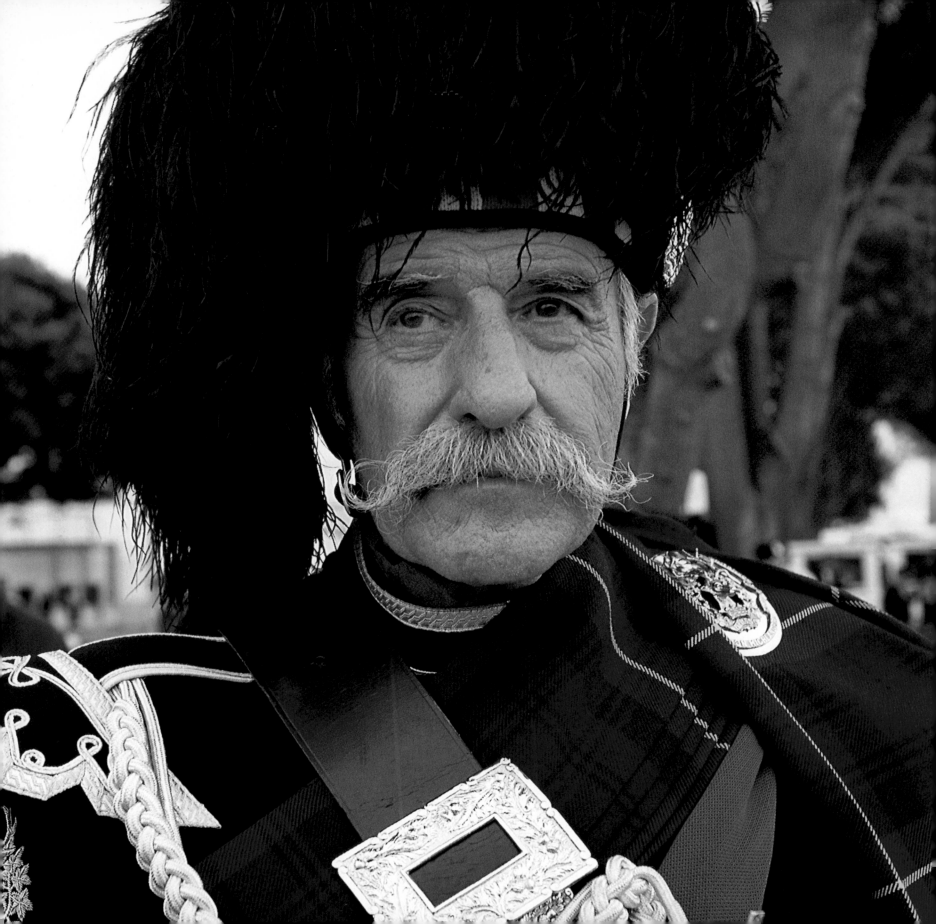

competing nobles as well as conflicts between high-landers and lowlanders were also ongoing in Scotland during these troubled times. It was also during this period that the men of the highlands began wearing kilts of patterned woolen cloth called *tartans*. Tartans ultimately became a symbol of clan kinship for the highland Scots.

By the middle of the sixteenth century, religious reformation was in full swing, and the Scots were at a fever pitch with religious zeal. Having known famine, plague, poor agricultural conditions, insecurity of life and property, and fighting aggression, they yearned for freedom. Coincidentally, around 1610, the British Crown was having problems with the Irish populace. Attempts at British colonization in Ireland had occurred many times over the previous centuries but with no great success. However, at this time the king of England and Scotland decided that the population of the new plantation in Ulster, Ireland, would do well to have Scottish participation. The king offered Scots an economic reward for moving to Ireland, and it is esti-mated that a quarter million Scots moved to Ulster over the next several generations.

What was of greatest interest to America was that these now-migratory Scots remained for several generations in Ireland, only to later transplant themselves to the east coast of America. Clearly, the largest migration of Scots came to America through Ireland, and that migration, coupled with the additional Scots coming from mainland Scotland, produced a significant increase in the population of the new American colonies. Historians and geographers refer to these immigrants as Scotch-Irish, a reflection of their dual heritage.

Virtually all of the Scots arriving in America held to their Presbyterian religion, steadfast in their opposition to the principle of absolutism and insistent upon the sovereignty of God. The Presbyterian church, by and through its structure of representative government and church councils, laid the democratic foundation for most of the Scots who came to America to help estab-lish a new country. With slight modification, the struc-ture of the American Presbyterian Church was the paradigm for the American political system, and thus the Scots became ardent supporters of the new gov-ernment.

Although religious freedom was a significant impetus in the initial movement and migration of Scots to America, the opportunity for economic growth was the most important factor. Aware of the vast opportuni-ty in this new land, the Scots made their way to east-ern Pennsylvania and south into Maryland, Virginia, and the Carolinas. In the fifty or so years prior to the Revolutionary War, it is estimated that between 200,000 and 300,000 Scots came to America through Ireland. By 1776, they had fully established themselves as loyal Americans with their well-educat-ed elders and slightly modified Presbyterian ways gov-erning their social as well as religious values. During the American Revolution, these noble fighters were some of the greatest patriots.

The influx of the Scots and the impact they had on this growing nation was significant. It was their per-

sonal strength of character, extraordinary religious zeal, value of work, and rugged individualism that mirrored the political establishment of a growing and vastly expanding new American way. Their high regard for the value of education was demonstrated by the founding of Princeton University in New Jersey. Even today, Princeton remains one of the most distinguished educational institutions in America. Our country owes a significant debt of gratitude to their original belief in the rule of law, education, and our American democracy.

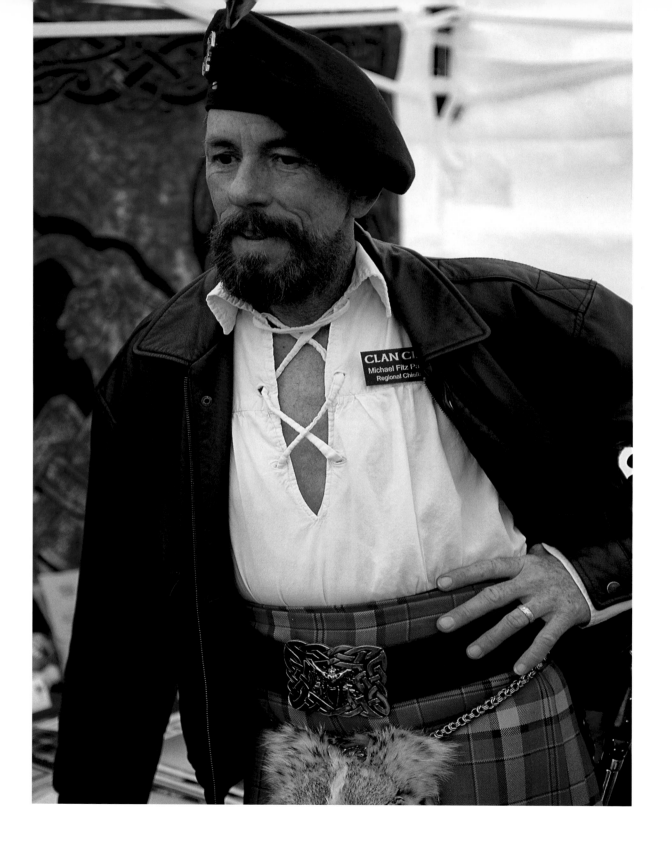

COSTA MESA, CALIFORNIA, 2003

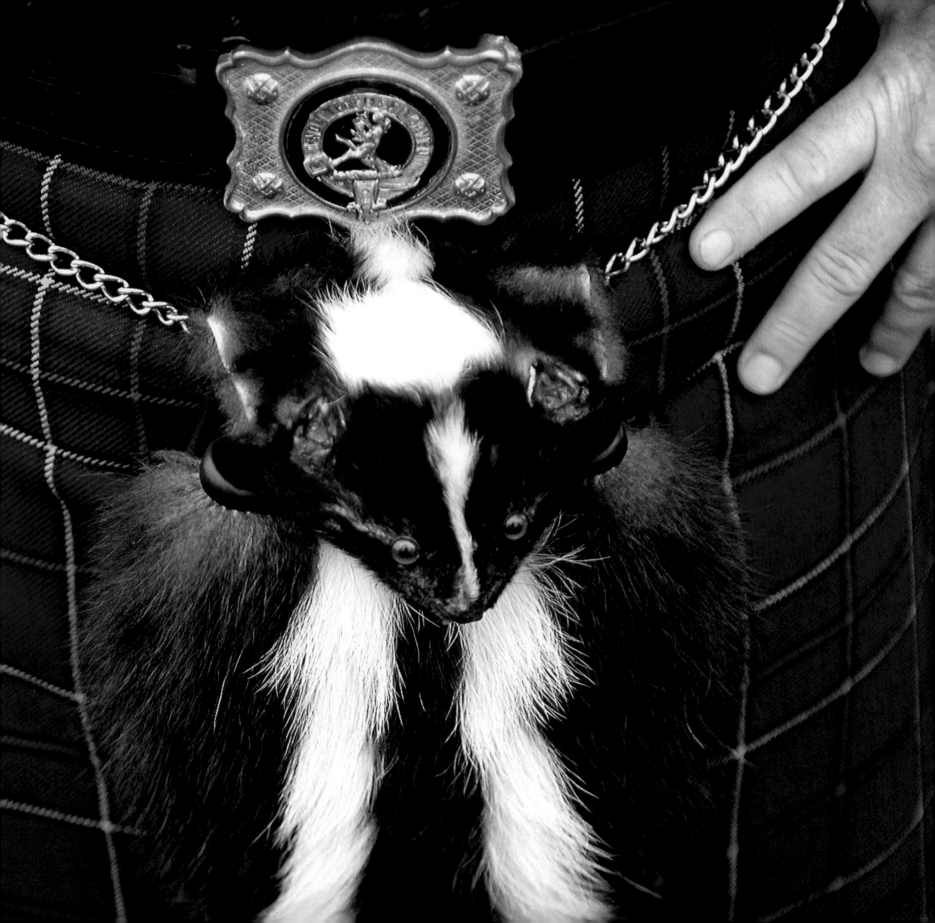

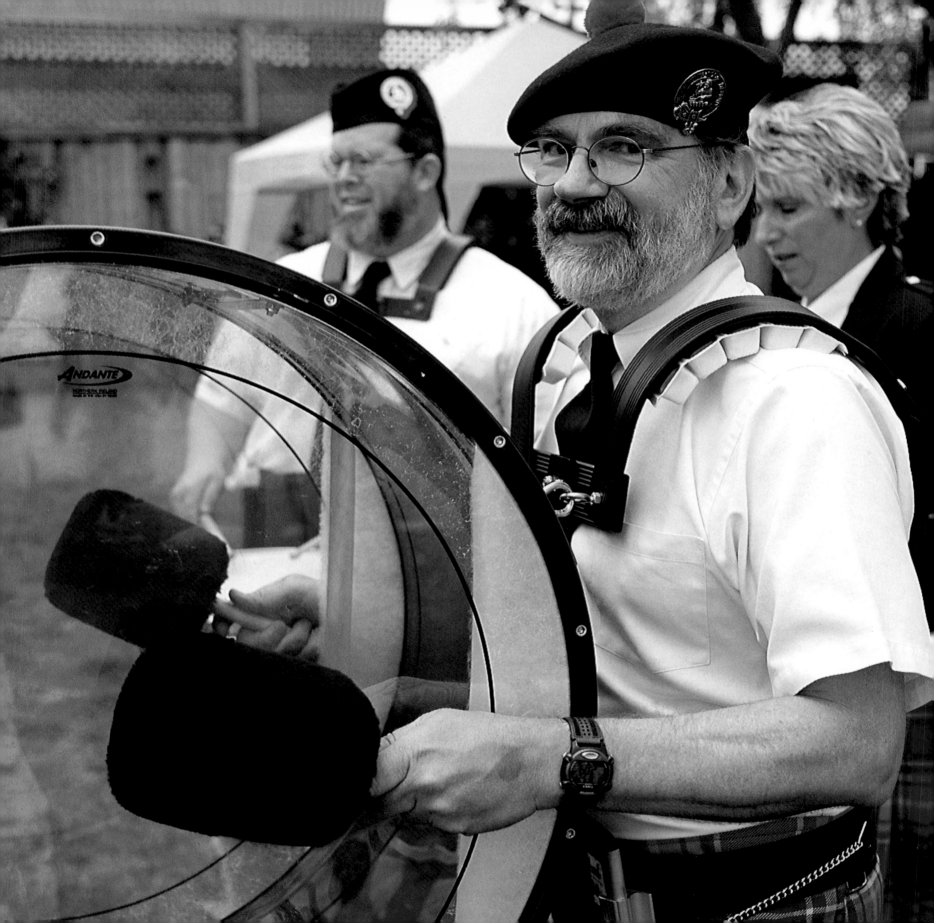

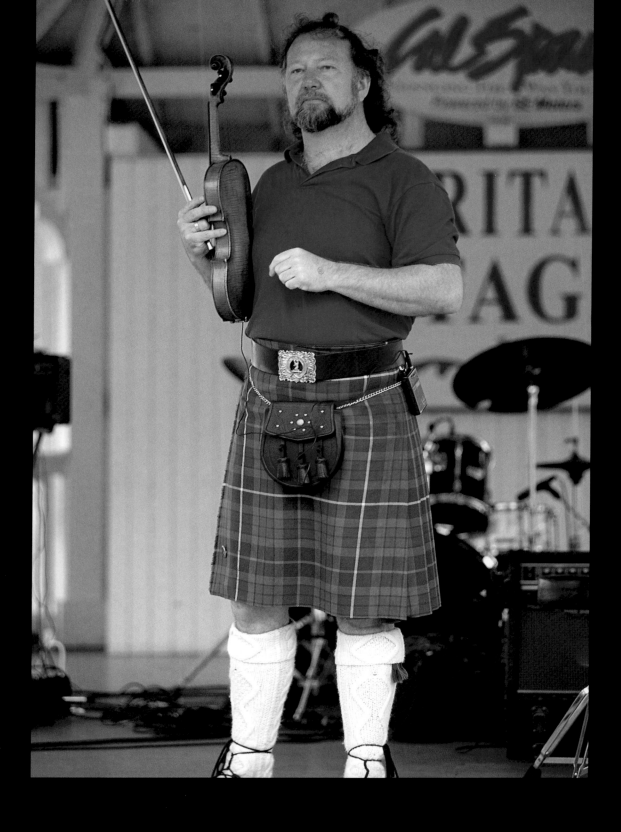

COSTA MESA, CALIFORNIA, 2003

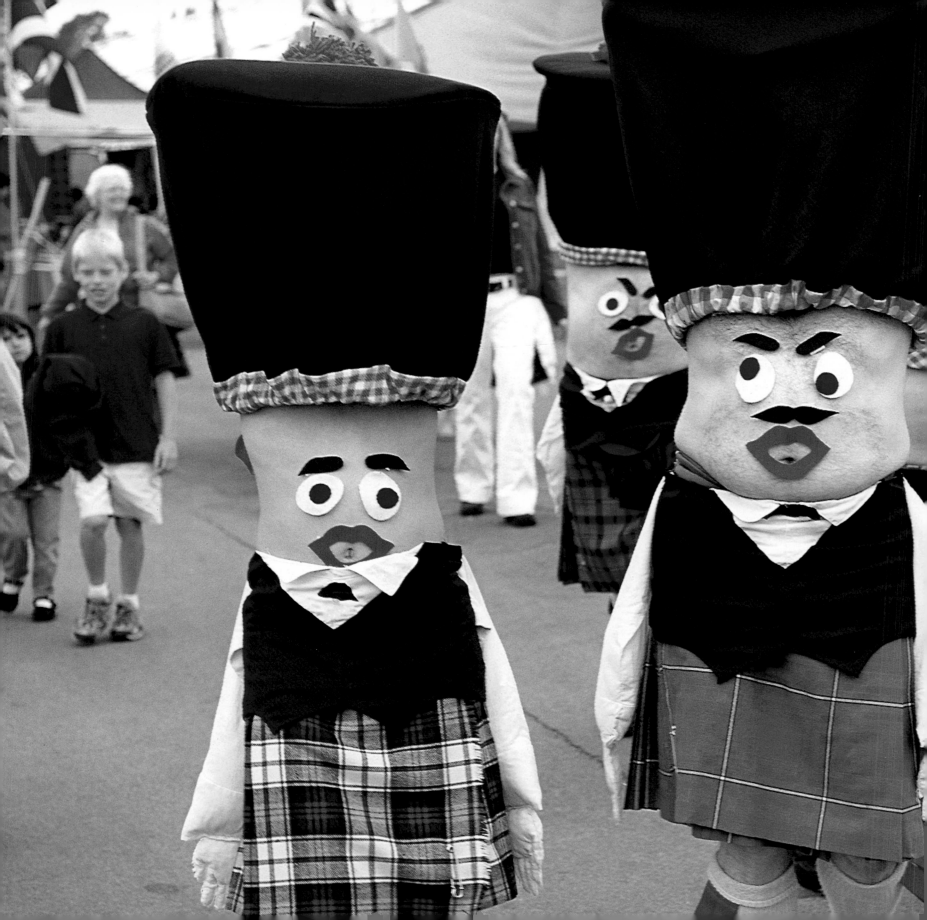

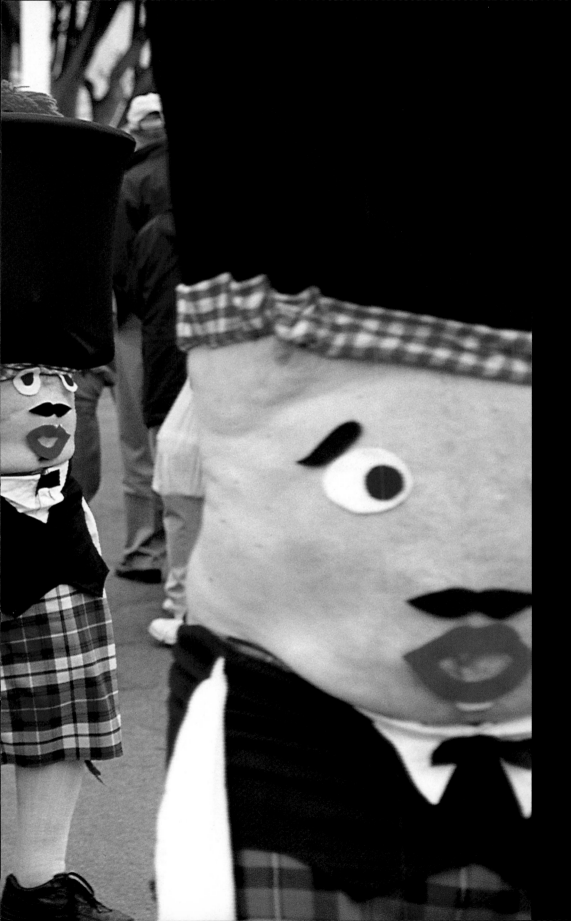

This photo was taken at a Scottish festival in Orange County, California, in early 2003. I had previously been in Minnesota and Michigan, also photographing the Scots, but this festival was quite large, and the Highland Games was not a celebration to miss.

I was photographing children and adults wearing various types of traditional Scottish clothing. When I turned around, I saw these peculiar creatures walking toward me. At first, I couldn't figure out what they were until I saw their fleshy stomachs. I finally realized that these men had pulled up their shirts over their heads, and held them with their arms extended and squared above them revealing their stomachs with eyes and a mouth over their navel. It was so amusing to me, and to everyone around, that we couldn't help but break out in laughter.

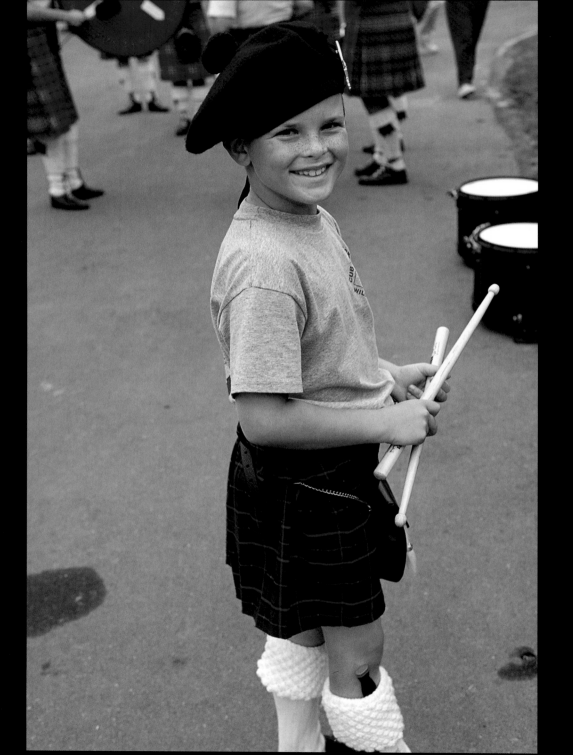

Initially, Scots kept their weapons at hand at all times. They always carried a knife in their socks for protection.

Over the years, however, this tradition was expanded to where the Scots now carry a knife and fork in their socks. These Highlanders carry on the tradition to this day.

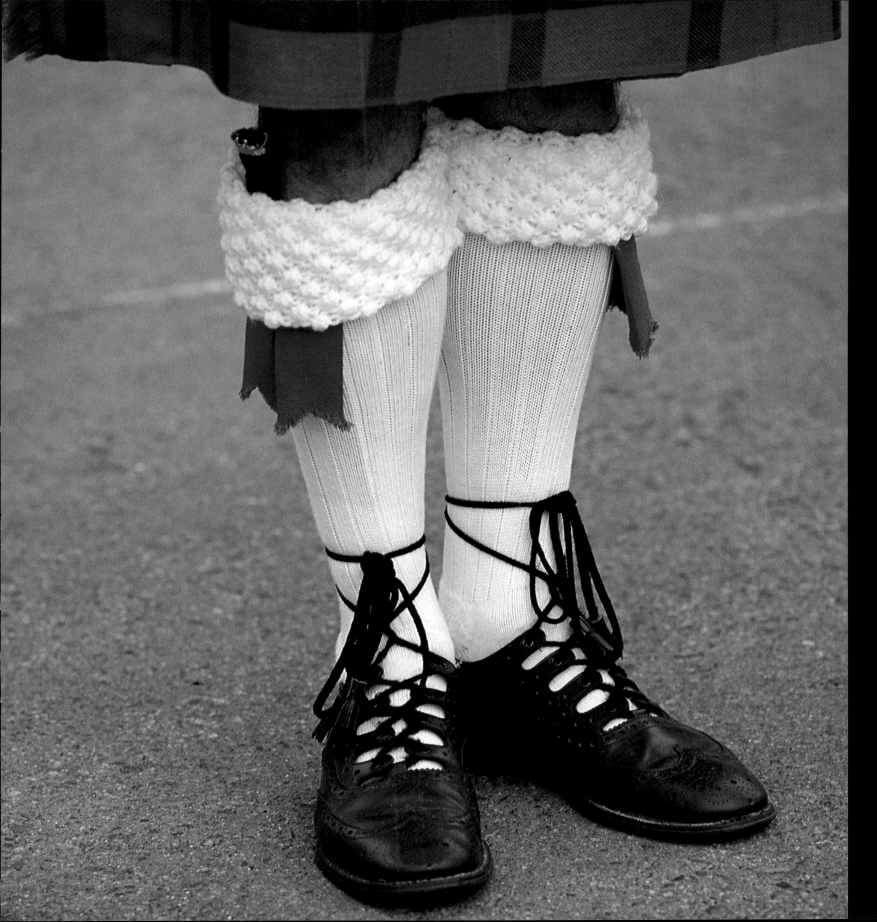

The Great Migration

1850 To 1915

HUNGARIANS

GREEKS

POLISH

ITALIANS

PUERTO RICANS

JAPANESE

FILIPINOS

CHINESE

ARABS

ARMENIANS

The Great Migration

By the middle of the nineteenth century, Europe was in turmoil. The division between the haves and have-nots was extreme. Those on the lower spectrum of society had little opportunity for upward mobility. Many found themselves persecuted in religion, struggling to feed their families, or politically shunned. They chafed under Victorian society's constraints. Similar situations existed in Asia and the Middle East: although their cultures were different, many people had grown weary of the strict rules of their societies. America offered hope and golden dreams. This new land, with new people, new ideas, and opportunities gave rise to the clarion call for these jaded souls.

As a result, anyone capable of mustering the resources gathered themselves together, with or without their families, and emigrated to America. It was a magnificent time of expansion and grand migration from all parts of the globe to this new and elegant country known as the United States of America.

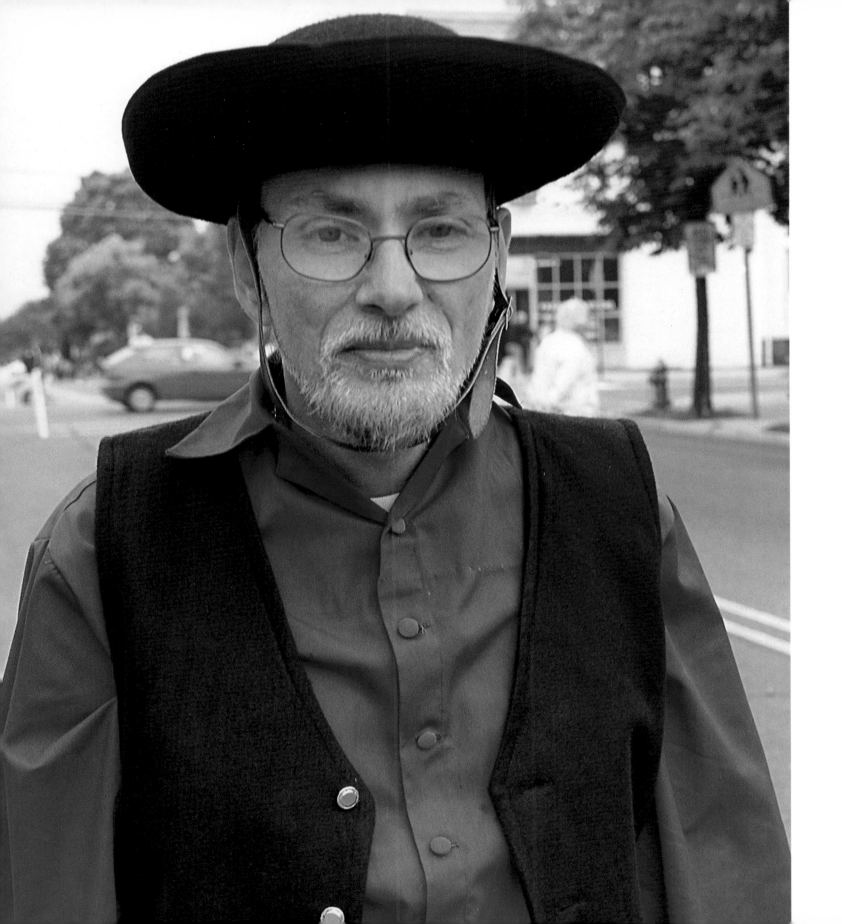

Of the more than thirty million immigrants who arrived on American shores between 1820 and 1914, well over ninety percent of them were Europeans, initially from western and northern Europe. By 1880, however, the number of immigrants from southern and eastern Europe far exceeded those from western Europe. While the earlier European immigrants were political refugees and professionals, the vast majority of immigrants arriving in the late 1800s and early 1900s were farmers and peasants coming to make a new life in America's young and economically mobile society. It was these immigrants who settled in America's new urban regions and found work in the manufacturing and mining industries that were being fueled by America's industrial revolution.

A strong and proud people, Hungarians were eager to embrace the freedom America offered. In their homeland, Hungarians had historically fought for freedom against oppression and tyrannical rule. And although their democratic

revolution in 1848 essentially ended their feudalist social system, conditions in Hungary continued to worsen politically, socially, and economically. This served to motivate throngs of Hungarians, like other European immigrants, to look to America as the land of promise.

The initial flow of intellectuals and professionals from Hungary soon gave way to strong, hardworking men and women from the peasant class whose character and work ethic made them excellent family providers. Due to their energy and hard work in almost every field of endeavor, their quest for social and economic mobility was rewarded. And although repatriation was common, approximately 80 percent of the 1.7 million immigrants who came here from Hungary prior to 1914 remained and settled in the United States. Although most were Magyar-speaking Hungarians, mixed in among them were Slovaks, Rumanians, Ruthenians, Serbs, and Croats. This is due principally to the multi-ethnic character of the kingdom of Austria-Hungary which previously existed in what is now Austria, Hungary, the Czech Republic and Slovakia. For the purposes of this book, all of these immigrants fall within the category of Hungarians.

While Hungarian immigrants had originally settled in the Northeast, by the early 1960s many younger immigrants seeking economic opportunity had migrated to Florida and California, where they established Hungarian communities as centers for support and socializing. They formed Hungarian-American associations, and based their communities around their church. Although there were Hungarian Jews who emi-

grated to America, most Hungarian immigrants were Christians. Today, Hungarian-American communities and associations continue their support and celebration of the traditions and cultural heritage of Hungary. They proudly remember all Hungarians whose brilliant minds have contributed to discoveries in science, medicine, advanced technologies, and inventions; and whose talents in the fields of entertainment and sports bring such enjoyment to the world.

Hungarian-Americans have continued to take the initiative in social, political, and economic arenas, distinguishing themselves by their accomplishments—people such as John von Neumann, computing pioneer who was the Father of Binary Code and the Stored Program Computer; Tódor (Theodore) von Kármán, the Father of the Supersonic Flight, a founder of the aeronautical and astronautical sciences, and the first recipient of the National Medal of Science, presented to him by President Kennedy; Peter Carl Goldmark, engineer and CBS Chief Scientist who invented the color television, 33-1/3 LP records, and the electronic video recorder. In the field of entertainment there are high-profile Hungarian-Americans such as Adolph Zukor, producer of the first full-length motion picture and founder of Paramount Pictures and Loew's Theatres; Andrew Vajna, Hollywood legend, producer, and president of Cinergi Productions, and co-founder of Carolco Pictures; William Fox, movie producer and founder of Fox Studios; George Pál, cartoonist and pioneer of stop-action animation, winner of six Oscars; Miklós Rózsa, triple Oscar-winning film composer; and

acclaimed movie actors like Béla Lugósi, Tony Curtis, and Brent Spiner (*Star Trek's* Lieutenant Commander Data).

Whether America's Hungarian family members are Hungarian-born or the offspring of Hungarian parents and grandparents, they are extraordinary achievers. Without a doubt, Hungarians have made the most of the promise of freedom in this land of opportunity by fulfilling their American dream, and we have all shared in their success.

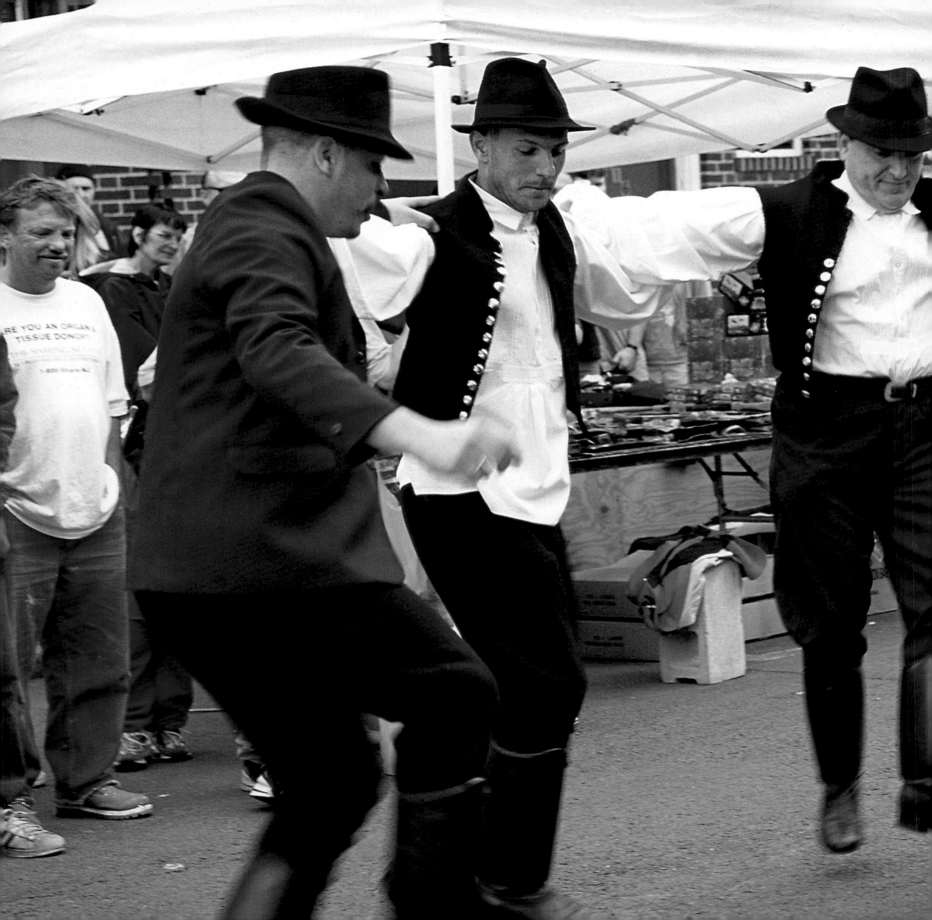

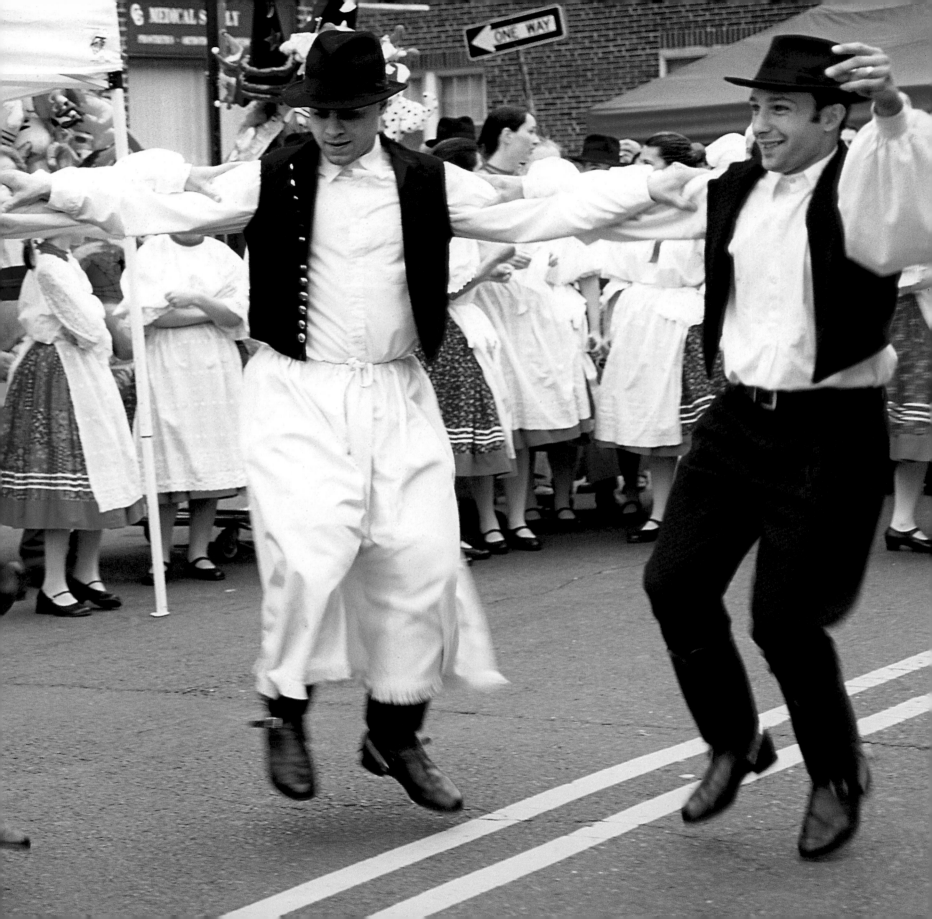

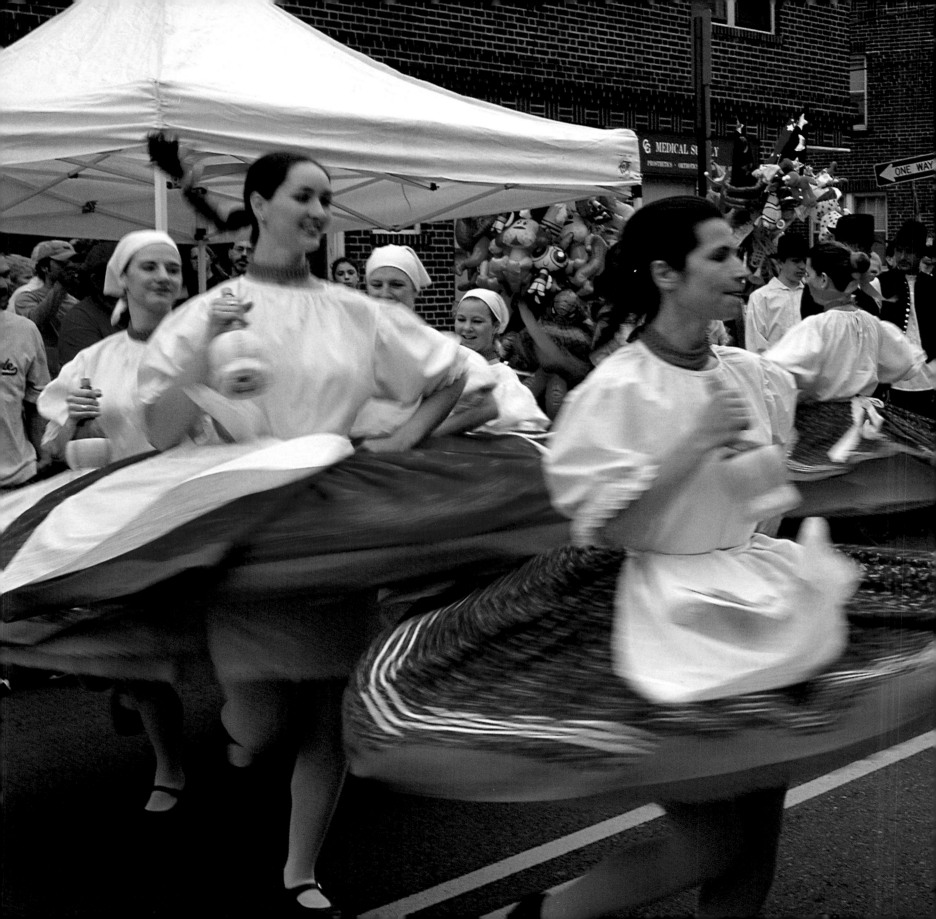

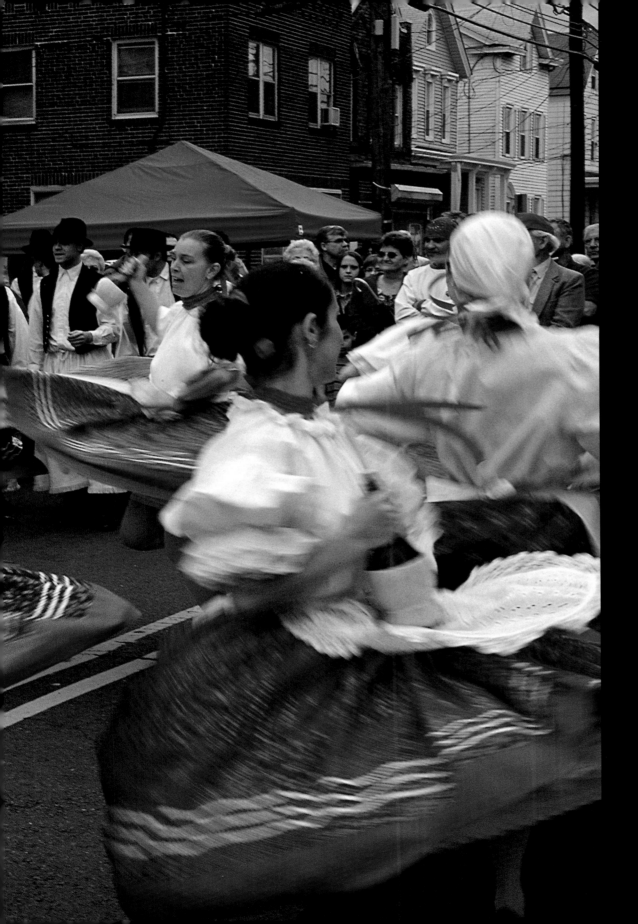

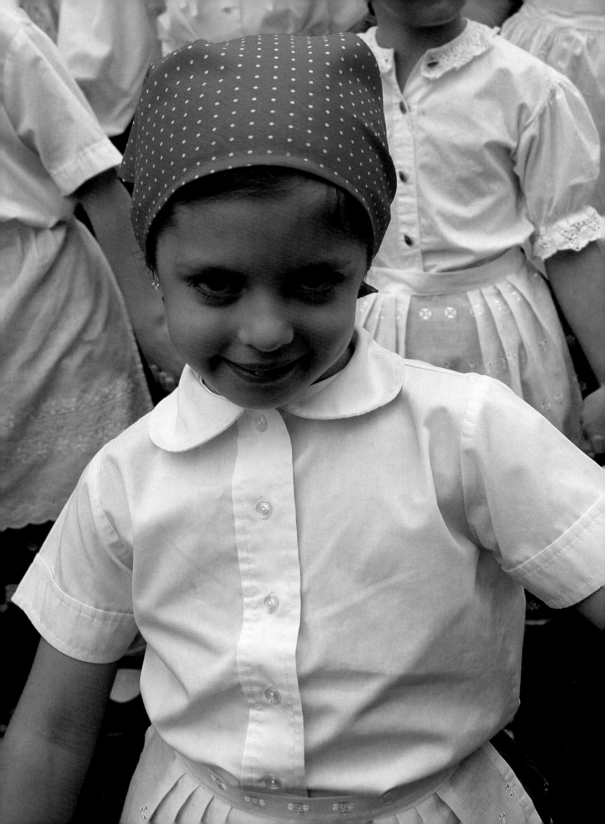

The ancient Greeks were responsible in many ways for the underpinnings of Western Civilization. It was they who established the basic concept of modern democracy. However, life was not peaceful in ancient Greece. Their loose array of city states constantly warred with each other until united by the Macedonians. Eventually, Greece became part of the Roman Empire and later its eastern successor, the Byzantine Empire. As the Byzantines collapsed in the fifteenth century, the Ottoman Turks occupied Greece and kept it as part of their empire until the 1820s, when the Greeks rebelled against the oppressive rule of the Islamic Turks. This bloody war lasted from 1821 until 1829, when Greek independence was won (with European help) and the modern country of Greece was founded. Finally, the Greeks had regained control of their homeland and their future.

Greeks were not among the earliest settlers to migrate to America, although there were a few initial stragglers who did immigrate to its eastern shores. But

prior to 1850, while hundreds of thousands of other European immigrants made it to America, very few Greeks emigrated. Greeks were happy in their homeland, taking great pride in making their living from their land as farmers while growing olives and currants. And even though their family farms did not produce enormous wealth, Greek families retained their cohesive units, with their religious and cultural traditions sustaining the most important aspects of their lifestyle.

However, conditions in Greece changed in 1890, when the French government refused to buy Greek currants in an effort to protect their own French currant farmers. The heavy taxes imposed on other Greek produce by the French rendered Greek crops virtually worthless, because France was the largest consumer of Greek produce. This was a tremendous blow to Greek agriculture. Anticipating the good foreign markets, many Greek farmers had cut down their olive trees to plant currant vineyards. Now they found themselves near bankruptcy, and with no other available markets for their goods. Thus, starting around 1890, there was an enormous migration of Greeks emigrating to America, desperate to start new lives.

Most of the arriving Greek immigrants had little money, and they found that jobs were scarce. These newcomers suddenly found themselves on the streets of the metropolitan areas of New York and Philadelphia, working as peddlers or employed by *Padrones*, who owned shoeshine parlors and carts that were used by peddlers to sell their wares. A few Greek immigrants joined forces with other Greek fami-

lies and purchased businesses that provided economic mobility. Many, however, worked for food and lodging with the dream of saving enough money to return home. Ultimately, most of these dreams would vanish as these new immigrants put down roots in America.

Greek immigrants migrated principally to the northeastern and north-central states; they settled in New York, Ohio, and Pennsylvania, and established Greek communities similar to the one found in Lowell, Massachusetts. Here they found jobs, working in textile mills, making hats and clothing. Other immigrants rekindled many of their Grecian talents and traditional skills to make a living, like diving in the warm waters off Florida to harvest sponges that they sold throughout the country. Demonstration of their other cultural traditions helped to focus attention on their Greek communities, namely their emphasis on strong family values and their faithful devotion to their Greek Orthodox religion, the church that had its center in Constantinople and competed with Catholicism as the main form of Christianity prior to the Reformation. By the 1920s there were over 140 Greek Orthodox churches across America.

Greeks traditionally honor many significant holidays such as Christmas and Easter, St. Basil's Day on January first, and Greek Independence Day on March 25, celebrating with religious services, festivals, and parades. And although "Greek towns" sprang up throughout the United States in the late 1890s and in the early 1900s, today Greek culture is a wonderfully integrated component of the American landscape, cel-

ebrated in many ways; enjoyment of traditional foods like baklava, gyros, moussaka, and other delicacies that delight the palate; and through music and entertainment. Who can resist joining in the merriment at their festivals with their joyful music and dancing that engages participation from every Greek around, thrilling everyone watching the extraordinary choreography?

We owe a great debt of gratitude to the Greeks, not only for their gifts of art, philosophy, and our democratic principles, but also for bringing the world together through sports competition at the Olympic Games. The games were founded by the Greeks in 776 B.C. to honor their gods. Today's modern Olympics are spectacular events that are respected and participated in by almost every country in the world. This "granddaddy" of festivals is held every four years, hosted by a different country, and encompasses all manner of athletic competitions, including dance and musical events. In 2004, as a tribute to the founding of the tradition, the Summer Olympic Games were held in Greece, and they were a resounding success.

Today, there are nearly two million Greeks living in large cities, small towns, and villages throughout the United States. The Greeks in America can be proud of their accomplishments. They are consummate professionals in medicine, law, politics, and the arts. Some notable Greek personalities include Olympia Snowe, United States Senator from Maine; Michael Dukakis, former governor of Massachusetts, and Presidential nominee in 1988; Jennifer Aniston, actress; and the late Telly Savalas, renowned actor. With their warm personae and boisterous personalities, Greeks have added a special spark to our American lifestyle and have also found a place in our hearts.

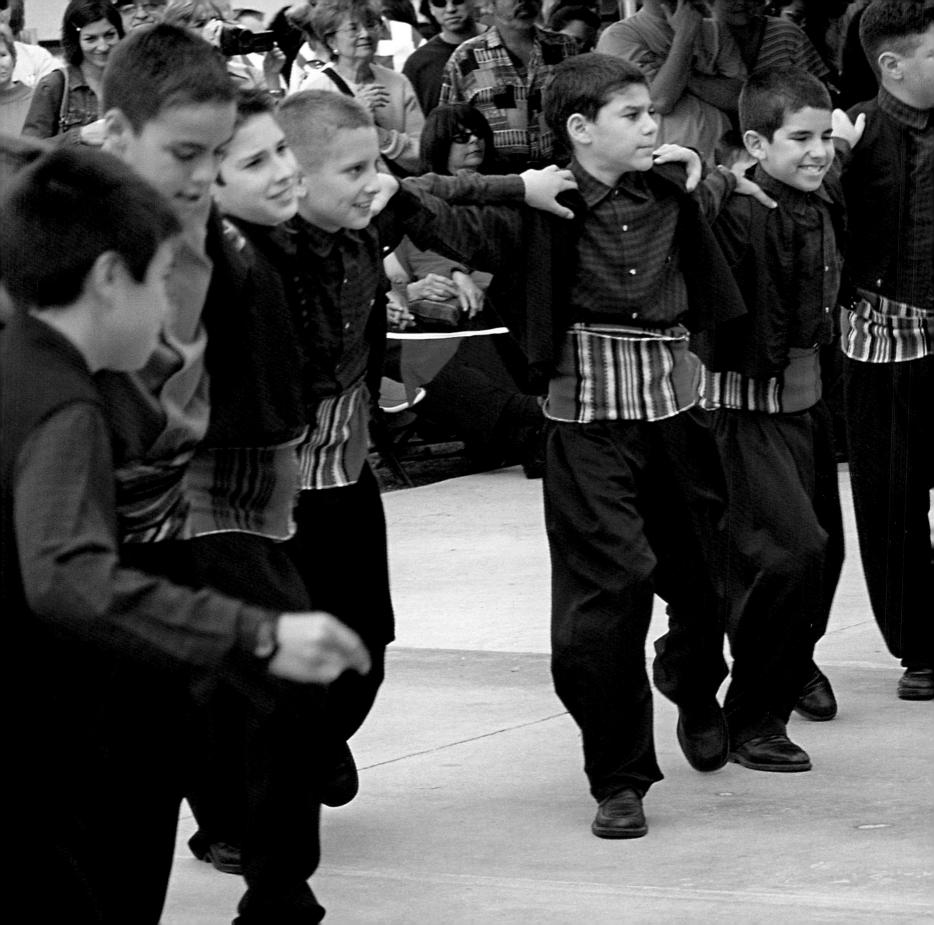

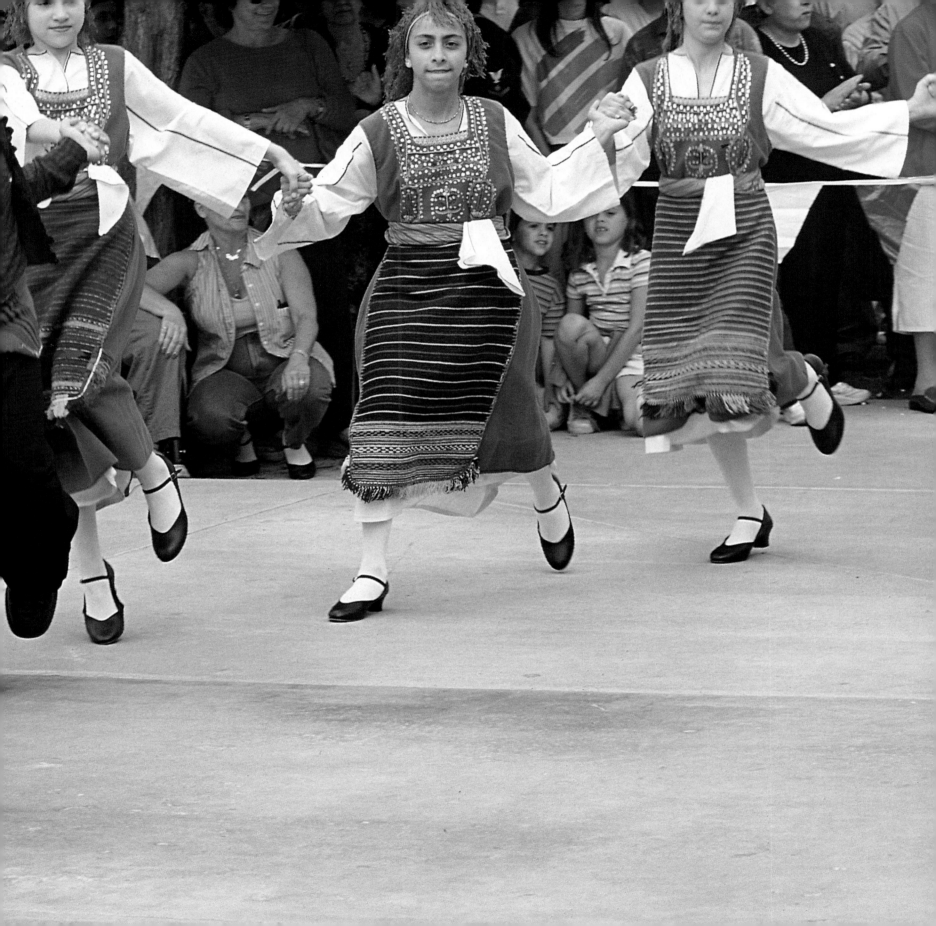

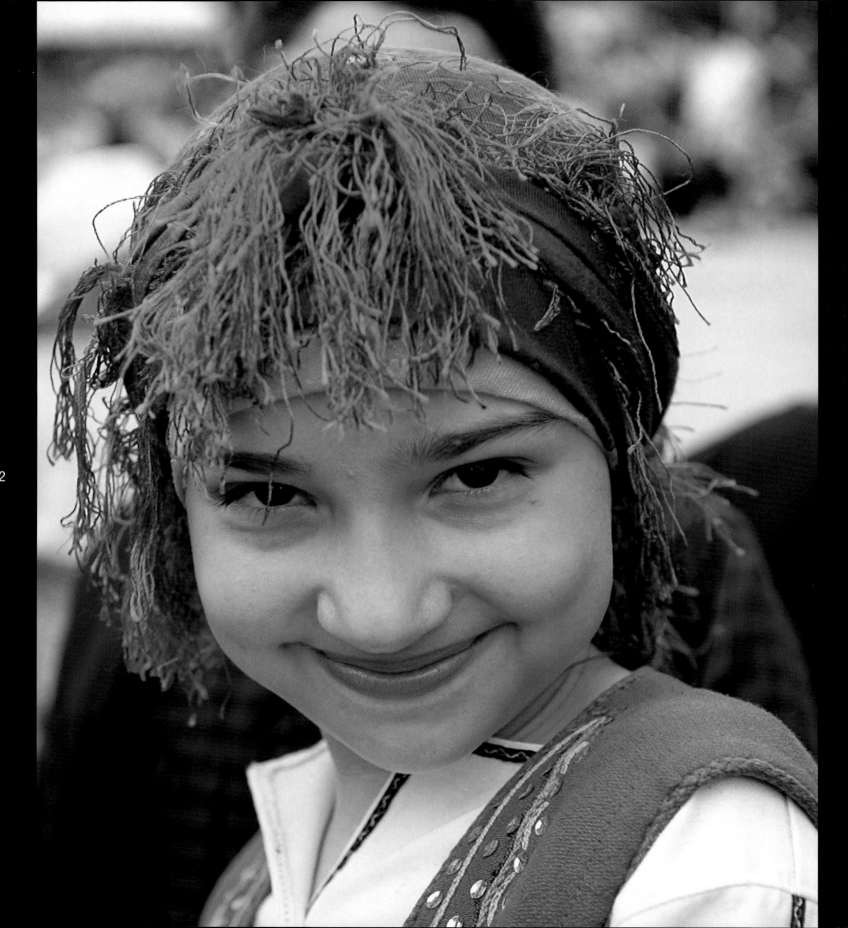

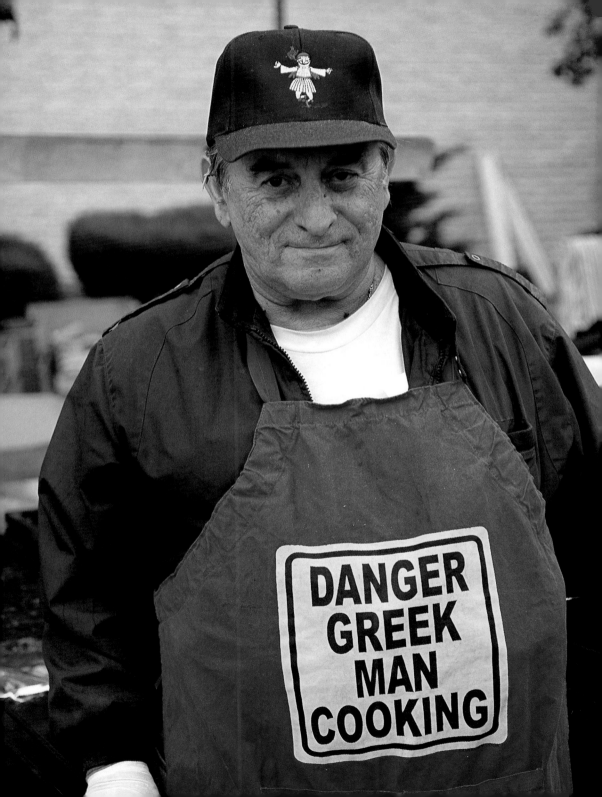

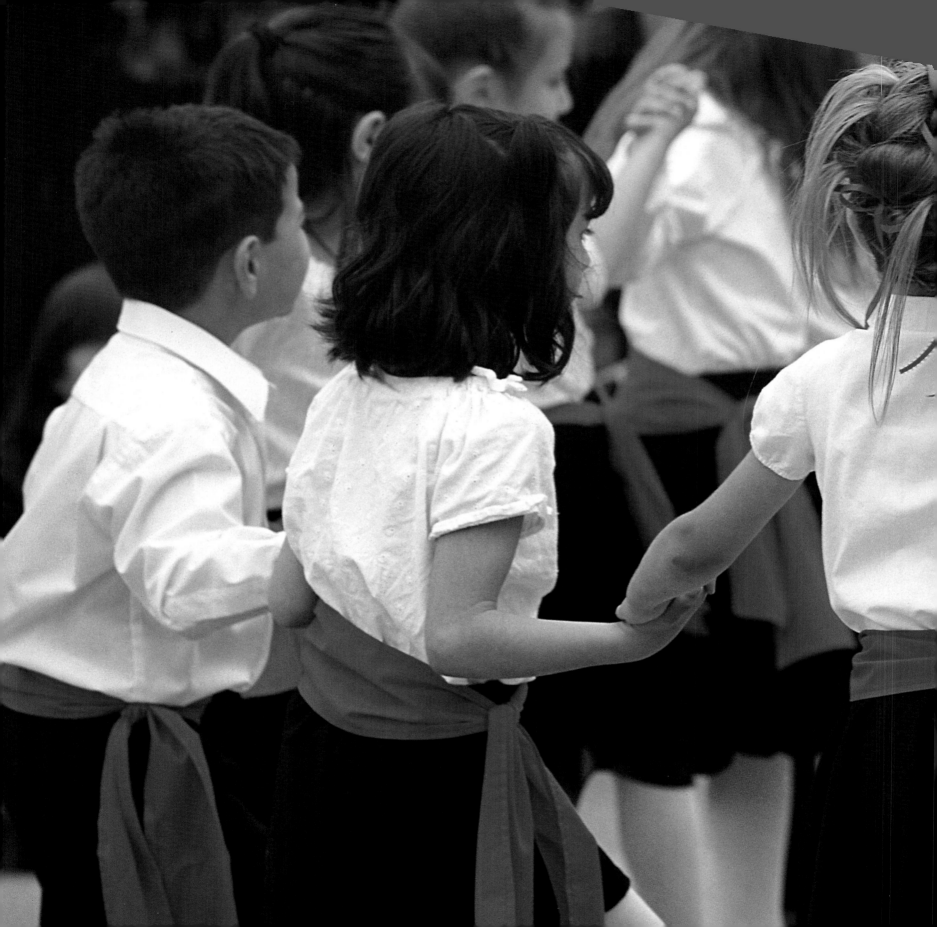

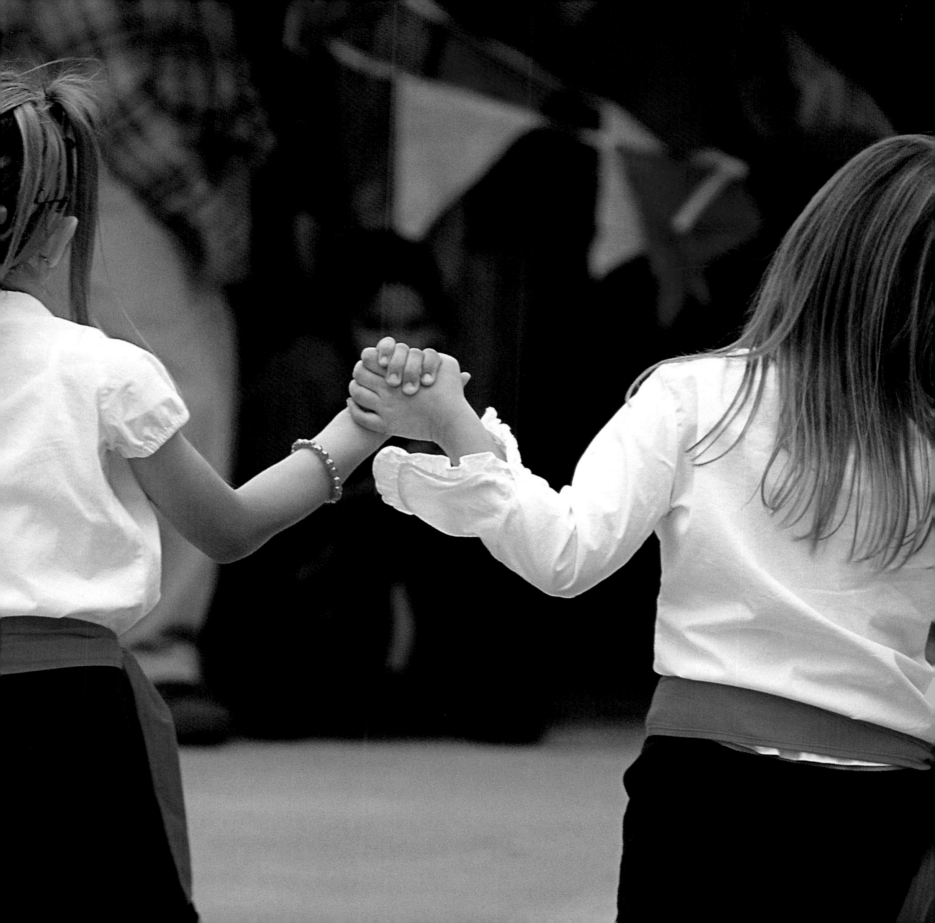

There has been a Polish presence in America since the early 1600s. Poles were among the small group of early settlers to come to the New World. And later, several Polish officers traveled to America to fight in the Revolutionary War in 1776. However, it wasn't until the 1870s that large-scale Polish migration to America began. Between 1870 and the early 1900s, America would receive over two million Polish immigrants.

Poland itself was at one time the largest nation in Europe. But, over time, a weak government and powerful neighboring states combined to destroy Polish independence. Poland ceased to exist in 1795 and was not reconstituted until after World War I. During World War II, a large portion of the Polish population was eliminated by Nazi persecution. It is estimated that six million Poles were killed, and two and one-half million Poles were deported to Germany for forced labor. The Polish Jews suffered the worst fate; all but about 100,000 of the three million prewar Polish Jews were exterminated by the Nazis.

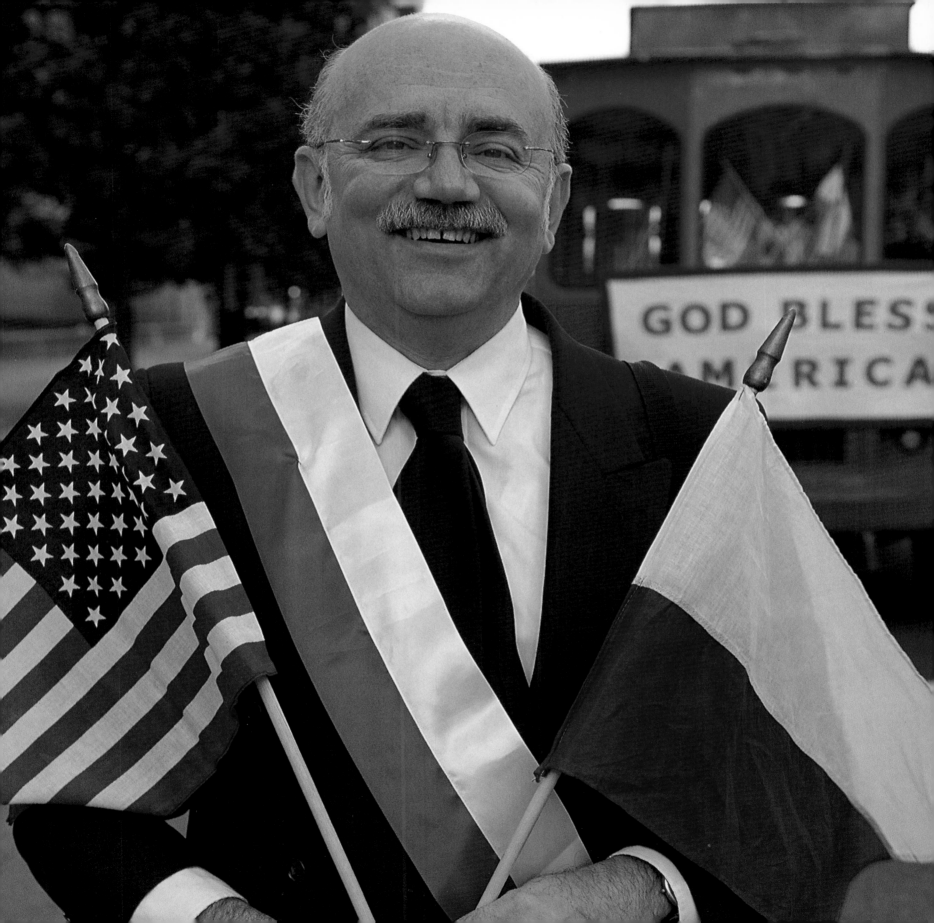

Most of the population of what is now Poland lived on small farms throughout the 1800s. Economic conditions were exceptionally harsh and oppressive laws made it even more difficult for the people to survive. With education reserved for the noble class, farming was the mainstay of Polish peasants. When the occupying governments demanded payment from the peasant farmers for the use of their land, many Poles chose to leave Poland and travel to America. Some married men came alone and sent money back to their families in order to save their farms. However, the wives and children who were left behind to manage the farms found it increasingly difficult to do so. Thus, many Polish farmers elected to bring their families to America, giving their land to relatives who stayed in Poland, or forfeiting the land to the government because they could not pay the taxes.

Making the trip to America was no simple task. The voyagers had to first find the money to even make the trip, and then they had to weather crossing the stormy Atlantic for three to five weeks just to get here. Once on American shores, many of the Polish farmers, who had little or no formal education and did not speak English, found work in factories and mines. These Polish immigrants were willing to work harder and longer than many other workers. They soon gained a reputation for their strong work ethic. Thus, as time went by, these hearty immigrants began carving out certain niches in American society, moving to those areas where they could find employment; the automobile industry in Detroit and the slaughterhouses of Chicago would support a large number of Polish workers. Poles would also establish communities in Pennsylvania and West Virginia, working in the coal mines and related industries there.

These new immigrants formed Polish neighborhoods called "Polonia," where they could speak their native language, share common interests, and celebrate traditional customs. Primarily Roman Catholic, they also congregated at their church—always a source of strength. Their communities featured Polish newspapers, theaters, dance halls, and clubs that served to bolster their spirit and Polish pride. By 1920, more than 400,000 Poles lived in Chicago, a number greater than in any other location outside of Poland. Their numbers soon multiplied in Philadelphia, Detroit, and New York to become the most dominant ethnic group in these areas as well.

Today, there are over nine and one-half million Poles in the United States. They are the ninth largest ethnic group in America, and have contributed a great deal to American politics, science, culture, sports, and the arts. Some well-known Polish-Americans are Zbigniew Brzezinski, President Jimmy Carter's national security advisor; Leon Jaworski, special prosecutor during the Watergate scandal; Albert Sabin, one of the developers of the polio vaccine; Isaac Bashevis Singer, winner of the Nobel Prize for literature in 1978; Wayne Gretzky, Canadian-born hockey legend; Stephen Wozniak, engineer, entrepreneur, and co-Founder of Apple Computer Company; Martha Stewart (born Martha Kostyra), businesswoman and media mogul for stylish living; and Eddie Blazonczyk, winner of the National Endowment for the Arts National Heritage Fellowship and Chicago's "polka king."

Polish-Americans are proud of their ethnic heritage. They delight in honoring their culture by wearing traditional red-and-white costumes at various parades and festivals throughout the country. They celebrate many special holidays, such as Pulaski Day, in remembrance of Count Casimir Pulaski, a Polish-American who fought and died for America during the Revolutionary War. Other Polish festival days include the Feast of Greenery; All Saints/All Souls Day; St. Nicholas Day; the Feast of the Three Kings; and Polish Easter. At such celebrations, Polish-Americans eat traditional foods like kielbasa (sausage), pierogi (dumplings), and babka, a cake-like bread that is sometimes filled with chocolate, cheese, raisins or prunes. On the day before Lent, they celebrate Paczki Day by eating a Paczki, a traditional fruit-filled frosted doughnut.

Four hundred years after the first Polish immigrants arrived on American shores, Poles are a vital part of American culture. Their spirited good humor, sense of fun, and enjoyment of life greatly deepens the American experience.

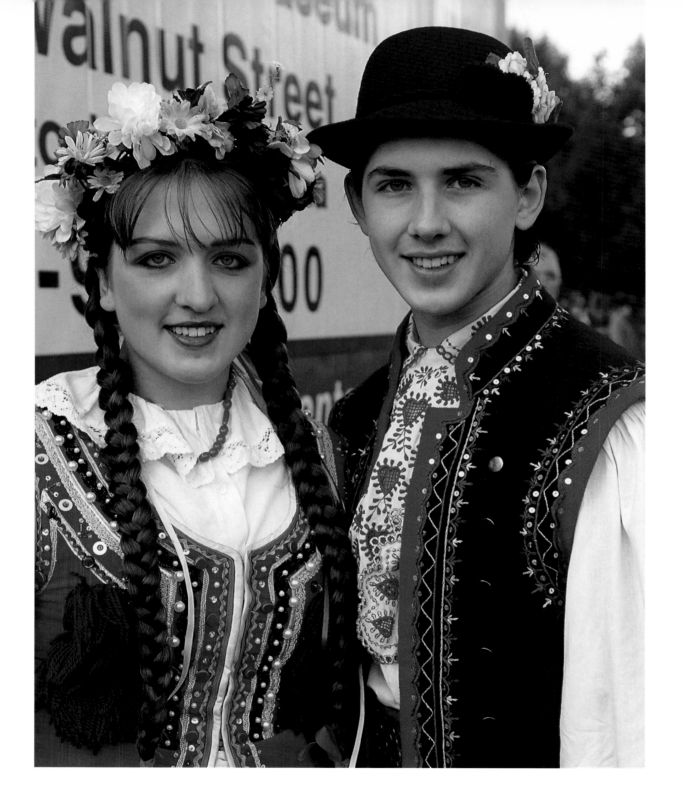

PHILADELPHIA, PENNSYLVANIA, 2003

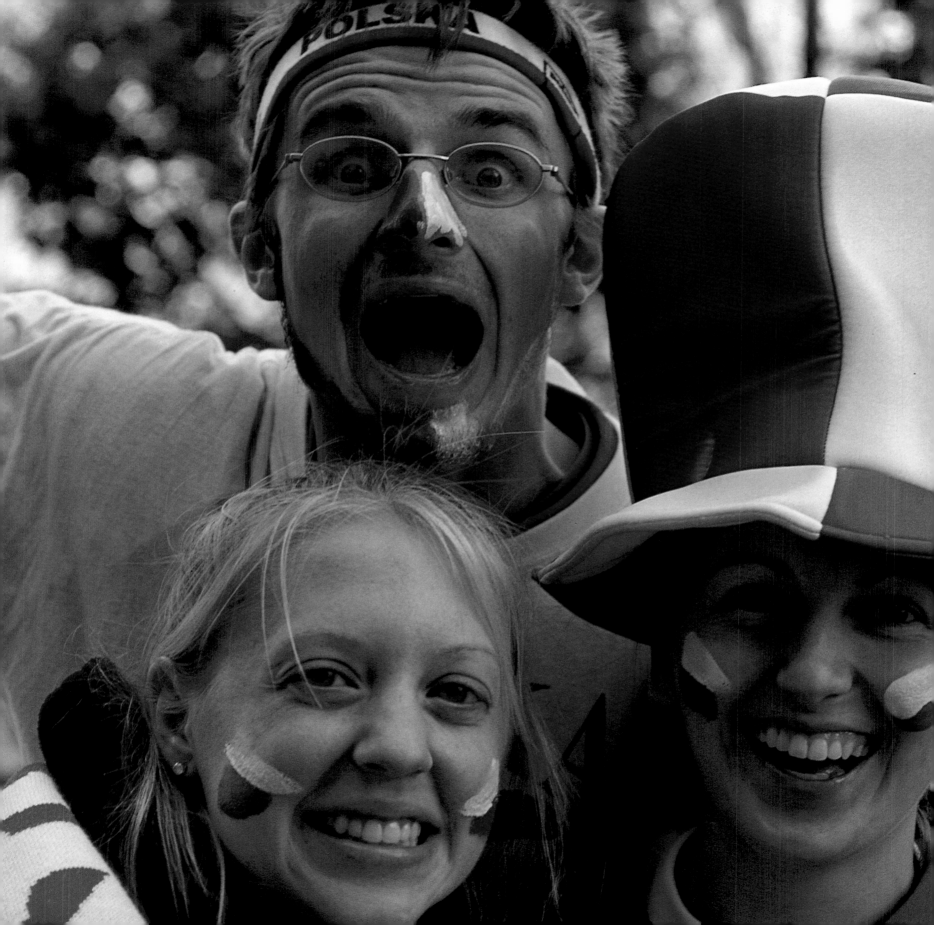

Although Chicago has the largest Polish population in the United States, Philadelphia is not far behind. The Polish parade winds throughout the downtown region, and consists of thousands of people in the parade, and thousands more observing it.

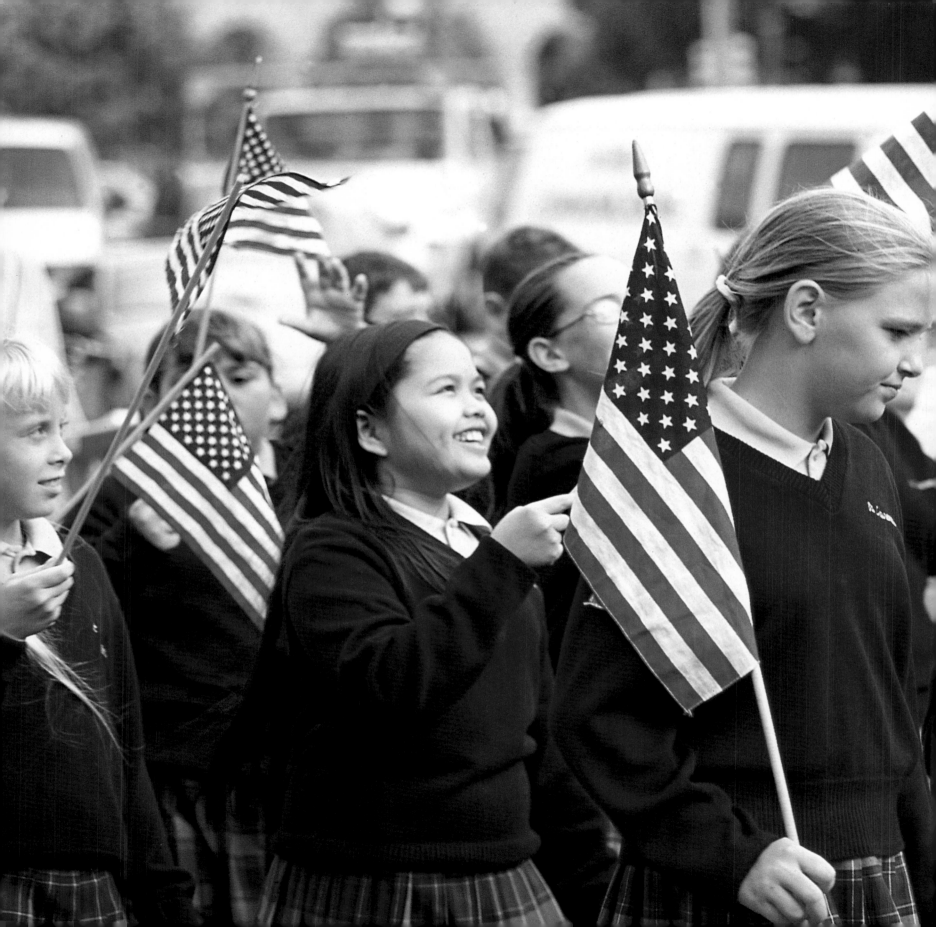

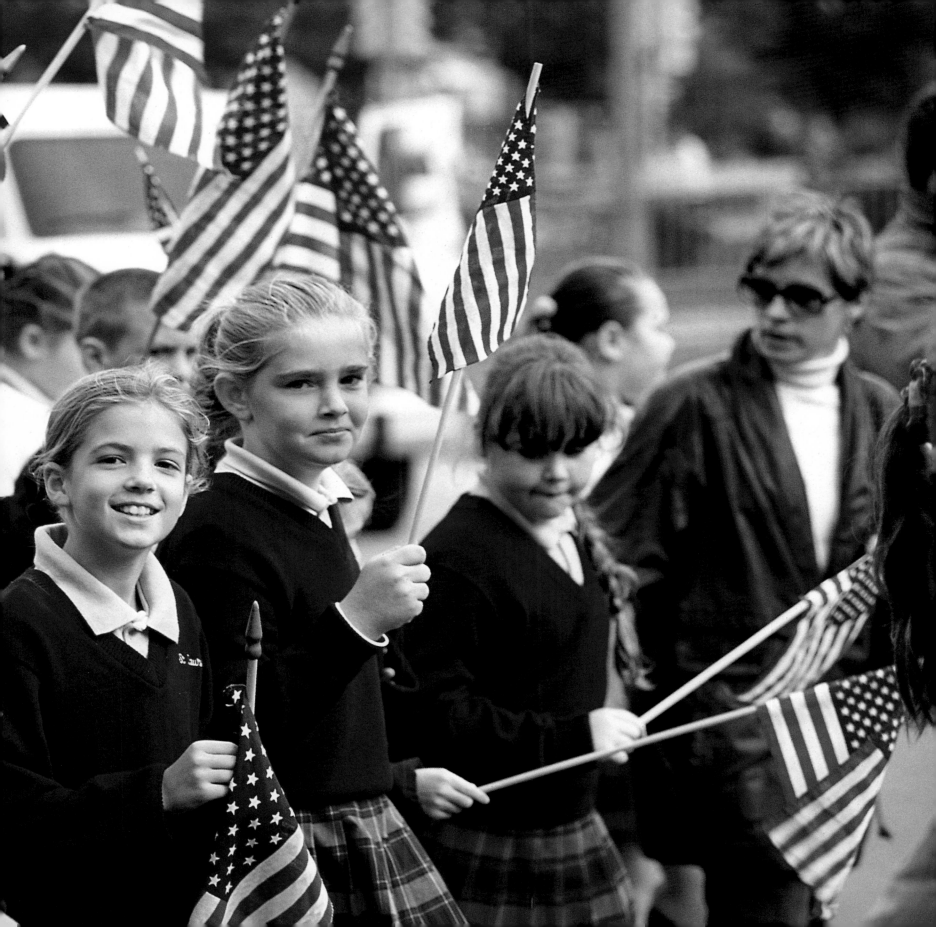

Italian immigrants themselves are from immigrant stock—culturally speaking. After the collapse of the Roman Empire in the fifth century, the geographical area known today as Italy endured numerous invasions and occupations from many diverse ethnic cultures; the Goths, Lombards, Byzantine Greeks, Arabs, Normans, German Catholics, French, and Spanish. With no unifying language prior to 1860, and no formalized borders until 1861, Italy's diverse populace spoke various dialects; their language developing under the ethnic influence of occupying powers.

Initially, Italians migrating to this country came from the more affluent northern provinces. They were motivated by a sense of adventure and cultural exploration. For the most part, they were doctors, lawyers, and merchants who could afford to travel. The number of Italians migrating to America between 1820 and 1880 was very sparse; just a trickle of a few hundred at first, to a few thousand by 1880.

However, between 1880 and 1920, nearly four million Italians emigrated to the United States. These newcomers came mainly from the less prosperous regions of southern Italy. For the most part, they were the poorer compatriots of the earlier immigrants. The economic conditions of their agricultural life in southern Italy were harsh. Increased competition for farm products from outside the country brought about by agricultural industrialization put immense pressure on farms that were shared and traditionally worked by Italian family units; there was less and less opportunity for economic advancement. As a result, many saw America as the land of gold and opportunity. And so they migrated. They entered the workforce as unskilled laborers and workers, seeking as much economic upward mobility as their talents and hard work could achieve. By the early 1900s, Italians had settled in many regions throughout the country, concentrating primarily in New York, New Jersey, Pennsylvania, Colorado, and California. They rolled up their sleeves and set to digging canals and coal, building roads and railways, and working farms and vineyards. They were not afraid of hard work, and it was their faith and cohesive family units that kept them focused.

Success would come, but not without its struggles. And all their hard work and good intentions would not shield them from discouragement or discrimination. Italians, like so many other newcomers, would battle prejudice. A majority of Italian immigrants were Roman Catholics, but were refused admittance to various Catholic churches dominated by the Irish Catholics. Italians would also feel the sting of discrimination from clubs and organizations that denied them participation because of religious and cultural differences. Undaunted, Italians took comfort in their traditions of family and faith. Like so many other ethnic groups, they found strength and security in joining together; congregating in tight-knit neighborhoods within various cities throughout the country known as "Little Italys." One such neighborhood is New York City's Mulberry Street, currently home to the largest and strongest Italian community in the United States, renowned for its yearly celebration of the feast of San Gennaro with its colorful parade and magnificent display of foods.

A popularized mental image of an Italian family evokes a portrait of young and old gathered around the dinner table enjoying wine, pasta, and bread; the room filled with music, talk, and laughter. That picture still holds true today. Italians are passionate people who treasure their families and their religion. Talented and hard working, Italian personalities have made contributions to every aspect of American lifestyle and culture. Some notable Italians that come to mind are: Fiorello LaGuardia, innovative New York City mayor; Frank Sinatra, legendary singer and Hollywood actor; "Joltin' Joe" DiMaggio, New York Yankees professional baseball player; Geraldine Ferraro, U.S. politician and three-term member of the United States House of Representatives; Rudolph W. Giuliani, Associate Attorney General of the

Department of Justice, and Mayor of New York City; and Madonna Louise Veronica Ciccone, pop singer, composer, and producer.

Italians continue to indelibly inscribe their signatures on the American scene. And while some Italians live in the spotlight, there are so many more behind the scenes whose artistic, educational, and civic contributions continue to reflect their great character, individuality, and generous spirit.

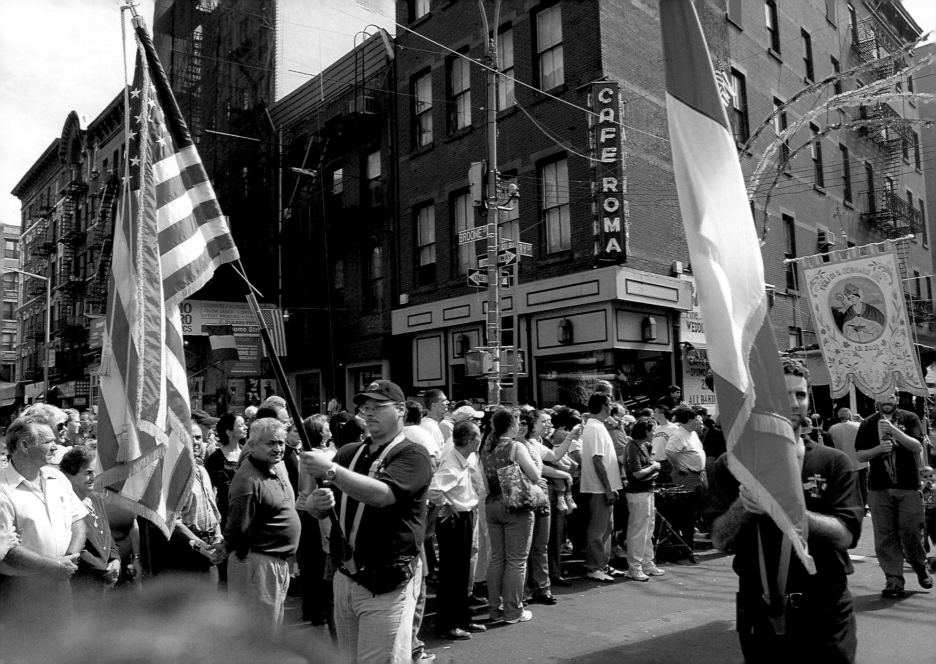

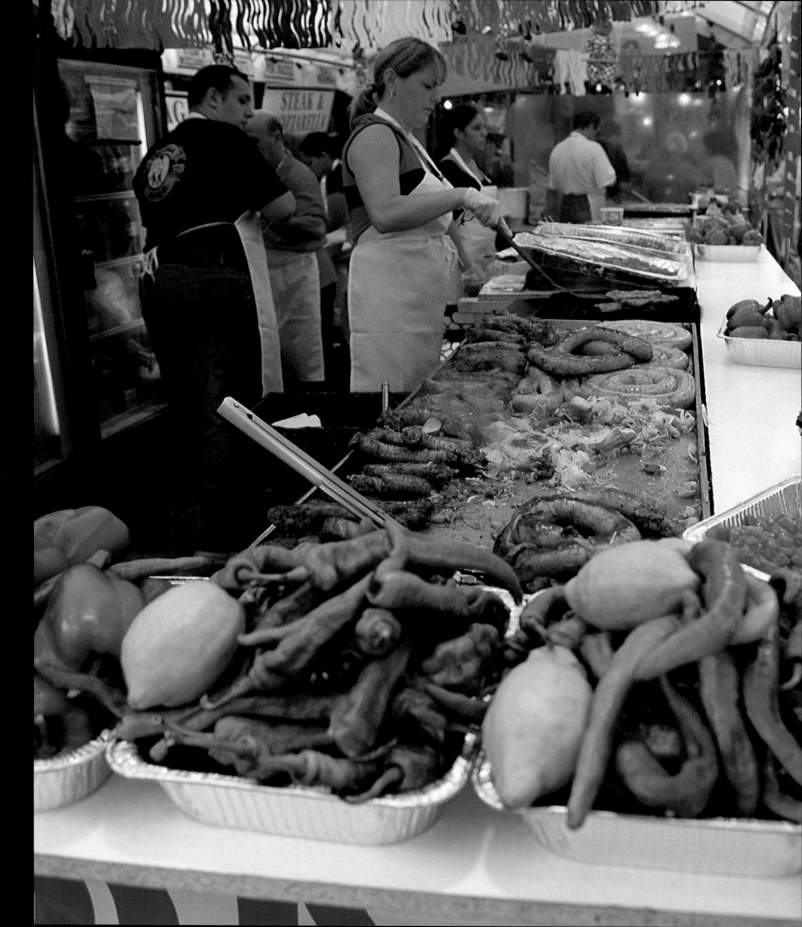

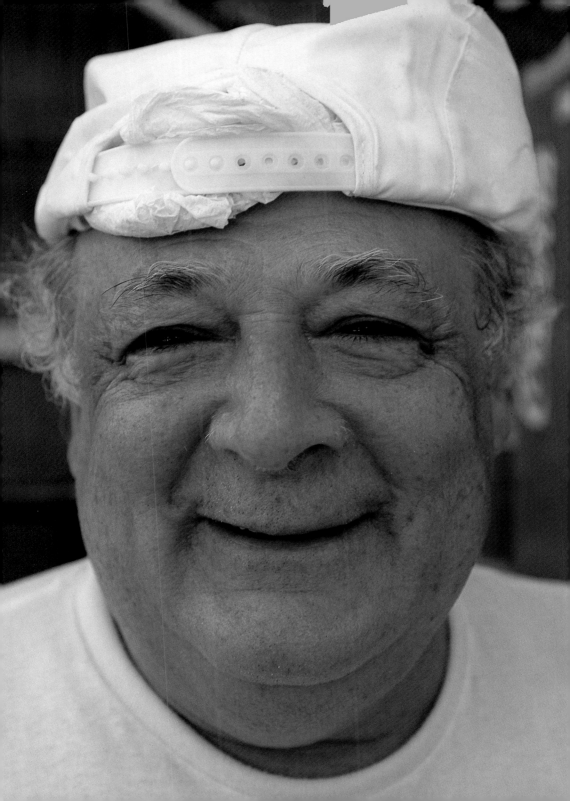

It was the summer of 2003, and I was photographing the feast of San Gennaro in New York City. As I was walking through the crowded Mulberry Street in lower Manhattan, a woman approached me and asked what I was photographing, and for whom. I told her I was working on a book and needed photographs of Italians since I was photographing ethnic groups in America. She took me by the arm and escorted me to her boyfriend, whom she asked to turn around. She told me "this man is a true Italian." She was blonde, blue-eyed, and didn't look Italian, nor did he at first blush. However, when he turned around his muscular back revealed a large tattoo spelling out his claim to Italian ethnicity.

These vivacious people are from a mixed ethnic background that has provided Puerto Ricans with their beautiful skin and exquisite physical features. Outside of their native island, the largest Puerto Rican population is found in New York, in the boroughs of Queens and the Bronx. Dance is a big part of the Puerto Rican culture, as depicted in the movie *West Side Story*. Their tropical island music enlivens some of the most crowded segments of New York City.

The Puerto Rican culture is believed to have originated thousands of years ago with the Taino Indians. These island inhabitants are said to have established a unique society that was flourishing long before the Europeans arrived. When Columbus dropped anchor near Aguadilla on his second voyage to the New World in 1493, he promptly claimed the island for Spain. Fifteen years later, Ponce de Leon became the first Spanish governor of Puerto Rico. The island had become an important military outpost, protecting Spain's control of

the Caribbean as well as acting as a stopover for ships traveling within the region. Under Spanish rule, the island's population swelled to approximately 45,000 by the mid-1700s. Over the next hundred years, Puerto Rico continued to serve as a transfer point for ships entering its port, and became an important trading post for goods such as sugar and ginger.

Spanish control continued until 1898, when Puerto Rico became a United States territory as a result of the American victory in the war with Spain. Shortly thereafter, the Foraker Act formalized Puerto Rico's colonial status with the United States, and Puerto Ricans were granted the rights and privileges of most Americans, and a presence in the United States Congress, although without voting representation. Today, Puerto Rico is a United States Commonwealth with its own local government. Over the years, Puerto Rican residents have conducted plebiscites to vote on statehood, but on each occasion they have failed. Many Puerto Ricans enjoy their political independence and are grateful for the military protection inherent in the island government's symbiotic relationship with the United States.

Puerto Ricans have contributed their talents to many aspects of American society. Examples of famous Puerto Ricans include New York Supreme Court justice and novelist Edwin Torres; historian and bibliographer Arturo Alfonso Schomberg, whose library became the internationally renowned Schomberg Center for Research in Black Culture in Harlem; opera singer Justino Díaz, who sang in more than 400 productions, and was awarded the National Cultural Medal by the Puerto Rican Cultural Institute, as well as the Handel Medal, the most important cultural distinction awarded by the City of New York; Hollywood actor José Ferrer, the first Puerto Rican to receive three Oscar nominations; renowned sculptor Tomás Batista; baseball player Roberto Clemente, who won four National League batting titles (1961, 1964, 1965, 1966) and earned twelve Gold Glove awards as the National League's premier right fielder; horse racing jockey Angel Tomás Cordero, Jr., winner of six Triple Crown races; singer José Feliciano, who earned over forty gold and platinum records, fourteen Grammy nominations, and six Grammy awards; stage and screen actor Raul Julia; and dancer and actress Rita Moreno, the first woman ever to win all four of the greatest awards in show business: Oscar, Tony, Emmy, and Grammy.

NEW YORK CITY, NEW YORK, 2004

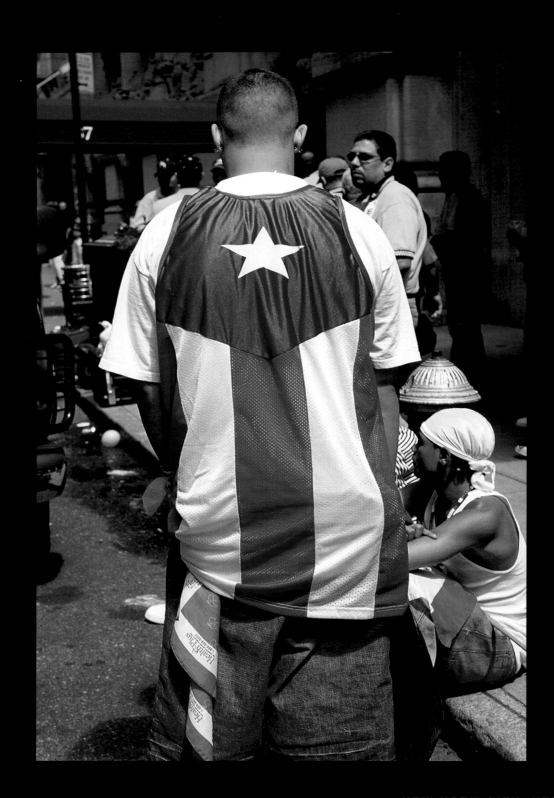

NEW YORK CITY, NEW YORK, 2004

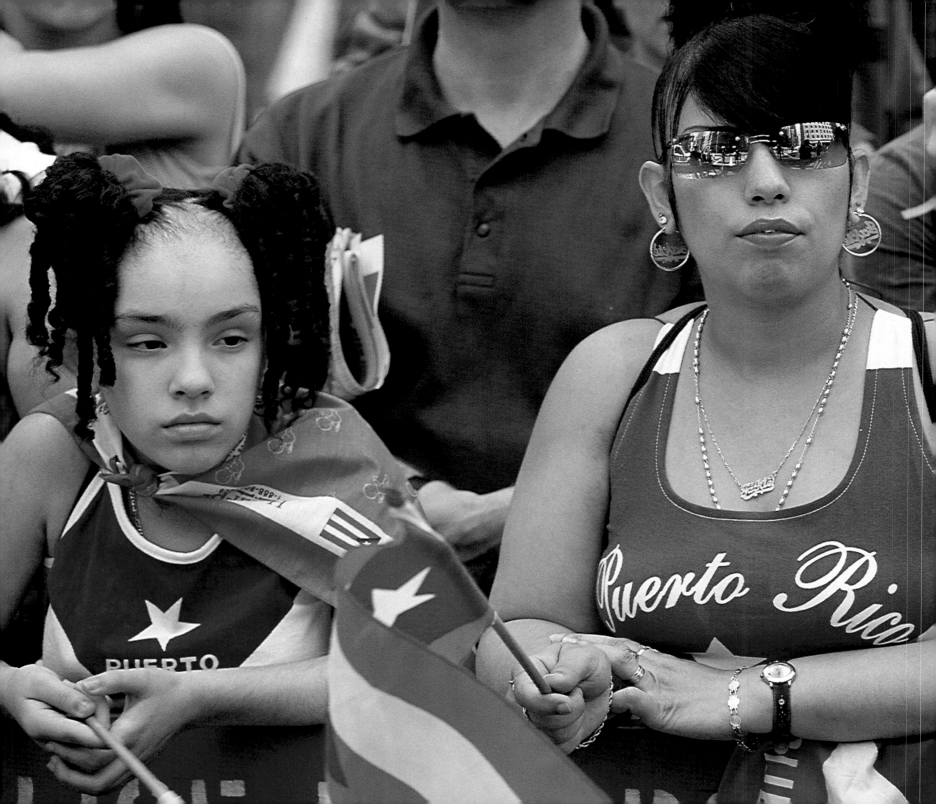

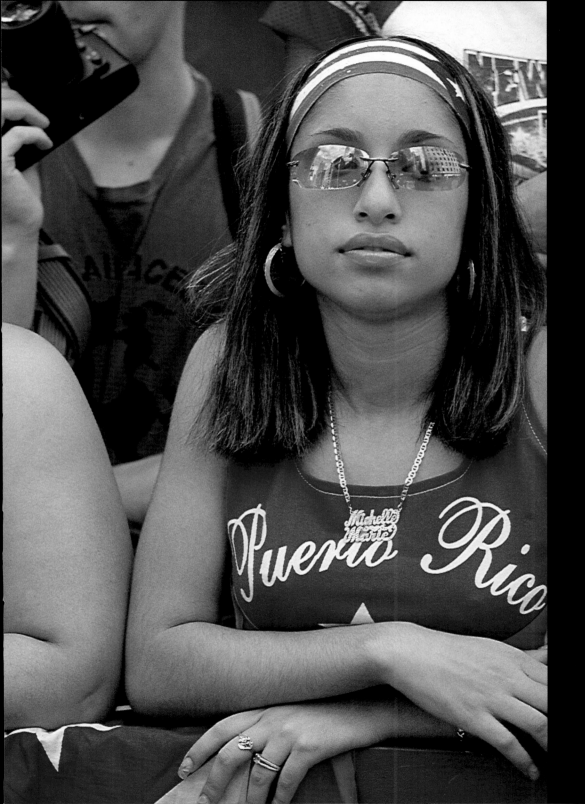

In New York City, the Puerto Rican Day parade is huge. Thousands of people turn out to march 40 blocks up Fifth Avenue. There is loud music, food and cheering from hundreds of thousands of people. I was fortunate to get inside the police lines and to walk along photographing the crowds who were outside the lines as I went by. Adults and children alike were waving American and Puerto Rican flags, wearing Puerto Rican shirts and hats, and showing their extraordinary pride in their Puerto Rican ethnicity. As I turned to take photographs, people would scream, blow whistles and wave flags at me, all in a joyous attempt to be photographed. I went through 12 rolls of film in 20 minutes. I have never seen a more fun-loving, boisterous crowd of people in my life.

In this photograph, I captured these three women in a moment of peace and lull in the parade. Once the parade started up again, they returned to their gala activity.

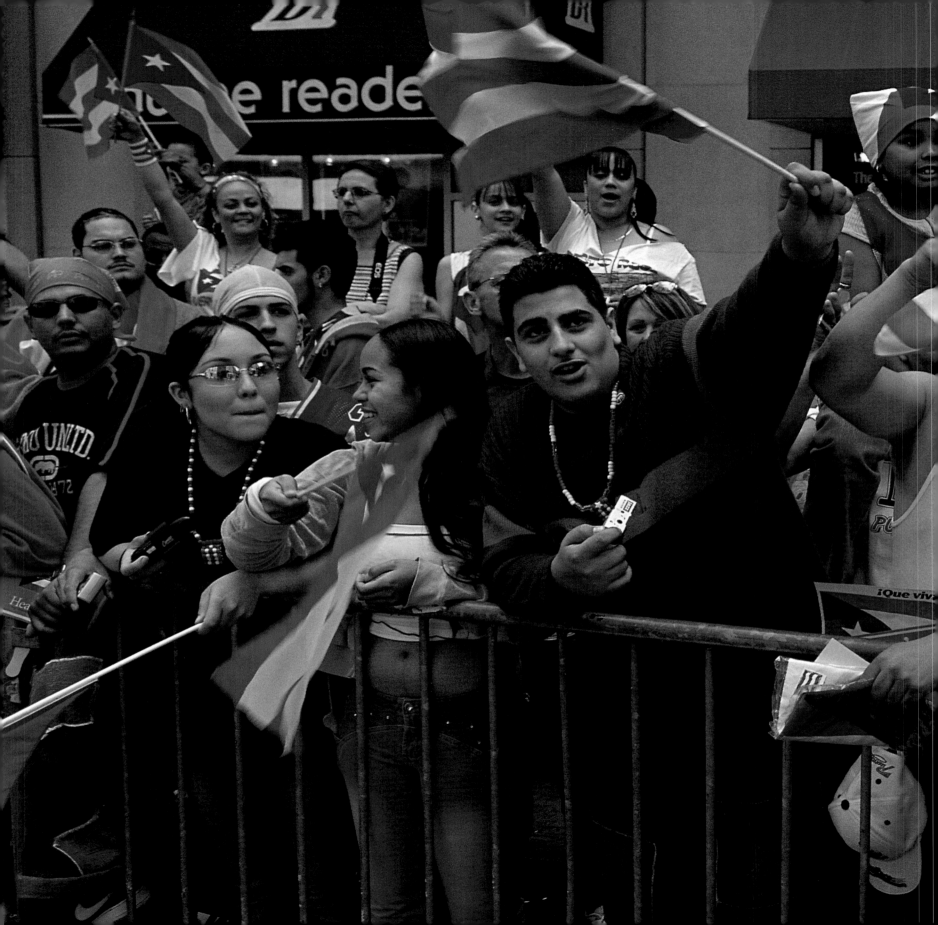

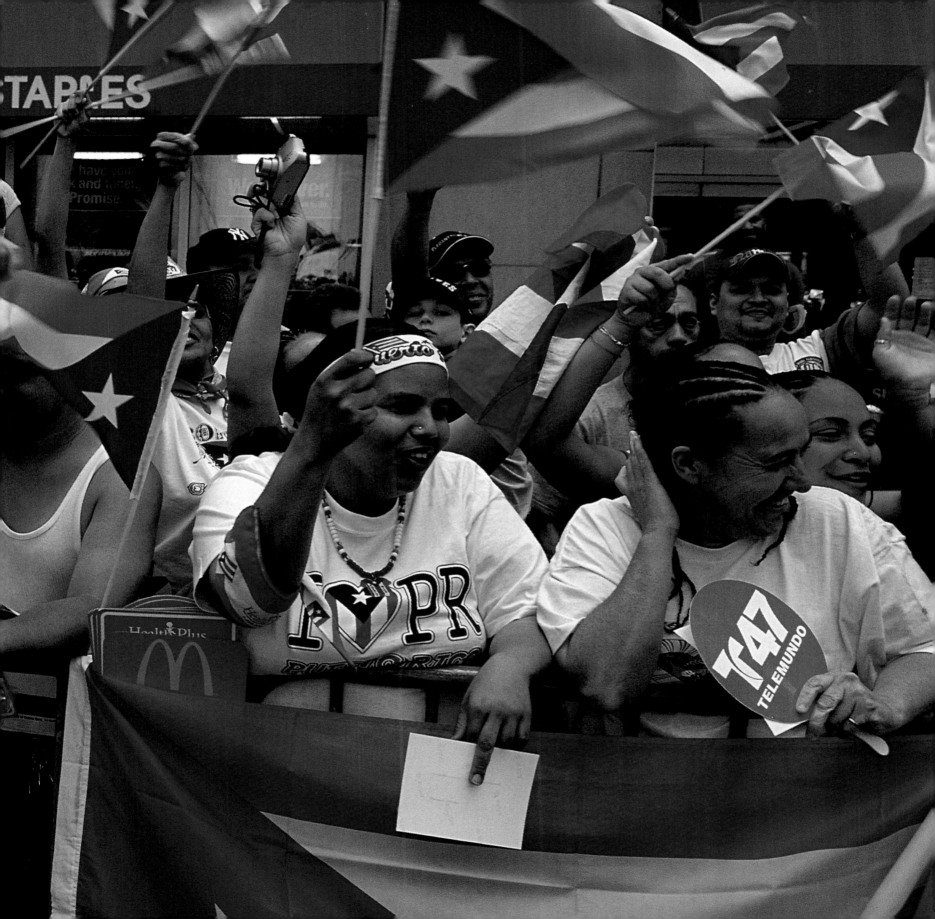

Japanese migration to the United States first began in the mid-1800s, although the numbers of Japanese immigrating to America did not significantly increase until the early 1900s. However, it wasn't until 1952, with the passage of the McCarren-Walter Act permitting Japanese and other Asians to become American citizens, that America would see the largest waves of Japanese immigration commence. Currently, over 75 percent of Americans of Japanese ancestry were born in the United States, with nearly a million Japanese immigrants coming to this country since the mid-1800s. The Japanese have not only infused the American landscape with their poise and strength of character, but have added a unique elegance.

For hundreds of years, Japan had a national policy of isolation. Japanese laws prohibited any non-Japanese from entering Japan, and no Japanese individual was permitted to leave the country for any reason. This forced isolation was mandated by Japan's powerful shoguns who wished to preserve the

integrity of Japan's cultural traditions. This policy continued until 1853, when Commodore Matthew Perry of the United States Navy sailed into Japan's Edo Bay with a mandate to establish trade between the United States and Japan. For first time in two centuries, Japan allowed the use of its ports for international commercial fleets. At the same time, Japan lifted the travel restrictions on its people, no longer prohibiting them from leaving the country, and outsiders were allowed to enter.

Whether they wanted to escape Japan's rigid caste system or take advantage of the economic opportunities possible in the United States, Japanese began to emigrate to America. For immigrants of many cultures, the dream of wealth was a powerful motivator, and this was particularly true for the Japanese. Under Japanese law, all inherited wealth passed from the father to the eldest son and therefore, the other children in the family were left with little or no money to begin their own businesses and provide for their families. So it was to America they went; to work and earn enough money to return to Japan and buy into businesses or, as many did, to stay and create new lives here.

The vast majority of Japanese entering the United States were from farming backgrounds, and it was these immigrants who settled in the agricultural areas of Hawaii and California. Most Japanese immigrants remained on the West Coast. Unfortunately, assimilation into American society was not easy for the Japanese. Not only did they have to meet the challenges typically encountered by newcomers adjusting to a new culture, many had to overcome their own cultural sense of reserve. Moreover,

California's Alien Land Act of 1913 prohibited all Asians from owning land, and there was another provision that prohibited Asians from even leasing land or living on it as tenant farmers. This situation was a tremendous psychological and economic setback to these new immigrants, who soon found themselves forced to work in very low-paying jobs as migrant workers harvesting fields, or taking positions as domestic servants.

By the early 1900s, the Japanese immigrants' problems were compounded when other American workers, who had previously settled in California, became threatened by these newcomers and were often hostile to them. Although the Japanese genuinely wanted to assimilate into the American lifestyle, when confronted by this bigotry, they bonded together to establish their own communities known as "Little Tokyos" and "Japan towns." They also united for support and formed labor groups and fraternal organizations, the most important of these being the Japanese-American Citizens League, founded in 1930.

Another heartache the Japanese-Americans endured was a result of Japan's attack on Pearl Harbor on December 7, 1941. In early 1942, with the United States government worried about a possible Japanese invasion, perhaps 112,000 Japanese-Americans living on the west coast were rounded up and sent to internment camps in isolated parts of the country. Deprived of their freedom, these Japanese-Americans were contained in patrolled, fenced-in camps, made to live in barracks, and were denied permission to leave. They were given no right of due process, and were forced to remain in these

"relocation centers" until the war was almost over. Ironically, some second generation American-born Japanese had previously entered the United States Army and were fighting bravely in the European theater. Many were decorated and received the highest of military honors. In late 1944, the United States Supreme Court ruled that Japanese-Americans of proven loyalty had to be released. All were released after World War II ended.

Ever resilient, Japanese-Americans rebounded after the war. With more determination than ever, they set to work contributing not only their strengths and talents to this country, but demonstrating a sense of American pride that is a showcase for all Americans. Outstanding accomplishments have been made by people such as Daniel K. Inouye, the first Japanese-American elected to the United States Senate, and Spark Matsunaga, the first Japanese-American to be elected to the United States Congress; Seiji Ozawa, the youngest director and conductor of the Boston Symphony Orchestra; George R. Ariyoshi, elected governor of Hawaii; and General Eric K. Shinsheki, four-star United States General and the Commanding General of the United States Army.

Not only have many Japanese-Americans achieved personal merit, they have also attained distinction as a group. Their extraordinary drive for educational excellence has enabled them to succeed in every aspect of American culture, and to live their dreams to the fullest. Many high-level educational programs in America proudly applaud their Japanese faculty and students that are leading the way. And while the Japanese have embraced their American lifestyle, they have done so without sacrificing the significance and beauty of their treasured cultural heritage. In celebrating their traditional ceremonies, rituals, and customs, they impart their sense of serenity and beauty that is appreciated in everything from architecture to landscaping to fashion to cuisine. Their polite and gentle mannerisms reflect their profound respect for honor and the dignity of protocol. They value the family and are devoted to their faith, whether it is Shinto, Zen Buddhism, or Christianity. Their love and loyalty to this country is unquestioned. They have earned the respect and honor of their American family.

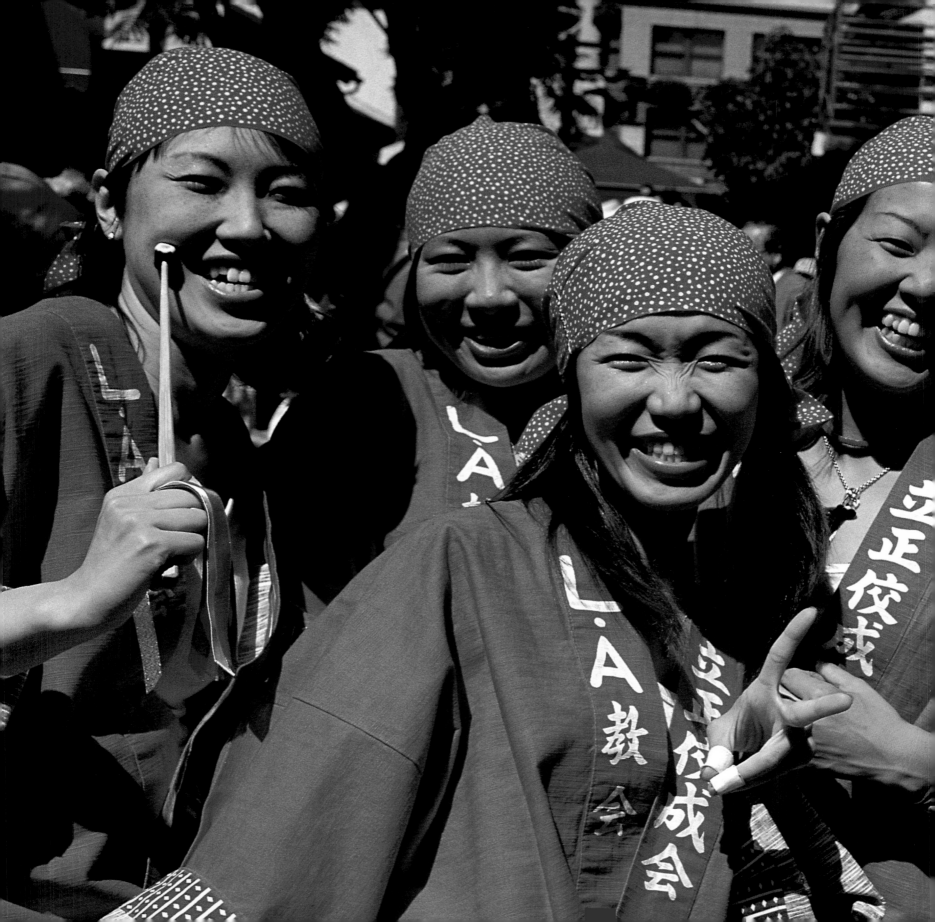

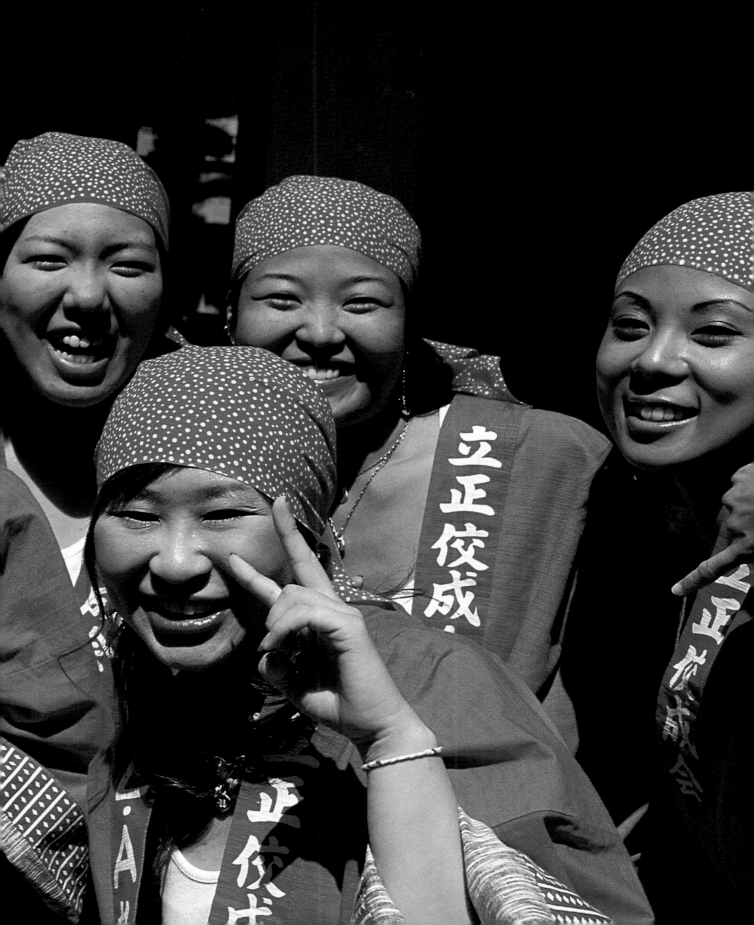

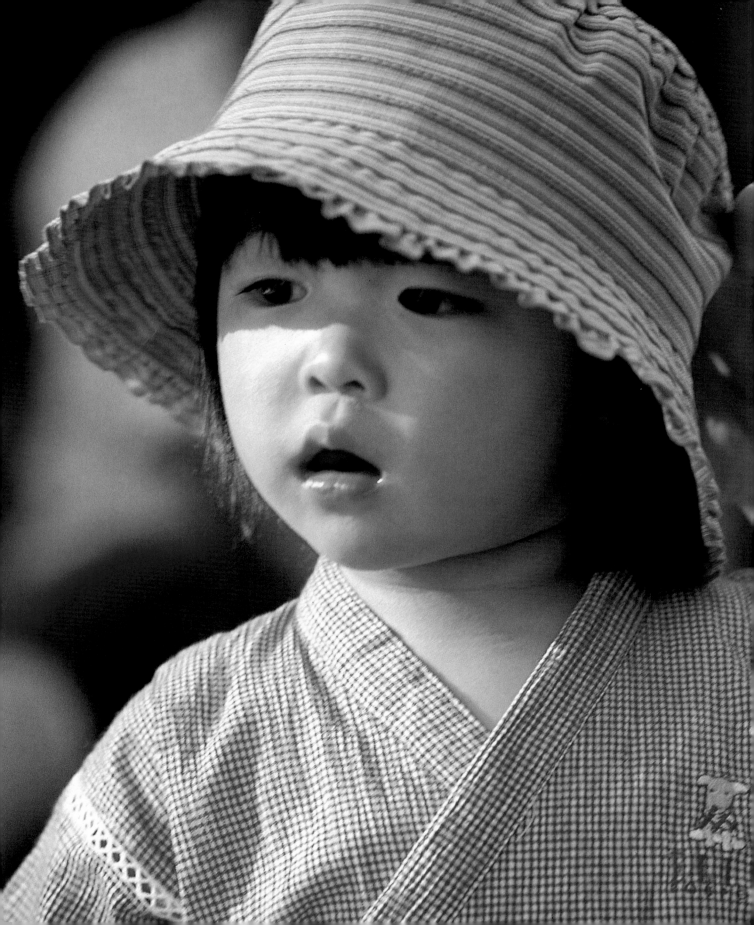

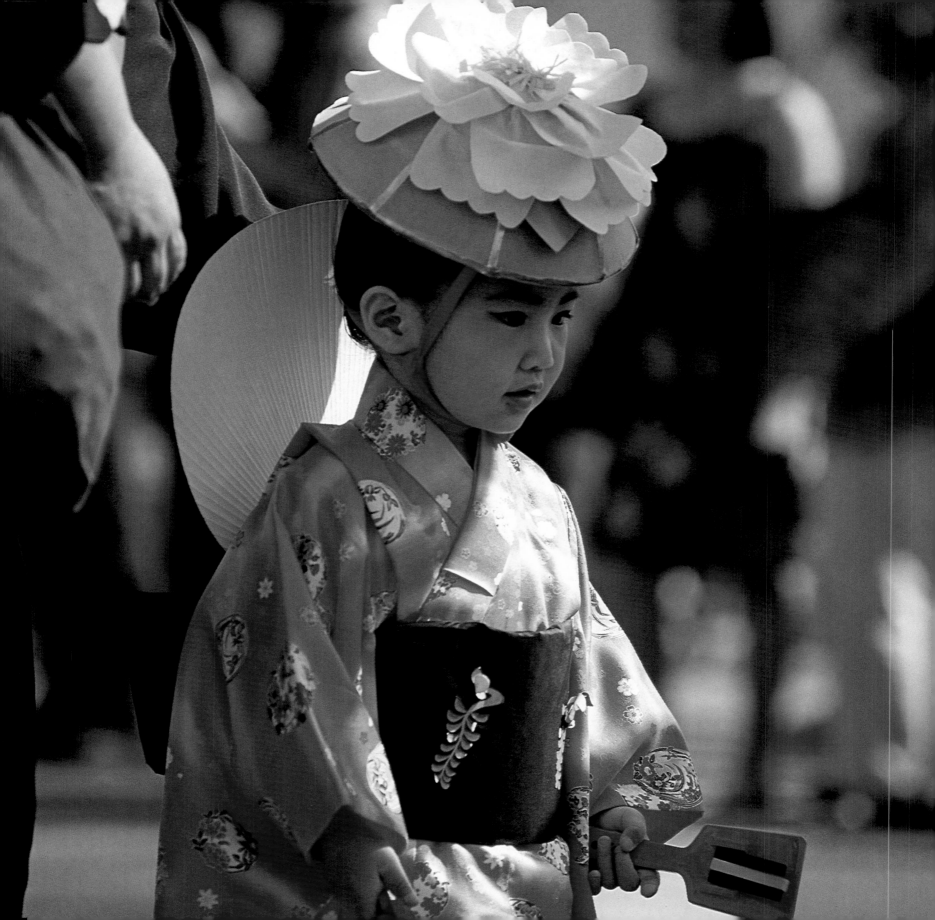

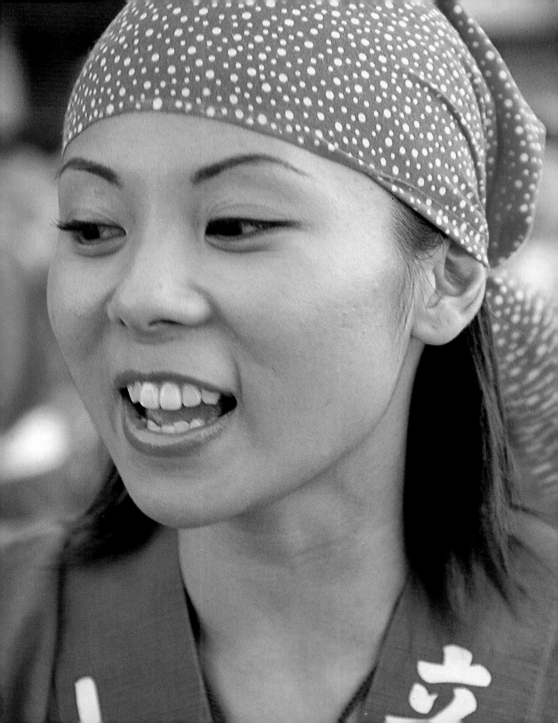

The inhabitants of the Philippines are Southeast Asians with a distinctive Spanish imprint. Filipinos are comprised of more than 65 cultural minorities, each having its own dialect or language. However, over 90% of all Filipinos are Christian, and about 85% of them are Roman Catholic. Thus, Filipinos have a significant European flavor to their culture even though they are a Southeast Asian people.

Colonized by the Spanish in the early 1500s, the Philippine Islands became one of many outposts of the Spanish regime and remained so for over three hundred years. Today, Spain's imprint can still be found in the nomenclature and cultural traditions of the Filipinos. Nevertheless, under Spanish rule, the Filipino people were subjected to many injustices and economic oppression. In 1896, Filipinos, united in their desire for reform, revolted. This created significant problems for the Spanish government.

War erupted between Spain and the United States in April 1898. On May first, Commodore George Dewey's naval squadron destroyed the Spanish fleet

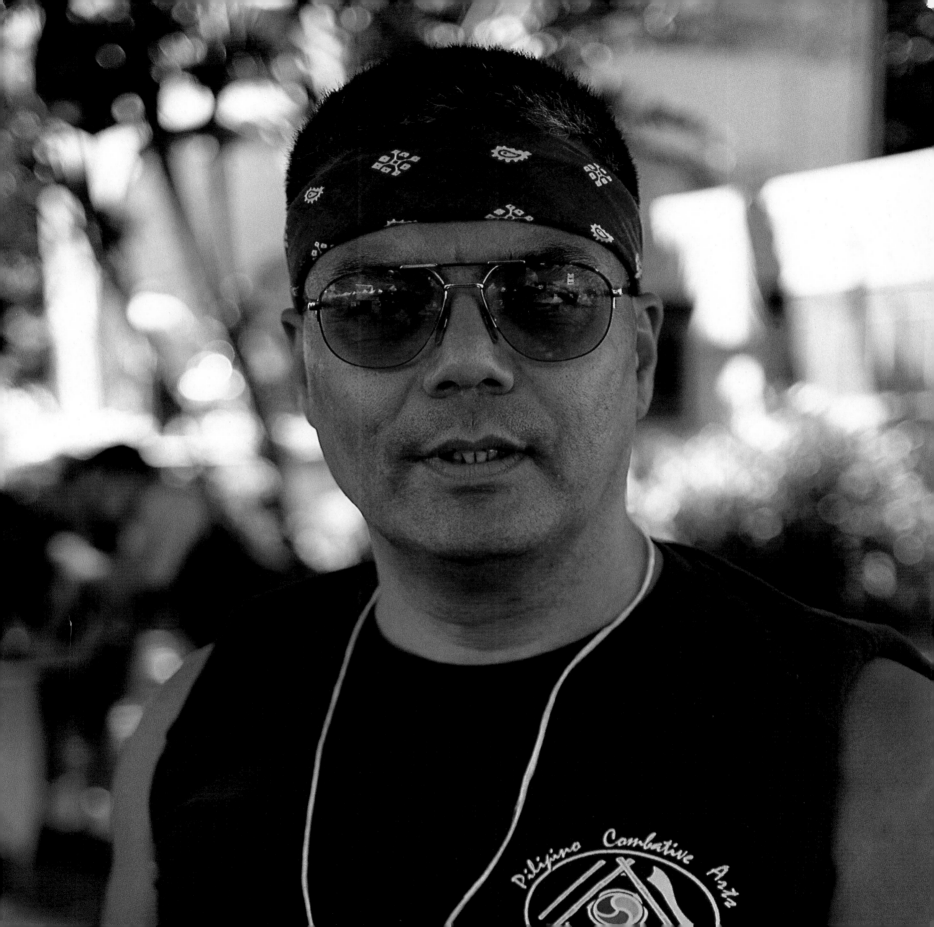

in Manila Bay. Two months later, American ground forces arrived and quickly subdued the Spanish. In 1899, after Spain and the United States signed the Treaty of Paris, the United States paid $20 million to Spain, and the Philippines was ceded to the United States. Shortly thereafter, Filipinos declared their independence and took up the fight against American troops until 190l, with the capture of Philippine leader Emilio Aguinaldo. Ultimately, order was restored and in 1902, the Philippines became a United States Territory, with provisions in place for a transitional period until 1946, at which time the Philippines would become completely independent.

On December 8, 1941, the Japanese invaded the Philippines and occupied it for three years. This set into motion a series of events that resulted in American forces liberating Manila in 1944, and thereafter in 1946 the Philippines celebrating its independence, as promised. Since 1946, the Philippines has gone through ten different regime changes, including an era between 1965 and 1986 when the elected presidential candidate imposed martial law, and declared the country to be ruled under a dictatorship.

All of these historical events influenced the decision of many Filipinos to migrate elsewhere. Some Filipinos, mostly seamen and those in the maritime trade, had emigrated to the United States between 1763 and 1903. From 1903 to 1934, Filipino military families and exchange workers arrived, however, the majority of the Filipino immigrants during that time were students. Significant numbers of Filipinos did not emigrate to

America until after 1965, when major changes were made to American immigration laws. Thereafter, vast numbers of Filipinos immigrated to the United States, seeking economic mobility and a better education for their children. Many of these new immigrants were medical professionals (including nurses) and engineers who would move to the West Coast, with nearly half of all the new Filipino immigrants ending up in California.

These newcomers thrived in America. Filipinos are industrious people whose sense of family, combined with a tradition of working tirelessly, proved them to be an invaluable asset to their communities. Also uniquely distinguishing them is their cultural definition of family; their family structure is enormous. Aside from their immediate family, Filipinos have a "bilateral" extended family that traditionally centers on the mother and her relatives, but also includes cousins and others who are connected to the nuclear family unit. Filipino families are warm and inviting; their large extended families often get together to celebrate holidays and other events. Filipinos feel an enormous kinship to all of those in their extended family and believe that the family interest far surpasses that of the individual.

Besides strong family ties, Filipinos are loyal to their faith. Principally Roman Catholic, Filipinos are also Protestant, Islamic, and Buddhist. They often gather at church activities, picnics, and festivals to chat and to share in honoring cultural traditions. They also enjoy celebrating the arts, with many talented artisans plying their crafts such as carving, sculpting, and painting. Dance and music are exceptional forums for their artistic expres-

sion, often intertwining the influences of their multicultural themes and rhythms with traditional western wind, string, and percussion instruments. Folk songs and dances are especially popular and are traditionally performed at weddings and religious celebrations. Classical dance like ballet is highly prized as are some of their more modern, stylized expressions of movement.

Filipinos have blended within the fabric of American culture, producing extraordinary depth and dimension. Publications like *Philippine News*, the *Filipino Reporter*, and the magazine for Filipino women called *Filipinas,* have helped to broaden their identity and recognition. Filipinos contribute and give perspective to every component of American society; in television and broadcasting, literature, music, fine arts, sports, business, industry, medicine, and politics. Some notable Filipino personalities are CNN World News broadcaster Veronica Pedrosa; NFL quarterback Roman Gabriel; Colorado Rockies outfielder Benny Agbayani; nationally syndicated writer and columnist Michelle Malkin; and two of the highest ranking Filipino-Americans in the United States Army, Major General Edward Soriano and Army Brigadier General Antonio M. Taguba.

Filipinos have proudly taken their place in this country, standing shoulder to shoulder with their neighbors across America. Although unique in their traditional ways, they are 100 percent American in heart and spirit. America is proud to call them family.

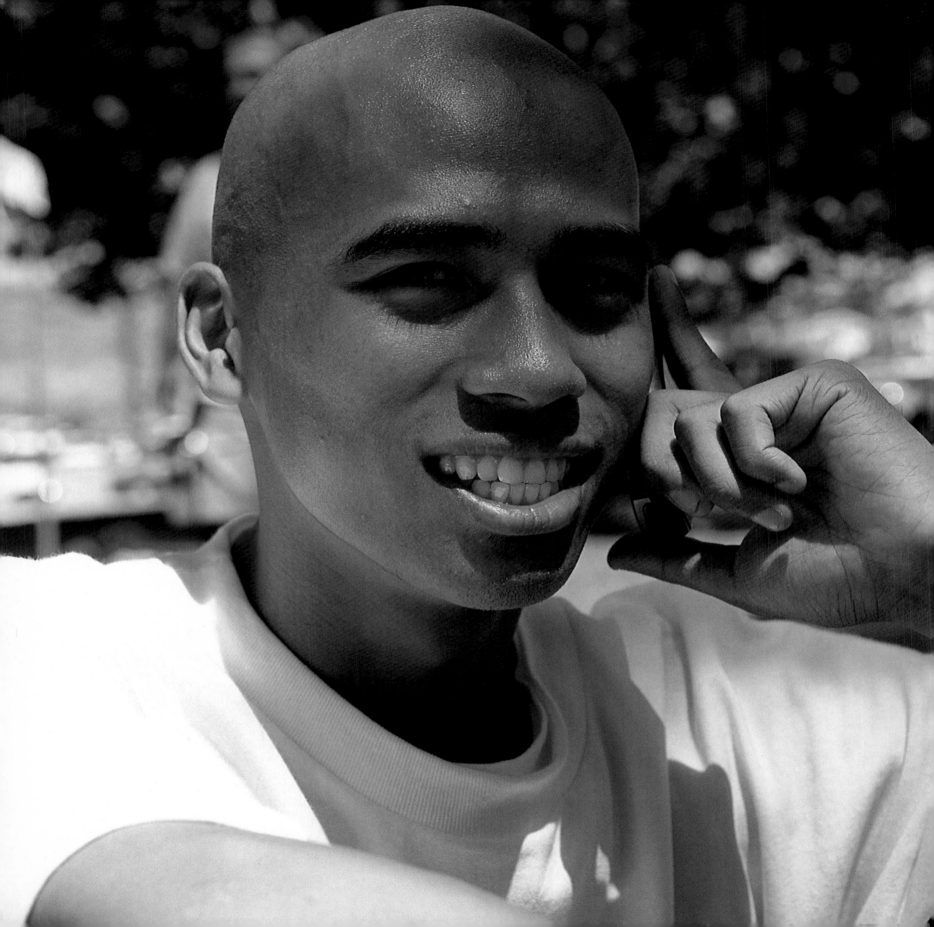

SAN PEDRO, CALIFORNIA, 2003

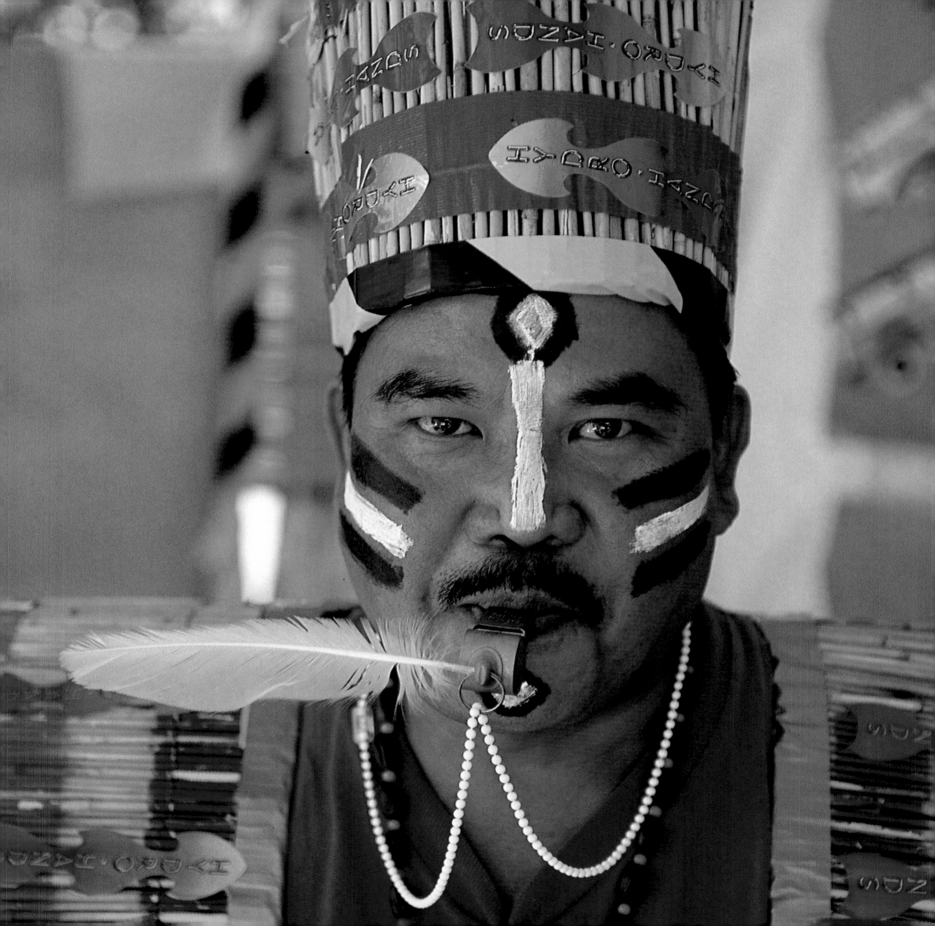

I AM **FILIPINO.** I AM AMERICA
es, I SPEAK PERFECT ENGLISH, B
I DO UNDERSTAND MY NATIVE
ongue. NO, I HAVE NEVER eaten D
MY PARENTS CAME HERE ON A Pla
NOT A BOAT. KNOW TAGALOG

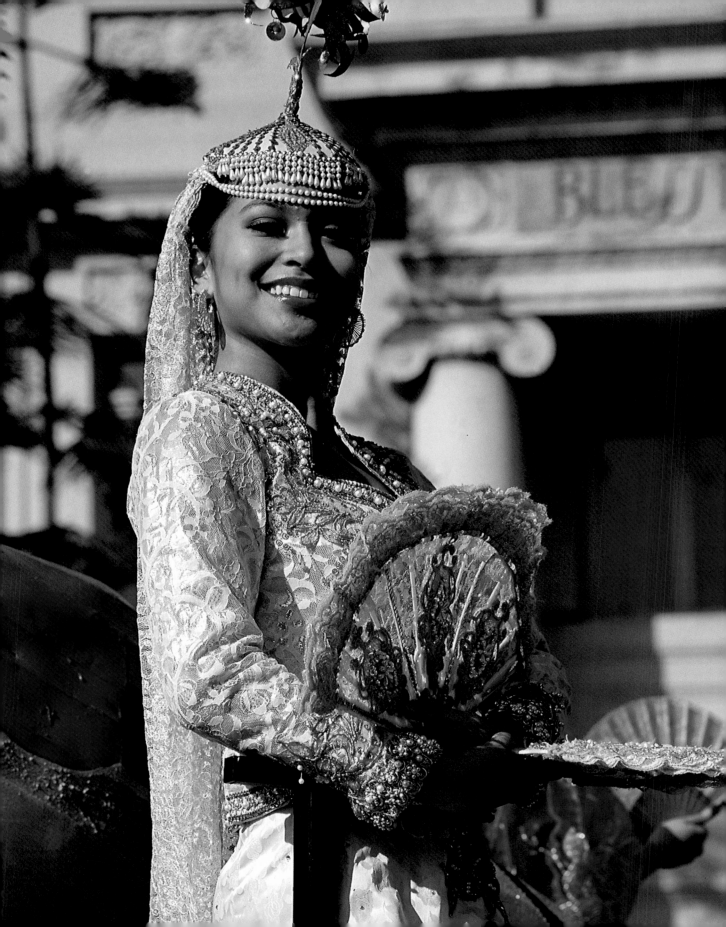

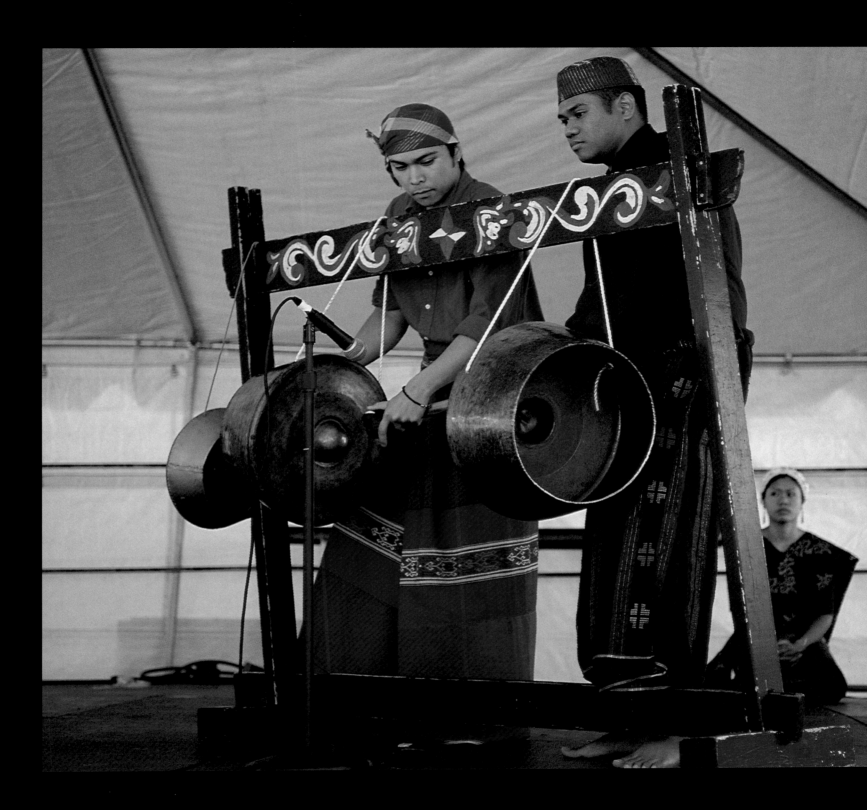

ABOVE: SAN PEDRO, CALIFORNIA, 2003
LEFT: LOS ANGELES, CALIFORNIA, 2003

Chinese immigrants to America were primarily motivated by extreme population pressures within the boundaries of China and by their desires for the opportunity of economic success that they anticipated would come from living in America.

Between 1840 and 1900, over two and one-half million Chinese emigrated from China to the United States. These immigrants consisted largely of free laborers, most of whom used the credit-ticket system to get here. Under this arrangement, their passage was purchased by someone else, usually a family member, with the understanding that the immigrants would pay back the debt out of the earnings they would make in America. While this system helped those who otherwise could not afford to make the trip, many became vulnerable to exploitation. Although the majority of Chinese immigrants settled on the west coast, many thousands moved inland to work as railroad laborers during the construction boom that took place in the western United States after the Civil War.

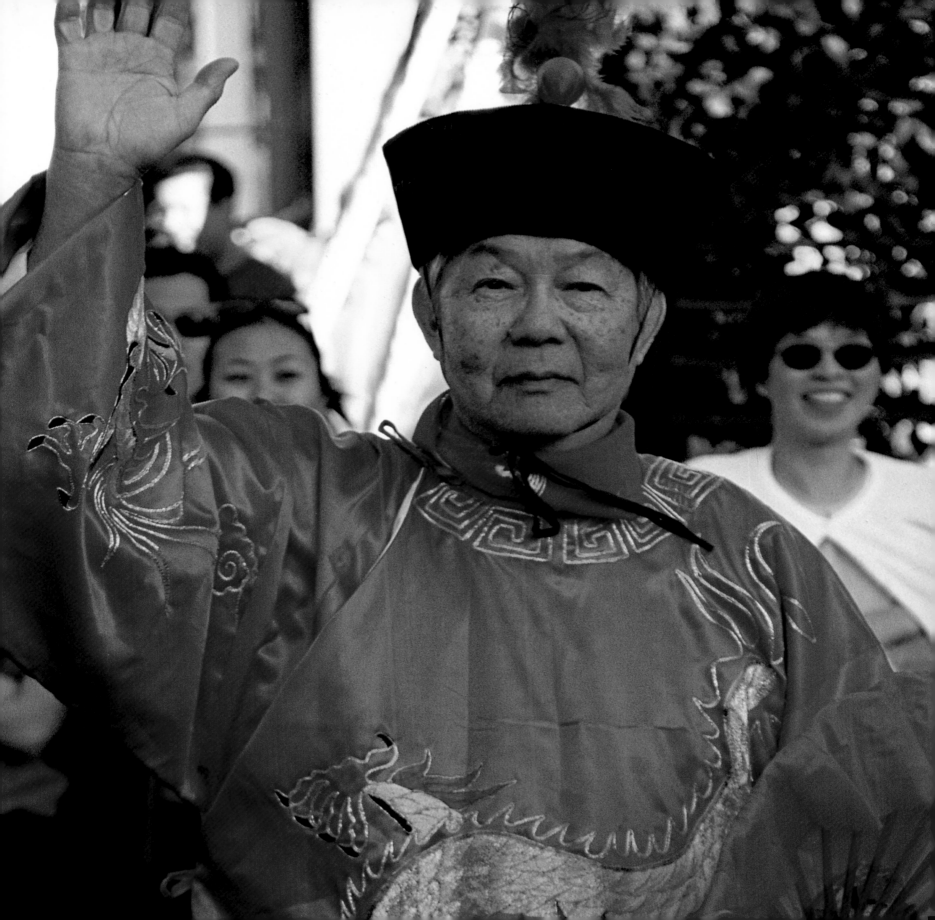

Initially, this mass migration was welcomed and actually encouraged by both the Chinese and American governments. However, by the late 1800s, feelings of American nationalism led to large-scale discrimination against various foreign immigrants, particularly Asians. The vast numbers of Chinese immigrating to this country were willing to work hard at low-paying jobs and were suddenly perceived as invading America's economic province, stealing jobs, and not giving back to the real society that "Americans" had built. Thus, these new Chinese immigrants, although attempting to assimilate into American culture, usually found themselves more isolated.

The isolation and shunning of Asians by other Americans helped to foster beliefs that these immigrants were less intelligent, less ethical, and less able than the average "Caucasian" American. Clearly unjustified, the bulk of this discrimination was due to the insecurities of the discriminators themselves. Americans misunderstood Chinese culture, and suspicions were compounded over religious differences. Most Chinese immigrants believed in Confucianism, which placed man at the center of their religious philosophy rather than the Puritanical view of God the Almighty. Resentment escalated, and by the late 1800s, both federal and state laws were passed implementing rigid restrictions on Asians. So radical were these laws that testimony of Chinese against Caucasians was deemed invalid because of their racial inferiority. Additional legislation further denied Chinese immigrants the right to be citizens for these same reasons. Many private companies refused to hire Chinese immigrants, and Anti-Asian demonstrations broke out throughout the country. Working-class Chinese went on strike in various locations to oppose the suppression of their right to work. For these reasons, Chinese immigration virtually came to a standstill in the late 1800s and remained so throughout the early 1900s.

By 1965, however, this discriminatory trend was reversed with federal legislation and the passage of the amendments to the Immigration and Nationality Act. Encouraged by this effort, Chinese immigration and integration into American society began to normalize. In fact, today, Asian-Pacific Americans are one of the fastest growing groups in the United States; first-generation immigrants far exceed the number of native-born Chinese in this country, and it is speculated that their population will grow to almost eighteen million by the year 2020. While their assimilation is an ongoing journey, Chinese-Americans continue to honor their ancestral customs, and the new generations are working to meld traditional values with their newer American lifestyles.

Not only have Chinese-Americans overcome the earlier struggles, but their rich culture has significantly enhanced our nation, and their ingenuity and hard work has greatly contributed to America's growth and development in all aspects of society—Eastern medical practices and philosophies; Chinese restaurants; fashion design; and Feng Shui, with its influence on interior and industrial architectural design. Some famous Chinese-Americans include news anchor Connie Chung, ice skater Michelle Kwan, actor Bruce Lee, novelist Amy Tan, chef Martin Yan, and Steven Chu, the 1997 Nobel prize winner in physics. America's unique ethnic diversity is so much the richer because of their presence.

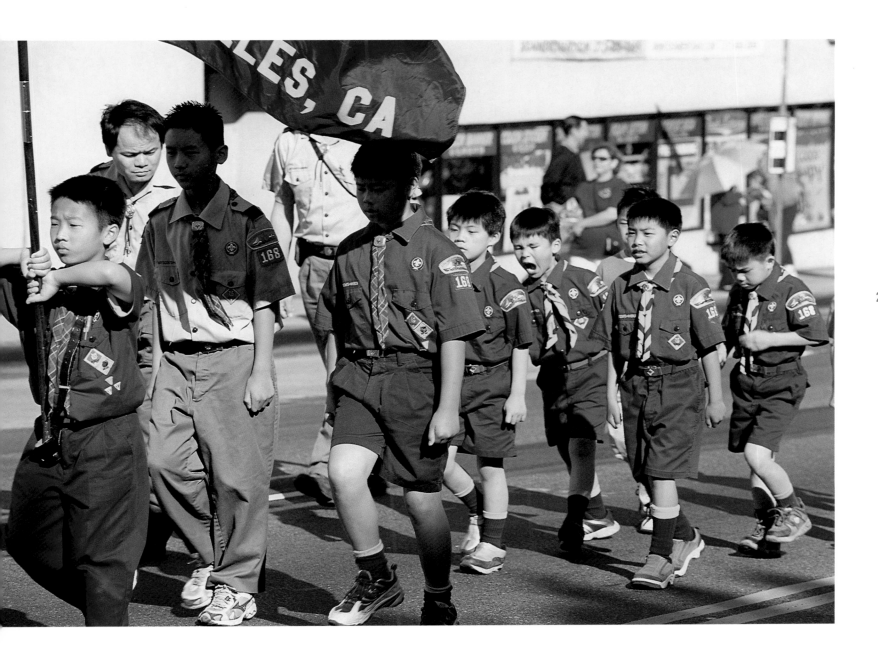

LOS ANGELES, CALIFORNIA, 2003

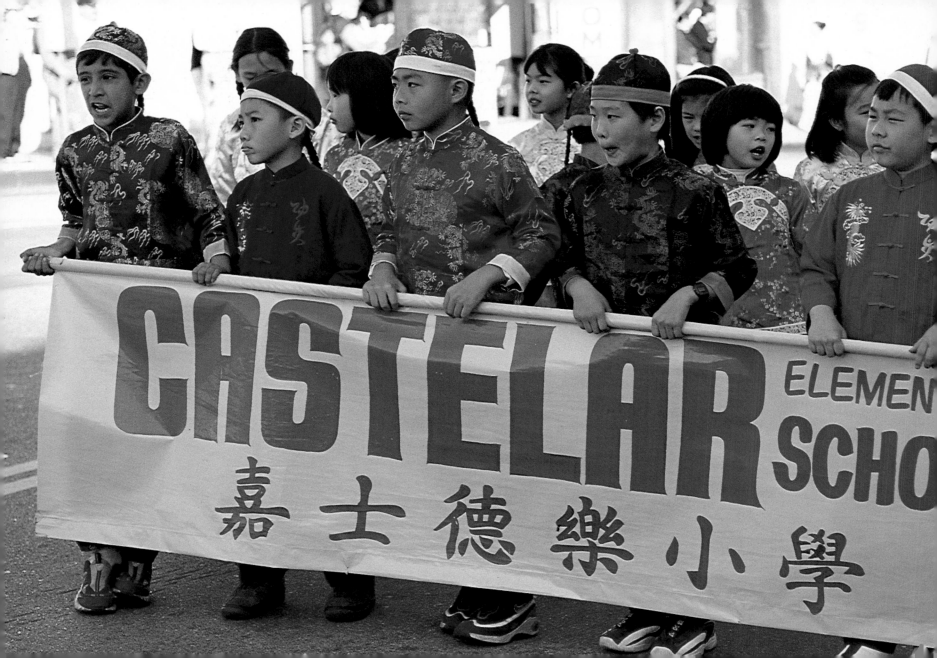

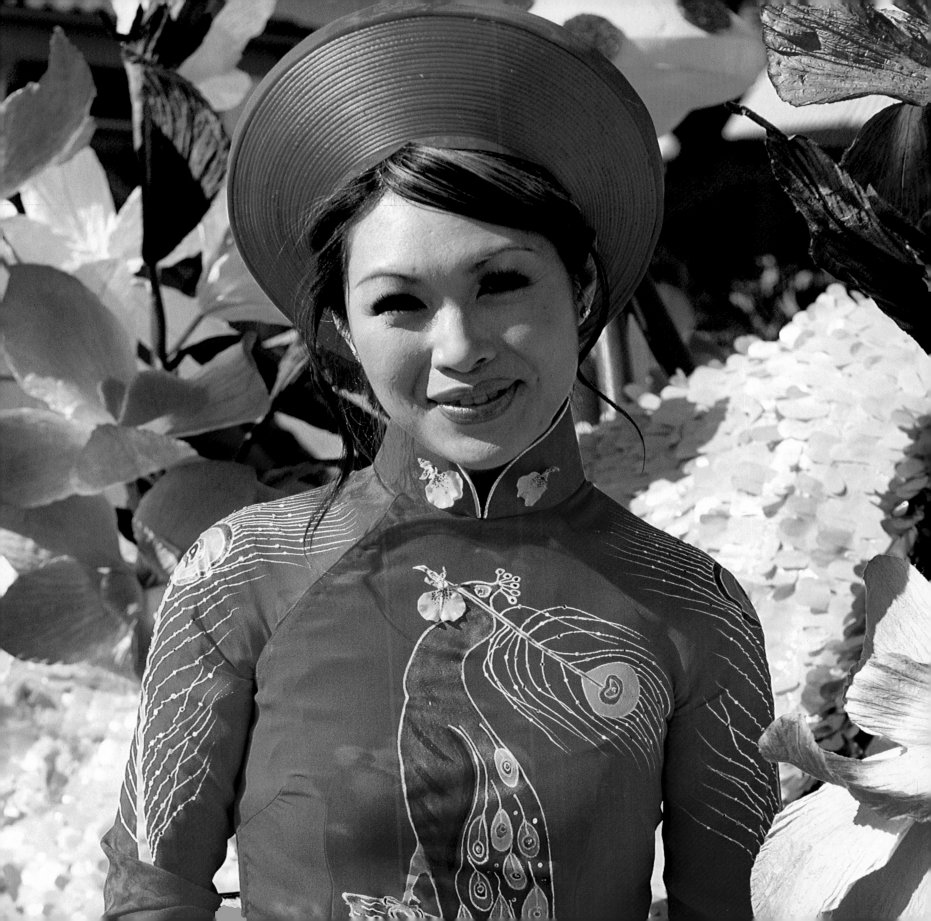

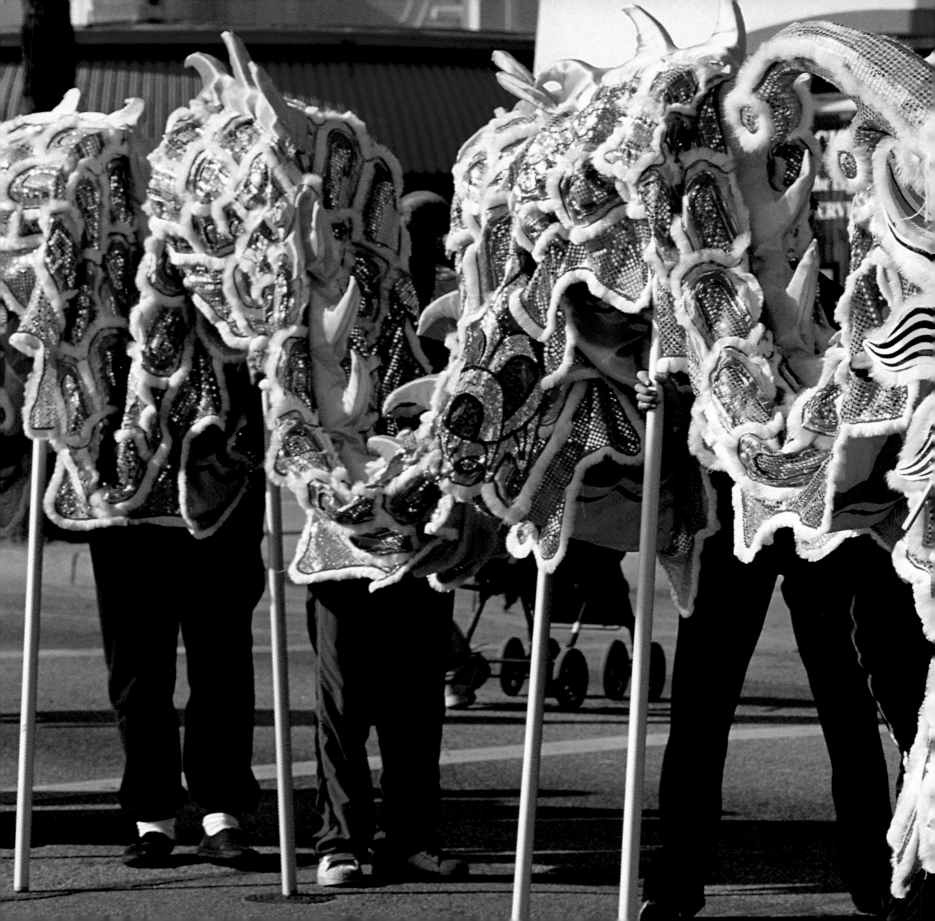

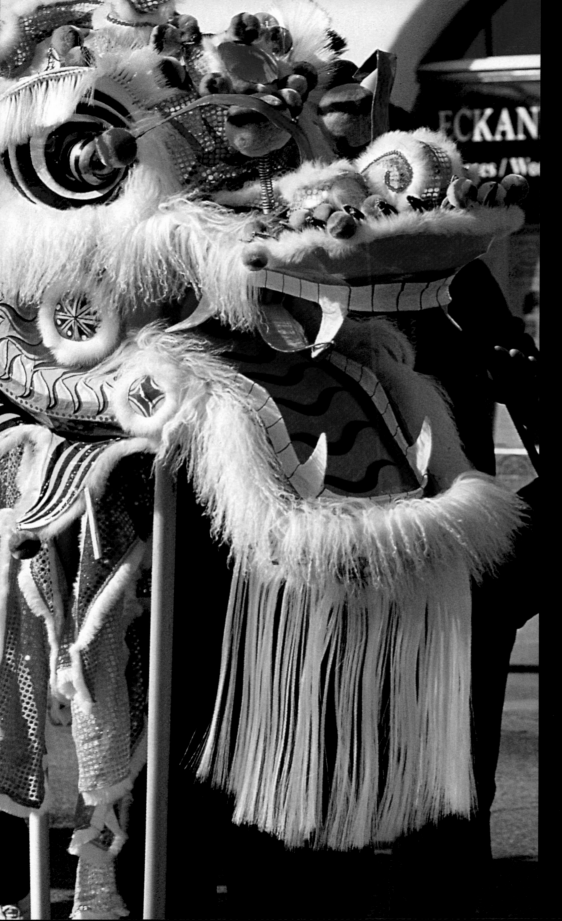

Although I photographed similar dragons in New York, San Francisco, and other American cities, some of the most elegant photographs I was able to capture were in Los Angeles, California, during the Chinese New Year Parade. I have photographed close to 100 Chinese dragons, some of them dramatic and more or less elegant than others. They are always colorful and inspiring to photograph. Some are short with only two people, while others are extremely long with 10-15 individuals trailing behind the head.

America's Arab population is a mix of Semitic peoples of numerous faiths, traditions, and cultures. They are a hardworking people who love their families and enjoy participating in social gatherings and sharing their love of music, dance, and food with others. Although primarily Islamic, many Arabs are members of the Egyptian Coptic Church, Syrian Orthodox Church, and the Catholic Church. Nearly half the Arab population living in the United States is Christian.

Prior to 1880, Arab immigrants to the United States consisted primarily of single Christian men from Syria and Lebanon who came to America to quickly find wealth, with the hope of returning to their native lands to assist their families. They soon discovered, however, that some dreams take longer to realize than others. Their extended absence from their families, coupled with increased taxation on their home front, caused many Arab immigrants to send for their family members to join them in America.

Arab migration to America increased dramatically between 1880 and 1917, one of America's largest immigration periods. The significant boom in Arab immigration during that time was principally due to the burgeoning automobile industry in the Detroit, Michigan, area, where jobs were the main attraction. And during the early 1920s, many Arabs moved to Dearborn, Michigan, to work at the Ford Motor Company's Rouge Plant. Even today, the country's most concentrated Arab-American community is located in Dearborn.

Immigration of Arabs to America slowed between 1917 and 1924, when the United States Congress passed legislation limiting the immigration of non-Europeans, including Arabs. It wasn't until the 1950s when immigration increased, and then again in the 1960s, when new legislation was passed welcoming large numbers of professional and other well-educated Arabs.

Today, America's Arab population is a rich multiplicity of highly motivated workers and professionals that include doctors, lawyers, and respected political figures. A testament to Arabs' successful matriculation into American society is that Spencer Abraham, the grandson of a Lebanese immigrant, became a United States senator. Other Arab-Americans of note include actors Danny Thomas and Jamie Farr (of MASH fame). Surgeon Michael DeBakey invented the heart pump. J. M. Haggar emigrated from Lebanon and founded a clothing company in 1926. Kahlil Gibran is perhaps one of the modern century's best-known author-poets. Other famous Arab-Americans include singers Paula Abdul,

Frank Zappa, and Paul Anka, Donna Shalala (former Health and Human Services secretary), astronaut Christy McAuliffe, 1984 Heisman trophy winner Doug Flutie, consumer advocate Ralph Nader, and radio personality Casey Casem.

The attack on America that took place on September 11, 2001, was a tragedy experienced by all Americans and particularly by the Arab-American community. They recoiled at the idea that America had been attacked by a radical Muslim-Arab group. And they were saddened to think that because of their ethnicity, they too had come under suspicion for the misdeeds of those few radical individuals who had created such horror. But because of their strong sense of community and love for this land, they were strengthened not only in their commitment to stand with dignity as Americans through the suspicion-laden days following the attack, but also in their resolve to illustrate that this is their country too, and though ethnically diverse, it is made up of one people, including Arab-Americans of both Christian and Islamic heritage.

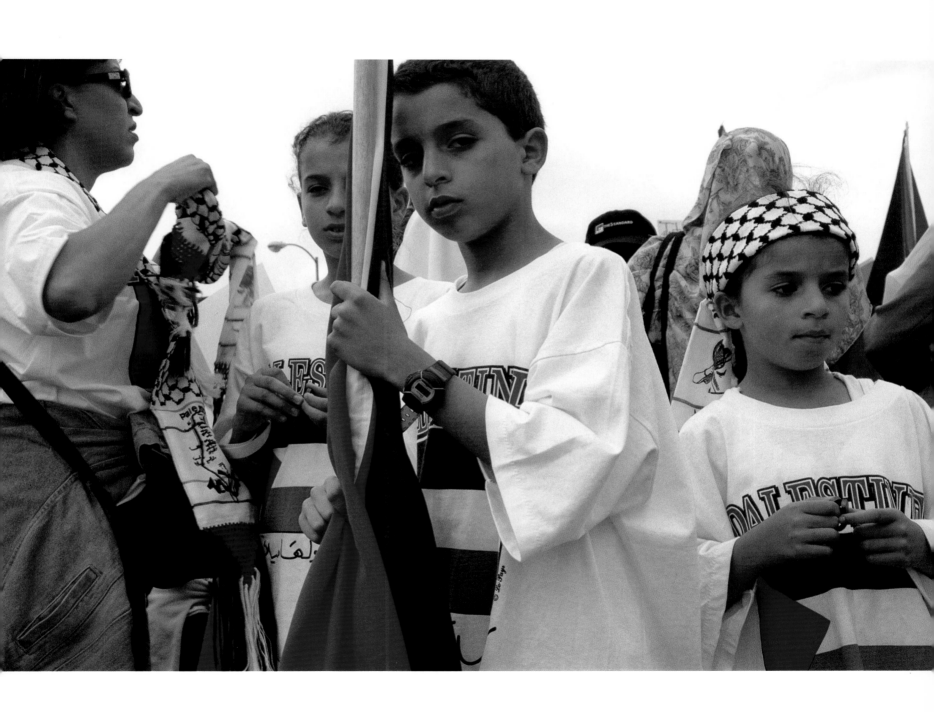

LEFT, DEARBORN, MICHIGAN, 2003
ABOVE, LOS ANGELES, CALIFORNIA, 2002

If we had to single out one defining attribute of Armenian immigrants, it would be perseverance. This is not to say that other ethnic groups coming to America did not endure hardships; it is just that the Armenians suffered near annihilation to get here. As one of the oldest continuous cultures on the planet, Armenia has experienced relentless persecutions. For thousands of years, their country has been marched through, trampled over, and attacked from every possible direction by neighboring tribes and peoples. There has not been an independent Armenia since medieval times, and though they were promised a new nation after World War I, Armenians were deprived of such a homeland. Even though the Soviet Union created an Armenian state within its borders, Armenians were not truly free to worship as they pleased until the collapse of the Soviet empire in the 1990s.

In spite of ongoing threats to their existence, the Armenians survived and prospered, holding fast to their values of family and hard work. Early on, they focused their energies on developing agriculture in their country's fertile valleys

and successfully establishing trade with those who passed through the region. But goods were not all that was traded; so, too, were ideas. First visited by St. Judas Thaddeus and then St. Bartholomew in the middle of the first century A.D., Armenians were eventually converted to Christianity in 301 A.D. by the evangelist Gregory. Armenia was proud to have been the first nation to adopt Christianity as a religion. Later, though some remained Catholic, the Armenian Church (a version of the Orthodox Church) became the nationally recognized state religion and Armenians embraced it with filial piety, sacrifice, and love. Unfortunately, their conversion and allegiance to this new religion staged yet another challenge for them when the Ottoman Empire overran the area and Armenia came under Ottoman Turkish rule. Although they had weathered rule by the Persians, Byzantines, and Arabs, these Armenian Christians were now under the total control of Muslim Turks.

Over the ensuing centuries, Armenians suffered terribly under the non-benevolent Ottoman Empire that turned a blind eye to the oppressive control of Armenian settlements by Muslim Kurdish tribesmen who were deliberately encouraged to settle in Armenia and dilute the Christian population. Prohibited by the Turks from possessing firearms, Armenians could not retaliate against the Kurds and had to endure repression, oppressive taxation, and surcharges forced upon them, keeping them at an extraordinarily low economic level. For hundreds of years Armenia continued to be a totally controlled outpost of the Turkish regime.

When they were no longer willing to tolerate the oppression, Armenians began to flee their country, their exodus accelerated by the advent of the Turkish pogroms. These orchestrated massacres of helpless Armenians sent waves of refugees traveling to various locations to avoid beatings, arrests, imprisonment, and death. They fled into Russia and throughout the Middle East in a desperate attempt to avoid the brutality of the deteriorating Ottoman Empire. From 1890 to 1914, migration was in full swing as young Armenians fled the country, leaving behind a sparse, older agricultural population. Although many emigrated to other countries in the Middle East, thousands of Armenians came to America. The trip was expensive and only a wealthy few could afford the journey. In many cases, Armenians who had already arrived on American shores helped to pay the fares for the new immigrants.

For those left behind, hope rallied during the years immediately preceding World War I, when the harshness of Turkish control seemed to lessen. However, their dreams turned to nightmares when in 1915 the genocide of Armenians began. During World War I, the Russians invaded the Ottoman Empire and occupied part of Armenia but were beaten back. The Turks, believing that the Armenians had aided the invaders, began a massive genocide that resulted in the deaths of over 1.5 million Armenians. This murderous campaign had an enormous impact on the Armenian community in Armenia as well as in America. Huge numbers of Armenians fled the ongoing slaughter, moving to countries throughout the Middle East as well as to America.

Thousands of Armenians arrived in New York harbor, were processed through Ellis Island, and found

sanctuary on American shores. Many stayed in New York, while others settled in Worcester, Boston, and other Massachusetts locations; New Jersey; and eastern Pennsylvania. The vast majority of the Armenians were too poor to open a business or purchase land. Unskilled yet undaunted, they entered factories and foundries in the northeastern portion of the United States, taking whatever jobs they could get. Relying on the lessons they had learned from their parents and life in Armenia, they knew that through hard work and sacrifice they would be lifted to greater heights.

Although Armenians originally settled in New York and along the northeastern seaboard, they also felt truly at home in the rich and fertile agricultural regions of California. It was there that the extraordinary growth of the Armenian-American community took hold. Settling in the beautiful San Joaquin Valley of California, specifically Fresno, they found the place they had been searching for after leaving the Armenian plains of Asia. And though their success in agriculture is one of their hallmark achievements, it is not their only outstanding contribution to America. Extraordinary leadership emerged as a product of the growth and development of the Armenian-American community.

Armenian-Americans have taken center stage in the arts and political arenas; the Pulitzer Prize-winning author William Saroyan, considered perhaps the most famous Armenian-American of his generation, grew up in Fresno, California. George Deukmejian, two-time governor of the State of California, served with distinction in the most populous state in the country. Today, Armenian-Americans are professors, doctors, dentists, lawyers, and political figures, while others excel in the arts. Each owes their success to the indomitable spirit and perseverance developed and refined by early Armenians.

Their strict sense of family values, religious conviction, and hard work continually drives Armenian-Americans to achieve the American dream. Ever mindful of the magnitude of their loss, their respect and appreciation for freedom serves to strengthen their commitment to be outstanding contributors to American society. And though some of the second and third-generation Armenian-Americans have experienced some conflict between their ancestral old-line values and their newer American ways, they have genuinely adapted their historical culture to the American lifestyle.

LOS ANGELES, CALIFORNIA, 2003

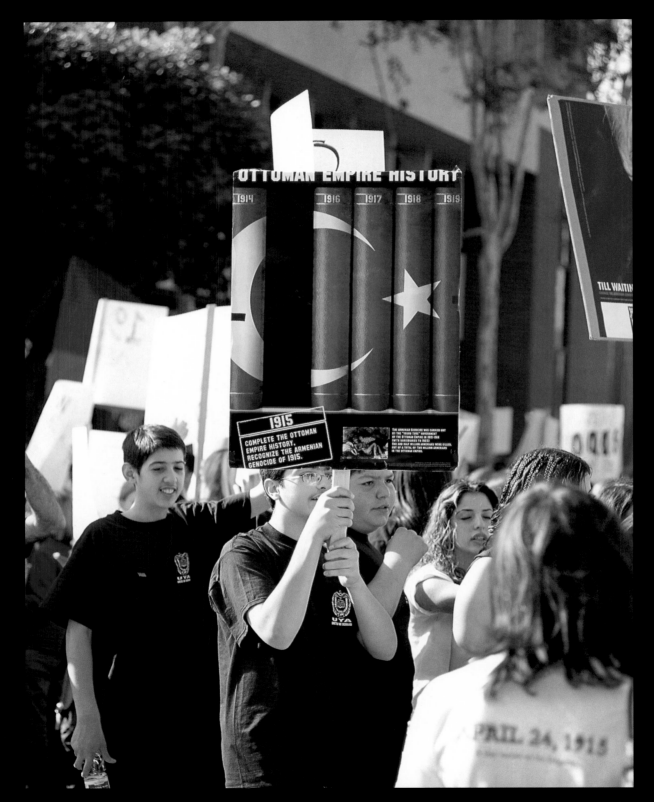

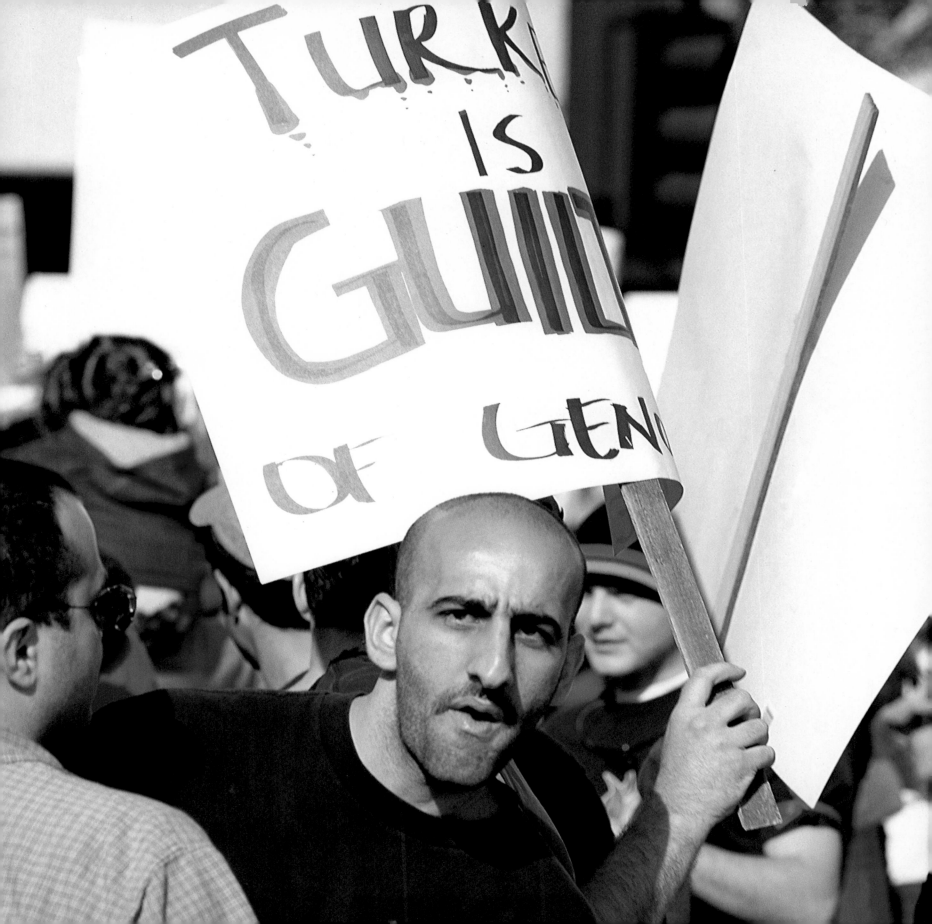

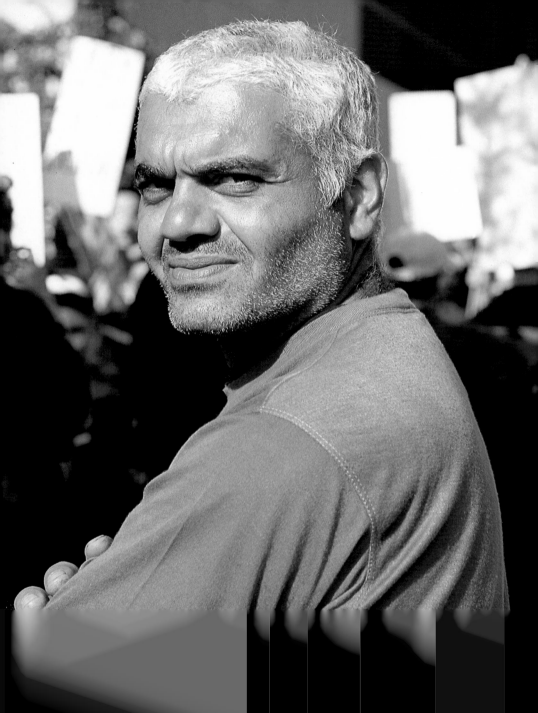

The War Years

1915 To 1965

KOREANS

SOUTH ASIANS

The War Years

The great migration of the late 1800s brought enormous diversity to American shores. However, not all those who entered were welcomed by the existing populace. Some Americans called for the restriction of all new immigrants, claiming that these new inhabitants would be the downfall of American society. Asians were often targets of discrimination. Immigration acts were passed restricting Asians from owning land, marrying non-Asians, and holding public office. Some Europeans were also regarded as too poor, uneducated, and barbaric to actually become part of our society. Thus, the United States immigration laws passed between 1915 and 1965 dramatically restricted our borders. During that period of time only Koreans and South Asians appeared as new immigrants, and then only in response to dramatic events in their homelands. It was a bleak period of time for immigration and acceptance of diversity on American soil.

One of the most notable characteristics of Koreans in America is their incredible sense of ethnic identity, demonstrated particularly by their active participation in the Korean community. In Korean society, traditional language and writing are honored, ancestral customs are shared, religious attitudes and beliefs are observed, and family values and behavioral norms are practiced. Gentle and well mannered, Koreans value harmony between themselves and others; they are extremely cooperative, and are rarely confrontational. Exceptionally disciplined, Koreans are driven by honor and achievement.

A key to understanding Koreans' strong sense of identity is found in their ancestral history. Geographically, the Korean peninsula is situated along the southern border of China, and is separated from Japan by the Sea of Japan. Thousands of years ago, nomadic clans established agricultural settlements in Manchuria (in Northern China) and on the Korean peninsula. These villages later evolved into walled towns and tribal states. These communities set the

mold for future social evolution on the Korean peninsula. Eventually, the people who lived on the Korean peninsula established their own kingdom, separate and apart from Manchurian China. As legend tells us, the first kingdom in Korea, then called *Choson*, meaning "Land of the Morning Calm," was established in 2333 B.C. by the rulers of the Koryo Dynasty, whose people had inhabited the land for thousands of years and helped to develop the cultural traits that became distinctive of the region.

The Korean peninsula was subject not only to political pressure from China, but was also vulnerable to attack by sea from other ambitious conquerors who wanted to make Korea their own. On the upside, Korea's geographic position served as a cultural bridge between the Asian mainland and Japan; its rugged and beautiful country proving fertile ground for nurturing a most remarkable and unique culture. While approximately 90 percent of Korean vocabulary can be attributed to Chinese roots, Korean spoken language is distinct, its development having been influenced by the Mongolians, Hungarians, and Japanese as well as by other Ural-Altaic languages throughout the centuries.

In more recent times, after victories over China (1894-5) and Russia (1904-5), the Japanese occupied the Korean peninsula, ruthlessly imposing their rule and attempting to strip the Korean people of their cultural heritage and national identity. Following the Japanese defeat in World War II, the peninsula was divided in half, with a communist government in the north, and a democratic one in the south. The communist north invaded the south in 1950, resulting in the Korean War (1950-53). The fragile peace that followed was achieved by keeping the peninsula divided into two countries at the 38th Parallel, with Soviet forces controlling North Korea, and the American and Allied forces controlling South Korea. To this day, South Korea is a democracy, while North Korea remains one of the last outposts of communism.

The migration of Koreans to the United States generally occurred in three distinct phases. The first phase was the migration of Korean males to Hawaii in 1903-5 to fill the need for inexpensive labor to operate the sugar plantations. Their "picture brides" would make the trip to join them between 1910 and 1924. The second phase of migration was the post-Korean War immigration that was dominated by the adoption of Korean orphans and the emigration of the Korean wives of American servicemen. The third phase, with largest number of Korean immigrants coming to the United States, occurred after the United States Congress passed the Immigration Act of 1965. Prior to 1965, the total number of Korean immigrants permitted into the United States was under 23,000. The 1965 legislation was the impetus for Koreans to emigrate to the United States to escape the political turmoil and division of their country that had separated families and created extreme economic hardships.

Most of the immigrants who arrived in the third wave were middle-class urbanites, capable of starting a business in the United States or having a transferable profession. As a result, many moved to large cities

such as Los Angeles, San Francisco, New York, Boston, and Miami. However, California has been the overwhelming destination of choice, with Los Angeles as home to one of the largest populations of Korean immigrants in the United States. By 1990, Koreans represented over 10 percent of the Asian population residing in the United States. And although the Korean population is only half the size of the Chinese population living here, their numbers are sufficient to rank them third on the list of Asians migrating to this country. Korean-Americans who have achieved national prominence include actor John Cho (*American Pie*, *Harold and Kumar Go to White Castle*), Dow Kim (executive vice president of Merrill Lynch), comic book artist Jim Lee, Soon-Yi Previn (Woody Allen's wife), Washington state senator Paull Shin, and golfer Michelle Wie.

While many Koreans living in America honor their cultural traditions, others are striving to assimilate and adapt to life in the United States. The older Korean men and women clearly appear more comfortable living their traditional Korean lifestyles apart from mainstream America or at least with as little interaction as possible. It is the younger men and women who have become more Americanized and engage in activities outside their traditional Korean communities. The young Korean children are adapting quite quickly, and they benefit from the teachings of their traditional behavioral ethics including showing respect for their elders, whether they are parents or grandparents or other seniors. The Korean discipline of respect and their emphasis on harmony not only helps to maintain their focus on the family unit, but reinforces their strong sense of ethnic identity. Their dedication to hard work, education, and their faith, whether it is Buddhism, Confucianism, Catholicism, or Protestantism, is unwavering.

Proud of their ancestral heritage, Koreans pay honor to their ancestors, elders, and religious figures, and celebrate their rich culture with the preparation of traditional foods like *kimchi* and *pulgolgi*, as well as other savory Korean delicacies made from fish, shellfish and seaweed. Korean barbeque restaurants have also started to become popular in urban areas. Koreans add a unique flavor to the American scene and their quiet strength is a boon to our American culture.

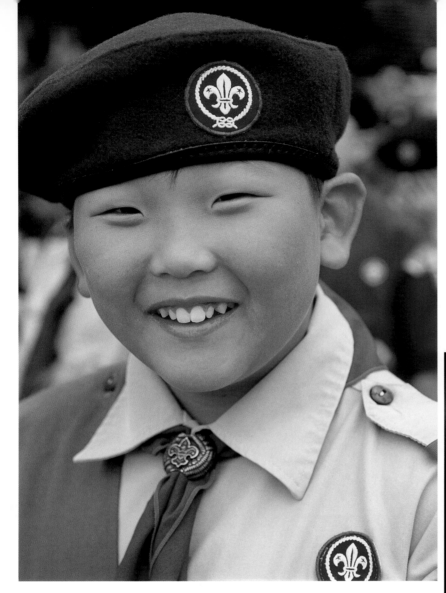

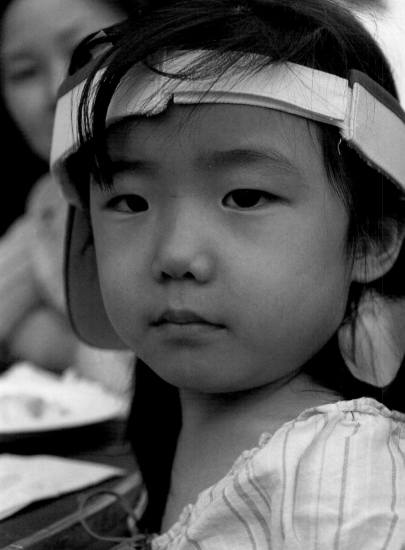

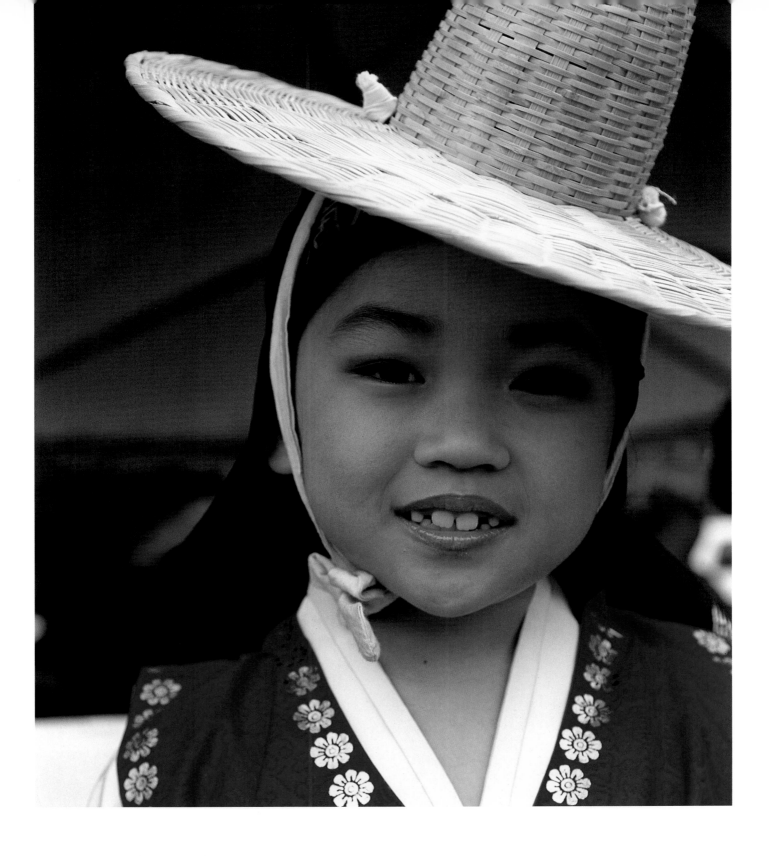

PASADENA, CALIFORNIA, 2004

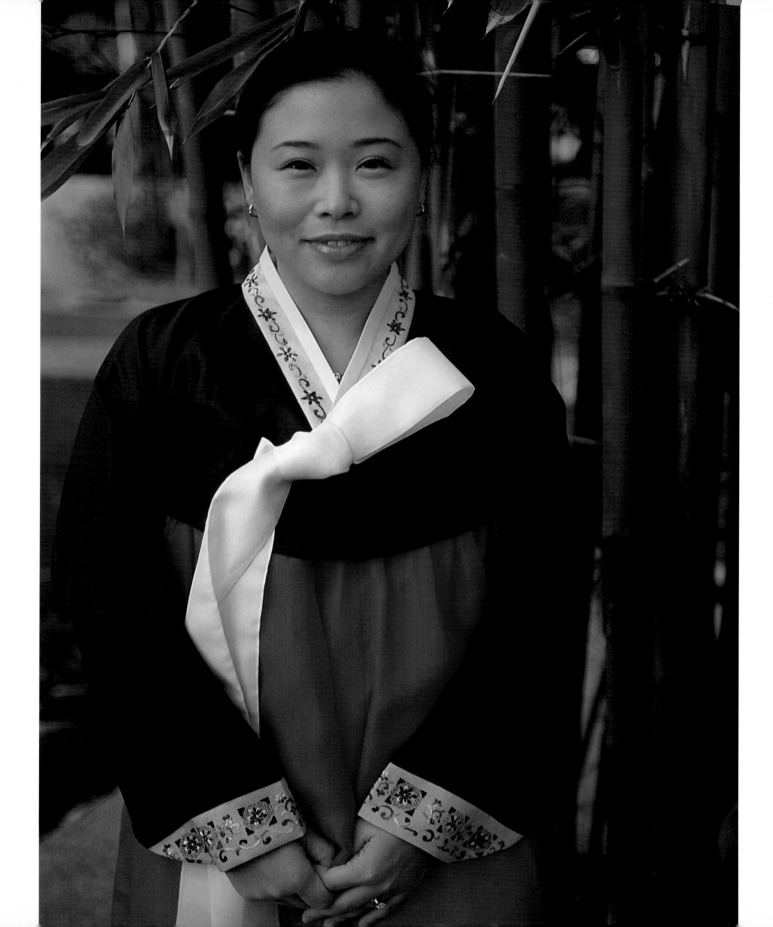

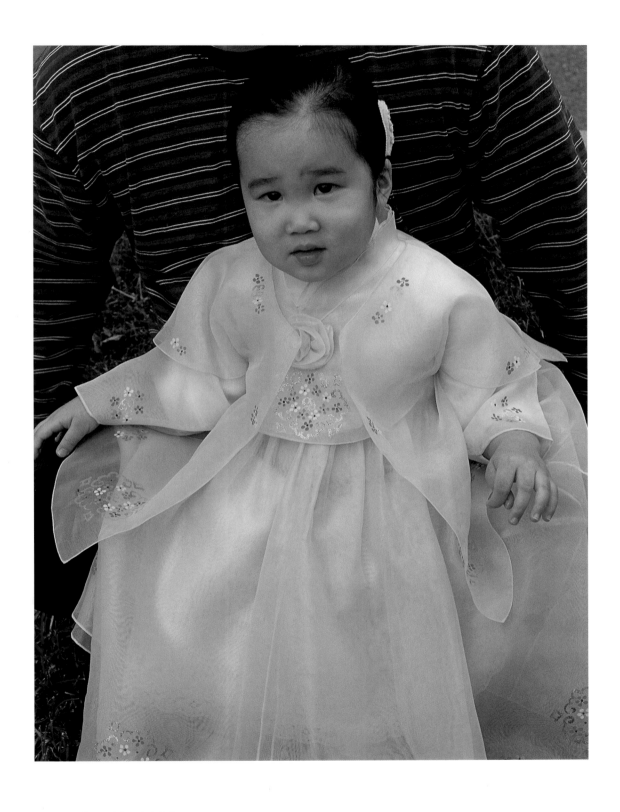

LOS ANGELES, CALIFORNIA, 2004

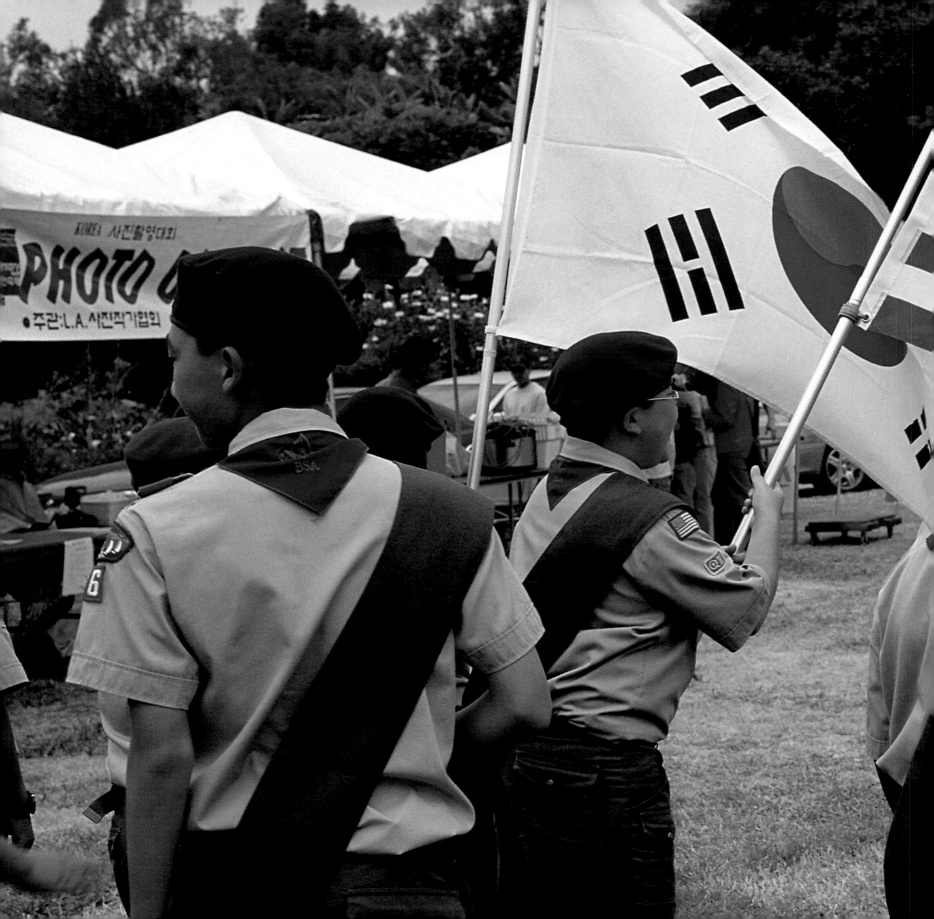

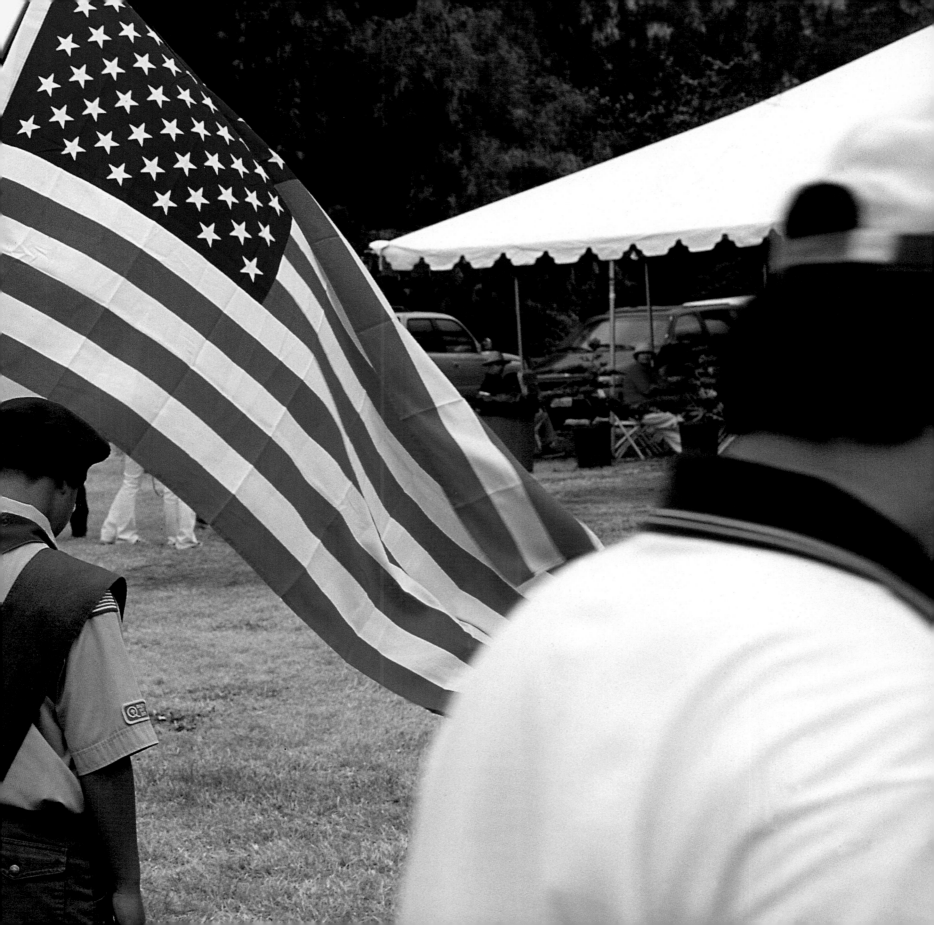

The South Asian population represents a composite of many fascinating cultures; Asian Indians, Pakistanis, Bangladeshis, Sri Lankans, Nepalese, and Bhutanese. Asian Indians make up the greatest number within this group. Although it is not known precisely when the first Asian Indians actually arrived in the United States, immigration records indicate a period shortly after 1907 when they began emigrating from the plains of Punjab, most likely as a result of the horrific famine in India that lasted from 1899 to 1902. So grave were the economic conditions at that time in India that many men were compelled to mortgage their land and belongings and, leaving their wives behind, move to America to find work. Between 1907 and 1920, America welcomed these newcomers, virtually all men, who relocated primarily to the western part of the United States, specifically California, to work in agriculture.

Originally, most Asian Indians thought their stay in America would be only temporary and, after earning enough money, they would return home to their

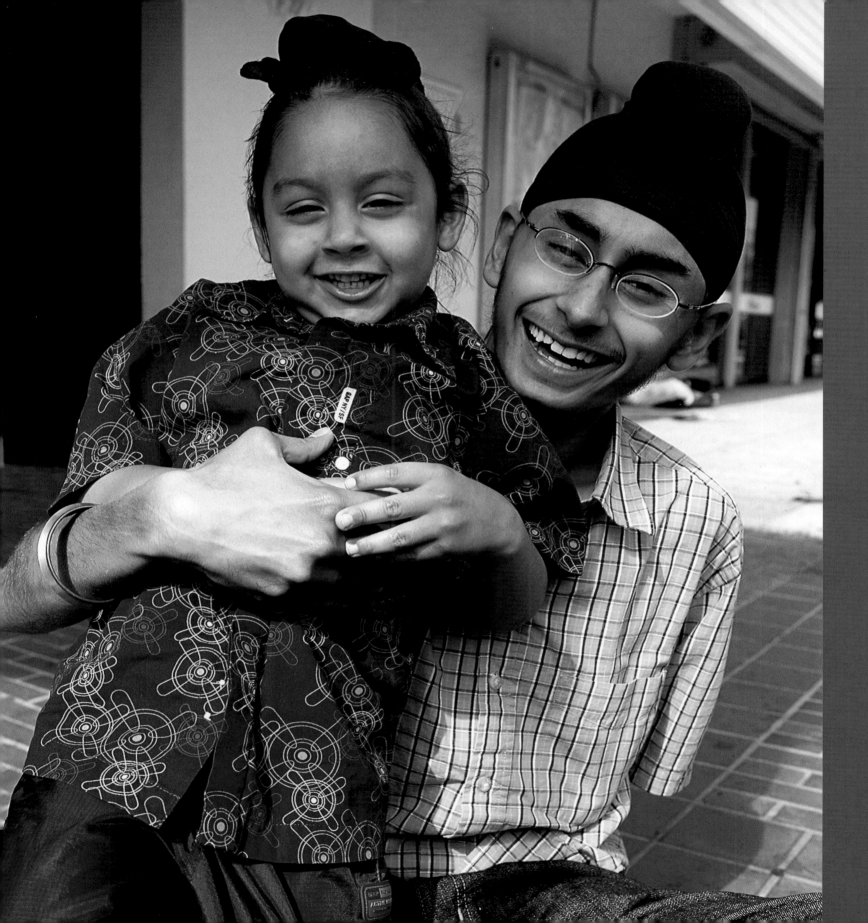

families. Others anticipated sending for their wives to join them here. Highly motivated, they took all manner of jobs and because the majority of Asian Indians were unskilled laborers and willing to work for cheap wages, they became targets of misunderstanding, jealousy, and discriminatory practices.

Unfortunately, the United States government would add to their miseries. In 1923, the United States Supreme Court ruled that Asian Indians were ineligible to be naturalized as citizens, and determined that these people were not Caucasians within the meaning of the law. A year after this decision, the United States Congress passed the 1924 Immigration Act, which denied immigration visas to people who were ineligible for naturalization. At the same time, the anti-miscegenation laws were extended to Asian Indian men seeking to marry white women and to own land. Shortly thereafter, the California attorney general began instituting proceedings to revoke Asian Indian land purchases. For the next forty years, South Asians struggled against these discriminatory laws. Some found a way around these regrettable restrictions by marrying Mexican women and taking the land in their wives' names. Thus, between 1913 and 1946, 47 percent of the wives of Asian Indian men living in the United States were Mexican. In central California alone, 76 percent of the wives of Asian Indian men were Mexican and most owned land.

In 1946, the United States Congress passed the Luce-Celler Act, extending the right of naturalization to Asian Indians and to other immigrants as well; however, only a small quota of Asian Indian immigrants were permitted to obtain naturalization in any given year. In 1952, the issue of quota limitations was readdressed with the legislation and passage of the McCarran-Walter Act, which essentially eliminated racial and ethnic restrictions on naturalization for Asians. But it wasn't until 1965 that America's doors were opened wide to all South Asian immigrants and the restrictive laws were revoked. And although Asian immigration remained at a trickle between 1966 and 1970, averaging only 5,000 immigrants per year, those numbers grew dramatically in the years after 1970, so much so that by 1980 there were 360,000 Asian Indians living in the United States. By 1990, the number had increased to 815,000, and reached 2 million by the year 2000.

The numbers of Asian Indians migrating to the United States were now substantial, and unlike the earlier immigrants who were principally farmers, the newcomers arriving after 1965 were principally from the urban areas of India. They were well educated and highly trained professionals, skilled in many fields including medicine, science, engineering, and business. As such, these Asian Indians are achieving a higher socio-economic level than any other foreign-born group in America. Today, Asian Indians are enjoying careers as diverse as orchestra conductors to filmmakers to astrophysicists; their award-winning achievements earning them the greatest respect within the American community—people such as Subrahmanyan Chandrasekhar, who was awarded the Nobel Prize in physics in 1983; and Dalip Singh Saund, who was born in Punjab, India, and came to the United States in 1920, earned his Ph.D. in

Mathematics from the University of California at Berkeley, and then in 1956, made history by being the first Asian in America to win a seat in the United States Congress.

Other South Asians have joined the migration to this country as well; by the year 2000, over 200,000 Pakistanis resided in the United States, along with 57,000 Bangladeshis. Motivated like other groups immigrating to America, these South Asians came to enjoy a better way of life, to take advantage of the economic opportunities, and to engage in freedom of expression. Today, South Asians are an outstanding contribution to American society, blending their rich traditions and talents to the collective wealth of our American culture. Their assimilation into the American lifestyle has been a remarkable one; they have taken their place within American neighborhoods, become soccer moms, drive to McDonald's for meals, and have embraced essentially every aspect of American suburban life. And while they continue to enjoy their rich South Asian culture with its superb traditional foods, colorful dress, and unique music, it can truly be said that South Asians are living the American dream and all of its promise.

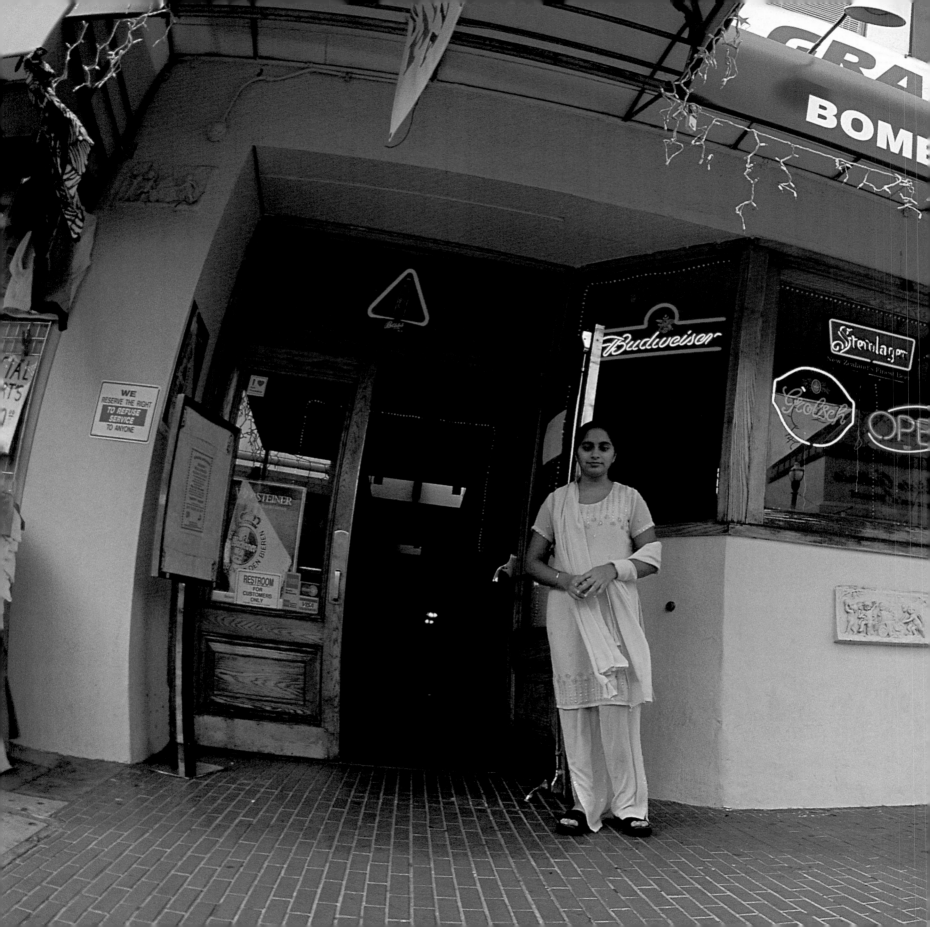

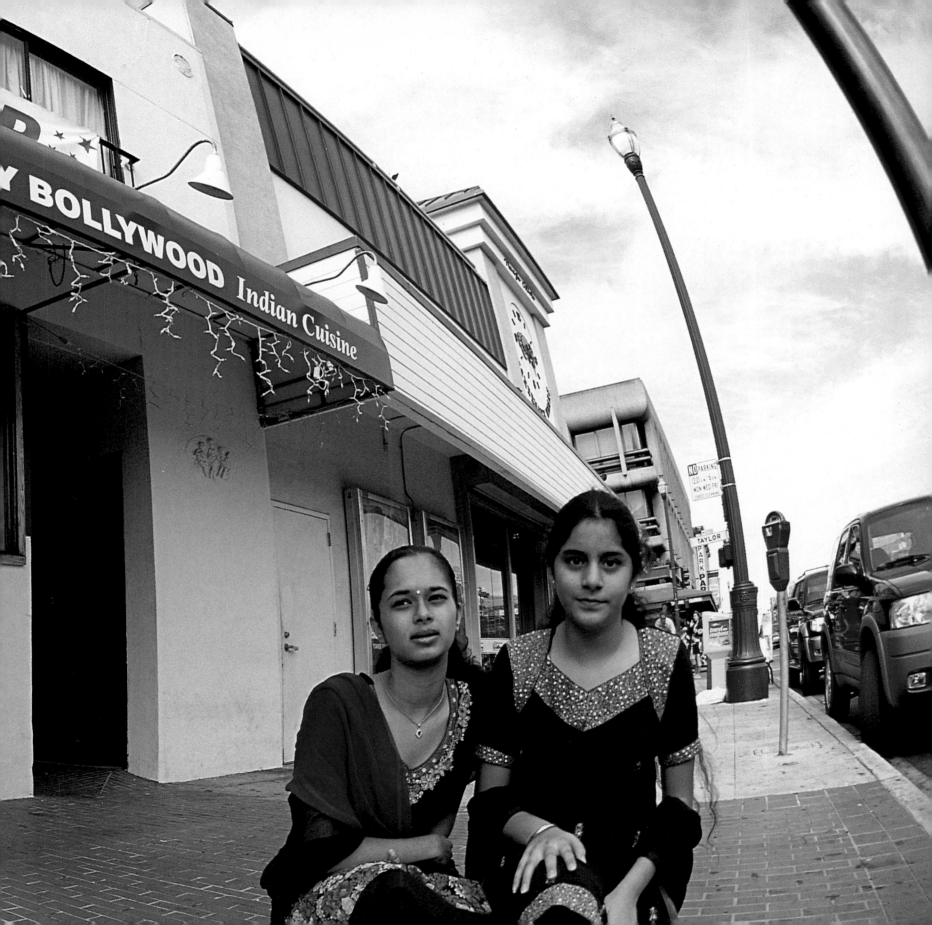

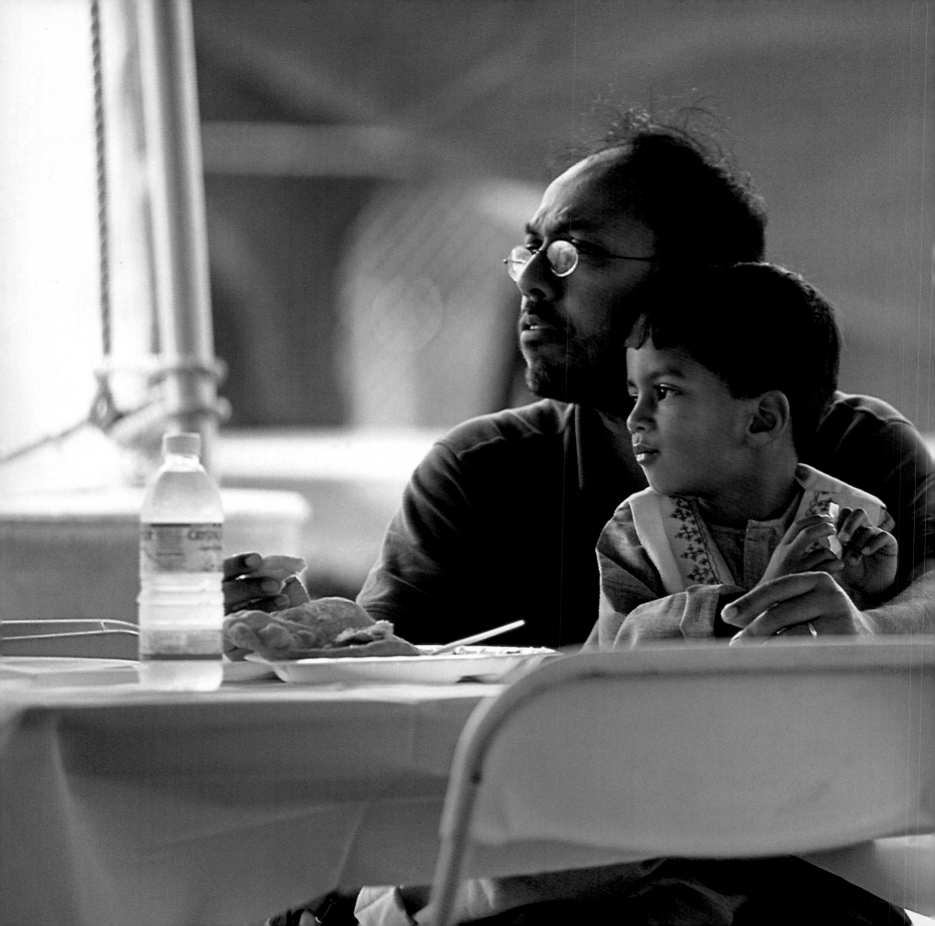

One of the largest South Asian populations in the country is located in Fremont, California. Several times a year festivals are held including this one celebrating Indian Independence Day. Surprisingly enough, this child is the entertainer of the family. During a celebratory performance, this young man danced and sang on stage in front of hundreds of South Asians gathered at the festival. This handsome and talented young man has quite a future, and I was fortunate to capture a candid photo of him with his father eating lunch.

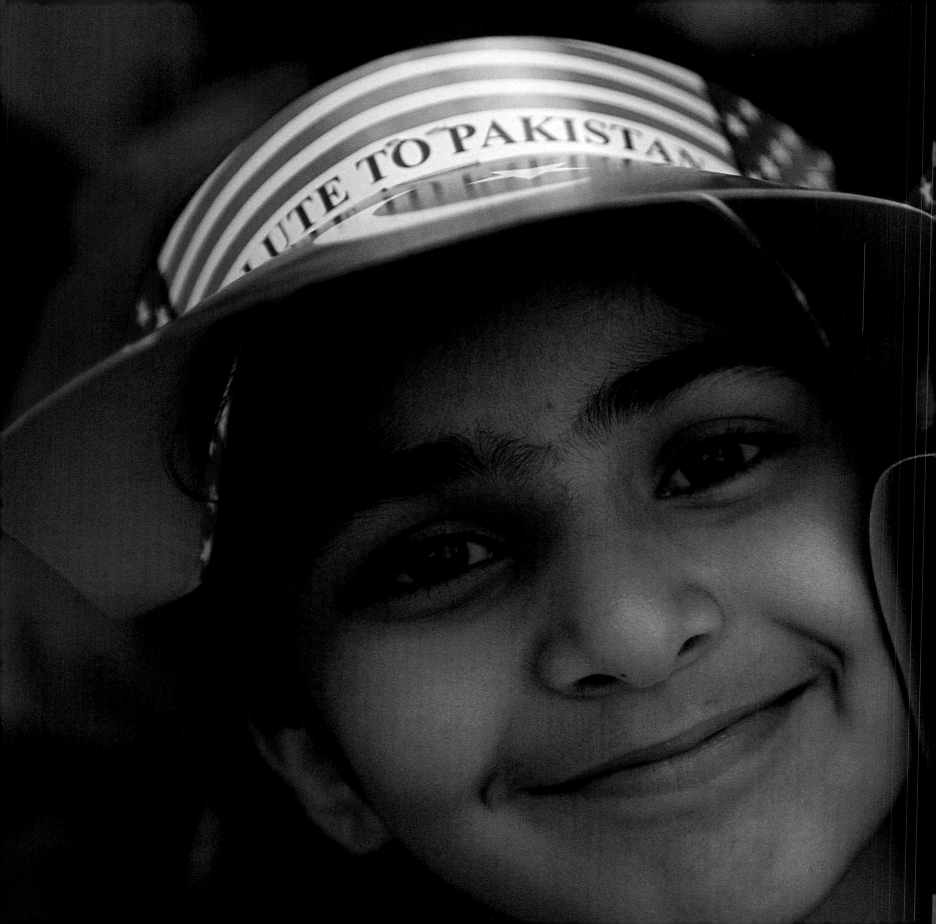

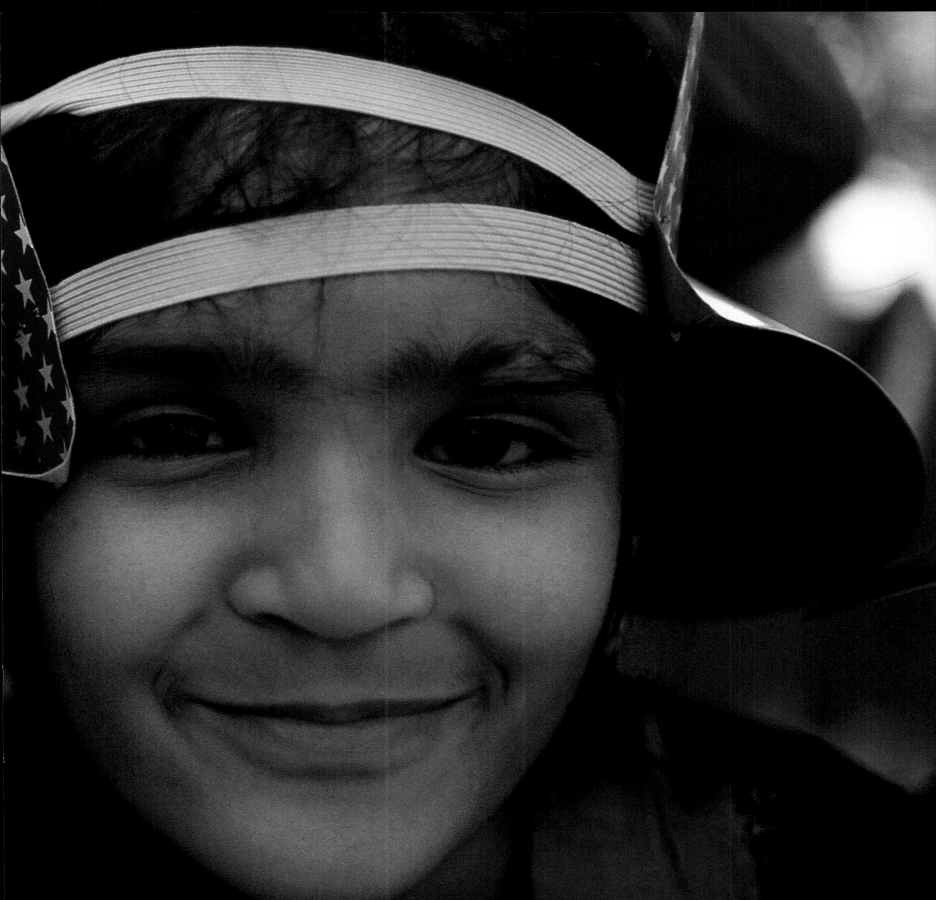

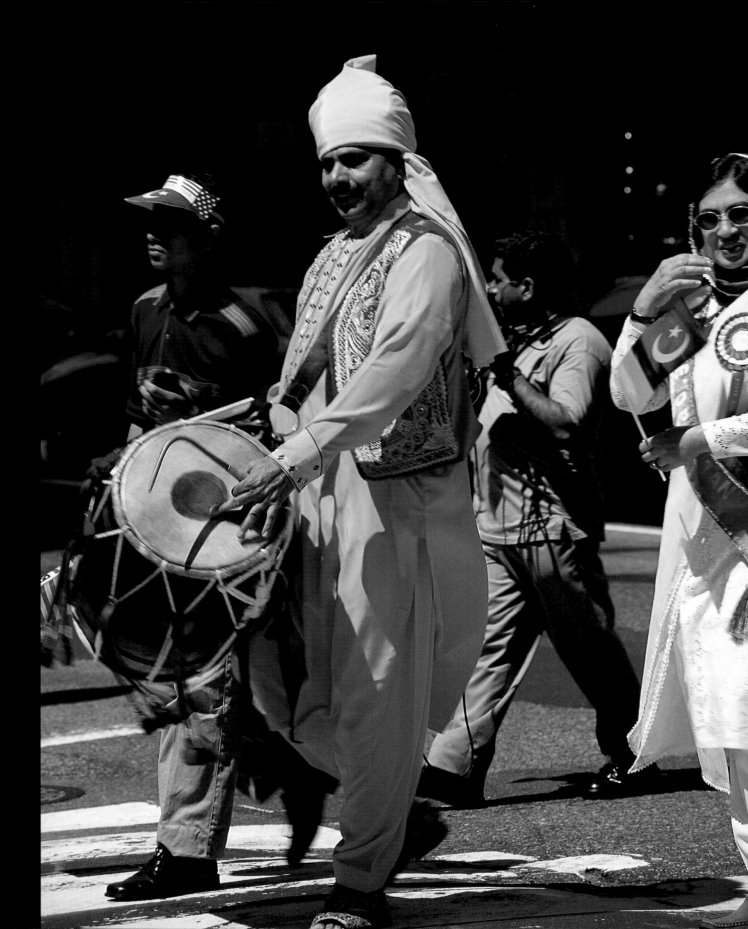

ABOVE: JACKSON HEIGHTS, NEW YORK, 2004
LEFT, NEW YORK CITY, NEW YORK, 2004

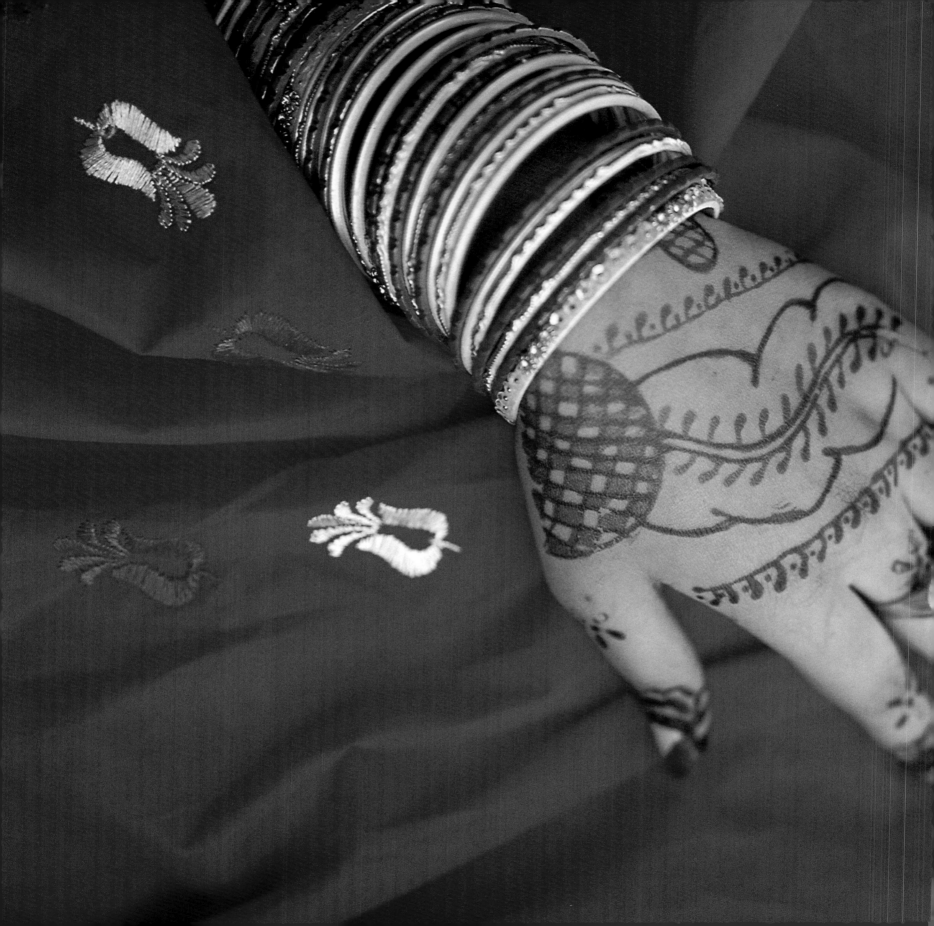

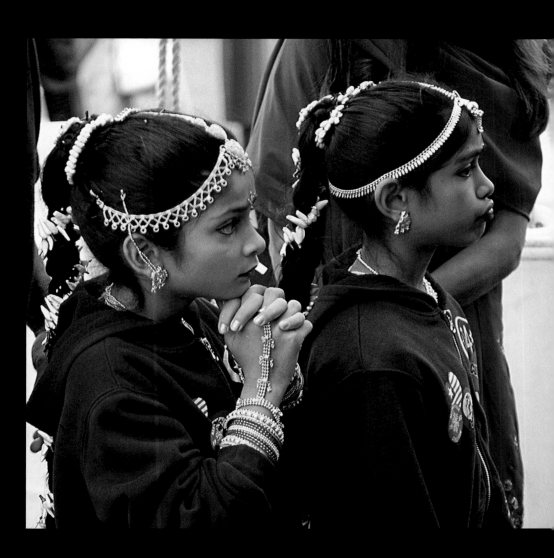

The Modern Era

1965 TO THE PRESENT

CUBANS

SOUTHEAST ASIANS

VIETNAMESE

PERSIANS

The Modern Era

In 1965, United States immigration laws were dramatically reversed, with the enactment of the most liberal immigration laws America had ever seen. Once again, the gates were flung open to accept new immigrants. This did not mean unrestricted access, but the hurdles to immigration that had previously existed for many were lowered.

America's stated desire is to welcome the downtrodden and oppressed. When conflict has arisen in other parts of the world, our doors have opened, at times, to assist those in need. Cubans fleeing the island's political crisis, Vietnamese looking for a new home after their country's destruction, and Persians seeking a secular democracy after religious upheaval all came to American shores in search of a new life. Our country is fortunate to have these additional cultures and ethnicities to share in our life and enhance our very existence.

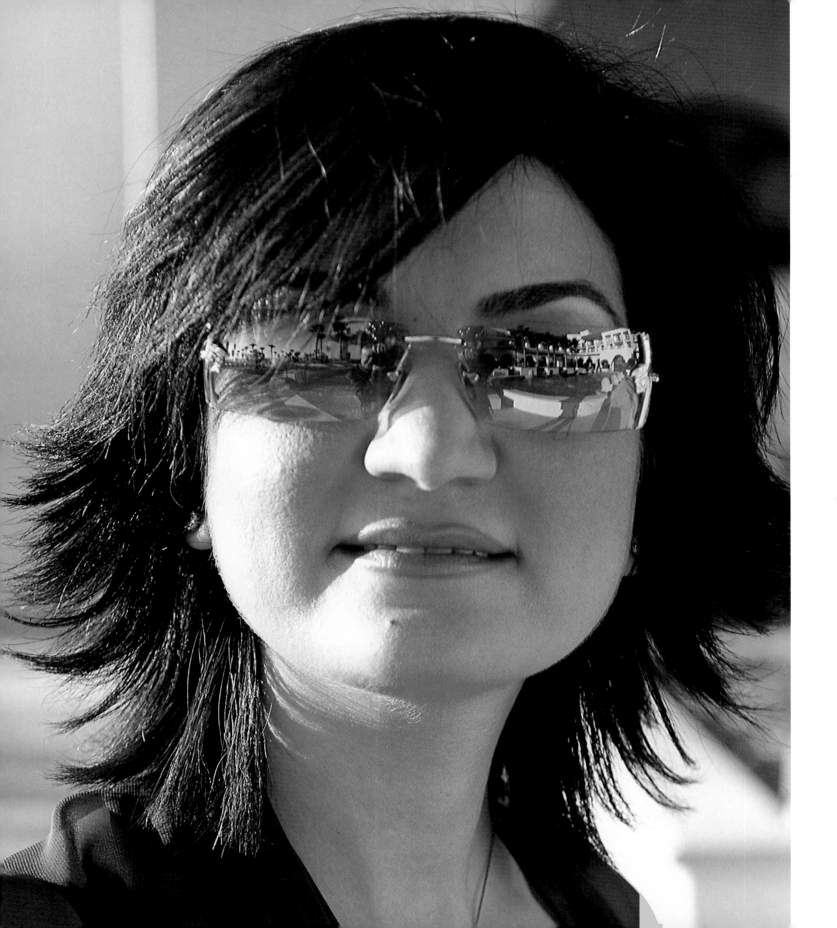

Cuban-Americans are descendants of one of the oldest cultures in all of the Americas, which was "discovered" by Christopher Columbus in 1492. From that time to the present day, the island nation of Cuba has endured extreme political turmoil, so much so that some of its freedom-seeking populace has sought refuge in the United States. Some Cubans immigrated legally, and others risked their lives in perilous journeys by small boats launched from Cuba's shoreline. After centuries of fighting for freedom and peace in their homeland, today many Cubans find themselves living in exile only ninety miles from their home shores.

The United States acquired Cuba from Spain as a result of the Spanish-American War in 1898. Four years later, Cuba received its independence from the United States, and the Cuban-American culture began to thrive. Skilled Cuban artisans, with their love for music and dance, soon infused America with their joyful spirit. As a result of the free tobacco trade, many Cubans had

mastered the art of making fine cigars. This skill helped them to quickly seize business opportunities by making their hand-made cigars for America's burgeoning ready-made market. Their cigar factories flourished, and although many exiled Cubans prospered, they never gave up their yearning to see Cuba freed from the dictatorial governments that denied Cubans their freedom.

In 1952, an army general named Fulgencio Batista overthrew the regime of President Carlos Prio Socorras. Cuban hopes rallied when a revolutionary upstart named Fidel Castro stepped forward, promising a democratic-styled leadership. Castro had populist appeal and the support of Cuban exiles. Obtaining financial aid and manpower, he took up the struggle against the oppressive Batista regime. Castro demanded that his revolutionary followers implement a humanistic, democratic model of reform, promising it would bring freedom to the Cuban citizens. However, shortly after his successful overthrow of Batista in 1959, Castro instituted his own dictatorship that resulted in denying the citizens of Cuba as well as the Cuban-American exiles any hope of their homeland becoming a free and democratic republic.

This turn of events was the genesis for yet another massive wave of fleeing immigrants. Tens of thousands of desperate Cubans seeking freedom fled to American shores. They made it across the ninety-mile ocean barrier in small boats, life rafts, and even inner tubes to escape this newest oppression. These Spanish-speaking newcomers settled in various regions within the United States; although many blended smoothly into the New York culture, the majority found the neighborhoods in South Florida ideal. South Florida's population exploded with Cuban growth, and Spanish became the dominant language spoken from Miami Beach to Key West, Florida. In 1980, 125,000 Cuban refugees from the Mariel boatlift arrived in South Florida to join the existing Cuban-American community.

Today, Cuban-Americans are a culture within a culture. Most Cuban-Americans still consider themselves to be living in exile, longing to return to their homeland. While ever faithful to this dream, America's Cuban population enjoys their proactive role in the American lifestyle: their zest for life energizing their communities; their Latin tempos enlivening America's music scene. Cuban dancers, musicians, and vocalists have made indelible marks in the area of Latin music with talents such as renowned musician Israel "Cachao" Lopez and band leader Perez Prado, who popularized the mambo; ten-time Grammy nominee and respected Latin vocalist Celia Cruz; singer and songwriter Gloria Estefan; world-famous jazz trumpeter Arturo Sandoval; as well as a host of other outstanding "Latin pop" entertainers.

Cubans living in America are proud of their two cultures. And while many of the older Cuban exiles, who were betrayed by their Cuban leaders, still feel frustrated, it is because they are living so close to their beloved homeland and yet so far away. The lives they are living now are what they had hoped their lives in Cuba would have been. And if you ask any Cuban living in the United States what they like most, they will tell you in one word: "freedom."

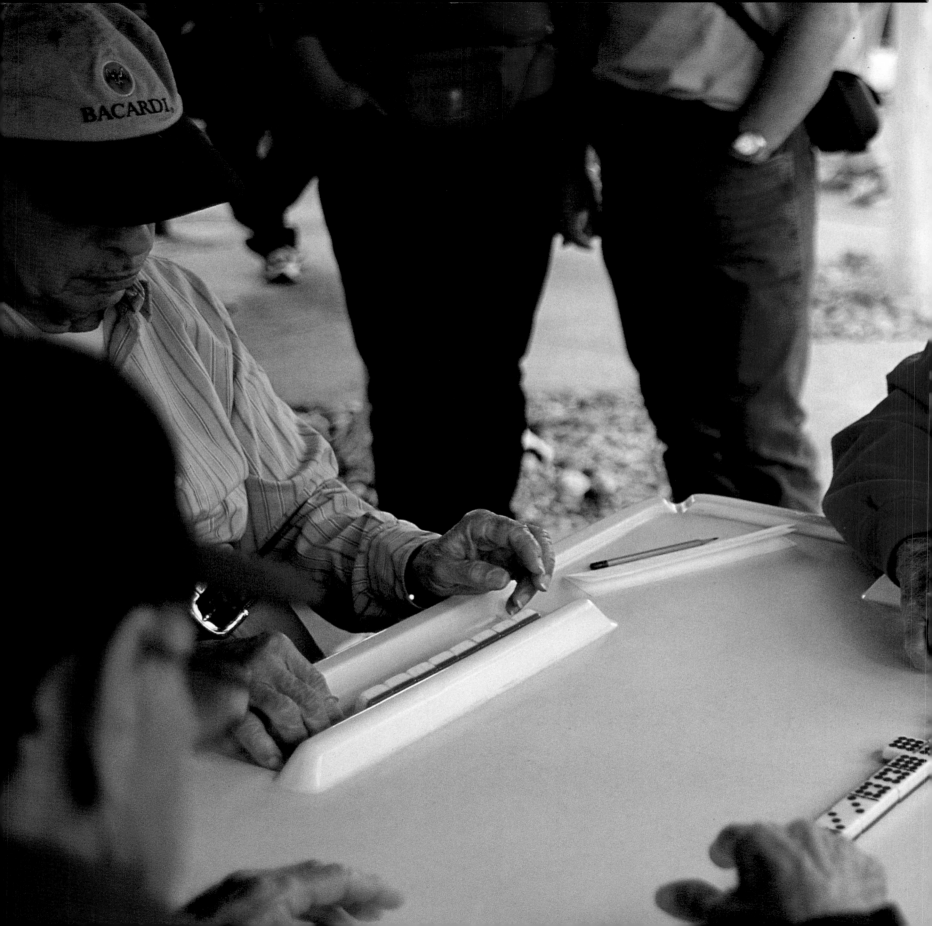

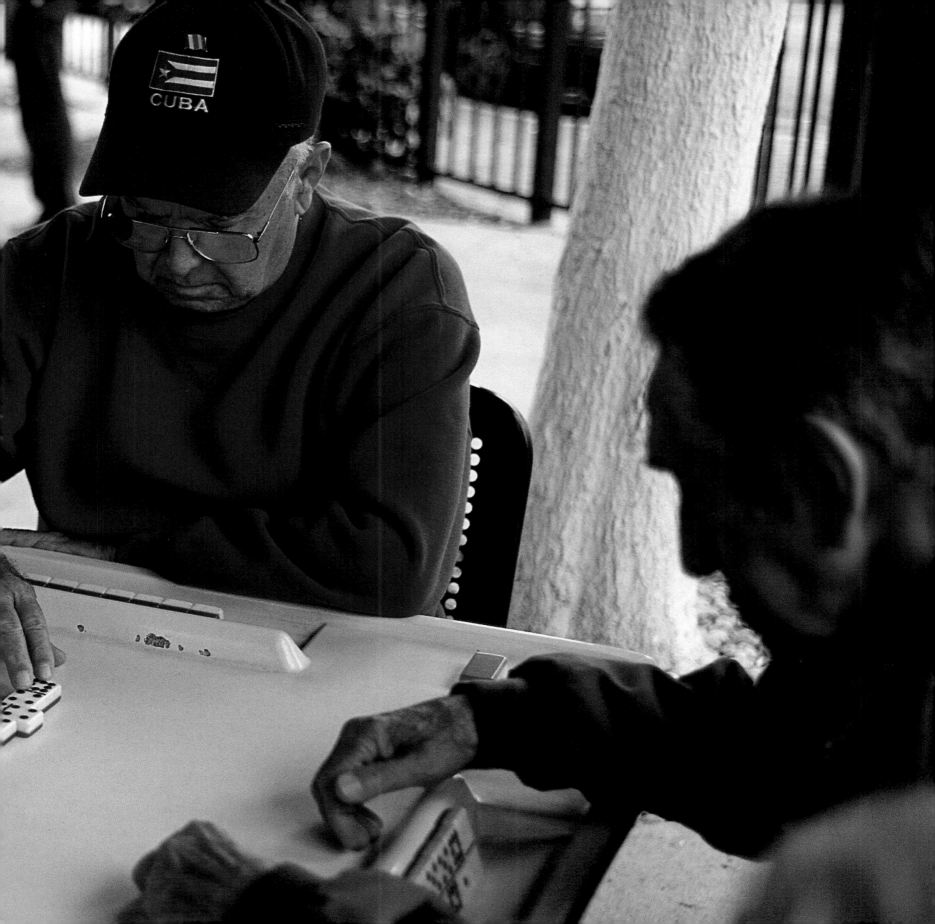

MIAMI, FLORIDA, 2004

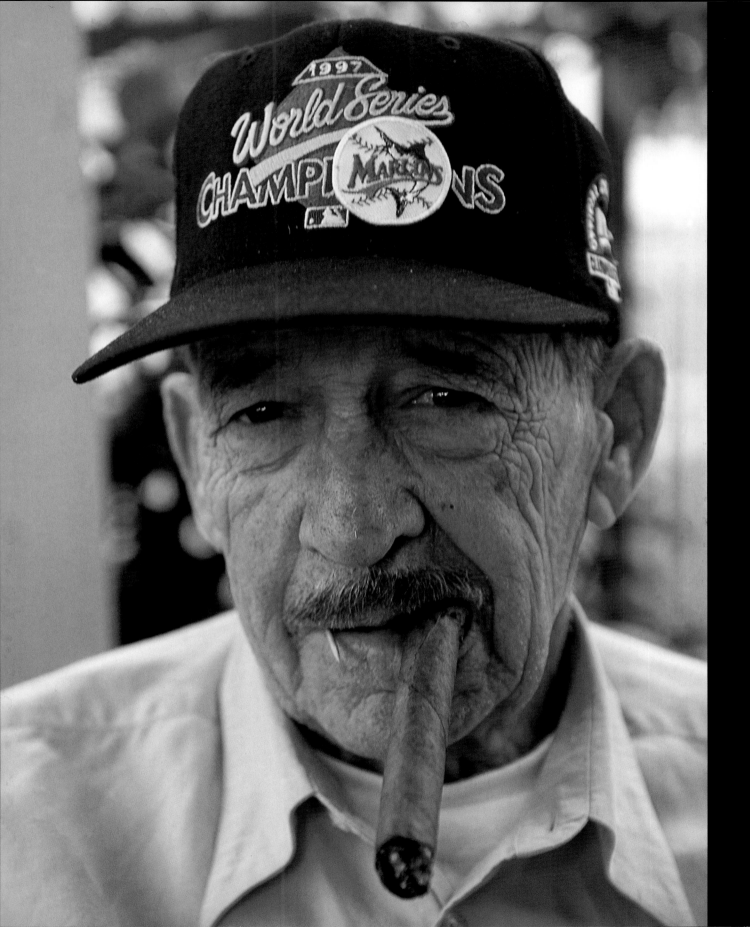

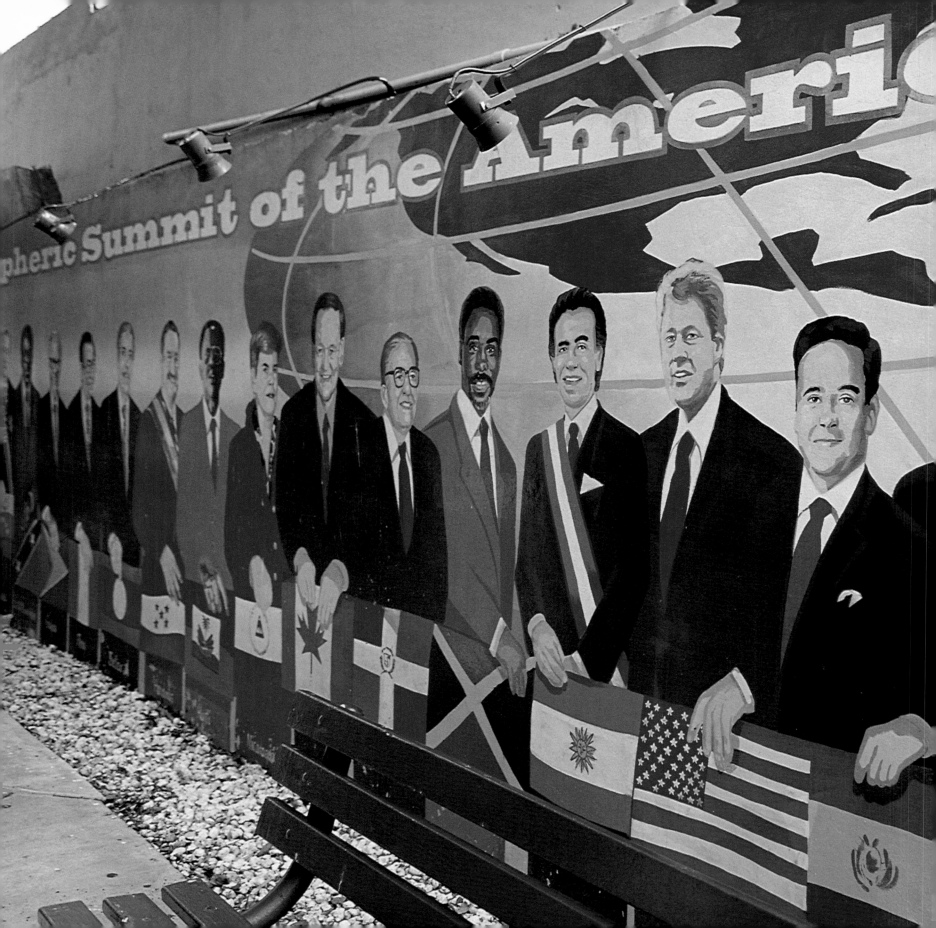

"Little Havana" in Miami, Florida is the headquarters and capital of Cubans in exile and their home in America. The Cubans have painted a mural on the wall of one of the domino parlors on 8th Street (known in Spanish as "Calle Ocho") in the heart of Little Havana. Represented in the mural are the leaders of all of the countries represented at the Hemispheric Summit of the Americas, as an elegant tribute to their heritage and belief in freedom.

As I was photographing these Cubans, I would, periodically, stop and interview various family members. When I would ask them why they are living in America, their response to me was always, "for only one reason, and I will give it to you in just one word." When I would then ask what that word is, they would always tell me "freedom." Freedom is so deeply valued within the Cuban community that is inspiring to anyone who crosses their path.

G eographically, Southeast Asia encompasses the countries of North and South Vietnam, Laos, Cambodia, Thailand, Myanmar (formerly Burma), and Indonesia. This vast region is home to millions of people whose cultures share many similarities, yet each is richly unique. However, the culture and ancestral traditions of the Hmong (*pronounced "mawng"*) are representative of the ethnic cultures within the Southeast Asian community. Historically, the Hmong (their very name meaning "free people") are associated with Laos. It is believed the early Hmong people migrated to southeastern China from central Asia (Mongolia) about 5,000 years ago, and later left China to settle in areas throughout Thailand, Laos, Vietnam, and Burma (now known as Myanmar). The Hmong, along with the Vietnamese, were one of the most significant Southeast Asian groups to immigrate to the United States as a result of the Vietnamese War in the 1970s. The sheer number of these war-torn refugees would come to make a significant impact on American society.

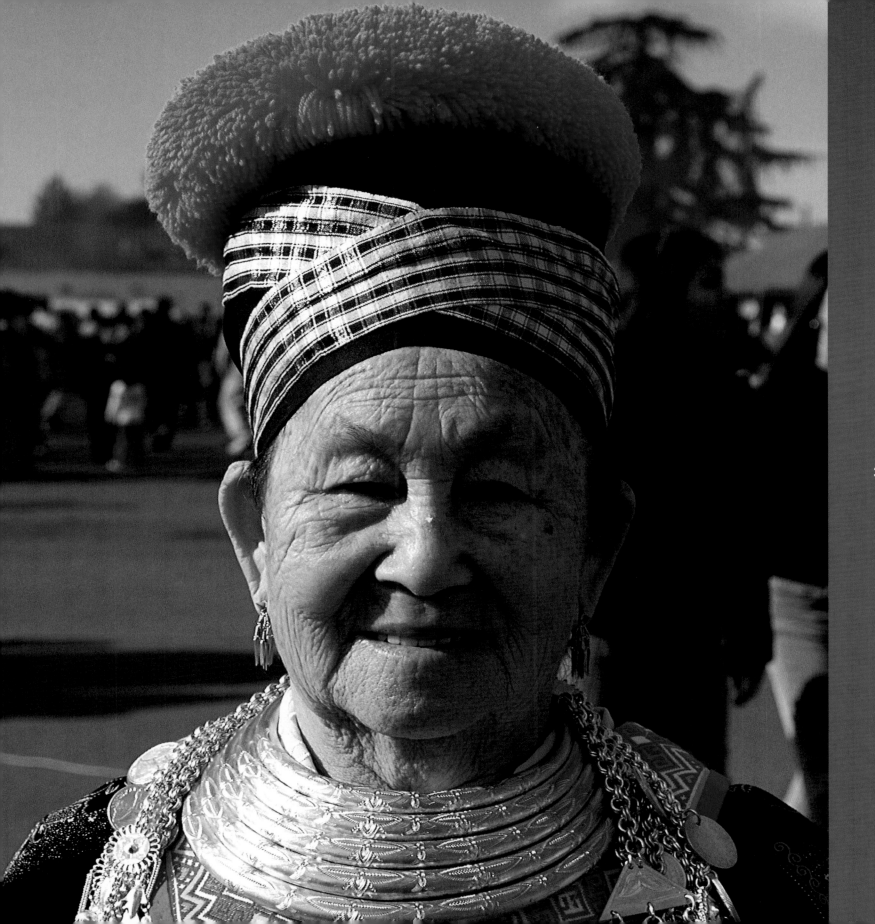

In Southeast Asia, political regimes have had a tremendous influence on the region's geographic borders as well as on the people and the evolution of their cultures. Subjected over time to imperialism, Southeast Asia was exploited initially by the Spanish and Portuguese, the Dutch, and eventually in the 1700s, by the British. By the early 1800s, the French came on the scene in their quest to establish trade with the Chinese, using Indochina (Southeast Asia) as their avenue north. Beginning in the 1850s, the French slowly occupied Indochina (today's Cambodia, Vietnam, and Laos). However, they ignored the development of the region's infrastructure, neglecting the support of education, the building of roads, and the construction of railroads. Instead, taxes were levied on goods, and adults were used as forced labor on various government projects. While some of the state governments in Southeast Asia were allegedly independent, the reality was that the French had veto power over their decisions. At the same time, Great Britain was controlling activities in southern China. And while the Hmong protested, their minor rebellions met with little success.

Matters changed in the region when the Japanese occupied the area during World War II. By 1946, Southeast Asians began to rebel against the French. In 1954, the French were resoundingly defeated; the resulting Geneva Conference recognized the independence of Cambodia and Laos, and divided Vietnam into two countries: the north controlled by communists, the south being anti-communist. When the communists began to send guerrillas into South Vietnam, the United States responded by sending in advisors to assist the Laotian, South Vietnamese, and Cambodian governments in their quest to thwart any encroachment by Communist forces. Over the ensuing years, this program would prove an extremely difficult process for the United States. This policy dramatically affected the Southeast Asians, particular the Hmong, many of whom were recruited to fight against the Communists.

The resulting Vietnam Conflict spilled over into all Indochinese countries, resulting in 1973 with the withdrawal of American troops from all of Indochina. The vacuum created by that withdrawal sent hordes of refugees fleeing the region, desperate to escape the ravages of war. The exodus was enormous: approximately 150,000 Vietnamese and 100,000 to 150,000 Hmong, principally from Laos, fled to western countries. Thousands of Indochinese spent years in refugee camps. Over time, the bulk of the refugees ended up on American shores. By 1990, over 100,000 Hmong refugees had come to America, as well as an equal number of Vietnamese.

Once in the United States, the immigrants dispersed across the country, and today the greatest populations of Hmong are found in Minnesota, Wisconsin, and California. On the west coast, the Hmong settled in the agricultural areas of San Diego and Fresno, California and Seattle, Washington. Once they had settled into their new communities, the Hmong organized into clans and extended families. In their homeland, they had relied heavily on agriculture and a barter-styled economy. Their adjustment to living in America and its

social practices proved to be very challenging: Hmong social structure centers on male dominance, and they practiced polygamy, a tradition unacceptable in contemporary American society. Because most Hmong immigrants were uneducated, finding employment proved difficult, and many of these newcomers were at the mercy of the federal and local welfare programs for support. However, they worked hard to catch up. Their children began attending American schools and this interaction with children from other cultures has helped them to assimilate much faster to the American lifestyle than their parents. Various American institutions and organizations also stepped forward in an effort to help ease the assimilation process for the Hmong and to facilitate cross-cultural understanding. Churches were also a great support effort: Christian faiths were a significant influence on the Hmong. Although the two main religions practiced by the Hmong are Catholicism and Animism, substantial numbers of Hmong are now Baptist, Presbyterian, Mormon, and Buddhist.

Today, the Hmong are actively involved in their American communities. They are hard-working citizens who revel in their extended families and in the sharing of their traditional customs. Their music resounds with the songs and melodies of their ancestral heritage; their art expresses their love of color and celebrates family and nature. They ceremonially honor the rites of passage including birth, naming, courtship, marriage, and death. The New Year is an especially important event for the Hmong. It is a time of giving thanks and celebration, with festivals lasting two weeks involving dancing, playing games, bull fighting, and the preparation of special foods. Their traditional costumes proudly display their beautiful, hand-embroidered and appliqué artwork that is reflective of their distinctive ancestral cultures. For thousands of years each generation has passed on their oral history, their melodic native language recounting folktales and stories of heroic events.

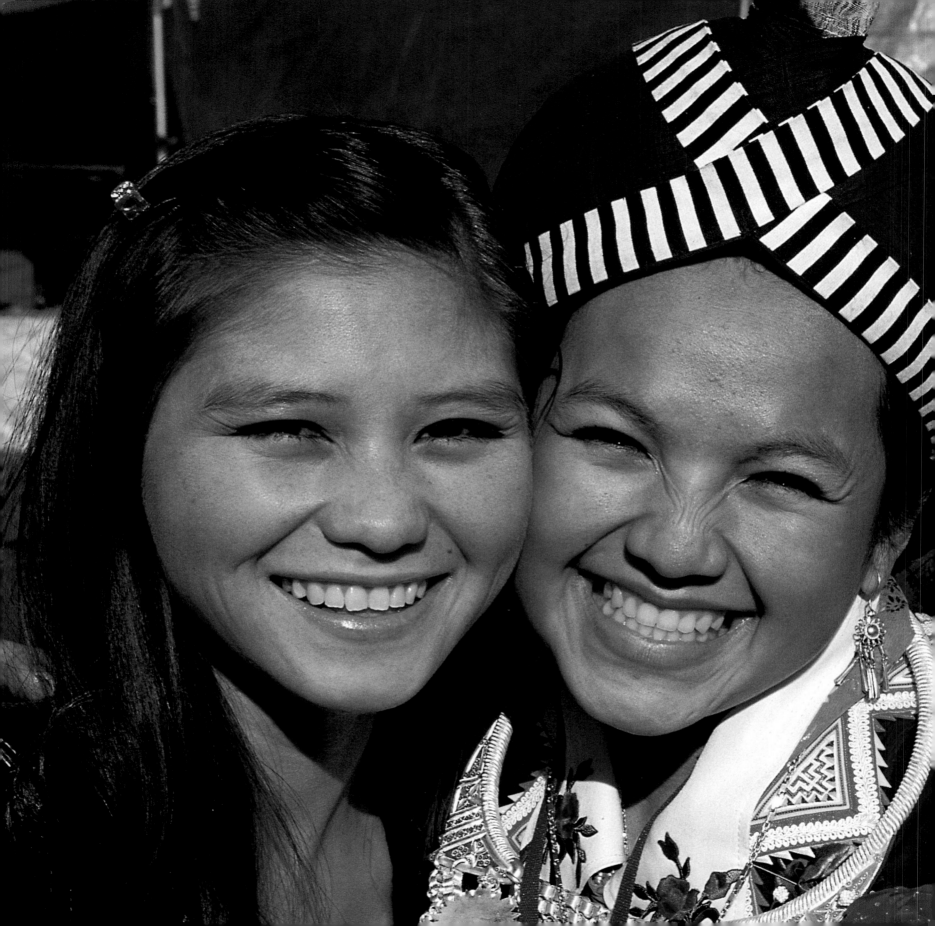

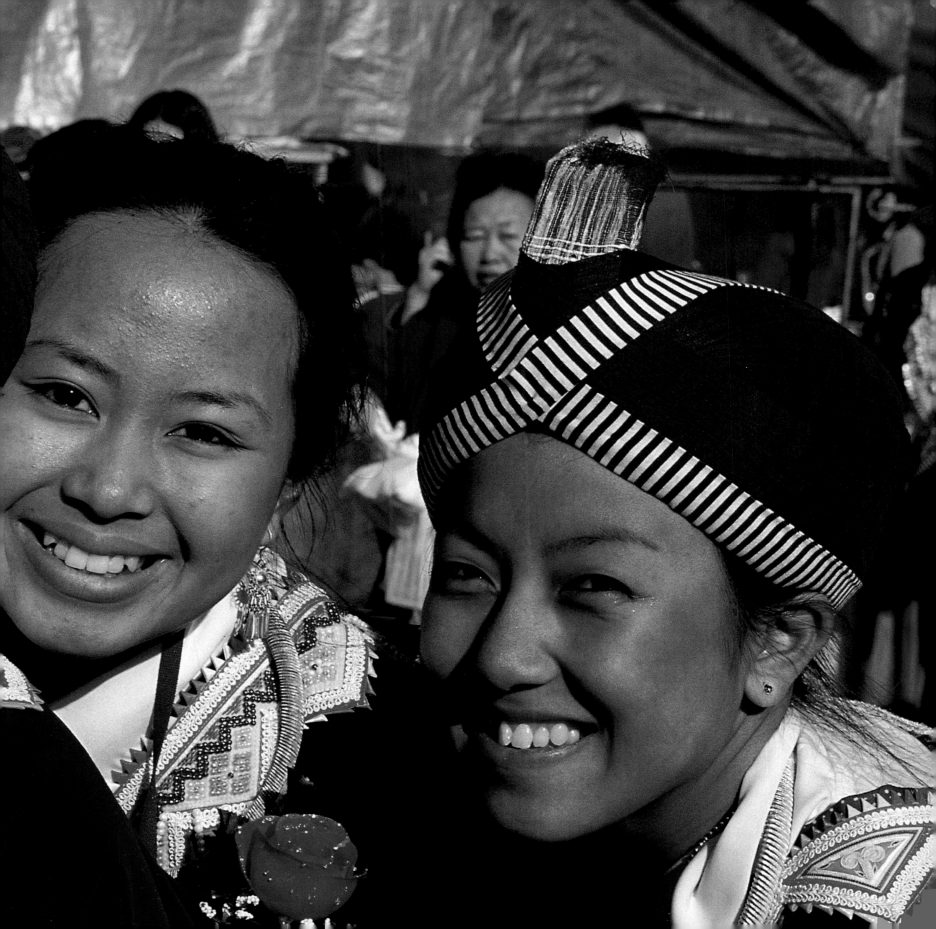

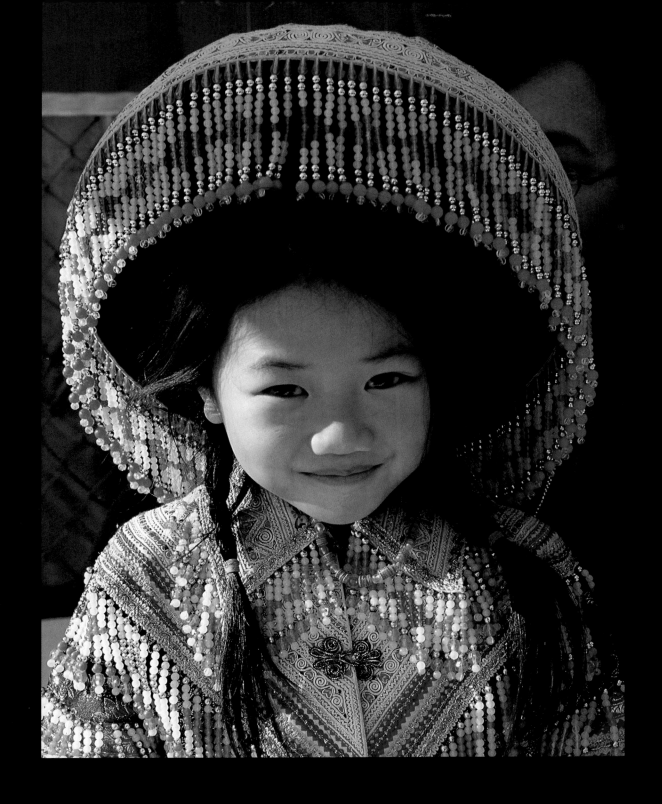

ABOVE: FRESNO, CALIFORNIA, 2004
LEFT: LOS ANGELES, CALIFORNIA, 2003

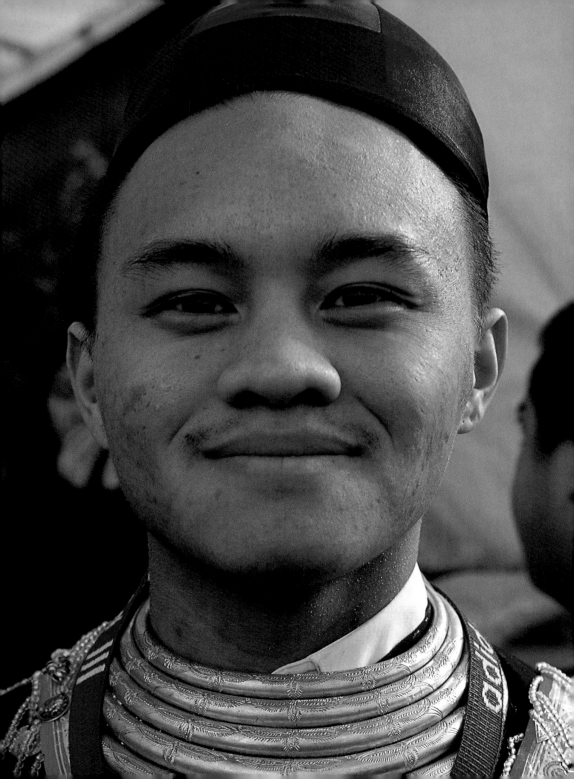

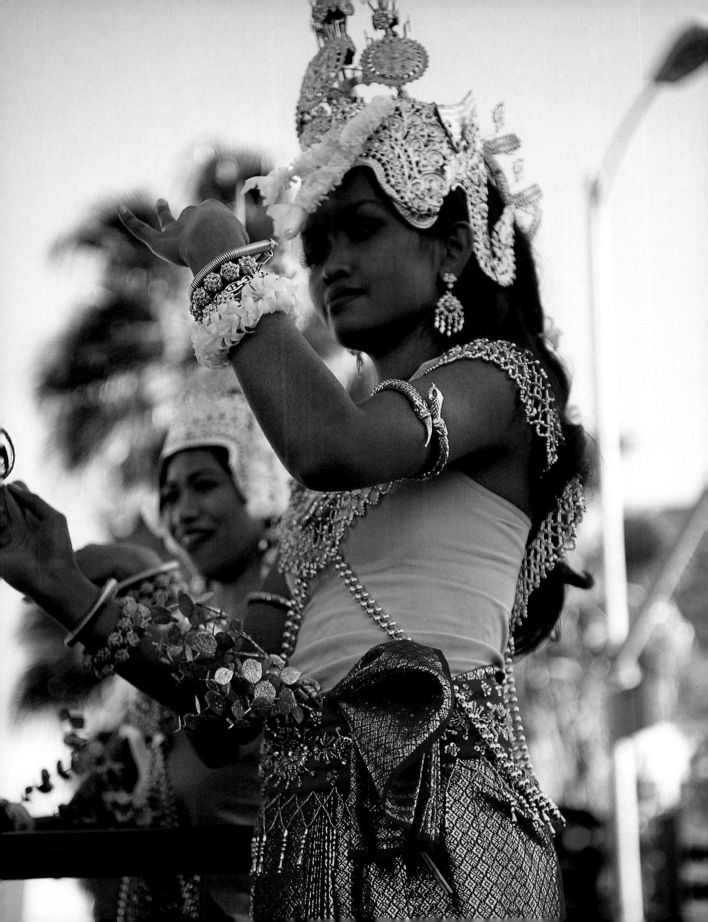

Southeast Asians share a revolutionary history that has experienced decades of imperialistic occupations. Over time, the Portuguese, Spanish, British, French, and Americans have each impacted the region, effectively altering borders between North and South Vietnam, Laos, Cambodia, Myanmar (formerly Burma), and Thailand. And while these areas of the world continue to experience conflict, amazingly their cultural integrity remains intact; their traditional values and practices serving to stabilize their family units as well as to strengthen their societal structures.

Culture serves to define the code for behavior and is fundamental to daily life. This maxim holds true for the Vietnamese whose Indochinese lifestyle and cultural activities center on their allegiance to family, respect for other people, and their love of learning. Within the family, the husband is the dominant figure, having authority over the wife and the children. Ethics of honor and respect are strongly rooted in the traditional teachings within the immediate and extended

family; Asian children are taught to suppress aggressive behaviors and to act cooperatively towards adults and others. Expressions of open conflict and hostility are not accepted. For Vietnamese, communication is a refined art inherent not only in the spoken word, but most importantly in the use of non-verbal behavior including body language, facial expressions, symbolic gestures, innuendos, and ceremonial ritual. Paramount to any manner of their communication is the importance of proper and respectful behavior.

These gracious people, who truly love their homeland, were among the many immigrants seeking new lives in America. The greatest migration of Vietnamese to the United States was triggered by the Vietnam Conflict. And while many refugees fled to the United States during the conflict, the vast majority would emigrate later at the end of the war, when their country was occupied by the Communists. Once on American shores, the Vietnamese soon settled in numerous regions throughout the country, collectively organizing and developing cultural zones of their own. The largest of these cultural zones are found in New York and in southern California, specifically Orange County, in an area called "Little Saigon."

Desperate to reestablish the traditional family structure that had in many cases been disrupted and torn apart by the separation from their family members during the war, and the pressures of relocation, many Vietnamese made certain adaptations in their cultural behaviors after they arrived in the United States. Although there are few studies examining the impact on Vietnamese social structure following their relocation to the United States, most evident were the changes to their lifestyle. In American society, both

Vietnamese men and women have the opportunity to work. This one factor alone significantly altered the family dynamics of the Vietnamese patriarchy. Wives, now free to work, exerted their economic influence and expressed their feelings. And in spite of the new balance within the family, Vietnamese have remained faithful to their cultural traditions of obedience and respect for family honor. While the Vietnamese people endured many tests and challenges within their own country, they have learned to adapt and have assimilated beautifully into their adopted homeland. Becoming more "Americanized," has only added to the Vietnamese character; they remain a dignified and proud people, who continually strive for excellence in every facet of their endeavors.

Contributing their talents and intellect, the Vietnamese have earned the greatest respect for their extraordinary accomplishments. Among their outstanding personalities are people such as Le Bui, Founder of Orchid, the first Vietnamese-American Hi-Tech Company; Tuan Nguyen, Father of PowerPoint; Xuong Nguyen-Huu, pioneer in AIDS research, and inventor of the X-ray Multiwire Area Detector; Kieu Chinh, legendary actress for over forty years, with roles in *Joy Luck Club* and *M.A.S.H.*; Truong Dinh Tran, philanthropist and businessman who donated $2 million to the 9-11 Fund; Thuy Thanh, named "Twenty-first Century Woman" by the National Organization of Women; and Eugene Trinh, the first Vietnamese-American astronaut (space shuttle *Columbia*, 1992). Clearly, we are most fortunate to include Vietnamese as part of our big American family. They are a dynamic force that continually inspires each of us to strive for personal excellence.

ABOVE: GARDEN GROVE, CALIFORNIA, 2004
RIGHT: LOS ANGELES, CALIFORNIA, 2004

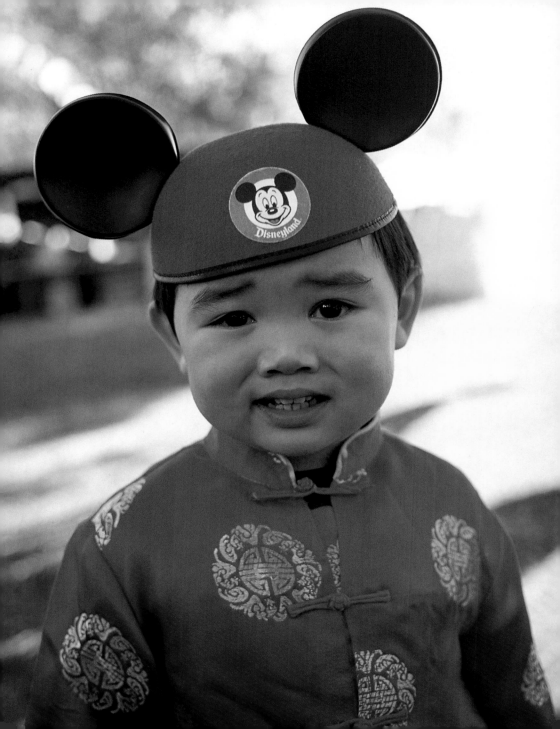

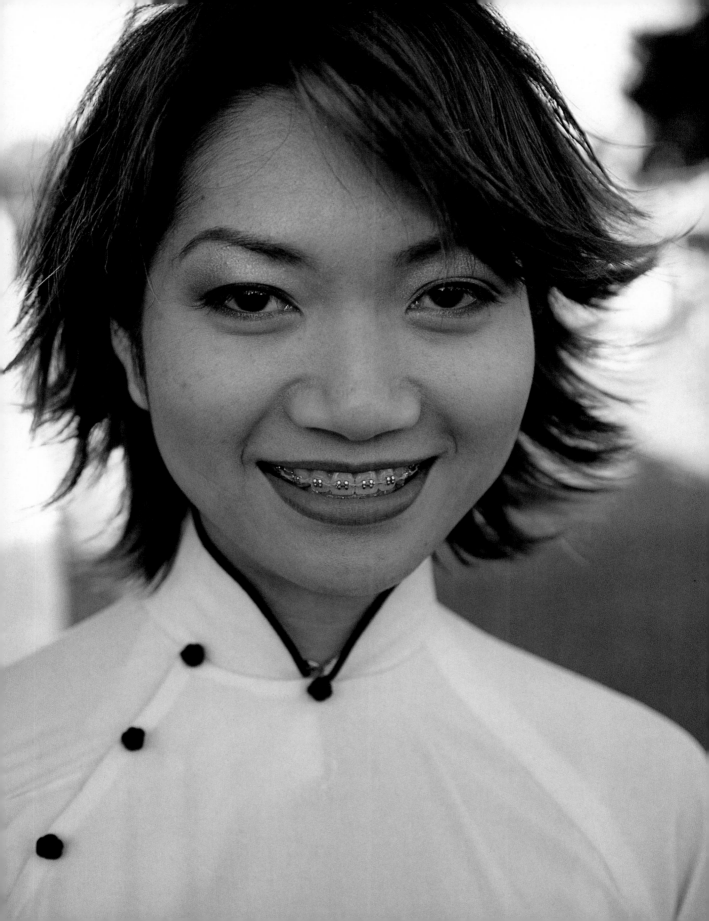

Since 1935, Persia has been known in the western world as the country of Iran. Persians are one of the last major ethnic groups to immigrate to the United States. These marvelous people have one of the oldest recorded cultures on the planet. Ancient Persian history spans several different empires. At times over the thousands of years of its existence, Persia controlled vast portions of the Middle East. However, the Persian kingdom was also conquered by invaders over the years. Iran is populated by people with light or olive skin, dark hair and dark eyes. However, a significant portion of the Iranian population has blond hair and light colored eyes. This diversity in physical characteristics is the result of the blending of the different ethnic groups that have invaded and conquered Persia over the millennia.

Most Persians ultimately adopted the Shiite version of Islam, which brought their country into conflict with the Ottoman Empire, the bastion of mainstream Sunni Islam. Although Shia Islam is the official religion in Iran, many Persians

follow other religious orders including Zoroastrianism, a religion that is thousands of years old, and predates the founding of Islam in the seventh century. Moreover, throughout history, there was almost always a small but significant Jewish community in Iran.

Over the years, Iran's confrontations with the Greeks, Turks, and Mongols and, in more recent times with western countries and neighboring Iraq, exposed their culture to new perspectives and traditions. As a nation, Iran's development has been a tumultuous one, suffering through periods when the population was politically controlled by individuals more interested in their own aggrandizement than in the development of their country. Numerous rulers would prove to be more figureheads than true political leaders, being manipulated by outside powers.

In 1925, Reza Khan (later known as Reza Shah Pahlavi) came to power and began to westernize the country. In 1941, with World War II under way and fearing that Iran was favoring Germany, the Allies forced Reza Shah to step down. His son, Mohammed Reza Shah Pahlavi, became the Shah of Iran. His "White Revolution" began in the 1950s as he continued to westernize Iran, building up his military forces, schools, and industries. The Shah also made courts available for dispute resolution, and he openly supported freedom of expression in art and literature throughout the country. During the Shah's rule, the severe political implementation of religious values on the populace was relaxed, women were permitted to vote, and men and women were permitted to dress in American and European style clothing. The

Shah instilled a great sense of pride in Iranians, and he encouraged communication among people of all social classes. These efforts were designed to develop a stronger, more modern Iran that would be able to compete successfully in the western world.

While the discovery of oil in Iran in 1908 produced wealth for the country as well as for many elite Iranian families, unfortunately this economic prosperity was not shared by the Iranian populace as a whole. As oil exploration increased, the gap between rich and poor in Iran became wider through the 1970s. The economic imbalance continued to shift between those wealthy Iranians who had the means to travel to the west (often to receive an education), and Iranians of the poorer classes who were without the means to make any connection with western culture. Poor Iranians remained isolated in their country and focused their energies on their religion.

The spiritual leader of Iran's Shiite Muslim population, Ayatollah Ruhollah Khomeini, had been exiled by the Shah in 1964. However, the Shah had underestimated the strength of the religious values held by the majority of the Iranian population, and their commitment to following their Muslim religion and Islamic law. A massive religious upheaval occurred in 1978, causing a complete revolution in the country and a change in the government, bringing the Ayatollah Khomeini to power. The Shah was forced to flee as religious groups took over, proclaiming Iran to be an Islamic Republic, controlled by religious leaders. New, strictly enforced religious laws replaced the secular government of the country; women were required to cover their bodies, and musical entertainment

was prohibited. Sexual relationships outside of marriage, the drinking of alcohol, and homosexuality were now offenses punishable by law. These dramatic changes in government and the shift in social laws and values resulted in millions of Iranians fleeing the country, with a significant portion of them coming to the United States.

The newly arriving immigrants represented Iran's wealthiest professional class and the upper segment of the middle class. These were the Iranians who had worked in the government but now no longer had jobs, or those whose businesses had suddenly been nationalized. The new Iranian government had instituted state control in every sector, forcing dramatic changes in protocol among all professionals; everything was to be controlled by the state, with Islamic law strictly enforced.

Many Iranian immigrants quickly assimilated into American society. Industrious and inventive, Iranians settled in neighborhoods where they could set up businesses which catered to Persians. A significant number of Iranians had substantial personal wealth; with such resources, they opened restaurants, rug stores, trading companies, and other businesses. Many of those who were trained as physicians and dentists in Iran obtained licenses to practice their professions in this country. Some of these new immigrants were able to purchase homes in elegant neighborhoods (including Beverly Hills, California). Others did not have such substantial wealth; they went to work in various industries and businesses and took government positions. Some Persian-Americans who are publicly recognizable include Christiane Amanpour and Rudi Bakhtiar of CNN and ten-

nis pro Andre Agassi. Physicist Ali Javan produced significant work on the laser.

Persian immigrants to the United States have brought with them a treasure of cultural Middle-Eastern values, a tradition of wonderful foods, a love of great conversation, and a heritage that dates back to antiquity. Unlike many other cultures, Iranians do not hold parades, but they do celebrate a limited number of festivals; the most significant is their Iranian New Year, called *Nou Rouz*, which means "The First Day of Spring." According to Persian tradition, each and every year, this "new day" is a rebirth of life. This joyful event is traditionally celebrated in Iranian homes with a special meal of symbolic foods. The very thought of life beginning anew each year is a wonderful tradition. It gives reason to give thanks for new beginnings, new experiences, and new friends.

FOLLOWING PAGES: HUNTINGTON BEACH, CALIFORNIA, 2004

Elaborate formal ceremonies are part of Persian culture. At the annual celebration of Nou Rouz, and also at weddings or other celebrations, a traditional and symbolic display is created for the guests. In this case, a Persian Muslim wedding ceremony, the display consists of spices, a mirror in a reflecting pond, candy, the Koran, and other symbolic items which are placed before the wedding couple. This type of elegant display is created by traditional purveyors who actually perform this function at various ceremonies hundreds of times per year.

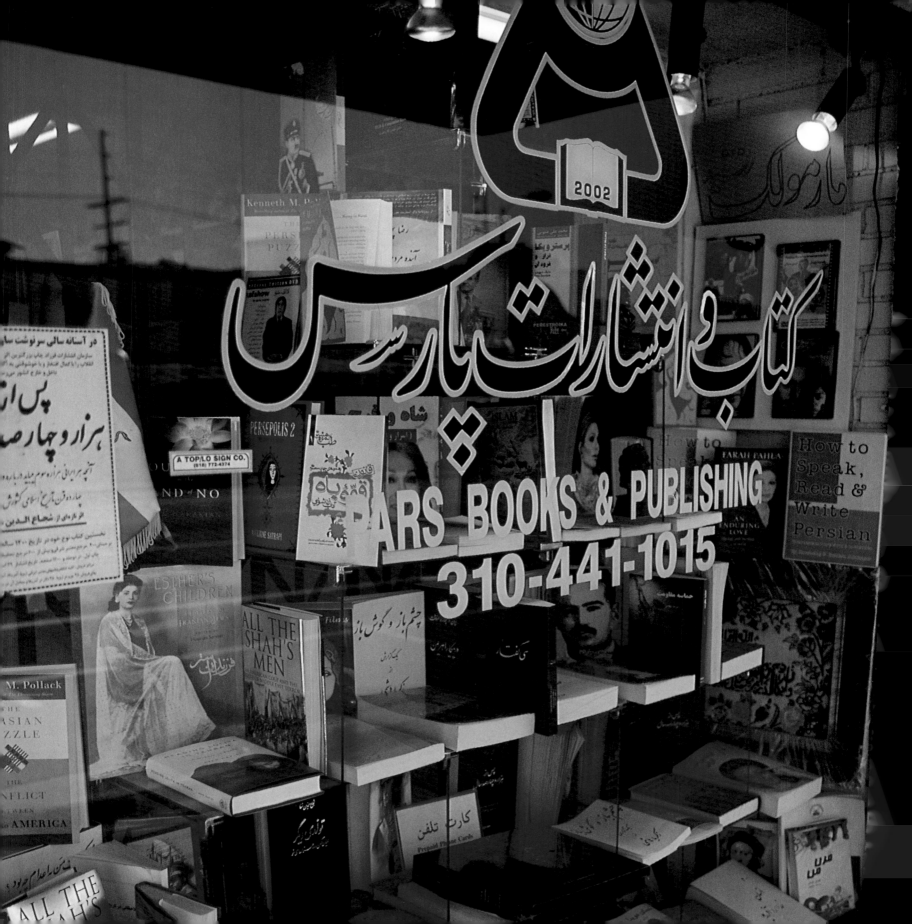

cepting Each Othe

Accepting Each Other

America is so wonderful; extraordinarily unique in that free-dom—and all aspects of its expression—is a privilege shared by every person living in this country. Each of us enjoys civil liberties, such as the freedom to engage in any act that is not injurious to another, to practice our religious beliefs, and to express our political feelings. Each one of us has opportunities for economic advancement and personal achievement. And although all of these freedoms come with responsibilities, we readily accept those responsibilities.

The magnificence of this country in all of its diversity is deeply felt and cherished by us all. Yes, by us all. We are not one monolithic culture, but a diverse group of people of many different cultures that have come together in one location on the planet to allow our dreams to flourish. We are a nation of laws that provide the parameters for our actions; affording us protection from being harmed and from our harming of others. Our Constitution and its Bill of

Rights are the foundation of our unique political and social structure, and guide us in the acceptance of those who come to our shores, whether they are pursuing economic opportunities or seeking refuge from horrific events.

As it has been said many times over, we are all different, but we are one. As illustrated throughout this book, America is one nation of different people with diverse cultures that has evolved into one of the most unique, multicultural societies on the planet. We are each a part of one another. That is the elegance and grace of the American society. It is through shared experiences with one another that we have found the common ground that makes us alike as a people, blurring the line between ethnicities, religions, and physical features. And it is in our diversity that we find our strength, individually and as a nation.

We are an incredible blend of every ethnicity on this planet—"we are one." Our acceptance of that common principle is played out again and again throughout our daily lives, demonstrated by who we marry, who we adopt as children, and who we love. Our diversity works because of the inclusion of the best in all of us. We embrace it, and we celebrate it. Each of us has been enriched by the talents and passions that every new immigrant brings to our collective family. We are grateful, and thankful, for the freedom to experience these differences.

As a marvelous testament to our American culture, we see those of different ethnicities enjoying the differences and diversity of others. We can see a Mennonite man with a Chinese woman, a person of African heritage with a light-skinned Scandinavian. We see Asian, African, European, Latino, and, as in this photograph, an and an Irish woman with a Southeast Asian man. Jews and Arabs, Christians and Muslims, white and black, we are all human beings. When we watch a marathon being run, we see bodies of every shape, color and gender. We celebrate their skills, their core values, and their ethnicities and their diversity for what it is that they bring to us. Each of us is interesting and unique. When we witness children of different ethnicities holding hands at the park and sitting in circles learning from each other, we celebrate that glorious love of each other. When we see those children skipping away from us, holding hands, we know, for certain, our future and its acceptance go with them.

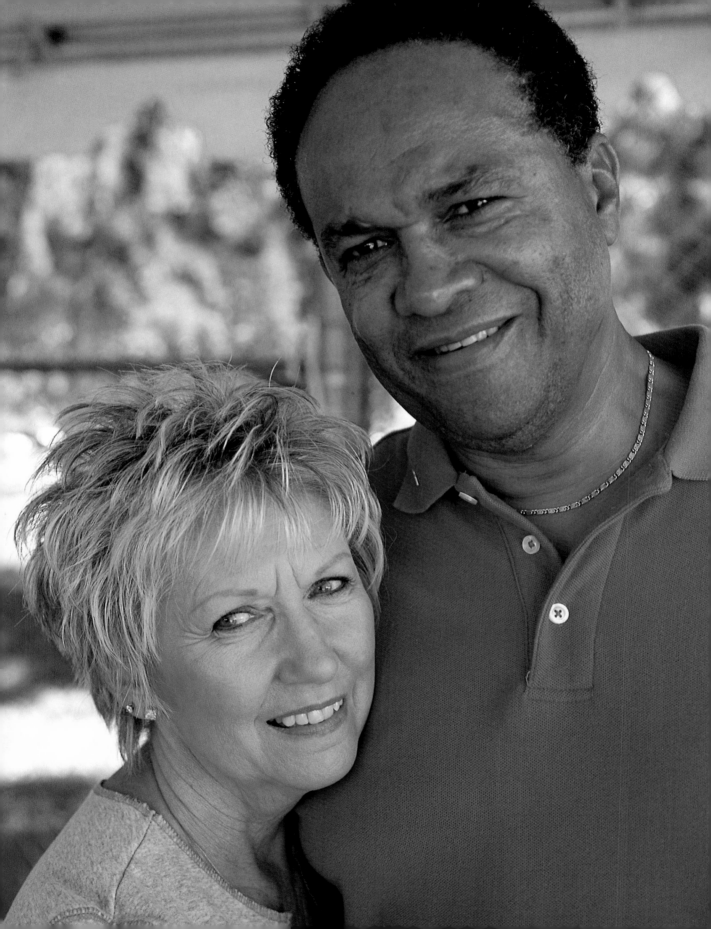

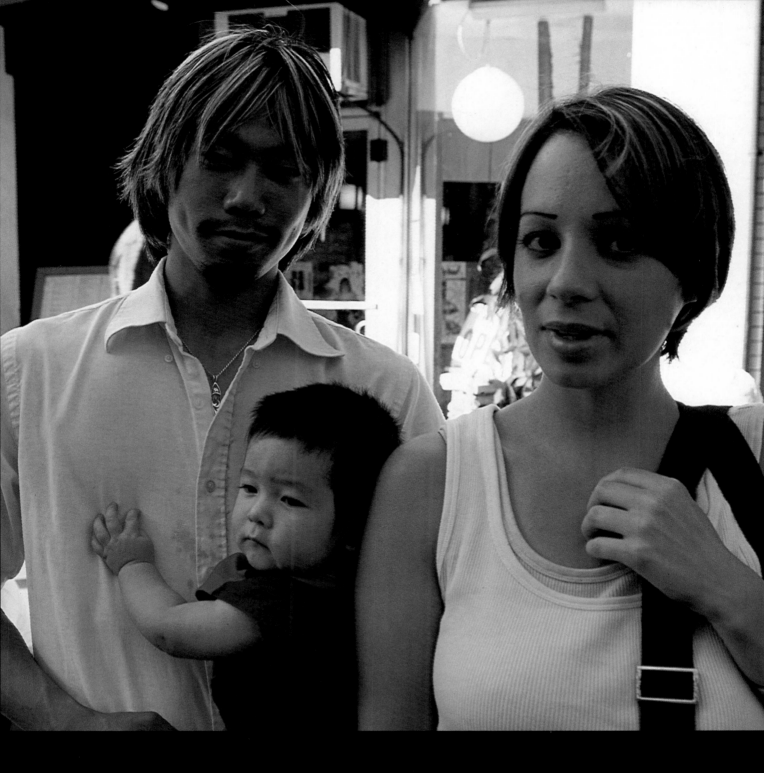

LOS ANGELES, CALIFORNIA, 2004

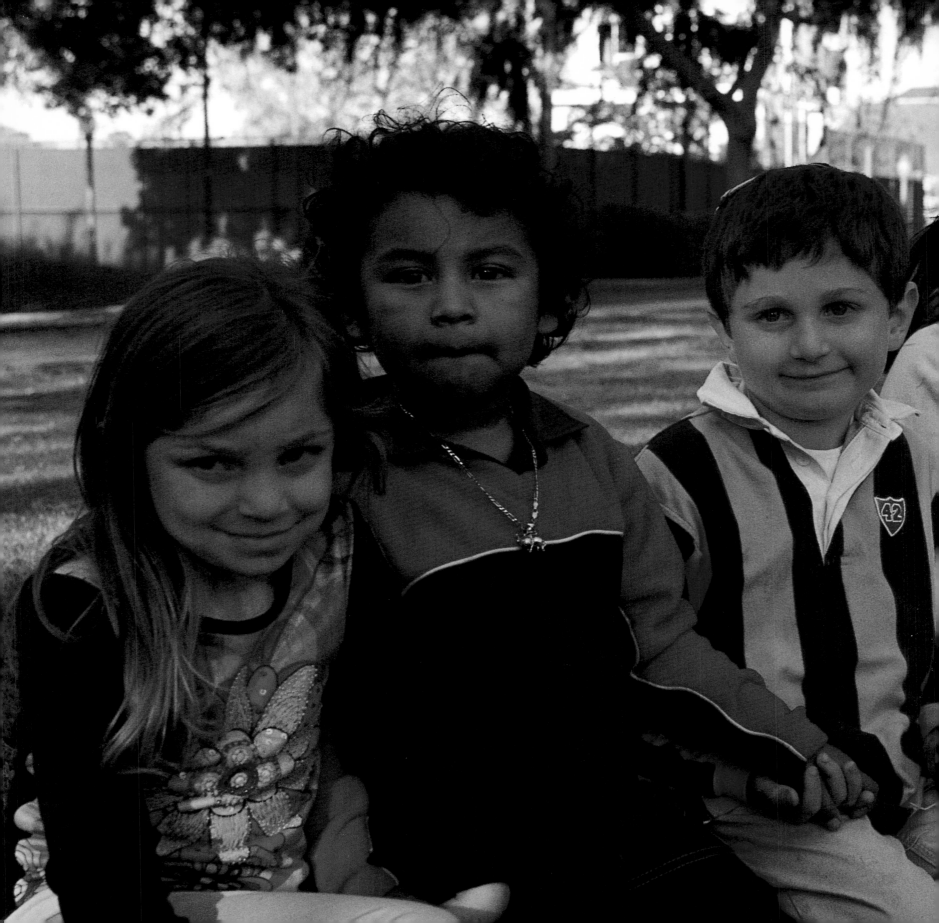

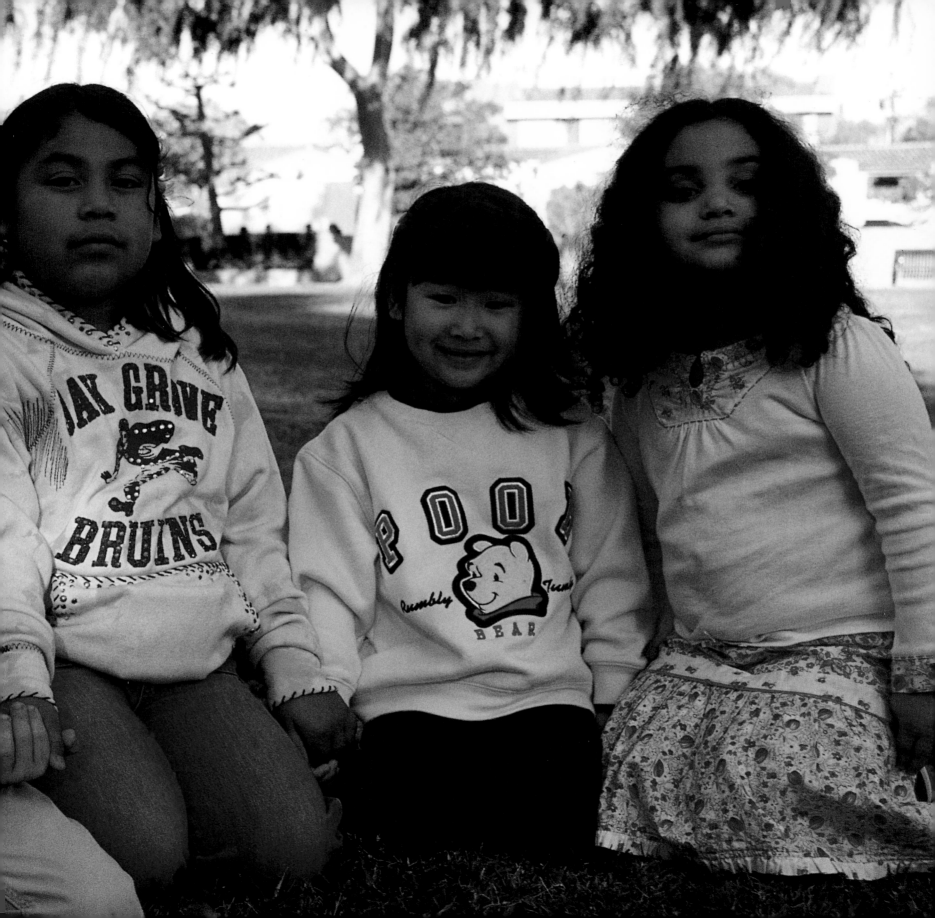

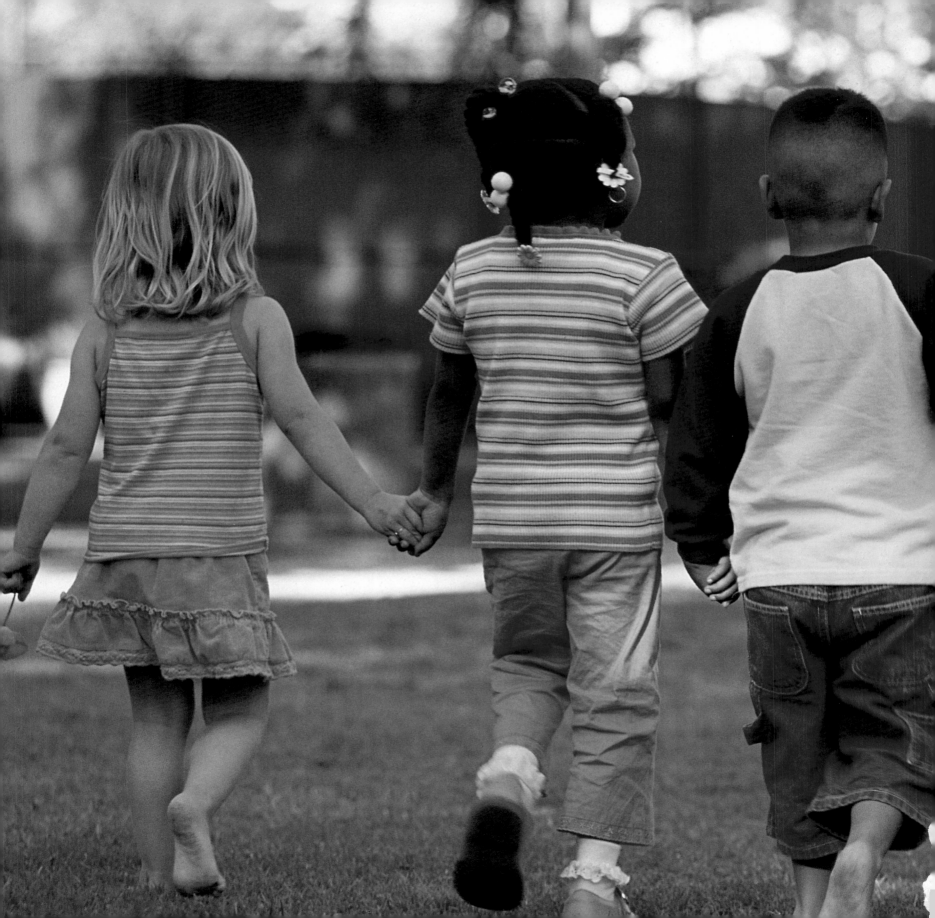

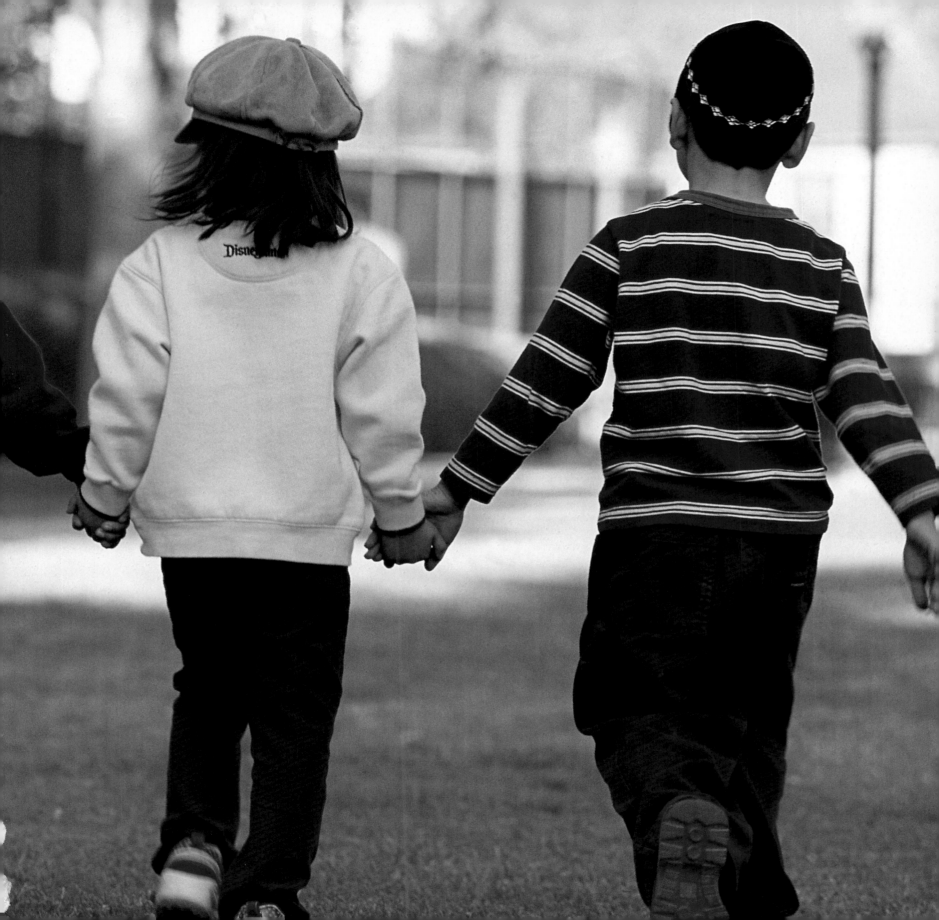

Beyond Words Publishing, Inc.
20827 N.W. Cornell Road, Suite 500
Hillsboro, Oregon 97124-9808
503-531-8700

Consulting Cultural Historian: Dr. Richard Sauers
Editorial Director: Ellen Nagler
Project Editor: Nancy J. Cash
Assisting Editor: Sarabeth Blakey
Proofreader: Marvin Moore
Bibliographer: Shelby Hiles
Cover and Book Design: Deibra McQuiston

Printed in China through Palace Press International
17 Paul Drive
San Rafael, CA 94903
800-809-3792

Library of Congress Cataloging-in-Publication Data

Hiles, Russel
 We are one / Russel Hiles.
 p. cm.
 Includes bibliographical references.
 ISBN 1-58270-133-4
 1. Immigrants—United States—Portraits. 2. Portrait photography.
 3. IHiles, Russel I. Title.

TR681.I54H55 2005
779'.9973—dc22
 2005012607

The corporate mission of Beyond Words Publishing, Inc.:
 Inspire to Integrity

ACKNOWLEDGMENTS

First and foremost, let me thank my four wonderful children who encouraged me at every step to pursue this project. Without their love and support, I never would have started this book, nor would I have finished it.

Also, I want to thank my Nikon cameras for their enduring performance, and amazing reliability. They have been trekked from every corner of the country and back again and have never failed me once. Although Fuji film was used exclusively for this project, my trusty Nikon cameras became my closest companions.

Ed Olmos was my inspirational leader. I had previously seen his magnificent volume entitled "Americanos," and went through it with Ed in some detail. He explained to me that my book will be a further extension of his thinking and needs to be completed. This warm and gracious man, unbeknownst to him, gave me courage and inspiration to complete this long journey.

Next comes my trusty film processor, Doris Sosa, and her tireless printer, Cherie Swann. Without them, I could never have selected the images necessary to put this book together.

Although I fully believed that the hardest part of the project was behind me once I completed the photography, I soon came to realize that I was only partway home. My new friend and tireless worker, Deibra McQuiston, went way above and beyond the call of duty. Not only did she assemble the project, design the book, and put the entire matter together, she constantly listened to the drivel of a new author with the patience of a saint. Thank you, Deibra, you were magnificent.

As with any volume containing text, an author becomes wedded to his or her editors. I was extraordinarily fortunate to have a great editing team. Ellen Nagler, my dear and trusted long-time friend, took the lead in that regard, and without her, my words would never have made it to the pages. Assisted by Richard Sauers and Nancy Cash, the editing team made my feeble script into a readable text.

With the able guidance of Cynthia Black and Richard Cohn at Beyond Words Publishing, my ultimate dream has become a reality. I thank their team, and my distributor, Publishers Group West, for their guidance and patience.

And finally, I cannot ignore the trusted relationship with my printer, Palace Press International, and my publicist, David Thalberg of Planned Television Arts, for all they have contributed and done for me.

BIBLIOGRAPHY

BOOKS

Aldridge, Rebecca. *Italian Americans*. Philadelphia: Chelsea House Publishers, 2003.

Ameri, Anan, and Yvonne Lockwood. *Arab Americans in Metro Detroit: A Pictorial History*. Chicago: Arcadia Publishing, 2001.

Andrews, Susan B., and John Creed. *Authentic Alaska: Voices of its Native Writers*. Lincoln: University of Nebraska Press, 1998.

Angelou, Maya. *I Know Why the Caged Bird Sings*. New York: Random House, 1969.

Angelou, Maya. *The Complete Collected Poems of Maya Angelou*. New York: Random House, 1994.

Angelou, Maya. *The Heart of a Woman*. New York: Random House, 1981.

Anton, Alex, and Roger E. Hernandez. *Cubans in America: A Vibrant History of a People in Exile*. New York: Kensington Books, 2002.

Balletto, Barbara. *Puerto Rico*. Maspeth: Langenscheidt Publishers, 2003.

Barrett, Pam. *Alaska*. Maspeth: Langenscheidt Publishers, 2002.

Bautista, Veltisezar. *The Filipino Americans (1763- Present): Their History, Culture, and Traditions*. Naperville: Bookhaus Publishers, 2002.

Bayor, Ronald H. *Race and Ethnicity in America: A Concise History*. New York: Columbia University Press, 2003.

Bender, Andrew, Martin Robinson, and Rob Whyte. *Korea*. Oakland: Lonely Planet Publications, 2004.

Berman, Eleanor. *New York Neighborhoods*. Guilford: The Globe Pequot Press, 1999.

Borneman, Walter R. *Alaska: Saga of a Bold Land*. New York: HarperCollins Publishers, 2003.

Breining, Greg. *Minnesota*. Oakland: Compass American Guides, 1997.

Bruun, Erik, and Robin Getzen. *Home of the Brave: America's Tradition of Freedom, Liberty, and Tolerance*. New York: Barnes and Noble Books, 1996.

Campbell, Edward D.C. Jr., and Emily J. Salmon. *The Hornbook of Virginia History*. Richmond: The Library of Virginia, 1994.

Cao, Lan and Himilce Novas. *Everything You Need to Know About Asian-American History*. New York: Penguin Books, 2004.

Carrion, Arturo Morales. *Puerto Rico: A Political and Cultural History.* New York: W.W. Norton, 1984.

Chan, Sucheng. *Hmong Means Free: Life in Laos and America*. Philadelphia: Temple University Press, 1994.

Chang, Iris. *The Chinese in America*. New York: Penguin Books, 2003.

Chavez, Linda. *Out of the Barrio*. New York: Basic Books, 1991.

Cofer, Judith Ortiz. *Silent Dancing: A Partial Remembrance of a Puerto Rican Childhood*. Houston: Arte Publico Press, 1990.

Commager, Henry Steele, William E. Leuchtenburg, and Samuel Eliot Morison. *The Growth of the American Republic*. New York: Oxford University Press, 1930.

Conzen, Kathleen Neils. *Germans in Minnesota*. St. Paul: Minnesota Historical Society Press, 2003.

Cordy, Ross. *Exalted Sits the Chief: The Ancient History of Hawai'i Island*. Honolulu: Mutual Publishing, 2000.

Dabney, Virginius. *Virginia: The New Dominion*. Charlottesville: University Press of Virginia, 1971.

Davies, Ben, ed. *Southeast Asia*. Foster City: IDG Books Worldwide, Inc., 2000.

De Vaney, Susan B., Nicholas A. Vacc, and Joe Wittmer. *Experiencing and Counseling Multicultural and Diverse Populations*. Levittown: Accelerated Development, 1995.

Dezell, Maureen. *Irish America: Coming into Clover*. New York: Anchor Books, 2000.

Dillehay, Thomas D. *The Settlement of the Americas: A New Prehistory*. New York: Basic Books, 2000.

Diner, Hasia R. *Lower East Side Memories: A Jewish Place In America*. Princeton: Princeton University Press, 2000.

Doyle, Robert E. *Our Continent: A Natural History of North America*. Washington, D.C.: National Geographic Society, 1976.

Dumas, Firoozeh. *Funny In Farsi: A Memoir of Growing Up Iranian in America*. New York: Villard Books, 2003.

Elliot, Nan. *Best Places: Alaska*. Seattle: Sasquatch Books, 2000.

Espiritu, Yen Le. *Asian America Panethnicity: Bridging Institutions and Identities*. Philadelphia: Temple University Press, 1992.

Espiritu, Yen Le. *Filipino American Lives*. Philadelphia: Temple University Press, 1995.

Fagan, Brian M. *Ancient North America: The Archaeology of a Continent*. New York: Thames and Hudson Ltd, 1991.

Fischer, David Hackett. *Albion's Seed: Four British Folkways in America*. New York: Oxford University Press, 1989.

Forbes, David W. *Hawaiian National Bibliography 1780-1900*. Honolulu: University of Hawai'i Press, 1999.

Friedman, Bonnie, and Paul Wood. *Hawaii*. New York: Dorling Kindersley Publishing, 1998.

Fuchs, Lawrence H. *The American Kaleidoscope: Race, Ethnicity, and the Civic Culture*. Hanover: Wesleyan University Press, 1990.

Fuson, Robert H. *Juan Ponce De Leon and the Spanish Discovery of Puerto Rico and Florida*. Virginia: The McDonald & Woodward Publishing Company, 2000.

Gabaccia, Donna R. *Immigration and American Diversity: A Social and Cultural History*. Malden: Blackwell Publishers, Ltd., 2002.

Garvey, Joan B., and Mary Lou Widmer. *Beautiful Crescent: A History of New Orleans*. New Orleans: Garmer Press, 1982.

Gonzales, Manuel G. *Mexicanos: A History of Mexicans in the United States*. Bloomington: Indiana University Press, 1999.

Gordon, Sue. *Boston*. New York: Fodor's Travel Publications, 1997.

Graves, Kerry A. *Irish Americans*. Philadelphia: Chelsea House Publishers, 2003.

Hakim, Joy. *Freedom: A History of Us*. New York: Oxford University Press, 2003.

Halter, Marilyn. *Shopping For Identity: The Marketing of Ethnicity*. New York: Schocken Books, 2000.

Hatchwell, Emily. *Florida*. New York: DK Publishing, 1997.

Henderson, Horace Edward. *The Scots of Virginia: America's Greatest Patriots*. Philadelphia: Xlibris Corporation, 2001.

Henderson, Timothy J., and Gilbert M. Joseph. *The Mexico Reader: History, Culture, Politics*. Durham: Duke University Press, 2002.

Hertzberg, Arthur. *The Jews In America*. New York: Columbia University Press, 1997.

Hightower-Langston, Donna. *The Native American World*. Hoboken: John Wiley and Sons, Inc., 2003.

Himmelfarb, Gertrude. *One Nation, Two Cultures*. New York: Vintage Books, 1999.

Hoobler, Dorothy, and Thomas Hoobler. *The Scandinavian American Family Album*. New York: Oxford University Press, 1997.

Horowitz, Donald L. *Ethnic Groups in Conflict*. Berkeley: University of California Press, 1985.

Hostetler, John A. *Amish Society*. Baltimore: The Johns Hopkins University Press, 1963.

Hurh, Won Moo. *The Korean Americans*. Westport: Greenwood Press, 1998.

Hutchens, Jerry Lee. *Powwow Calendar 2003*. Summertown: Native Voices, 2002.

Hutchinson, John and Anthony D. Smith. *Ethnicity*. Oxford: Oxford University Press, 1996.

Hutchinson, Thomas. *The History of the Colony and Province of Massachusetts-Bay*. Harvard University Press, 1936.

Johnson, Charles and Patricia Smith. *Africans in America: America's Journey Through Slavery*. New York: Harcourt, Inc., 1998.

Jones, Colin. *France*. New York: Cambridge University Press, 1994.

Jordan, Terry L. *The U.S. Constitution and Fascinating Facts About It*. Naperville: Oak Hill Publishing Company, 2002.

Kalita, S. Mitra. *Suburban Sahibs*. New Brunswick: Rutgers University Press, 2003.

Kane, Herb Kawainui. *Ancient Hawai'i*. Captain Cook: The Kawainui Press, 1997.

Katz, Daniel R. *Why Freedom Matters*. New York: Workman Publishing, 2003.

Kishinevsky, Vera. *Russian Immigrants In The United States: Adapting To American Culture*. New York: LFB Scholarly Publishing LLC, 2004.

Kohler, John Michael. *Hmong Art: Tradition and Change*. Wisconsin: John Michael Kohler Arts Center, 1986.

Laes, Ron. *The Art of Hula*. Maui: Goldsmiths Publishing, 1996.

409

Langdon, Steve J. *The Native People of Alaska: Traditional Living in a Northern Land*. Anchorage: Greatland Graphics, 2002.

Lee, Joann Faung Jean. *Asian Americans*. New York: The New Press, 1991.

Leeson, Pat, and Tom Leeson. *The American Eagle*. Hillsboro: Beyond Words Publishing, 1994.

Leyburn, James G. *The Scotch Irish*. Chapel Hill: The University of North Carolina Press, 1962.

Lunn, Julia, and Peter Winfield. *Ultimate Pocket Book of the World Atlas*. New York: DK Publishing, 1996.

Macartney, C.A. *Hungary: A Short History*. PocketPCPress, 2000.

Martinez, Ruben. *The New Americans*. New York: The New Press, 2004.

Mattern, Joanne. *Japanese Americans*. Philadelphia: Chelsea House Publishers, 2003.

Matthiessen, Peter. *Sal Si Puedes (Escape If You Can)*. Berkeley: University of California Press, 1969.

Meier, Matt S., and Feliciano Ribera. *Mexican Americans/American Mexicans: From Conquistadors to Chicanos*. New York: Hill and Wang, 1972.

Michener, James A. *Alaska*. New York: Random House Trade Paperbacks, 2002.

Mirak, Robert. *Torn Between Two Lands: Armenians in America, 1890 to World War I*. Cambridge: Harvard University Press, 1983.

Mitchell, Donald D. Kilolani. *Resource Units in Hawaiian Culture*. Honolulu: Kamehameha Schools Press, 1982.

Monge, Jose Trias. *Puerto Rico: The Trials of the Oldest Colony in the World*. New Haven and London: 1999.

Monterrey, Manuel, Edward James Olmos, and Lea Ybarra. *Americanos: Latino Life in the United States*. Boston: Little, Brown and Company, 1999.

Morgenroth, Lynda. *Boston Neighborhoods*. Guilford: The Globe Pequot Press, 2001.

Moslehi, Shahnaz. *An Introduction to Iranian Culture*. Canoga Park: Eqbal Printing and Publishing, 1987.

Nagel, Joane. *American Indian Ethnic Renewal: Red Power and the Resurgence of Identity and Culture*. New York: Oxford University Press, 1996.

Neville, Peter. *A Traveller's History of Russia*. New York: Interlink Books, 2001.

Nguyen, Kien. *The Unwanted: A Memoir of Childhood*. Boston: Little, Brown and Company, 2001.

Niiya, Brian. *Encyclopedia of Japanese American History: An A-to-Z Reference from 1868 to the Present*. New York: Checkmark Books, 2001.

Nolt, Steven. *A History of the Amish*. Good Book, 1992.

Notes, Akwesasne. *Basic Call To Consciousness*. Summertown: Native Voices, 1978.

Olmert, Michael. *Official Guide to Colonial Williamsburg*. Williamsburg: The Colonial Williamsburg Foundation, 1998.

Oppenheimer, Stephen. *The Real Eve: Modern Man's Journey Out of Africa*. New York: Carroll and Graf Publishers, 2003.

Oswalt, Wendell H. *Eskimos and Explorers*. Lincoln: University of Nebraska Press, 1999.

Paine, Thomas. *Common Sense*. Hinesville: The Nova Anglia Company, 1776.

Portes, Alejandro. *The Economic Sociology of Immigration: Essays on Networks, Ethnicity, and Entrepreneurship*. New York: Russell Sage Foundation, 1995.

Portes, Alejandro and Ruben G. Rumbaut. *Immigrant America: A Portrait*. Berkeley: University of California Press, 1996.

Portes, Alejandro and Ruben G. Rumbaut. *Legacies: The Story of the Immigrant Second Generation*. Berkeley: University of California Press, 2001.

Pyrah, Carolyn. *Vienna*. New York: DK Publishing, 1994.

Ramos, Jorge. *The Other Face of America*. New York: HarperCollins Publishers, 2002.

Rouse, Irving. *The Tainos: Rise and Decline of the People Who Greeted Columbus*. New Haven and London, Publishers, 1993.

Rushdie, Salman. *Fury*. New York: The Modern Library, 2002.

Sanchez, George J. *Becoming Mexican American: Ethnicity, Culture and Identity in Chicano Los Angeles, 1900-1945*. New York: Oxford University Press, 1993.

Sanders, Ronald. *The Lower East Side Jews: An Immigrant Generation*. Mineola: Dover Publications, Inc., 1969.

Santiago, Esmeralda. *When I Was Puerto Rican*. New York: Vintage Books, 1993.

Schlesinger, Arthur M. Jr. *The Almanac of American History*. New York: Barnes and Noble Books, 1993.

Shapiro, Martin. *The Constitution of the United States and Related Documents*. Wheeling: Harlan Davidson, Inc., 1966.

Shaw, Antony. *Portable Ireland: A Visual Reference To All Things Irish*. Philadelphia: Running Press, 2002.

Sinclair, Mick. *Miami*. New York: Fodor's Travel Publications, 1997.

Sonneborn, Liz. *German Americans*. Philadelphia: Chelsea House Publishers, 2003.

Suarez-Orozco, Carola, and Marcelo M. Suarez-Orozco. *Children of Immigration*. Cambridge: Harvard University Press, 2001.

Takaki, Ronald. *A History of Asian Americans: Strangers From a Different Shore*. Boston: Little, Brown and Company, 1989.

Takaki, Ronald. *A Larger Memory: A History of Our Diversity, With Voices*. Boston: Little, Brown and Company, 1998.

Tarrant-Reid, Linda. *Discovering Black New York*. New York: Citadel Press, 2001.

Time-Life Books. *The Way of the Spirit*. Virginia: Time-Life Inc., 1997.

Tong, Benson. *The Chinese Americans*. Boulder: The University Press of Colorado, 2003.

Uba, Laura. *Asian Americans: Personality Patterns, Identity, and Mental Health*. New York: The Guilford Press, 1994.

Valent, Dani. *New York City*. Melbourne: Lonely Planet Publications, 2002.

Van Middeldyk, R.A. *The History of Puerto Rico from the Spanish Discovery to the American Occupation (The Puerto Rican Experience)*. Ayer Company Publishing, 1975.

Vardy, Steven Bela. *The Hungarian-Americans*. Boston: Twayne Publishers, 1985.

Waldman, Carl. *Atlas of The North American Indian*. New York: Checkmark Books, 2000.

Wallner, Rosemary. *Greek Immigrants 1890-1920*. Mankato: Capstone Press, 2003.

Wallner, Rosemary. *Polish Immigrants 1890-1920*. Mankato: Capstone Press, 2003.

Williams, China. *New Orleans*. Melbourne: Lonely Planet Publications, 2003.

Zelinsky, Wilbur. *Cultural Geography of the United States.* Revised edition. New Jersey: Prentice Hall, 1996.

Zelinsky, Wilbur. *Enigma of Ethnicity: Another American Dilemma.* Iowa City: University of Iowa Press, 2001.

Zenfell, Martha Ellen. *New Orleans*. Maspeth: Langenscheidt Publishers, 2001.

Zinn, Howard. *A People's History of the United States 1942-Present*. New York: HarperCollins Publishers, 1980.

ARTICLES

Chavez, Stephanie. "The Flowering of Cinco de Mayo." *The Los Angeles Times*, May 6, 2003.

Chester County, Pennsylvania. *Chester County Official Visitors Guide*, Fall/Winter 2003.

Colvin, Russ. *Highland Gathering and Festival*, May 24, 2003.

"Defining America." *U.S. News and World Report*, June 28/July 5, 2004.

"Diversity Works." *The New York Times Magazine*, September 14, 2003, p. 74.

Garvey, Sarah. "Happy in His Job, Jurist Loves Blues, Isn't Singing 'Em." *The Los Angeles Daily Journal*, November 13, 2003.

Getlin, Josh. "Mexicans Finding a Place in a City of Immigrants." *The Los Angeles Times*, October 6, 2003.

Grow, Brian. "Hispanic Nation." *Business Week*, March 15, 2004, p. 58.

"Island-Style Accommodations." *American Way*, October 15, 2003.

Jones, Grahame L. "MLS All-Stars Win Game, Then Praise." The *Los Angeles Times*, August 3, 2003.

Kang, K. Connie. "Marvelous Modesty." *The Los Angeles Times*, November 11, 2003.

Klestoff, Michael Y. *Russian Festival*. February 21, 2003.

Lancaster County, Pennsylvania. *Lancaster County Map and Visitors Guide*, 2001.

Lavery, Brian. "Mitchell Scholars Delve Into Irish Culture, Too." *The New York Times*, July 30, 2003.

Mathews, Derek. *Gathering of Nations Powwow*, April 24, 2003.

McClure, Rosemary. "A Sea Change on Oahu." *The Los Angeles Times*, September 28, 2003.

McLeod, Paul. "Standing Together." *The Los Angeles Times*, May 1, 2003.

Mulkey, Stan. *This Week Big Island*. September 1, 2003.

Murphy, Dean E. "This Land Is Made, Finally, for Chinese Settlers." *The New York Times*, June 29, 2003.

Nakazawa, Donna Jackson. "A New Generation is Leading the Way." *Parade Magazine*, July 6, 2003, p. 4.

Neuman, Johanna, and Emma Schwartz. "This Time, It's Native Americans Who Stake a Claim to Prime Land." *The Los Angeles Times*, September 22, 2004.

New Ulm Convention and Visitors Bureau. *New Ulm Minnesota: 2003 Visitors Guide*, 2003.

Peirson, David. "Mainlanders Make Mark Among Chinese Emigres." *The Los Angeles Times*, August 13, 2003.

Perry, Tony. "$2-Million Donation Fits Tribe's Bold Profile." *The Los Angeles Times*, September 3, 2003.

Peterson, Karen S. "Adoptions Reflect Diversity." *USA Today*, August 25, 2003.

Quintanilla, Michael. "Of Culture and Commodity." *The Los Angeles Times*, June 4, 2003.

Romney, Lee. "Bill Spurs Bitter Debate Over Hmong Identity." *The Los Angeles Times*, May 24, 2003.

Rosenblatt, Susannah. "Tribes With Casino Profits Averse to Aiding Strapped States." *The Los Angeles Times*, July 10, 2003.

Sauerwein, Kristina. "Award-Winning Professor Sees Art in Science." *The Los Angeles Times*, April 11, 2004.

Sondheimer, Eric. "Persistence Pays Off for the Turcios Family." *The Los Angeles Times*, February 1, 2004.

Stammer, Larry B. "Menorahs' Designs Tell Stories of Freedom." *The Los Angeles Times*, December 13, 2003.

Wiesel, Elie. "Why I Am An American." *Parade*, July 4, 2004.

NETWORK RESOURCES

Park, Kyeyoung. "Korean Organizations in Queens." Online. Availablehttp://www.qc.edu/Asian_American_Center/aac_menu/ research_resources/aacre2 1.html, April 12, 2003.

Santos, Hector. "A Short History of PHGLA." Online. Available http://www.bibingka.com/phg/phg.htm, April 12, 2003.

Siasoco, Ricco Villanueva. "Japanese Relocation Centers." Online. Available http://www.infoplease.com/spot/internment1.html, April 22, 2005.

Silverman, Deborah Anders. "Polish-American Folklore." Online. Available http://wings.buffalo.edu/info-poland/DAS.html, April 13, 2003.

"A Brief History of the Hungarian Society." Online. Available http://www.epixmed.com/hunsocma/egyesulet/egyesulet_hist_en.htm, April 11, 2003.

"Adios, Borinquen Querida: The Puerto Rican Diaspora, its History, and Contributions." Online. Available http://www.albany.edu/celac diaspeng.htm, April 12, 2003.

"American Hungarian Folklore Centrum." Online. Available http://www.magyar.org, April 11, 2003.

"American-Scandinavian Foundation of Los Angeles." Online. Available http://asfla.org, April 12, 2003.

"America's Polish American Community." Online. Available http://www.polish.org/en/frames/Old/com_com_main.html, August 5, 2003.

"Black Heritage Festival 2203: Schedule of Events." Online. Available http://www.savstate.edu/news/bhf03/schedule.htm, February 2, 2003.

"California Journal for Filipino Americans." Online. Available http://www.cjfilam.com, April 12, 2003.

"Chinese American Cultural Bridge Center." Online. Available http://www.cacbc.org/About/InterestingFacts.htm, April 12, 2003.

"Chinese Culture Center's Calendar." Online. Available http://www.c-c-c.org/act/calendar.html, February 2, 2003.

"Chinese Holidays." Online. Available http://www.sandiego-online.com/forums/Chinese/htmls/holidays.htm, April 12, 2003.

"Council for the Development of French in Louisiana." Online. Available http://www.codofil.org/english/links.html, April 12, 2003.

"C.R.E.O.L.E., Inc." Online. Available http://www.creoleinc.com/index2.htm, April 12, 2003.

"Cultural H through M." Online. Available http://southflorida.sun-sentinel.com/news/multicultural/cultural3.htm, April 11, 2003.

"Eastern Europeans." Online. Available http://www.carnegielibrary.ort/subject/ethnic/easteuropean.html, September 29, 2003.

"Explore North- The World Eskimo-Indian Olympics." Online. Available http://www.explorenorth.com/library/aktravel/bl-eskolympics.htm, April 7, 2003.

"Fairbanks, Calendar of Events." Online. Available http://www.fairbanksvisitors.com/artman/publish/article_105.shtml, April 7, 2003.

"Family, Home, and Heritage." Online. Available http://www.wmich.edu/evalctr/arlen/webdoc4.htm, April 12, 2003.

"Federation of Filipino American Associations, Inc." Online. Available http://www.ffaai.org/about.shtml, April 12, 2003.

"Festivals La Louisianne." Online. Available http://www.intersurf.com/~aevinc/05fest.htm, April 12, 2003.

"Filipino American Service Group." Online. Available http://www.fasgi.org, April 12, 2003.

"French-American Organizations, sites and events." Online. Available http://www.cs.iupui.edu/~smckee/ethnic_france.html, April 12, 2003.

"French-American Relations." Online. Available http://www.info-france-usa.org/franceus/culture.asp, April 12, 2003.

"French-Americans in the Civil War." Online. Available http://www.civilwarhome.com/french.htm, April 12, 2003.

"French Culture." Online. Available http://www.frenchculture.org/people/index.html, April 12, 2003.

"French Festival." Online. Available http://www.frenchfestival.com, April 12, 2003.

"German-American Festival." Online Available http://www.gafsociety.com/festival/festivalmain.html, August 4, 2003.

"Hispanic Influences on Culture and Politics." Online. Available http://www2.worldbook.com/features/cinco/html/influences.htm, April 12, 2003.

"Hungarians and their Communities in Cleveland." Online. Available http://web.ulib.csuohio.edu/hungarians/pg208.htm, April 11, 2003.

"Hungarian Announcements & News." Online. Available http://hungaria.org/han.php?topicid=621&messageid=657, May 21, 2004.

"Hungarians in America." Online. Available http://www.euroamericans.net/hungarian.htm, April 11, 2003.

"Immigration and Racial Elements." Online. Available http://newdeal.feri.org/guides/mn/ch06.htm, August 5, 2003.

"Japanese American Cultural & Community Center." Online. Available http://www.jaccc.org/event_%2Orelated/festivals.html, February 2, 2003.

"Korean American Professionals Society." Online. Available http://www.seattlekaps.org/contact.html, April 12, 2003.

"Korean Cultural Center, Los Angeles." Online. Available http://www.kccla.org/html.contactus.asp, April 12, 2003.

"Latin American Folk Institute." Online. Available http://www.lafi.org/events/festival.html, April 12, 2003.

"Los Angeles Connections Korean Americans." Online. Available http://www.msmc.la.edu/ccf/LAC.Korean.html, April 12, 2003.

"Louisiana Folk Roots." Online. Available http://lafolkroots.org/0_Main/FrameLogos.htm, April 12, 2003.

"Mexican American Research Guide." Online. Available http://www.usc.edu/isd/archives/ethnicstudies/mex_main.html April 12, 2003.

"Mexican American Traditional Arts and Culture." Online. Available http://beta.open.k12.or.us/start/visual/basics/folk/vbas9c.html, April 12, 2003.

"Ministry of Culture & Tourism, Republic of Korea." Online Available http://www.mct.go.kr/english/K-_heritage/overview.html, April 12, 2003.

"National Puerto Rican Coalition, Inc." Online. Available http://www.bateylink.org/about.htm, April 12, 2003.

"National Puerto Rican Day of New York." Online. Available

http://www.gale.com/free_resources/chh/activities/puerto.htm, April 12, 2003.

"Pageantry Productions 2003 Parade List." Online. Available http://www.pageantryproductions.com/parlist4.html, February 2, 2003.

"Polish American Cultural Institute of Minnesota." Online. Available http://www.pacim.org, August 5, 2003.

"Puerto Rico." Online. Available http://www.nyise.org/caribe, April 12, 2003.

"Puerto Rican Day Parade." Online. Available http://www.nyc.com/list.aspx?e=attractionID&s=720&v=122, June 10, 2004.

"San Francisco Festivals." Online. Available http://sanfrancisco.about.com/library/blfest4.htm, April 12, 2003.

"Scandinavian American Heritage Society." Online. Available http://www.sahsnj.org/aboutus.html, April 12, 2003.

"South of the Border." Online. Available http://www.ruizfood.com/sotb/festivals_celebrations.htm, April 12, 2003.

"The Polish American Studies Fund: Ensuring the Future of the IHRC's Polish American Collection." Online. Available http://www1.umn.edu/ihrc/endw-cpol.htm, August 5, 2003.

"The Scandinavian-American Heritage." Online. Available http://www.gjenvick.com/lib/book/scandinavian/0816016267.html, April 12, 2003.

"World Eskimo-Indian Olympics." Online. Available http://www.weio.org, April 7, 2003.

"World Eskimo-Indian Olympics-A History." Online. Available http://www.ankn.uaf.edu/nativegames/wei-olympics.html, April 7, 2003.

"You Decide: Was the Wartime Internment of Japanese Americans Appropriate?" Online. Available http://www.learner.org/biography ofamerica/prog22/feature. April 22, 2005.

414